THE HERMITAGE
LENINGRAD

THE HERMITAGE

ENGLISH ART

SIXTEENTH TO NINETEENTH CENTURY

PAINTINGS, SCULPTURE,

PRINTS AND DRAWINGS

MINOR ARTS

AURORA ART PUBLISHERS • LENINGRAD

COLLET'S PUBLISHERS LIMITED • LONDON & WELLINGBOROUGH

Compiled and introduced by LARISSA DUKELSKAYA

Notes on the plates
by NINA BIRIUKOVA (29, 31–34, 81, 82, 185, 186, 325–327, 350–352);
KIRA BUTLER and RODA SOLOVEICHIK (111–118, 187–204, 210, 211,
245–250, 277–287, 290, 291, 337, 338); MAGDALINA DOBROVOLSKAYA
(62–65, 91, 92, 309, 310, 323, 324); LARISSA DUKELSKAYA (70, 72–78,
83, 84, 165, 167–179, 253–266, 317, 318); OLGA GOMZINA and
XENIA GRIAZEVA (119–121, 328–331, 344–349); YULIA KAGAN (7, 8,
13, 17, 26, 220–244); ASYA KANTOR-GUKOVSKAYA (39–42,
162–164, 166, 251, 252, 294, 301, 305, 334–336); MILITSA
KORSHUNOVA (149, 150, 158–161); NINA KOSAREVA (145–148);
ALEXANDRA KROL (4, 6, 20, 21, 35, 43–46, 71, 123–144, 267, 268,
295–300, 302–304, 306–308, 332, 333, 353, 354); MARINA LOPATO
(1, 30, 53–61, 66–69, 85–90, 93–110, 122, 180, 181, 205–209, 216–219, 269,
288, 289); OLGA MIKHAILOVA (319, 320, 339–343); YURY MILLER
(5, 270, 321, 322); NADEZHDA PETRUSEVICH (16, 36–38, 212–215);
TAMARA RAPPE (80, 182–184, 271–276); YEVGENIA SHCHUKINA
(2, 3, 9–12, 14, 15, 18, 19, 22–25, 47–52, 292, 293, 309–316);
TATYANA TUMANOVA (27, 28, 79); ANNA VORONIKHINA (151–157)

Designed by IRINA PTAKHOVA

Photographs by LYDIA TARASOVA

Translated from the Russian
by PHILIP TAYLOR, NELLY FIODOROVA, MIKHAIL KHAZIN,
ALLA PEGULEVSKAYA, VERONIKA SALYE,
YURY TRETYAKOV, INNA VASILEVICH, VLADIMIR VEZEY,
YELENA YABLOCHKINA, VARVARA YELISEYEVA

ISBN 569-08426-1

© Aurora Art Publishers, Leningrad, 1979
PRINTED AND BOUND IN AUSTRIA
GLOBUS, VIENNA

The Hermitage collection of English art, which includes works of painting, graphics and applied art, is notable for its variety. Its beginnings go back to the last quarter of the eighteenth century. It was at this period that the collection began to take shape and that attempts were made to acquire works in a systematic way.[1] However, the first examples of English art found their way to Russia as early as the late sixteenth century, chiefly in the form of silverware brought as gifts from foreign embassies.

Between 1730 and 1760 a number of very fine objects in silver by distinguished English craftsmen were acquired for the Imperial palaces. For example, in 1731–32 Nicholas Clausen of London produced a number of chased plaques in silver gilt to decorate the throne of Empress Anna Ivanovna. Towards the end of the 1730s a twenty-four piece toilet set was purchased from Edward Vincent for Duke Biron, a favourite of Anna Ivanovna. Many of the pieces were made in the 1720s by other craftsmen and were subsequently finished by Vincent in the mature rococo style. From this period also, dates a capacious wine cooler — the unique work of Charles Kandler — striking for its monumental forms and elaborate decoration. A fine example of the late rococo style is the so-called Oranienbaum service produced between 1745 and 1758 by Nicholas Sprimont, Thomas Hemming and Fuller White in an elaborate, sumptuous manner making wide use of oriental motifs. The most remarkable acquisition of this period, however, was some of the early works of Paul de Lamerie: a wine cooler, a wine fountain and a toilet box from the Biron set. Unique and finely wrought ornamentation, variety and an exceptional nobility of form are the hall-mark of this original craftsman who was the foremost exponent of English applied art in the eighteenth century. The acquisition of some superb jewellery, particularly of châtelaine watches, also dates from this period.

As we have noted above, the systematic acquisition of works by English artists began in the last quarter of the eighteenth century, when purchases were made on the orders of Catherine II for the decoration of the Winter Palace and the Empress's country residences. In the eighteenth century Russia was one of the few, if not the only country in Europe, interested in English art. In 1779, on the advice of Count Alexei Musin-Pushkin, the Russian ambassador in London, the famous Houghton Hall collection of paintings, which

had previously belonged to Robert Walpole, was acquired. This acquisition laid the foundations of the Hermitage collection of English painting. Alongside works by Continental masters, the Hermitage collection was now enriched by paintings of such English artists as Hans Eworth, William Dobson, Peter Lely, John Wootton and Godfrey Kneller — the founders of the English national school of painting. The works of Dobson and Lely may be considered the culmination of seventeenth century English art, and show their adherence to the Van Dyck tradition. Two superb portraits by Kneller revealing keen psychological insight and fidelity, bear witness to the flourishing state of eighteenth century portrait painting. The name of John Wootton is associated with the emergence of the uniquely English genre: sporting painting. These canvases now introduce the visitor into the first of the halls devoted to English art in the Hermitage.

At the end of the eighteenth century three large pictures were purchased from the painter Joseph Wright. These were *An Iron Forge* and a pair of landscapes, *The Eruption of Vesuvius*[2] and *Firework Display at the Castel Sant'Angelo*. Benedict Nicolson, a major authority on the art of Wright, comments on this event as follows: "It is astonishing that the only ripple Wright ever stirred up on the European continent was in remote St. Petersburg, before he was forty and before he had achieved comparable success in his own country town."[3] To this day there are few works[4] by this highly original painter, who was the first to take up the themes and subjects of the Industrial Revolution, in the major Western European collections. These three marvellous canvases, and in particular *An Iron Forge*, with its somewhat mysterious and pensive quality, show Joseph Wright to be an artist attuned to the spirit of the approaching Romantic era.

Even in the eighteenth century *An Iron Forge* captured the attention of art specialists. Johann Georgi, the noted traveller and scholar, who, in 1774, compiled a detailed description of St. Petersburg and its art collections, wrote: "Joseph Wright. Three pictures, of which the best depicts an iron forge at night."[5] The picture continued to attract attention in the twentieth century. In 1921 the well-known Russian painter and art historian Alexander Benois published an article on Joseph Wright providing a deep insight into the English painter's work. He wrote about *An Iron Forge*: "This picture offers a magnificent proof of Wright's consummate craftsmanship. To this day it enchants the viewer with its graceful contrasts, the tangible depth of its darker areas and the gentle power of its illumination...

Wright's picture presents a fragment of life the way he perceived it, and in this lies its chief merit, its undefinable charm, the quality that makes it into a work of lasting artistic significance."[6]

Between 1787 and 1797 one of the best known and most important works of Thomas Jones, *Landscape with Dido and Aeneas*, was acquired. The art of Thomas Jones, a pupil of Richard Wilson, one of the foremost English painters of the eighteenth century, still tends towards the classical tradition, but the Hermitage landscape is marked by a greater spirituality and a higher emotional intensity than his other works. Jones valued this picture very highly and wrote in his *Memoirs*: "...in March last I began the Picture (a Storm) which was now finished, and in which my friend Mortimer had introduced the Story of Dido and Aeneas retiring to the Cave from Virgil — This was one of the best Pictures I ever painted, and attracted much attention — My friend Wollett with an Ardour of inclination, immediately engaged to engrave a print from it..."[7]

In 1788 Prince Potiomkin bought from Joshua Reynolds, first president of the Royal Academy of Arts and one of England's greatest painters, his *Cupid Untying the Girdle of Venus*. A year later, the Hermitage acquired two of the master's large historical canvases: *The Infant Hercules Strangling the Serpents* and *The Continence of Scipio*. The negotiations between Catherine II and Reynolds were carried out by the British ambassador in St. Petersburg, Lord Carysfort, who had pointed out to the Empress the lack of works by the celebrated English painter in the Hermitage. Historical canvases are neither the best nor the most original aspect of Reynolds's work, but these Hermitage paintings are amongst those which merit the greatest attention. Perhaps it is precisely in these works that Reynolds expressed most fully and logically the idea of the morally ennobling function of the historical genre to which he alludes in his *Discourses*.[8] The history painter and classical scholar James Barry, Reynolds's contemporary, admired *Hercules* and deeply regretted that "...this picture is in the hands of strangers, at a great distance from the lesser works of Sir Joshua, as it would communicate great value and *éclat* to them. What a becoming and graceful ornament would it be in one of the halls of London."[9]

Whilst none of Reynolds's portraits appear in the Hermitage collection, his *Cupid Untying the Girdle of Venus* may serve in some measure to bridge the gap, for there are inherent in it certain traits which are to be found in his best portraits. Furthermore, in this work Reynolds

seems to abandon those principles which had hitherto hampered his style. Captivated by the striking grace of his model, he shows her in the image of Venus. The picture is not encumbered by any tiresome rhetoric characteristic of many of Reynolds's works on historical or mythological subjects, and free of any speculative reconstruction of classical ideals and the cold abstraction and austerity of the neo-classical Venuses as in Benjamin West's *Venus Consoling Cupid*.

In the late 1770s the Hermitage acquired several large-scale paintings, such as the twin portraits of *Queen Charlotte Sophia* and *King George III* by Nathaniel Dance and *George, Prince of Wales, and His Brother Henry Frederick* by Benjamin West, representative of the academic school. These pictures were commissioned for the Chesmensky Palace.[10]

In the last quarter of the eighteenth century English works of art began to appear in Russia with increasing frequency, as may be seen from the numerous reports published in the St. Petersburg paper *Sankt-Peterburgskiye Vedomosti*. Thus in 1779 the following advertisement appeared: "For sale on Nevsky Prospekt... from Signor Rospini, who has just arrived in St. Petersburg, a collection of English, Roman and French engravings, including many architectural decorations, also... English gardens, etc..."[11] In 1793 the same paper published some interesting reports. One announced the sale of two thousand English prints and another that "a collection of old pictures by various painters priced at 600 roubles, and a collection of pictures by celebrated contemporary English painters are to be sold next to the Smirnov residence on the fifth line of the embankment, house 35, Vasilyevsky Island."[12] Engravings in single sheets and sets[13] were purchased for the Hermitage from Rospini, the renowned bookdealer Weitbrecht and the antiquarian Klostermann, whose shops were located in the centre of St. Petersburg. By the beginning of the 1790s the Hermitage had acquired quite a collection of prints which, according to Georgi[14], were noted for their scope, number and span of time. It was probably at this period too that the Hermitage laid the foundations of its excellent collection of mezzotints containing some rare prints. In addition, it also acquired engravings by William Hogarth, including a set of his prints done in 1764, and a large collection of works by Francesco Bartolozzi.

English engravings became so well known that in 1773, a student at the Academy of Arts, Gavrila Skorodumov, was sent to London to study stipple engraving under Bartolozzi. James Walker, a pupil of the celebrated engraver Valentine Green arrived in St. Petersburg in

1784 and worked there for eighteen years. He was appointed official engraver to Her Majesty. Walker produced many mezzotint engravings including some made from paintings in the Hermitage; we know, for instance, that the engraving of Reynolds's *Infant Hercules Strangling the Serpents* was on sale in St. Petersburg at Klostermann's shop.

In 1799 the Scottish architect Charles Cameron arrived in St. Petersburg from Edinburgh. He worked in the Imperial palaces around St. Petersburg. He redecorated many of the interiors of the Ekaterininsky Palace at Tsarskoye Selo (nowadays Pushkin) in the neo-classical style, designed the palace and laid out landscaped gardens at Pavlovsk. He also designed the gallery (the now famous Cameron Gallery) and the Cold Baths Pavilion in the Ekaterininsky Park at Tsarskoye Selo, which are the most original and celebrated achievements of the architect. It was in Russia rather than in England, where he was largely unknown, that Cameron made his name. The Hermitage still has some of his original sketches and they are of great artistic value.[15] Some are drawn in a surprisingly free and easy manner, whilst others are striking for their wealth of imagination, extravagant forms and the warmth of their black and white tones. They bear witness to the growth of romantic art in the mainstream of neo-classicism.

In 1791 the first example of English sculpture arrived at the Hermitage. This was a marble bust of the opposition leader Charles Fox by Joseph Nollekens. The acquisition of this piece was motivated largely by the political sympathies of Catherine II and it produced quite a stir in England at the time.

During the last quarter of the eighteenth century the Hermitage acquired the nucleus of its varied collection of items of applied art. Catherine II's enthusiasm for collecting engraved gems brought her into contact with the work of the outstanding craftsmen — the brothers Charles and William Brown. After 1786 the works of the Brown brothers began to arrive in St. Petersburg regularly, chiefly through the agency of Weitbrecht — bookdealer to the Imperial court. Within ten years the Hermitage had acquired nearly 200 of their gems and intaglios, comprising about half of the entire output of these craftsmen. It is worth pointing out that even the museums in England possess only a few examples of their work. The Brown brothers produced several gems on subjects from Russian life. Their works, noted for their distinct national style and superb craftsmanship, are the most interesting and valuable examples, not only of English, but also of European glyptic art of the eighteenth century in

the Hermitage. In 1781 fifteen thousand impressions of gems in the possession of all the principal European collections were ordered from James Tassie.[16] To store the impressions, several kinds of magnificent cabinets were specially produced in England. The scholar and writer Rudolf Erich Raspe, who spent his last years in England, compiled a manuscript catalogue of these impressions.

One of the most significant acquisitions of this time was a large dinner service comprising 952 pieces produced in 1773 and 1774 by Josiah Wedgwood for the Chesmensky Palace. Besides being a remarkable specimen of applied art, this unique service is also of great historical interest. Each piece in the service portrays a different English landscape executed in the topographical style, popular at this time. For us in the twentieth century, this is not only a superb example of Wedgwood porcelain, but at the same time a kind of encyclopaedia of English architectural landscapes of the eighteenth century.

In the meantime, the collection of English silver was also expanding. In 1762 a travelling set by the famous masters of the rococo period, Samuel Courtauld and Pierre Gillois, was acquired for the Winter Palace. At the end of the 1770s or in the early 1780s a wine cooler by Philip Rollos — a fine example of English eighteenth century silverware — and a pair of vases by Andrew Fogelberg in the neo-classical style, were purchased.

Thus, by the beginning of the nineteenth century, a representative and varied collection of English art had been amassed in St. Petersburg. At that time it was probably the largest European collection outside Britain. Although many of the works were intended not for the Hermitage but for the Imperial country palaces, they were gradually absorbed into the Museum's collection.

Between 1805 and 1814 the celebrated Scottish painter William Allan was living in Russia. Allan, a *protégé* of Walter Scott, made many journeys around Russia and some of his work reflected the impressions of his travels. Two of his small pictures, *Bashkirs* and *Frontier Guard*, now in the Hermitage, were most likely purchased from the painter in 1815.

In 1819 George Dawe, a member of the Royal Academy of Arts, arrived in St. Petersburg to paint the portraits of Russian generals who had taken part in military campaigns against Napoleon. In the next ten years, he painted 332 half-length[17] and three full-length portraits — of the Russian fieldmarshals Kutuzov and Barclay de Tolly and of the Duke of Wellington. They all now hang in the 1812 War Gallery of the Winter Palace. Fine expression

and the romantic elevation of the subjects, organically combined with a remarkable trueness to life, are characteristic of the best works in this enormous cycle of paintings, notably the portraits of Generals Bagration, Yermolov, Tuchkov and Seslavin. In addition to the works done for the 1812 War Gallery, George Dawe also painted numerous portraits of Russian aristocrats.

The events of the war of 1812 and the destruction of Napoleon's army in Russia, found expression in English medals, drawings and caricatures of the period. The Hermitage possesses a silver medal cast by Thomas Hallidey in honour of fieldmarshal Kutuzov, a medal by John Milton depicting the war hero Count Platov and some caricatures by John Cruikshank and William Elmes.

If in the eighteenth century it was Hogarth's engravings which dominated the Hermitage collection of English satirical art, in 1815 about 5,000 new sheets of caricature were added to the collection. By the mid-nineteenth century, it contained not only the works of leading English caricaturists such as James Gillray and Thomas Rowlandson, but also works by lesser artists such as Henry Bunbury, Richard Newton, George Woodward, Henry Wigstead, George and Robert Cruikshank. Thus, the hey-day of English satirical art — the late eighteenth and early nineteenth centuries — is extensively represented in the Hermitage collection.

In a description of the Hermitage collections made in 1861, the Russian engraver Fiodor Iordan, who was the keeper of prints, singled out in particular the engravings of William Hogarth, William Sharp, Richard Earlom and William Wollett. Of the last of these, Iordan wrote: "He combines fine taste with an extraordinary strength of tone and clarity of finish."[18] Amongst the works of Earlom, Iordan made particular mention of the *Nature Class at the Royal Academy in London*, which he called "a remarkable work" and the artist "one of the finest mezzotint engravers . . ."[19]

At the end of the century, in 1896, the Hermitage acquired some drawings and sketches by Alexander Cozens, one of the celebrated English painters in watercolours of the late nineteenth century, whose work greatly influenced the development of English romantic landscape painting.

It is worth mentioning that in the course of the eighteenth and nineteenth centuries, the Hermitage acquired a large collection of English coins and some fine, rare medals. The

medals and engravings were originally kept in the Imperial Library and it was not until the close of the nineteenth century that special departments for coins and engravings were created in the Museum.

In *The Catalogue of Paintings in the Imperial Hermitage*, published in 1863, it was noted that eight paintings of the English school acquired back in the eighteenth century, were put on display in the rooms of the New Hermitage. Another acquisition, made in 1900, was a portrait of Count Vorontsov, the Russian ambassador in London from 1785, painted by Thomas Lawrence. In 1904 *The Connoisseur* published an article by Dr. George C. Williamson which stated that "the Hermitage Gallery is one of the very few on the Continent which contains a special department for English pictures. It is, unfortunately, a very small department..."[20]

It was true that there were still big gaps in the collection of paintings, but in 1912 the situation changed. The well-known St. Petersburg collector Alexei Khitrovo bequeathed his magnificent collection of English art to the Hermitage. Excellent portraits by Thomas Gainsborough, George Romney, Henry Raeburn, John Hoppner, John Opie and Thomas Lawrence now graced the galleries of the Museum. If prior to this English portrait painting of the second half of the eighteenth century had been represented only by the official, stately portraits of Dance and West which in their generalising academic manner tend to under-play the role of national characteristics, the new additions now revealed the individual character of English portraiture.

Gainsborough, one of the most original artists of the eighteenth century, produced a superb gallery of portraits which are striking for the spirituality and poetic qualities of their subjects. Painted by a skilful hand and unique in its range of colours, the *Portrait of a Lady in Blue* unquestionably belongs to the finest works of the master. With economy of means, the artist succeeded in instilling the nervous anxiety and fragile grace of his model into the picture. No other portrait could have better fitted the words uttered by Reynolds in a speech to the memory of Gainsborough: "This excellence was his own, the result of his particular observation and taste... His grace was not academical, or antique, but selected by himself from the great school of nature... Gainsborough's portraits were often little more, in regard to finishing, or determining the form of the features, than what generally attends a dead colour; but as he was always attentive to the general effect, or whole

together, I have often imagined that this unfinished manner contributed even to that striking resemblance for which his portraits are so remarkable."[21]

A kind of antithesis to Gainsborough's picture is the *Portrait of Miss Grier* by Romney. This shows none of the slightly mysterious charm and reserve characteristic of many of Gainsborough's portraits. Above all Romney strove here to express the earthly attractiveness of his model, the femininity and coquettish allure of the young woman. The soft, lyrical *Portrait of Lady Bethune* by Raeburn and the somewhat cold though impressive *Portrait of Lady Raglan* by Lawrence give some idea of the character of English portrait painting in the last decade of the eighteenth and the beginning of the nineteenth centuries.

The importance of these new acquisitions by the Hermitage was immediately noted by the people of the time. An article on the Khitrovo collection[22] appeared in the magazine *Stariye gody*, the St. Petersburg papers published information on the additions to the Museum's collection of English art. On 27 November 1912 the paper *Rech* reported that "behind the closed doors in one of the rooms in the Hermitage a series of portraits by celebrated English artists of the second half of the eighteenth century have been set out temporarily on easels — these are a gift from the late Alexei Khitrovo... These portraits are possibly one of the most valuable acquisitions made by the Hermitage in recent years not only because they will increase the size of the section, but on their own account as works of the greatest artistic rarity for us today."

A new stage in the history of the Hermitage and the shaping of the English art collection came after the October Revolution of 1917 when the Hermitage became state-owned. During the 1920s the Hermitage incorporated paintings from nationalised private collections and individual works, through a special museum commission known as the State Museum Fund, from the Winter Palace and from the former Imperial palaces at Peterhof, Gatchina, Oranienbaum, Pavlovsk and elsewhere.

Between 1919 and 1925 the Hermitage acquired six pictures by George Morland — genre scenes and landscapes, including *The Approach of the Storm*. Morland's landscapes depicting poetic corners of the English countryside, are free from the false elegance of the academic canon, and the artist captivates us by the unpretentious charm of his vision. The work of Morland seems to herald the coming of English realistic landscape painting in the nineteenth century. During these years the English art section was enriched by two more

of Lawrence's portraits and his excellent drawing — *Portrait of Princess Lieven*. The engravings collection too made significant acquisitions.

It was, however, the collection of English applied art which grew most notably after the October Revolution. Textiles, embroidery, Mortlake tapestries from cartoons by Raphael, porcelain, faïence, arms and armour came to the Hermitage chiefly from the museum of the St. Petersburg School of Art and Industrial Design founded by Baron Stieglitz. It is worth while drawing attention to two unique centrepieces produced by Samuel Wood and Augustine Courtauld. Of Courtauld's famous work, the English art critic Charles Oman wrote that it is "not only a splendid example of English rococo silver, but is also singularly complete."[23]

After the October Revolution the lay-out of the Museum was radically altered. Today, the English art section occupies four rooms in the Winter Palace. Alongside paintings and sculpture are the finest examples of applied art — silver, porcelain, faïence and furniture. Tapestries, gems, arms and armour, and coins are on display in other, special departments of the Museum. The English art collection, built up over two centuries, occupies a place of honour amongst the immense art treasures of the Hermitage.

Larissa Dukelskaya

[1] The foundation of the Hermitage is usually taken to be 1764 when a large collection of paintings belonging to the Berlin merchant Heinrich Gotskowski was acquired. The collection was accommodated in two galleries of the Hermitage Pavilion adjoining the Winter Palace. Later the Hermitage gave its name to the entire Museum which was considered to be the personal property of the Imperial Family. In 1852, when the New Hermitage was built, the Museum was opened to the public.

[2] *The Eruption of Vesuvius* is in the Pushkin Museum of Fine Arts in Moscow.

[3] B. Nicolson, *Joseph Wright of Derby. Painter of Lights*, London–New York, 1968, vol. I, p. 107.

[4] In his monograph *Joseph Wright of Derby. Painter of Lights* (1968), Benedict Nicolson points out that there are only four of Wright's paintings in Europe including those in Moscow and Leningrad.

[5] J. Georgi, *Opisaniye rossiysko-imperatorskogo stolichnogo goroda Sankt-Peterburga i dostoprimechatel'nostei v okrestnostiakh onogo* (*A Description of St. Petersburg, the Capital City of the Russian Empire, and the Places of Interest Around It*), St. Petersburg, 1774, vol. II, p. 481.

[6] A. Benois, "Joseph Wright", in: *Gosudarstvenny Ermitazh. Sbornik* (*The Hermitage. Collection of Articles*), issue I, Petrograd, 1921, pp. 37–42.

[7] T. Jones, "Memoirs of Thomas Jones. Penkerrig, Radnorshire. 1803", *Walpole Society*, vol. XXXII, London, 1951, p. 19.

[8] In 1790 Reynolds's *Discourses* were published in St. Petersburg in Russian.

[9] See A. Graves, W. V. Cronin, *A History of the Works of Sir Joshua Reynolds, P.R.A.*, vol. III, 1900, p. 1162.

[10] The Chesmensky Palace (1774–77) was a country palace of Catherine II. It was built by Yury Velten who used the design of Longford Castle (1591) as his model.

[11] P. Stolpiansky, "Stary Peterburg. Torgovlya khudozhestvennymi proizvedeniyami v XVIII veke" ("Old St. Petersburg. The Trade in Works of Art in the 18th Century"), *Stariye gody*, June 1913, p. 53.

[12] P. Stolpiansky, *op. cit.*, p. 37.

[13] Unfortunately, no documents directly relating to the acquisition of the engravings have survived in the Hermitage archives. All we have are bills indicating the amounts paid for them without mention of the engravers' name or the number acquired.

[14] J. Georgi, *op. cit.*, p. 419.

[15] After the death of Cameron's widow, his sketches and drawings were taken to England, but in 1820 they were purchased by the Russian ambassador, Count Lieven.

[16] James Tassie (1735–1799) is known for his portrait medallions and impressions from cut gems made of vitreous paste which he discovered together with the physicist Henry Quinn.

[17] Dawe had as assistants two Russian artists — Alexander Poliakov (1801–1835), and Wilhelm Golike (died 1848).

[18] *Muzei Imperatorskogo Ermitazha. Opisaniye razlichnykh sobraniy sostavliayushchikh muzei, s istoricheskim vvedeniyem ob Ermitazhe imperatritsy Yekateriny II i obrazovanii Muzeya Novogo Ermitazha* (*The Imperial Hermitage Museum. Description of the Various Collections with an Historical Introduction on the Hermitage by Empress Catherine II and a Description of the Formation of the New Hermitage Museum*), compiled by F. Gille, St. Petersburg, 1861, p. 178.

[19] *Ibid.*, p. 204.

[20] G. C. Williamson, "Collection of Pictures in the Hermitage Palace in St. Petersburg", *Connoisseur*, May 1904, p. 12.

[21] J. Reynolds, *Discourses on Art*, London, 1969, pp. 223, 227, 228.

[22] P. Veiner, "Sobraniye A. Khitrovo" ("The Khitrovo Collection"), *Stariye gody*, December 1912.

[23] Ch. Oman, "English Plate at the Hermitage, Leningrad, and the State Historical Museum, Moscow", *Connoisseur*, August 1959, p. 15.

PLATES

SIXTEENTH AND SEVENTEENTH CENTURIES

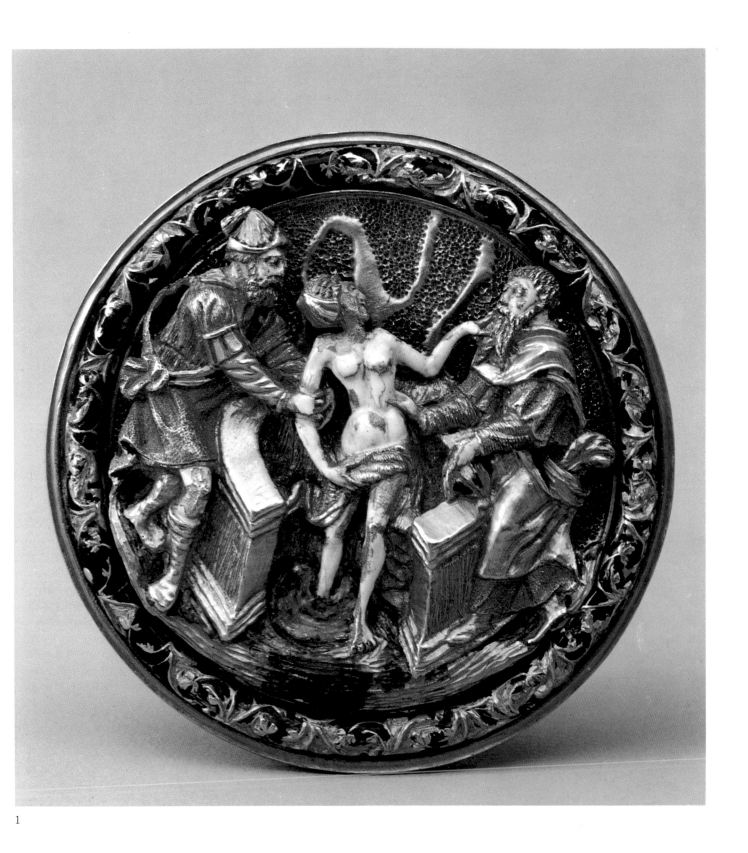

1

1

Beret buckle: Susanna and the Elders. *C.* 1500

Chased gold, enamel. Diameter 4.9 cm

Transferred from the Winter Palace. Recorded in the inventory of 1789. Inventory. No. 4783

Published for the first time.

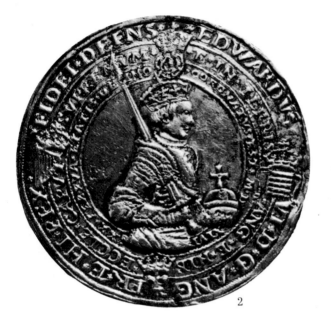

2

2, 3

Coronation medal of Edward VI. 1547

Struck in silver, gilded. 66 mm, 59.52 gm

Acquired before 1850. Inventory No. 7351

Obverse. Half-length figure of the King. The legend in three circles, divided into four parts by the Tudor emblems, the rose, portcullis, fleur-de-lis and harp, each crowned: EDWARDVS. VI.D.G.ANG. FR.E.HI.REX.FIDEL.DEFNS. E.IN.TERRIS.ANG.E.HIB. ECCLE.CAPVT. SVPREMVM. CORONATVS.EST.MD XLVI XX. FEBRVA.ETATIS.DECIMO.

Reverse. The same legend but in old Hebrew and classical Greek. At the top, the barely legible word: LAMBHITH (probably the artist's signature).

A rare instance of an early English coronation medal.

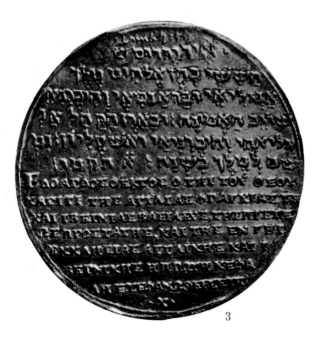

3

4

HANS EWORTH (?) (active from 1530 to the beginning of the 1570s)

Portrait of Edward VI. Between 1547 and 1553

Oil on wood. 50.5×35.6 cm

Acquired in 1779 with the Robert Walpole collection (Houghton Hall, Norfolk). Prior to this, the picture had first hung in Charles I's picture gallery, and then, following the sale of the gallery, was discovered in Lisbon by Lord Tyrawly, the English ambassador to Portugal. The latter purchased the painting and presented it to Robert Walpole, Earl of Orford (*Aedes Walpolianae* 1752, p. 69)*. Inventory No. 1260

The authorship of the portrait has been ascribed at different times to various artists. The painting entered the Hermitage as the work of Hans Holbein the Younger, in the catalogue of 1863 it was attributed to the Holbein school, in the catalogues of 1908 and 1916 to a French artist of the 16th century, and in the 1958 catalogue to an English artist of the 16th century.

Closely similar to the Hermitage painting is Eworth's *Portrait of Henry Stewart, Lord Darnley and His Brother Charles, Earl of Lennox*, 1563, in the Royal collection at Windsor (Millar 1963, No. 56). However, in terms of composition it is similar to a portrait of Edward VI by an unknown artist (Windsor Castle; see Millar 1963, No. 44). Furthermore, we know that a portrait of Edward VI painted by Hans Eworth existed in Charles I's picture gallery (see *A True Inventory of the Pictures in Hampton Court* 1970–72).

* For full references see the corresponding section of the *Bibliography* (in this case, *Painting*)

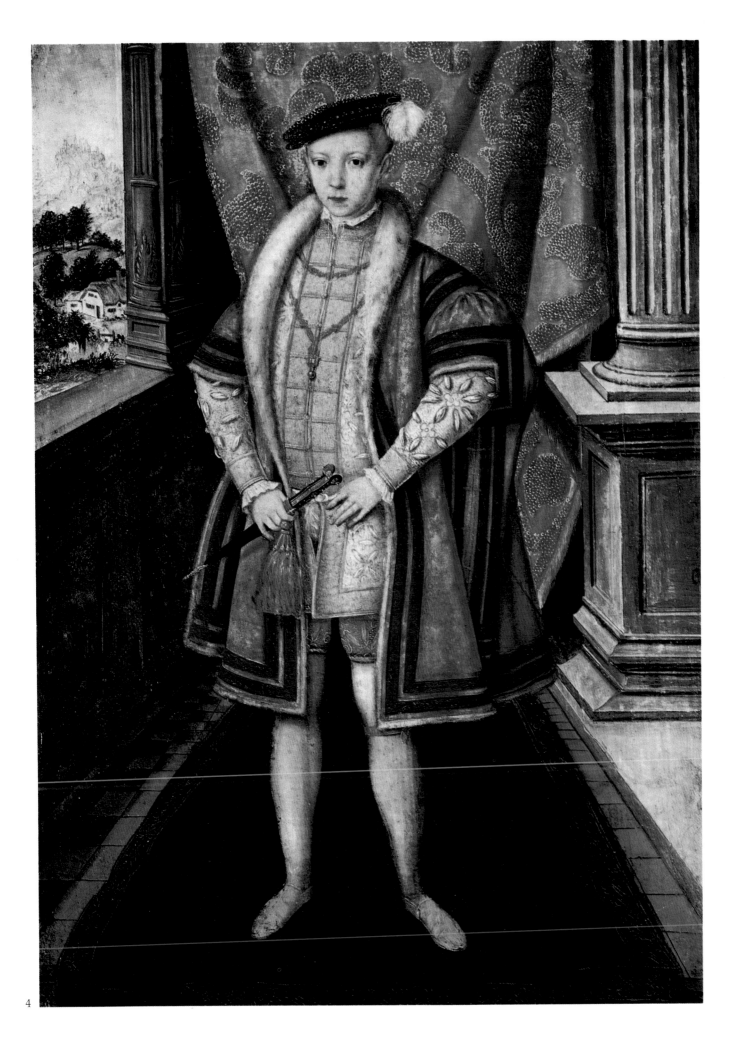

4

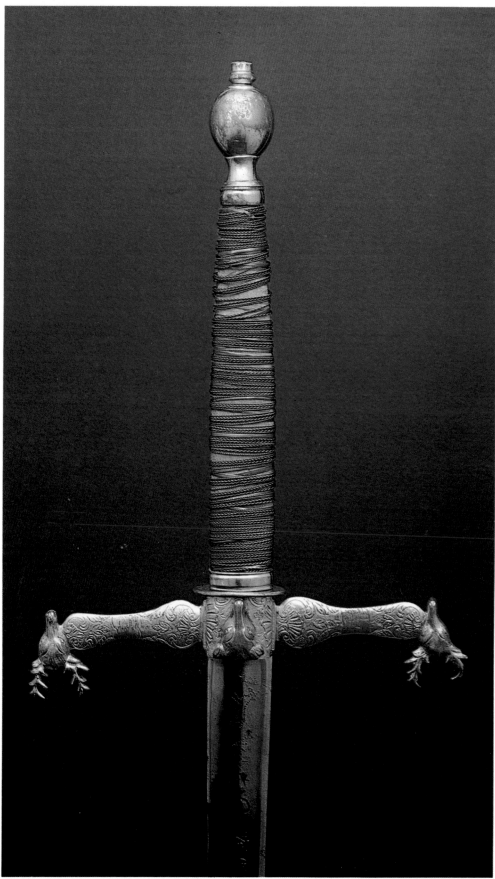

Ceremonial sword.

First half of the 17th century
Steel, bronze, engraved and
gilded. Total length 130 cm,
length of blade 98 cm

Engraved on the blade is
the Latin inscription: *Vivus
Carolus Rex Britannorum.
A.D. 1642*, and the figure
of a wolf (in imitation of
the hall-mark used
by the armourer Solingen);
it also bears a hall-mark
in the shape of a crescent
and some undecipherable
symbols. The same hall-marks
are on the reverse of the blade.

Details of acquisition are
missing. Inventory No. 1381

The cross-piece of the hilt is
decorated with the moulded
heads of a bear and a hart.
Possibly the sword was some
attribute of the King's
master of the hunt.

Published for the first time.

6

**MARCUS GHEERAERTS
THE YOUNGER** (1561?–1635)

**Portrait of an Unknown
Man.** 1595

Oil on wood. 114.5×89 cm

Inscribed and dated, top right:
ÆTATIS SVÆ. 32, 1595.

Acquired in 1921 through
the State Museum Fund
from a private collection
in Petrograd.
Inventory No. 7333

The picture entered the
Hermitage as the work of
an unknown Dutch painter
of the 16th century (*Portrait
of a Man in a White Doublet*).
It is attributed to Marcus
Gheeraerts the Younger on
the strength of its stylistic
affinity to the attested works
of this artist, such as *Portrait
of Barbara Gamadge
and Her Children*, 1596
(Penshurst Place).

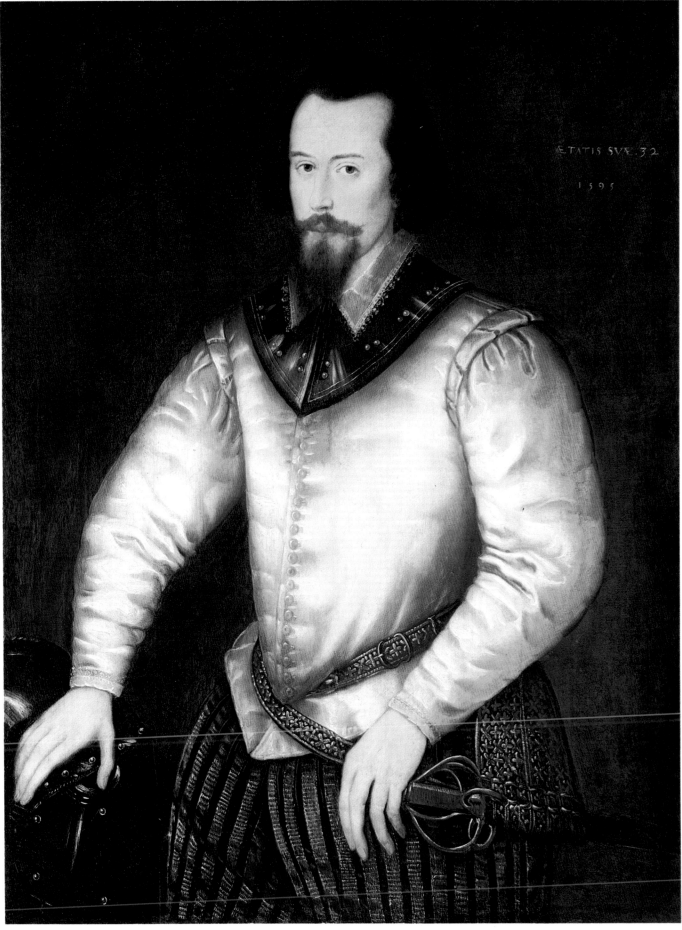

ÆTATIS SVÆ. 32

1595

6

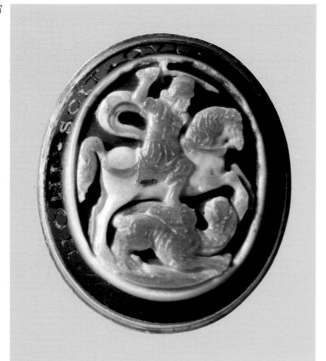

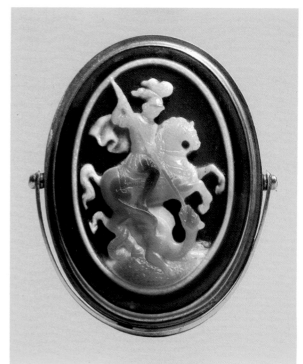

7

Cameo: St. George and the Dragon. Late 16th century

Sardonyx. 3.6×2.7 cm

Acquired in the late 18th century. Inventory No. 652

Published for the first time.

8

Cameo: St. George and the Dragon. 17th century

Sardonyx. 2.3×2 cm

Inscribed: *HONI.SOIT.QVI.MAL.Y.PENSE*

Acquired in 1925. Previously belonged to the Yusupov collection in St. Petersburg. Inventory No. 6348

Both cameos may have been used as insignia of the Order of the Garter and represent the so-called "Lesser George", which after 1522, on the orders of Henry VIII, the Knights of the Garter were commanded always to wear attached to a collar instead of the "Great George" (a large pendant of gold, enamel and precious stones). The first cameo is the earliest example in the Hermitage collection. The other, bearing the motto of the order engraved on the chamfered edge, probably dates from the time of Charles I. The Hermitage collection of the "Lesser George" is second in size only to that of the Royal collection at Windsor.

9, 10

Counter with a portrait of Elizabeth I. 1572

Struck in silver. 23 mm, 2.36 gm

Acquired in 1858 from the Ya. Reichel collection in St. Petersburg. Inventory No. 7353

Obverse. Bust of Elizabeth, between the Tudor emblems, the portcullis and rose. *Leg.* QVID.NOS.SINE.TE.
Reverse. In the centre, a castle on a hill between the legend: ER (Elisabeta regina). *Leg.* QVID.HOC.SINE.ARMIS.
At the bottom, a sphere with scroll inscribed: O QVANTO.

11, 12

Counter commemorating Elizabeth I's donation to sick and wounded soldiers and sailors. 1601

Struck in silver. 25 mm, 4.4 gm

Acquired before 1850. Inventory No. 7355

Obverse. Bust of Elizabeth. *Leg.* VNVM.A.DEO.DVOBVS. SVSTINEO.
Reverse. Leg. AFFLICTORVM.CONSERVATRIX. Monogram of Elizabeth, crowned, dividing the date, 1601.

13

Cameo: Portrait of Elizabeth I. *C.* 1575

Sardonyx. 6.2×4.7 cm

Acquired in 1787 from the Duc d'Orléans collection in Paris. Inventory No. 1020

This cameo portrait of Queen Elizabeth I ranks with the finest examples of cameos of this kind in the Bibliothèque Nationale in Paris, the Museum of Art and History in Vienna, the Victoria and Albert Museum, the Royal collection at Windsor, and the collection of the Duke of Devonshire. In all there are over thirty engraved portraits of Elizabeth I in various museums and collections, including those mentioned above. Five of these are to be found in the Hermitage.

Cameos of this type were used as commemorative tokens, gifts to foreign diplomats or as rewards for service. Cameos bearing the bust of the Queen in profile are commonly seen in portraits of the Elizabethan era, suspended on a chain or ribbon from the necks of dignitaries. Mention of these cameos is often encountered in various historical documents of the period.

In spite of the rigid adherence to the stereotyped composition, none of these cameos is a mere copy of others. Rather, each is a replica with its own artistic merit.

The present cameo shows Elizabeth wearing the Order of the Garter. Consequently, it may be said to belong to the so-called "Garter" portraits, datable from about 1575 onwards (Strong 1963, p. 62).

9

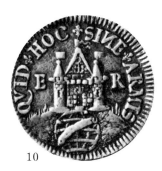

10

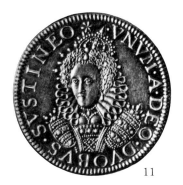

11

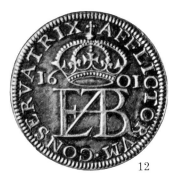

12

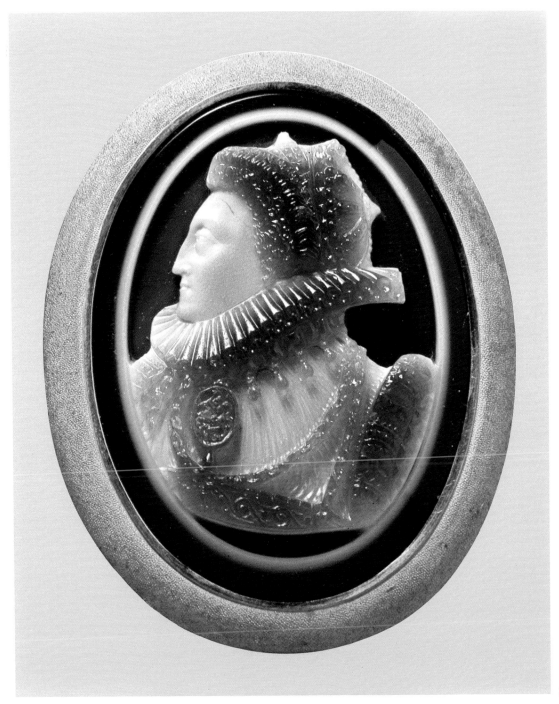

13

The authorship of these cameos has not been resolved. After unsuccessful attempts made in the 18th century to attribute them to the great craftsmen of the Italian Renaissance — Valerio Belli and Giovanni Bernadi — art historians were for a long time undecided on the matter. There were two prevalent opinions. According to one, the authorship of these cameos belonged to an Englishman, Richard Atsyll (or Atzell), who had begun his career as a gem cutter at Henry VIII's court. The other opinion, largely put forward by French researchers, attributed them to the gem cutter Julien de Fontenay, who, according to tradition, was sent by the French King Henry IV to Elizabeth's court.

Roy Strong makes mention of a certain Lennier who did at least one cameo of Elizabeth and was in the service of the crown (Strong 1963, p. 128). However, it is clear from Strong's source (*Diary of John Evelyn*, Oxford, 1955, pp. 79–80) that Lennier merely owned one of the portrait cameos.

It is doubtful whether such a large series of pieces could have originated from a single craftsman. Rather, we should think in terms of a great court workshop where these cameos were cut from patterns and then passed to jewellers for mounting in the form of medallions, rings and clasps.

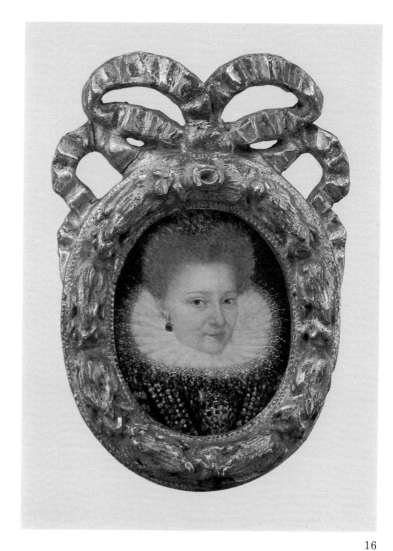

16

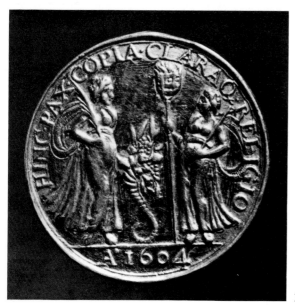

14

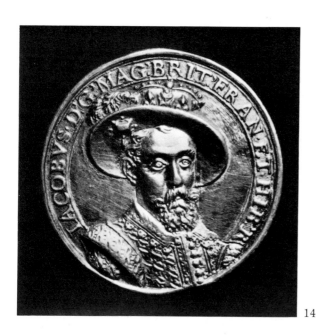

15

14, 15

Medal commemorating the Peace between England and Spain. 1604

Struck in silver, gilded. 34 mm, 14.12 gm

Acquired in 1858 from the Ya. Reichel collection in St. Petersburg. Inventory No. 7359

Obverse. Bust of James I, his hat crowned and plumed. *Leg.* IACOBVS.D.G.MAG.BRIT.FRAN.ET.HIBR.
Reverse. On each side of a horn of plenty, figures personifying Peace and Religion. *Leg.* HINC.PAX.COPIA.CLARAQ.RELIGIO. *Ex.* A° 1604.

16

**UNKNOWN MASTER
OF THE LATE 16TH — EARLY 17TH CENTURIES**

Portrait of a Lady. Late 16th century

Oil on copper plate. 4.5×3.6 cm

Inscribed, on the frame, in a later hand: *la rein Elizabeth. Portrait du temps.Boys Ax.*

Acquired before 1924 from the A. Dolgorukov collection in Petrograd. Inventory No. 1920

Published for the first time.

THOMAS RAWLINS (?) (*c.* 1620–1670)

Cameo: Portrait of Charles I

Sardonyx. 2.1×1.8 cm

Acquired in 1787 from the Duc d'Orléans collection
in Paris. Before 1741 belonged to the Pierre Crozat
collection in Paris. Inventory No. 986

Iconographically and in manner of production, the cameo is very
similar to the memorial tokens of Charles I, made immediately after
the execution of the King in 1649, by the court medallist Thomas
Rawlins (see Hawkins, Franks & Grueber 1885, vol. I, Nos. 340,
341, 355). The documentary information we have, suggesting that
Rawlins was also a gem cutter, gives us some grounds for linking
his name with the Hermitage cameo. In the Crozat collection, as
seen from its catalogue (Mariette 1741, p. 60, N° 942), the original
mount in the form of a ring with black enamel, had still survived.
Possibly it was similar to the mount of the cameo portrait of
Charles I which is in the British Museum (Dalton 1915, No. 388).
Another cameo portrait of Charles I is in the Duke of Devonshire's
collection at Chatsworth House (King 1866, p. 248). All the
above-mentioned cameos follow the pattern established in
medallic art under the influence of Van Dyck's portraits.

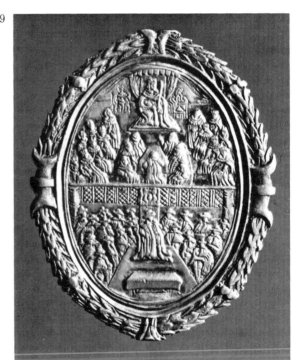

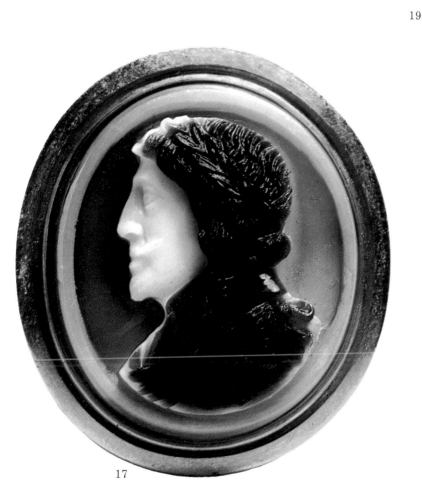

17

18, 19

THOMAS RAWLINS (*c.* 1620–1670)

**Medal commemorating the Declaration
of Parliament.** 1642

Struck in silver, engraved. 37×44 mm (oval), 14.36 gm

Acquired before 1850. Inventory No. 7372

Obverse. Bust of Charles I. *Leg. incuse*: SHOULD HEAR
BOTH HOUSES OF PARLI AM ANT FOR TRUE REIG
ION AND SUBIECTS FREDOM STAN D.
Reverse. The two Houses of Parliament assembled.

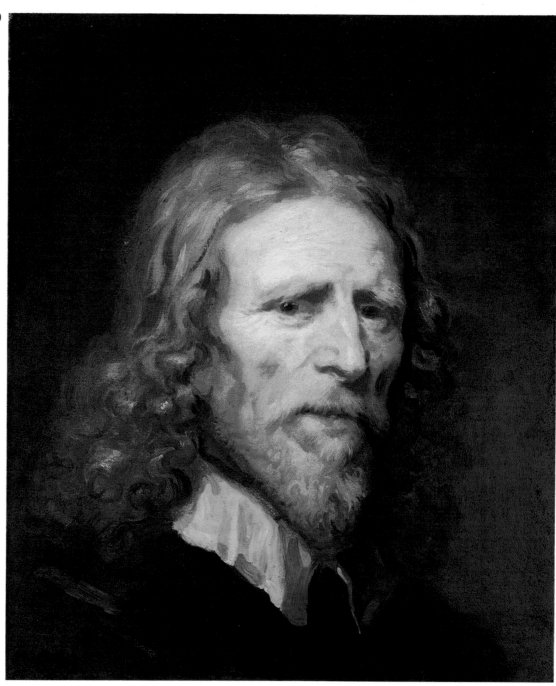

20

WILLIAM DOBSON (1610–1646)

Portrait of Abraham van der Doort. Before 1640

Oil on canvas. 45×38 cm

Acquired in 1779 from the Robert Walpole collection
(Houghton Hall, Norfolk). Inventory No. 2103

Abraham van der Doort (died in 1640) was an artist and medallist,
keeper of pictures and antiquities to Charles I and author of a
catalogue of the Royal collection published in 1757.

The portrait was acquired by the Hermitage and recorded in
18th century inventories as the representation of the artist's father
(an assumption based on the signature of Valentine Green which
can be seen beneath an engraving made from the portrait).
However, referring to information given out by Vertue, Walpole,
in his *Anecdotes*, asserted that the subject of the portrait was
Abraham van der Doort.

A very similar portrait of Abraham van der Doort, possibly copied
from Dobson's original, now hangs in the National Portrait Gallery
in London (Piper 1963, No. 1569).

The authorship of the Dobson painting, was contested in 1911 by
Charles Holmes and John Miliner, in whose opinion the original
painting was replaced in the Walpole collection by a forgery dating
from the second half of the 18th century. The probability of the
paintings being exchanged just before the famous collection was
sold is completely unlikely and the conclusions of the authors lack
any real foundation. The same view is shared by the specialist in
English art history of the 16th and 17th centuries, Collins-Baker,
who in an article on Dobson written for the Thieme-Becker
Lexikon, published four years after the Holmes and Miliner article,
included the Hermitage portrait of Abraham van der Doort in his
list of the most important works of the artist.

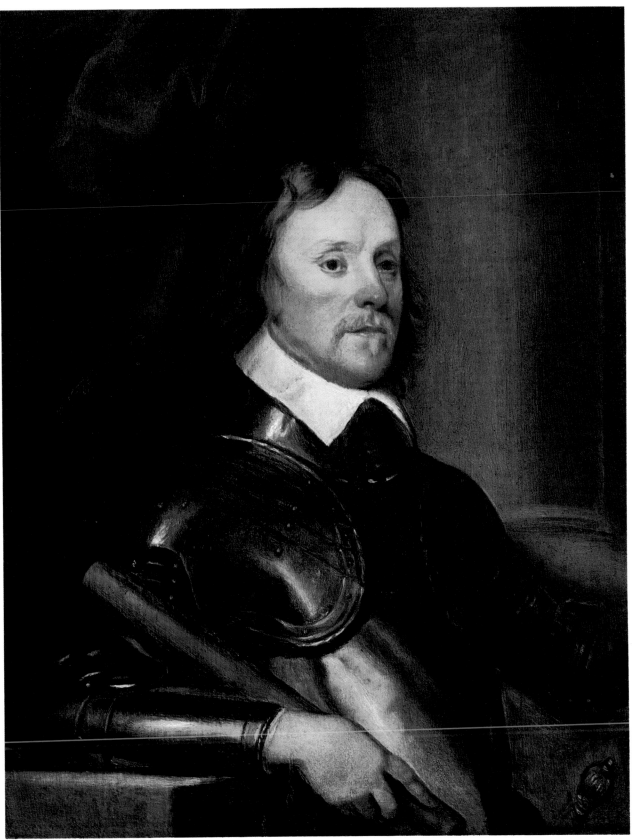

21

ROBERT WALKER (?) (1607–1658/60)

Portrait of Oliver Cromwell

Oil on wood. 39×31 cm

Inscribed and dated, on the back: *Oliver Cromvel peint en 1657 (?)*
en legation Mr de Vandom

Acquired in the late 18th century. Inventory No. 1699

The portrait was thought to be the work of Anthony van Dyck, which would have meant that the subject could not have been Cromwell (Van Dyck died in 1641 and Cromwell became general in 1644). We know that the subject is in fact Cromwell and therefore the painter could not have been Van Dyck. However, not one of the attested portraits of Cromwell by Walker coincides with the manner of the Hermitage portrait.

THOMAS SIMON (1618–1665)

**Service medal commemorating the naval battle
on 1 August 1650**

Struck in silver. 34×47 mm (oval), 21.39 gm

Transferred in the mid-19th century from the Kunstkammer
in St. Petersburg. Inventory No. 7382

Obverse. An anchor bearing the cross of St. George for England
and a harp for Ireland. *Leg.* MERUISTI.
Reverse. Leg. SERVICE.DON.AGAINST.SIX.SHIPS. JVLY.Y.
XXXI.&.AVGVSTY. I. 1650.
Like the medal of the same year struck to commemorate
the Battle of Dunbar (the Hermitage, inventory No. 7426)
this is one of the earliest military service medals.

24, 25

THOMAS SIMON (1618–1665)

**Medal commemorating the establishment
of Oliver Cromwell as Lord Protector.** 1653

Struck in silver, gilded. 38 mm, 19.15 gm

Acquired in 1858 from the Ya. Reichel collection
in St. Petersburg. Inventory No. 7429

Obverse. Bust of Cromwell (after a miniature of Samuel
Cooper). *Leg.* OLIVERVS.DEI.GRA.REIPVB.ANGLIÆ.
SCO.ET.HIB.&.PROTECTOR. At the bottom: THO SIMON F.
(artist's signature).
Reverse. A lion sejant supporting the shield of the Protectorate.
Leg. PAX.QVÆRITUR.BELLO.

THOMAS SIMON (?) (1618–1665)

Cameo: Portrait of Oliver Cromwell

Sardonyx. 3.4×3 cm

Acquired in 1787 from the Duc d'Orléans collection in Paris.
Until 1741 in the Pierre Crozat collection in Paris.
Inventory No. 1013

The cameo is in the strict form of Roman portraits and is similar
to the coins of Thomas Simon issued in 1656 and 1658 as souvenirs
(never circulated) (A. J. Nathanson, *Thomas Simon. His Life and
Work*, London, 1975, p. 27, fig. 26). After Cromwell's death,
the coins and the cameos were mounted on rings and given to
his friends and comrades-in-arms.
Simon evidently made use of Samuel Cooper's portrait of Cromwell
as a point of departure. This can be attested from Simon's surviving
drawings which show each stage in the reworking of Cooper's
portrait into his own final version (D. Allen, ''Thomas Simon's
Sketch-book'', *Walpole Society*, vol. XXVII, 1938–39, pp. 26–27).
A sardonyx cameo from the Duke of Devonshire's collection also
belongs to this group of pieces (King 1866, p. 488), as well as two
cameos on bloodstone from the Bibliothèque Nationale in Paris
(E. Babelon, *Catalogue des camées antiques et modernes de la
Bibliothèque Nationale*, Paris, 1897, Nᵒˢ 970, 971, pl. LXXI).
It is not only the iconographic similarity, but also the low flattened
relief common to all the above-mentioned pieces, and characteristic
of Simon's coins and medals too, which allows us to conclude that
the engraver of the cameo was this same celebrated English
engraver and medallist.

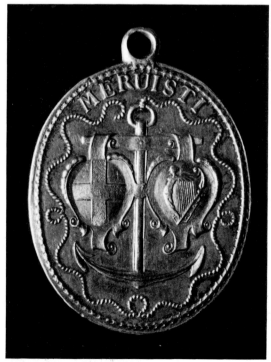

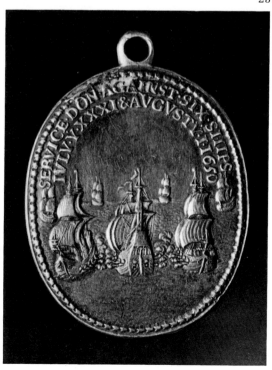

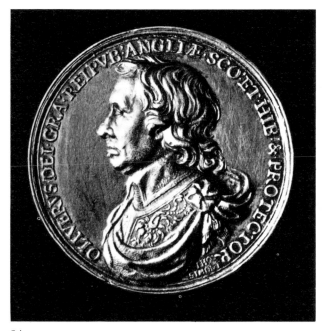

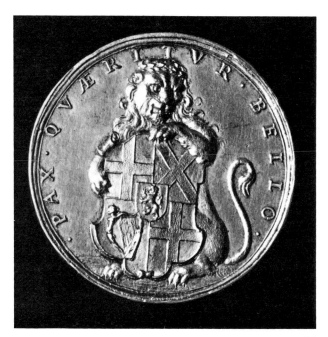

24

25

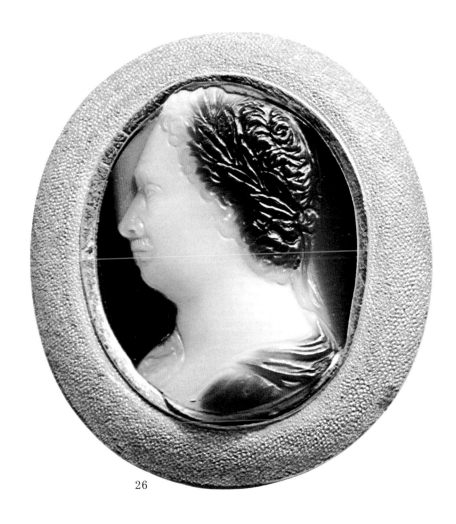

26

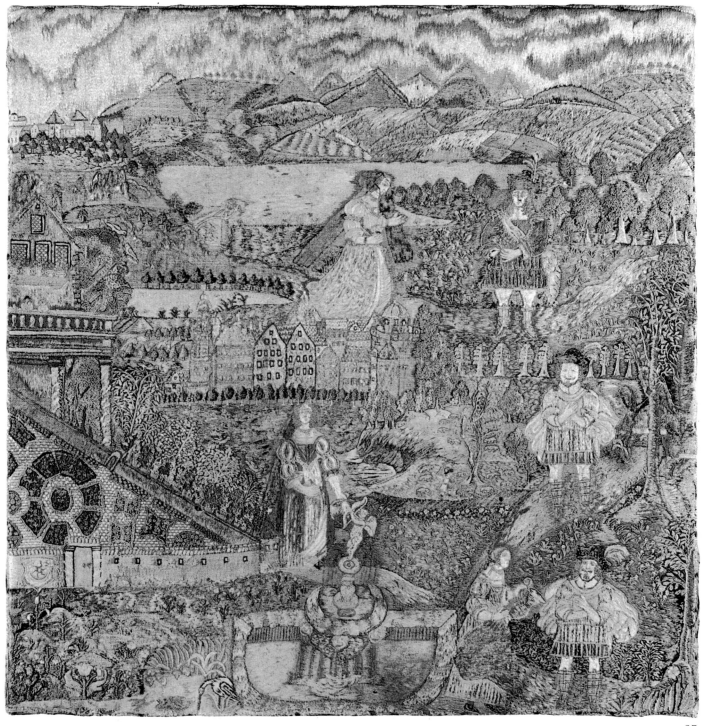

27

Panel: Eleazar and Rebecca. 1665

Embroidery in wool and silk on canvas: long and short
French knots, stem and chain stitch. 59×59 cm

The date, *1665*, embroidered at the bottom.
Along the sides of a heraldic shield, the initials: *E. N.*

Acquired in 1923. Inventory No. 15932

This is one of the few examples of needlework in the Hermitage
collection which can be accurately dated. In the Untermyer
collection there are some examples of 17th century English
needlework (see *English and Other Needlework Tapestries and
Textiles in the Irwin Untermyer Collection*, Cambridge, 1960,
pls. 50, 51, 57, 61). In terms of composition (sharply raised horizon,
scenes arranged in tiers), and in their treatment of the subject
(the combination of several scenes on one panel) they are similar
to the example in the Hermitage. However, in contrast to the
Hermitage piece, they employ tent stitch. The stylistic similarity
to these examples of needlework panels, allows us to regard
it as English work.

Published for the first time.

Embroidery. First third of the 17th century

Embroidery in gold thread on silk: long and short stitch, laid and couched work. 55×58 cm

Transferred from the Stieglitz School Museum in Petrograd. Inventory No. 3285

Ornamentation in the form of a ring of interwoven stems with a large flower was typical of English embroidery in the 16th and 17th centuries. Similar motifs can be found in sketches from the book of patterns *Commonplace Book* compiled by Thomas Trevelyon in 1608. This same pattern occurs in examples of English embroidery work in the Untermyer collection (see *English and Other Needlework Tapestries and Textiles in the Irwin Untermyer Collection*, Cambridge, 1960, pls. 4, 6, 10).

28

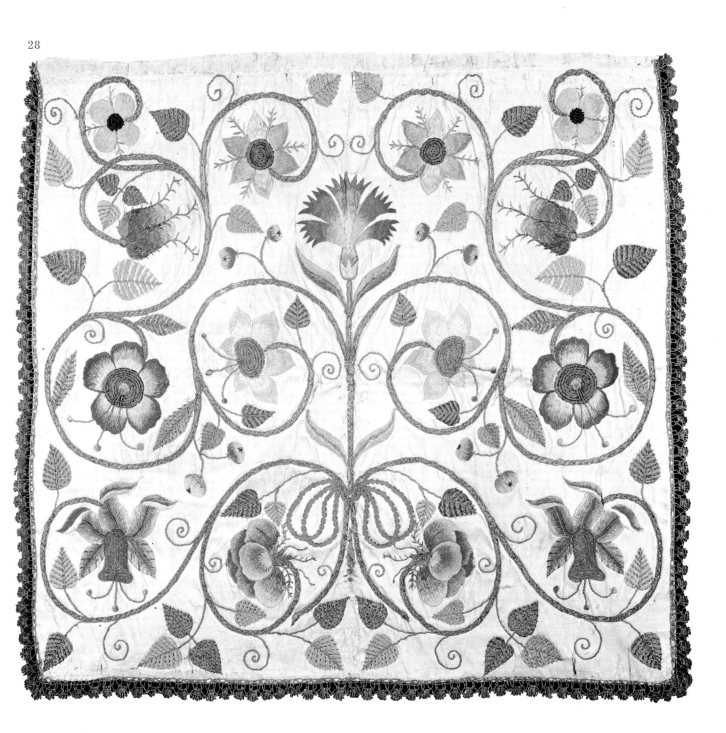

29

Lace sampler: Judith with the Head of Holofernes.
17th century

Flax thread, loop stitch. 8.2×15 cm

Transferred in 1923 from the Stieglitz School Museum
in Petrograd. Inventory No. 8840

An interesting facet of lace making and needlework is the so-called
sampler, which in the 16th to 18th centuries was in common use
throughout Western Europe, but especially in England, from
designs in the numerous pattern books.
Similar lace samplers showing Judith can be found in the Victoria
and Albert Museum (see *Victoria and Albert Museum. Samplers*,
London, 1965, p. 7). It is possible to trace the resemblance in
the character of composition, the treatment of certain details
of clothing, the tent of Holofernes, and also in the general
manner of execution.

30

MASTER IB

Incense burner. London hall-mark for 1680–81

Silver-gilt, cast and chased. Height 40.9 cm.
Diameter 20 cm

Acquired in 1937 from the Purchasing Commission.
Inventory No. 14784

The maker's mark *IB* is given in C. I. Jackson's handbook *English
Goldsmiths and Their Marks* (London, 1905, p. 128). This incense
burner is a rare piece. Its character bears witness to the influence
of Dutch silversmiths.
Published for the first time.

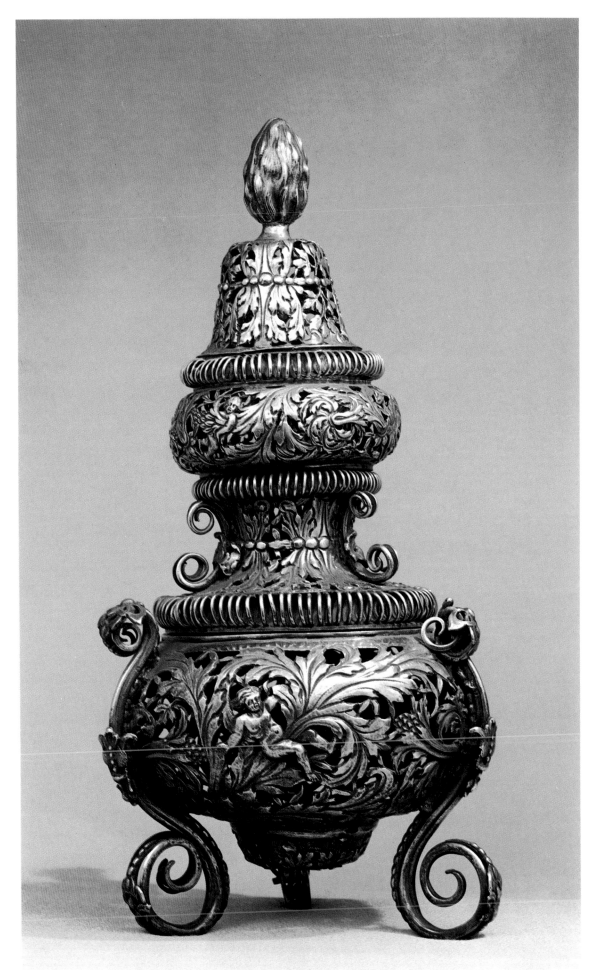

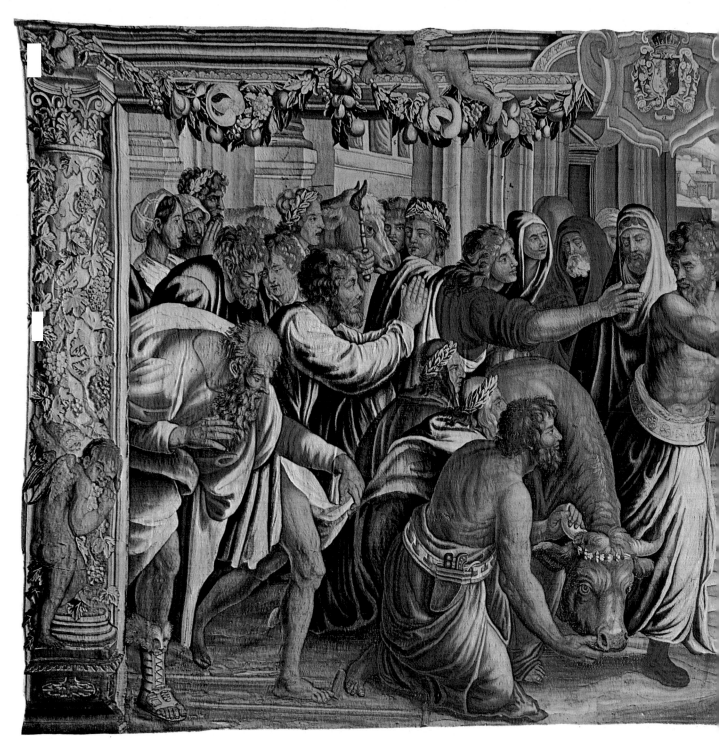

31

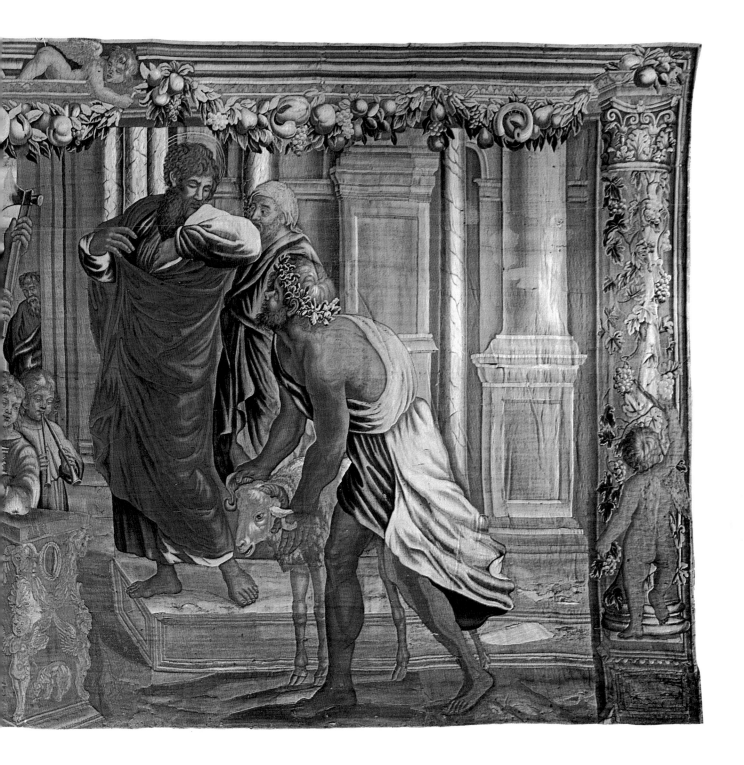

31

Tapestry: Sacrifice in Lystra.
From the series *The Acts of the Apostles*. Mortlake.
Mid-17th century

After Raphael's cartoon
Wool, silk, woven. 310×670 cm
Acquired in 1886. Inventory No. 2922

32

Tapestry: The Miraculous Draught of Fishes (detail).
From the series *The Acts of the Apostles*. Mortlake.
Mid-17th century

After Raphael's cartoon
Wool, silk, woven. 305×395 cm
Acquired in 1886. Inventory No. 2920

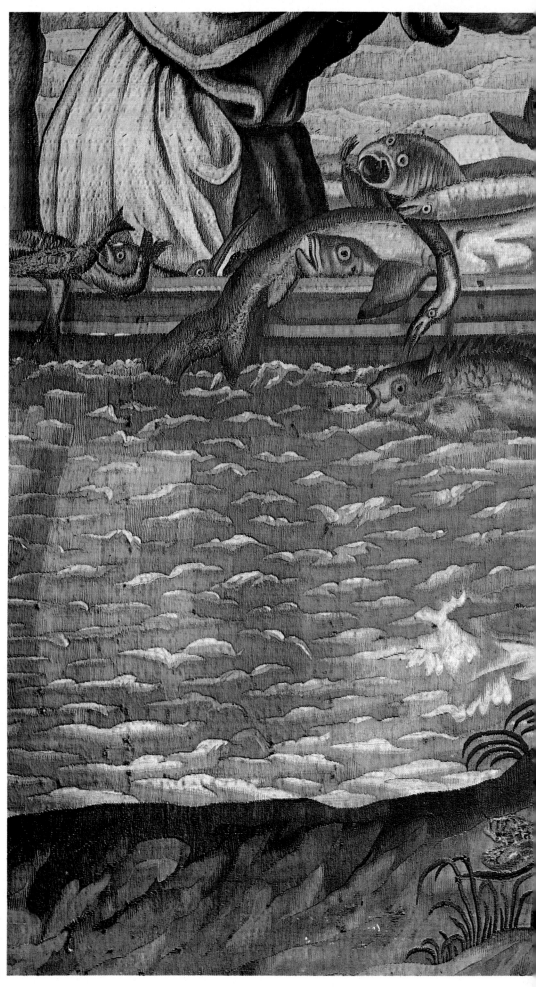

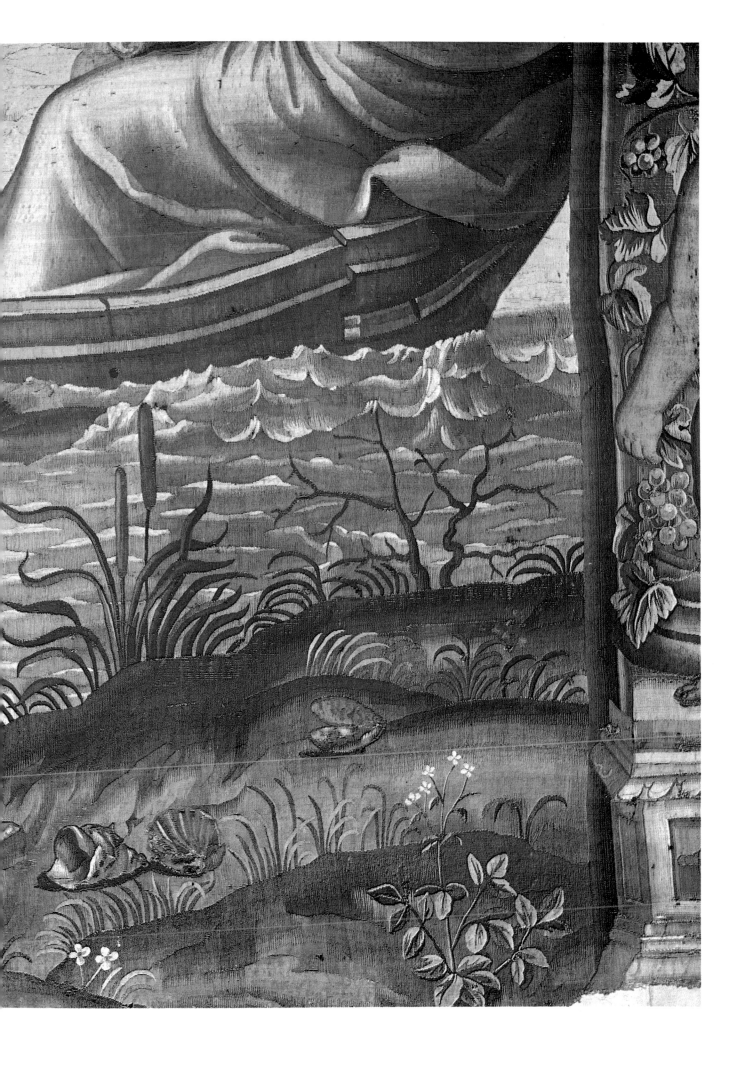

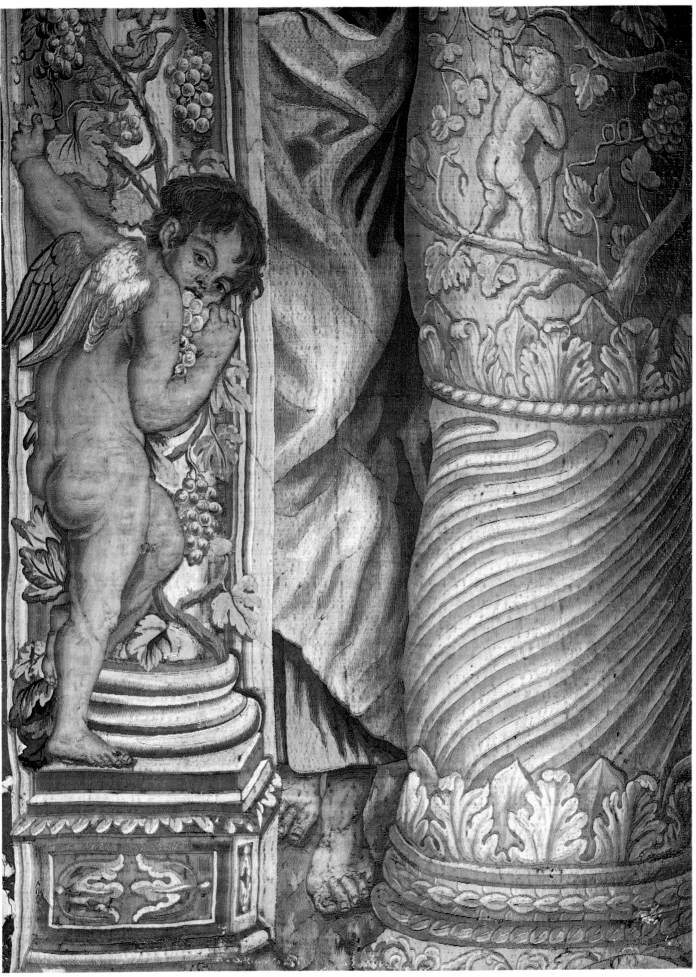

33, 34

Tapestry: Healing of the Man Sick of Palsy.
From the series *The Acts of the Apostles*.
Mortlake. Mid-17th century

After Raphael's cartoon
Wool, silk, woven. 312×368 cm
Acquired in 1886. Inventory No. 2921

Cartoons for a series of tapestries *The Acts of the Apostles* were
made by Raphael from 1514 to 1516 on the orders of Pope Leo X.
The tapestries were to have adorned the Sistine Chapel. However,
not enough experienced weavers could be found in Italy for so
responsible a task, so the cartoons were sent to Brussels. The first
series of tapestries for the Sistine Chapel were woven in the
workshop of Van Aelst and these are now in the Vatican Museum.

Throughout the 16th century, series of tapestries were produced in
the workshops of Brussels. In 1623, through the agency of Rubens,
Charles I obtained the cartoons for a factory which had been
established in Mortlake, near London in 1619. At present the seven
Raphael cartoons known to have survived, are in the Victoria and
Albert Museum.
The borders framing the Hermitage tapestries *The Miraculous
Draught of Fishes*, *Healing of the Man Sick of Palsy* and *Sacrifice in
Lystra*, were put together in England. The coat-of-arms of the Earls
of Pembroke can be seen in the centre of the upper border. It is
possible that the tapestries could have been brought to Russia
by the Vorontsovs who were related to the Pembrokes. In the
mid-19th century, they came into the hands of Meshkov, a merchant
from the Kaluga district, and later to Von Haupt. The Hermitage
acquired them in 1886.

35

PETER LELY (PIETER VAN DER FAES) (1618–1680)

Portrait of Cecilia Killigrew (?)

Oil on canvas. 70×55.5 cm (the original canvas
was oval but has been relined onto a rectangular one.
The size of the original 69×54 cm)

Acquired in 1886 from the Golitsyn Museum in Moscow.
Inventory No. 562

Cecilia Killigrew was the wife of Sir Thomas Killigrew, poet
and playwright.

The portrait was acquired by the Hermitage as a work by Anthony
van Dyck. The catalogue of 1902 still attributed it to Van Dyck,
but in the index to the catalogue, it is recorded as the work of Pieter
van der Faes. In the 1916 catalogue of the museum it was ascribed
to an unknown Flemish artist of the 17th century, and in the 1958
catalogue, to Peter Lely.

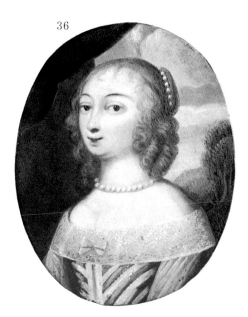

36

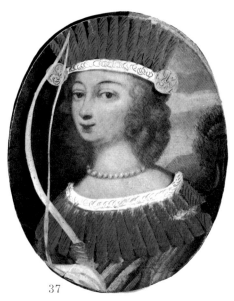

37

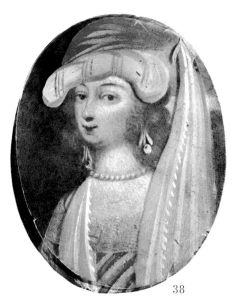

38

36–38

UNKNOWN PAINTER OF THE MID-17TH CENTURY

Portrait of a Woman. 1661

Oil on copper plate. Mica. 8×6.6 cm

Inscribed and dated on the silk lining of the box:
Qristoff Danielson. Bruntin. Anno 1661

Acquired before 1917. Inventory No. 272

Accompanying the miniature portrait is a box containing cut-outs in mica depicting various costumes. These could be used to superimpose over the miniature to change the appearance of the woman. Such "toys" were common in Europe in the 17th and 18th centuries.

Published for the first time.

39

PETER LELY (PIETER VAN DER FAES) (1618–1680)

A Knight of the Order of the Garter. C. 1671

Black and white chalk on grey paper. 66×33.5 cm

Acquired in 1768 with the collection of Count Karl de Kobentzl in Brussels. Inventory No. 5926

In the first half of the 18th century the drawing was ascribed to Peter Lely. However, in the catalogue of the Kobentzl collection and after its acquisition by the Hermitage, it was attributed to Anthony van Dyck. Nowadays it is considered beyond doubt to be the work of Lely. The drawing belongs to a set of character studies, *Grand Procession of the Sovereigne and the Knight Companies*, dated about 1671. Sixteen sheets in this set which were bound together in an album were sold at an auction in Amsterdam on 23 March 1763 and then found their way into various collections (the Albertina in Vienna; the Ashmolean Museum in Oxford; the Crocker Art Gallery in Sacramento, California; the State Print Rooms in Amsterdam and Berlin; and private collections). The one which most closely resembles the Hermitage drawing, is in the State Print Room in Amsterdam. The two sheets depict the same figure, but the Amsterdam drawing shows the back of the figure and bears a 17th century (?) inscription.

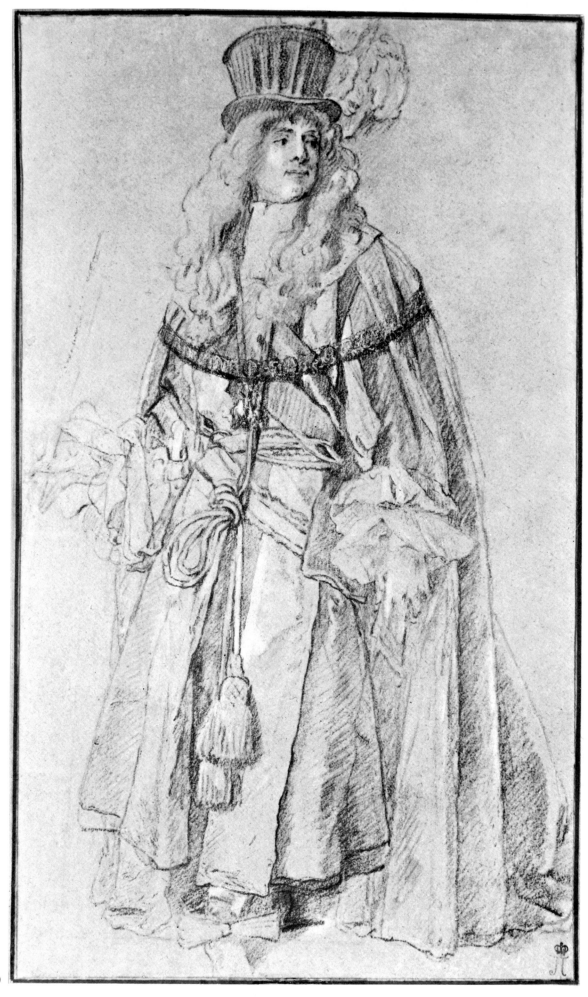

39

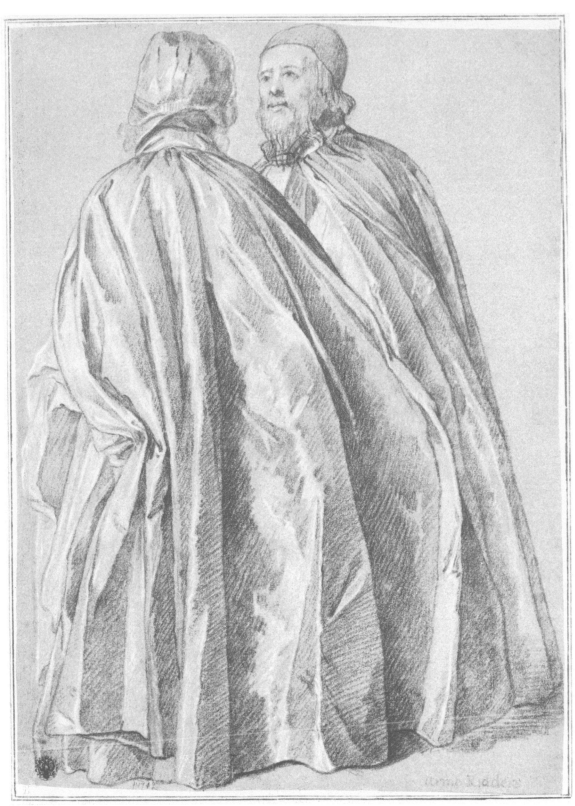

40

PETER LELY (PIETER VAN DER FAES) (1618–1680)

Two Figures Taking Part in a Procession of Knights of the Order of the Garter. C. 1671

Inscribed, bottom right, in lead pencil, in a later hand: *Arme Ridders*.

Black and white chalk on grey-blue paper. 49×36 cm

Transferred in 1924 from the Petrograd Academy of Arts. Previously in the Julienne collection in Paris. Inventory No. 14712

At the time the drawing entered the Hermitage, the artist was unknown. It was attributed to Lely by Mikhail Dobroklonsky. Judging from the descriptions given in the catalogue for the Amsterdam auction of 23 March 1763, the Hermitage drawing was put up as lot 16 or 25. It closely resembles a study of two clerical figures in the Crocker Art Gallery, Sacramento, California.

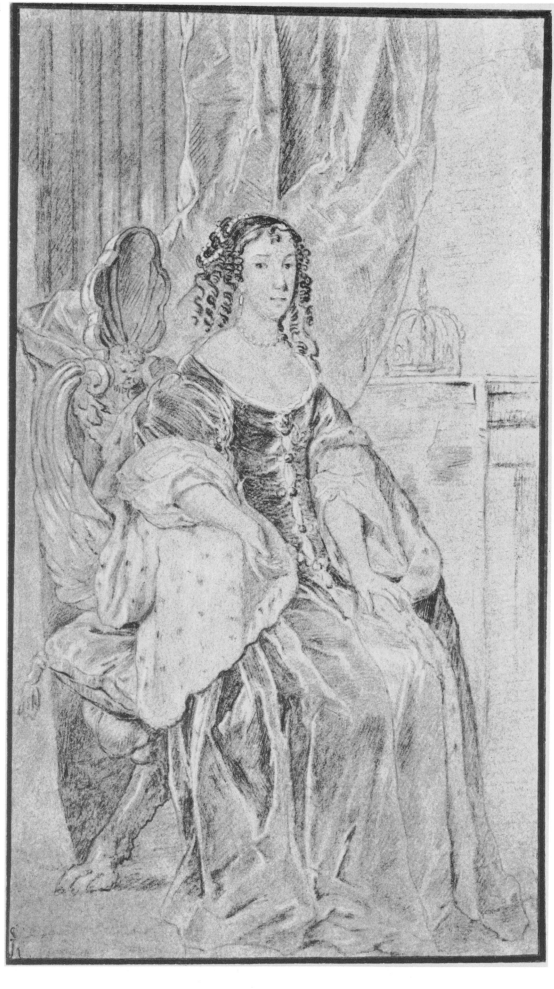

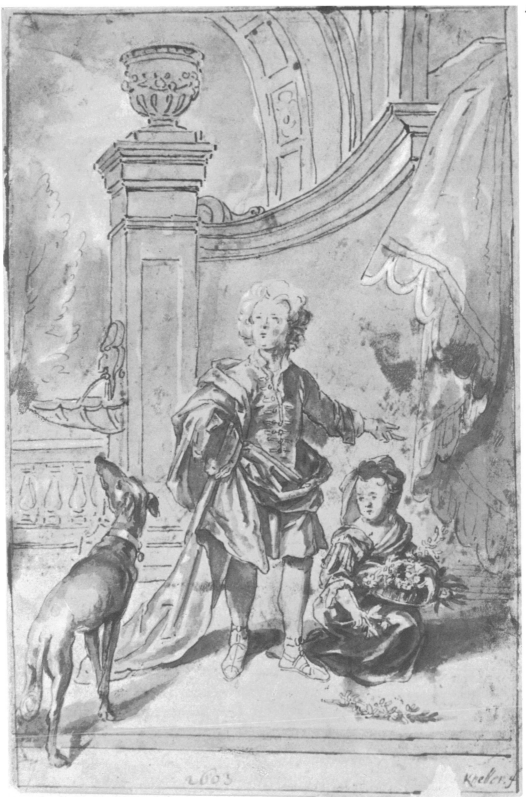

41

PETER LELY (PIETER VAN DER FAES) (1618–1680)

Portrait of Queen Catherine of Braganza. *C.* 1668

Black and white chalk on grey-blue paper. 52.8×31.1 cm

Acquired in 1768 from the collection of Count
Karl de Kobentzl in Brussels. Inventory No. 5925

Catherine of Braganza (1638–1705) was the daughter of the King of
Portugal, John IV, and after 1661, wife of Charles II of England; in
1704 and 1705, Regent of Portugal.

In the catalogue of the Kobentzl collection and after its acquisition
by the Hermitage, the portrait was recorded as *The Portrait of an
Unknown Lady* by Anthony van Dyck. It was attributed to Lely
by Mikhail Dobroklonsky, and appears to be a preparatory sketch
for a painting of the Queen produced by Lely in 1668 (now in the
collection of the Marquis of Bath at Longleat).

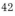

43

42

GODFREY KNELLER (1646–1723)

**Richard Boyle, Lord Clifford,
and Lady Jane Boyle His Sister.** *C.* 1701

Inscribed bottom right: *Kneller f*; and to the left: *2603*

Pen and ink, grey wash. 30×20.5 cm

Transferred in 1924 from the Petrograd Academy of Arts.
Previously in the collection of I. Betskoi. Inventory No. 15589

The drawing shows Richard Boyle, Lord Clifford, later the third
Earl of Burlington, an amateur architect, collector and member
of the Kit-cat Club, and his sister, Jane Boyle.
A mezzotint engraving of the same subject made by John Smith
bears the following inscription: *Richard Lord Clifford and Lady
Jane his sister. G. Kneller S.R. Imp: at Angl: Eques. Aur: pinx:
J. Smith fec.* (Smith 1884, vol. III, No. 53). As the engraving dates
from 1701, the drawing must be earlier.
Both figures appear in the picture *Lord Burlington and His Sisters*
(*c.* 1700, Chatsworth), and a dog, in the study of a borzoi (the British
Museum). Evidently the artist was working simultaneously on two
variants of the picture, one of which is known only from the
Hermitage drawing and the John Smith engraving.

Published for the first time.

43, 44

PETER LELY (PIETER VAN DER FAES) (1618–1680)

An Historical Scene. *C.* 1648–50

Oil on canvas. 115.5×156.5 cm

An illegible signature can be seen to the left
on the pedestal of the statue of Justice.
The initial letter of the artist's surname seems to be *L*.

Acquired between 1769 and 1774. Inventory No. 2210

In a late 18th century inventory of pictures in the Hermitage made
by Minikh from 1773 to 1783, the subject was identified as
Kunigunde. However, in the legend of Kunigunde there are no
episodes set in the East. When acquired by the Hermitage the
picture was thought to be the work of the Italian painter Antonio
Leli (1591–1640). It was later attributed to Peter Lely on the
strength of its affinity to such works by this painter as *The Idyll*,
1648 (formerly the Davies collection in England; in 1940 the picture
was destroyed in the blitz), and *Susanna and the Elders*, 1650
(the Birmingham Art Gallery).

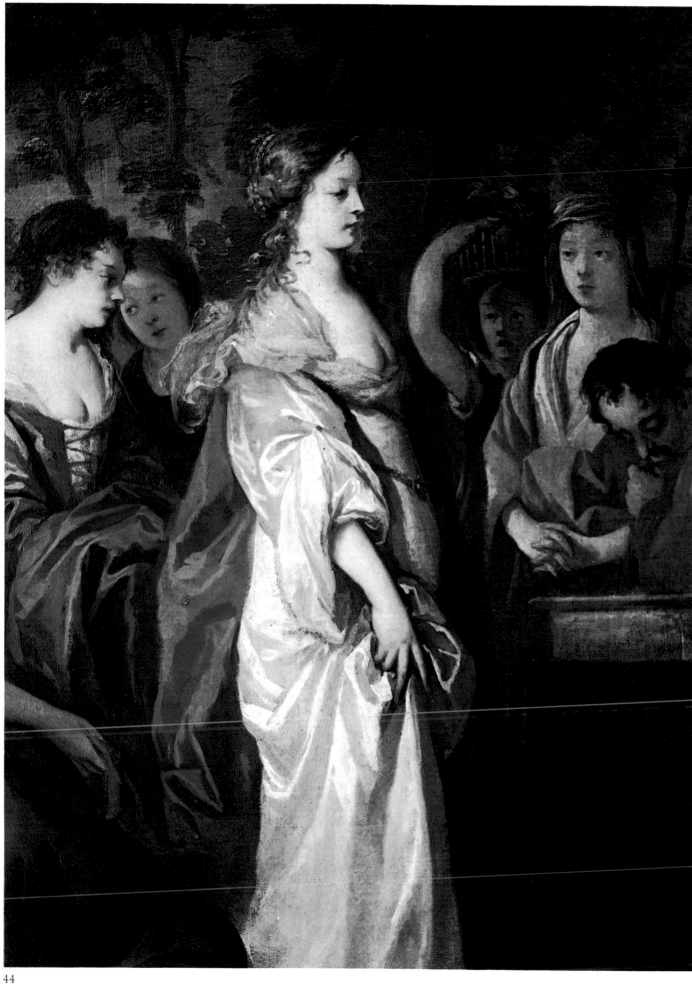

44

45

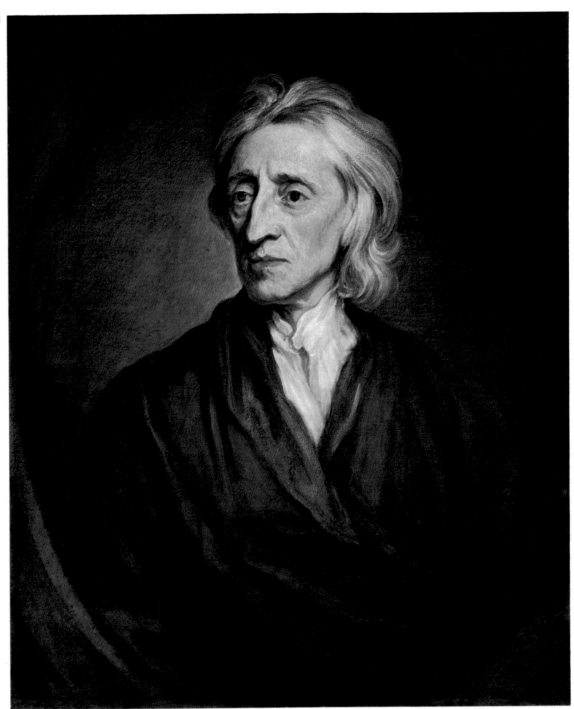

45

GODFREY KNELLER (1646–1723)

Portrait of John Locke. 1697

Oil on canvas. 76×64 cm (oval in rectangular)

Inscribed on the back of the canvas: *Mr. John Locke by Sir G. Kneller*

Acquired in 1779 from the Robert Walpole collection (Houghton Hall, Norfolk). Inventory No. 1345

John Locke (1632–1704) was a prominent English philosopher and author of the famous book *An Essay Concerning Human Understanding* (1690).

A number of portraits of Locke by Kneller are known to exist: in Hampton Court, in Oxford (Christ Church), and elsewhere. A copy of the Hermitage portrait can be found in the National Portrait Gallery in London (Piper 1963, No. 550).

46

GODFREY KNELLER (1646–1723)

Portrait of Grinling Gibbons. Before 1690

Oil on canvas. 125×90 cm

Acquired in 1779 from the Robert Walpole collection (Houghton Hall, Norfolk). Inventory No. 1349

Grinling Gibbons (1648–1720) was a sculptor and wood-carver. On the right is the head of Proserpina from Lorenzo Bernini's sculptural group *The Abduction of Proserpina*.

This portrait is one of Kneller's most important works. In a description of the Houghton Hall collection, it was recorded as "a masterpiece not inferior to any work of Van Dyck".

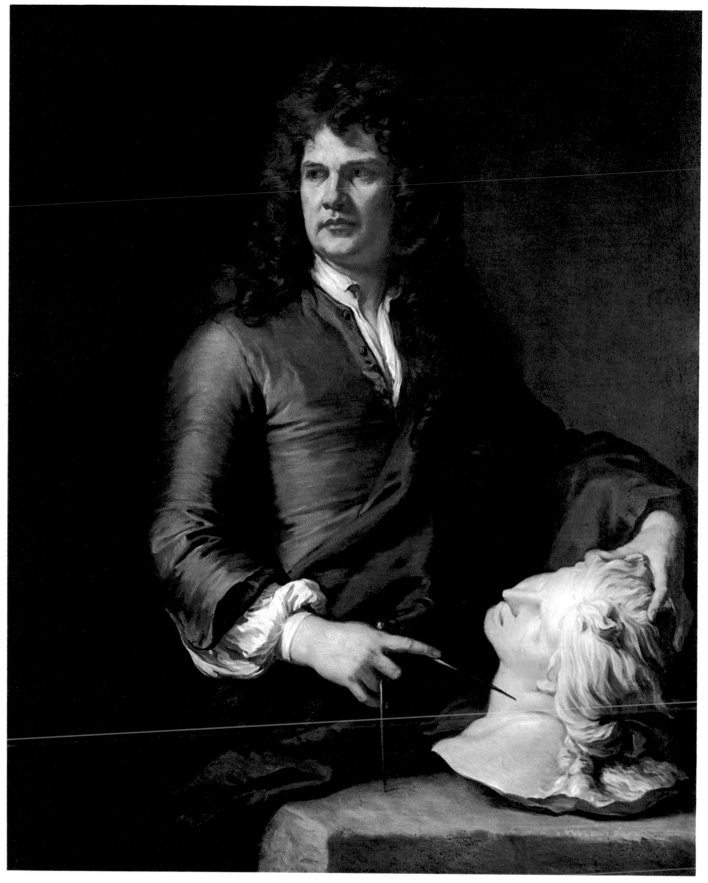

47

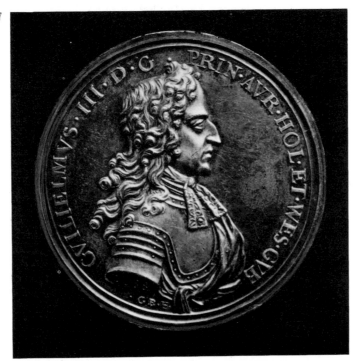

48

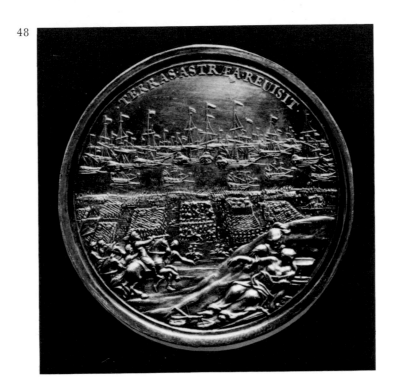

47, 48

GEORGE BOWER (?–1690)

**Medal commemorating the landing of William
of Orange at Torbay.** 1688

Struck in silver. 50 mm, 50.56 gm

Acquired before 1850. Inventory No. 7498

Obverse. Bust of William of Orange. *Leg.* GVILIELMVS.III.D.G.
PRIN.AVR.HOL.ET.WES.GVB. On the arm truncation, the date:
1688, and below, the initials: G.B.F. (artist's signature).
Reverse. William of Orange in the guise of a classical warrior is
raising the fainting figure personifying Justice. In the distance, his
troops are drawn up on the shore and the fleet is on the open seas.
Leg. TERRAS.ASTRÆ.REUISIT. (the legend taken, after
the custom of the time, from Ovid's *Metamorphoses*).

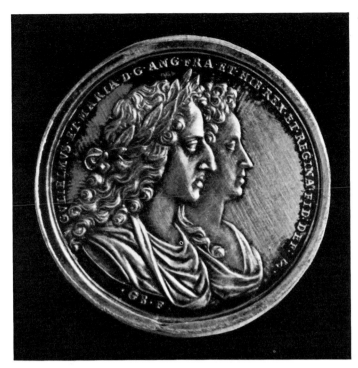

49

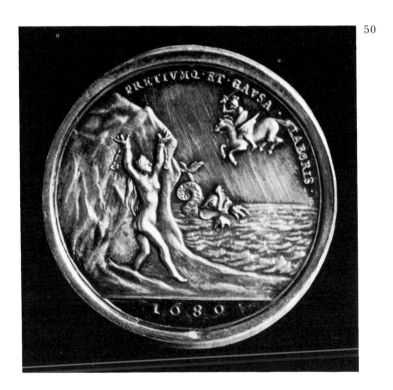

50

49, 50

GEORGE BOWER (?–1690)

Coronation medal of William and Mary. 1689

Struck in silver. 38 mm, 19.52 gm

Acquired in 1923 with the collection
of Count Stroganov. Inventory No. 7500

Obverse. William and Mary. *Leg.* GVILIELMVS.ET.MARIA.D.G.
ANG.FRA.ET.HIB.REX.ET.REGINA.FID.DEF. At the bottom,
near the edge, the initials: GB.F. (artist's signature).
Reverse. The naked figure of Andromeda bound to the rock,
a monster in the sea, and above it Perseus seated on Pegasus.
Leg. PRETIVMQ.ET.CAVSA.LABORIS. *Ex.* 1689.

FIRST HALF OF THE EIGHTEENTH CENTURY

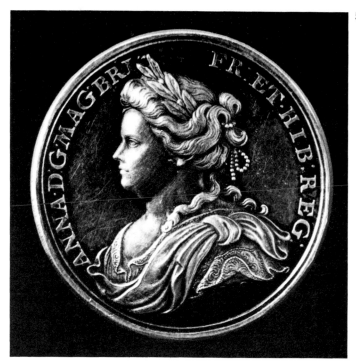

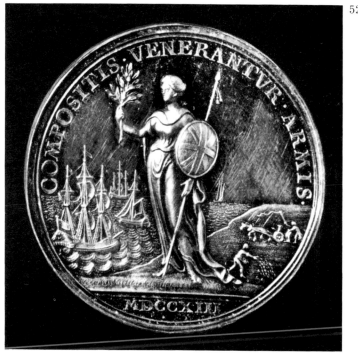

51, 52

JOHN CROKER (1670–1741)

Medal commemorating the Peace of Utrecht signed by England, France and the Netherlands. 1713

Struck in silver. 35 mm, 15.9 gm

Acquired before 1850. Inventory No. 7468

Obverse. Bust of Queen Anne. *Leg*. ANNA.D.G.MAG. BRI.FR.ET.HIB.REG. On the arm truncation, the initials: J.C. (artist's signature).

Reverse. Britannia with an olive palm in her right hand stands against the background of men working in the field and ships on the sea. *Leg*. COMPOSITIS.VENERANTVR.ARMIS. *Ex*. MDCCXIII.

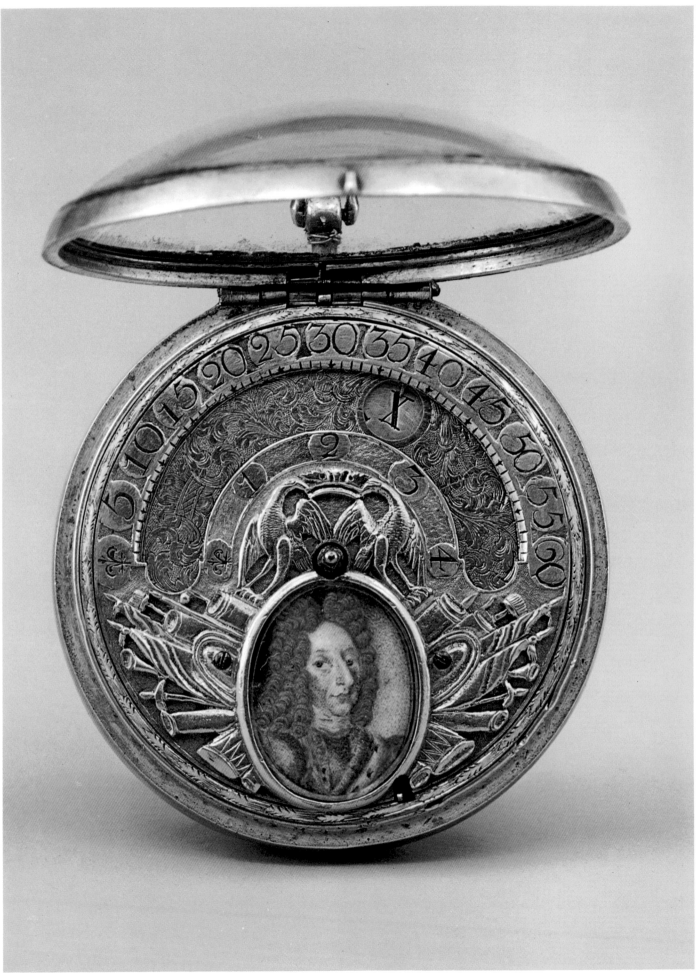

Turnip watch. London. *C.* 1700

Silver, chased and painted. Diameter 6 cm

Signed on the mechanism: *Joh.Jac. Serner London*

Acquired in 1914 from the Pliushkin collection
in St. Petersburg. Inventory No. 6697

The lower part of the dial is decorated with military
trophies in gold relief and an oval miniature bearing
the portrait of William III.

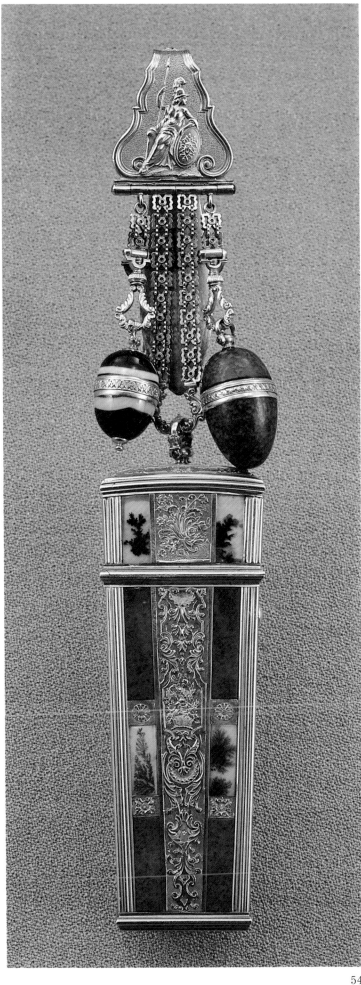

Necessaire on a chain. Early 18th century

Gold, lapis lazuli, moss agate; hanger brackets in onyx
and lapis lazuli; hook in gilded copper. Length 17.7 cm

The hook bears the hall-mark: *Joyce Hussy*

Transferred from the Winter Palace. Inventory No. 3013

Published for the first time.

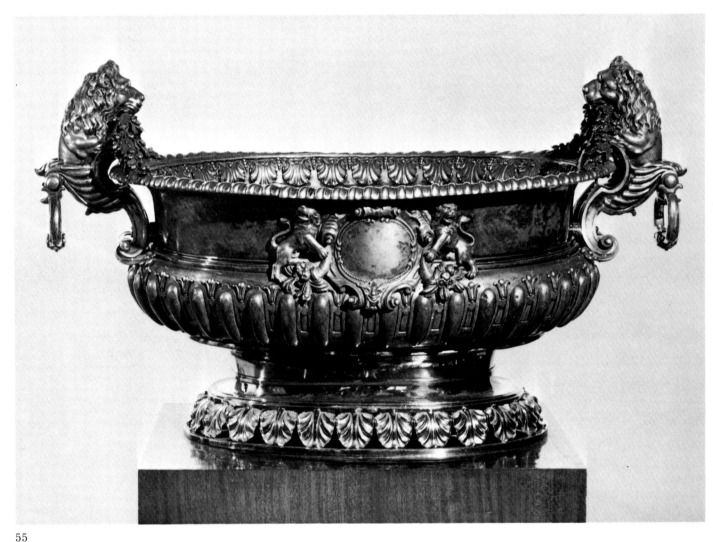

55

55, 56

PHILIP ROLLOS (active from the late 17th
to the early 18th centuries)

Wine cooler. London hall-mark for 1705–6

The bottom of the cooler bears the arms
of Evelyn Pierrepoint, 5th Earl,
afterwards 1st Duke of Kingston.

Cast in silver, chased. Height 82 cm, width 145 cm

Transferred from the Winter Palace. Inventory No. 7021

The cooler was brought to Russia by Elisabeth Chudleigh, Duchess
of Kingston, who came to St. Petersburg in 1776 and in 1782. It was
acquired by Catherine II and presented to Prince Potiomkin, after
whose death it went into the treasury. The cooler was mentioned by
T. Kiryak in a description of the famous Potiomkin festival in 1791
(*Russky arkhiv*, 1867, p. 679).

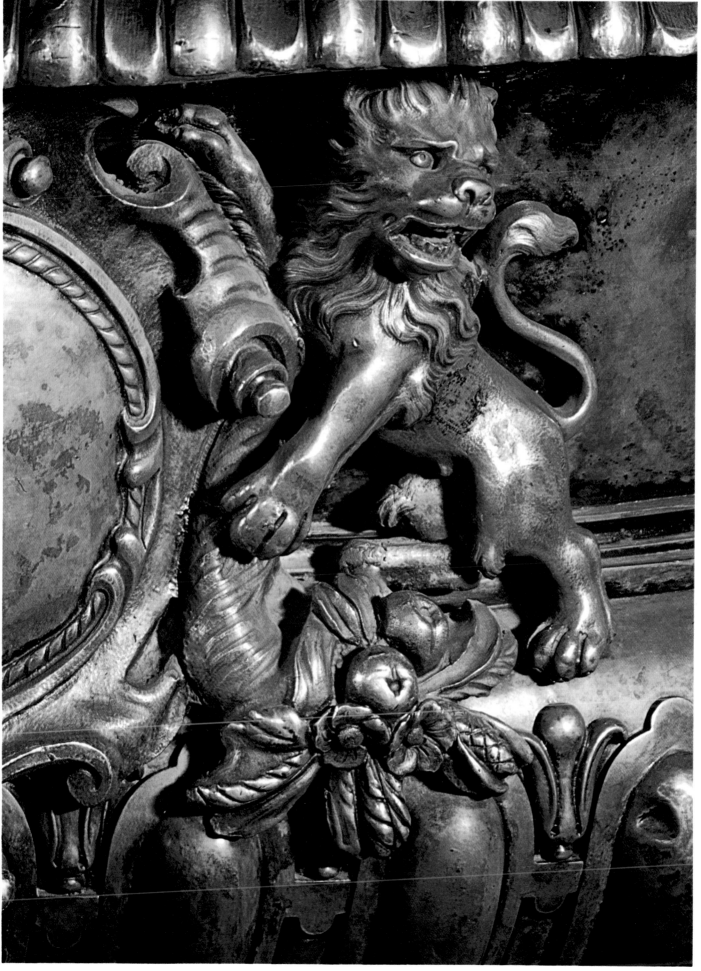

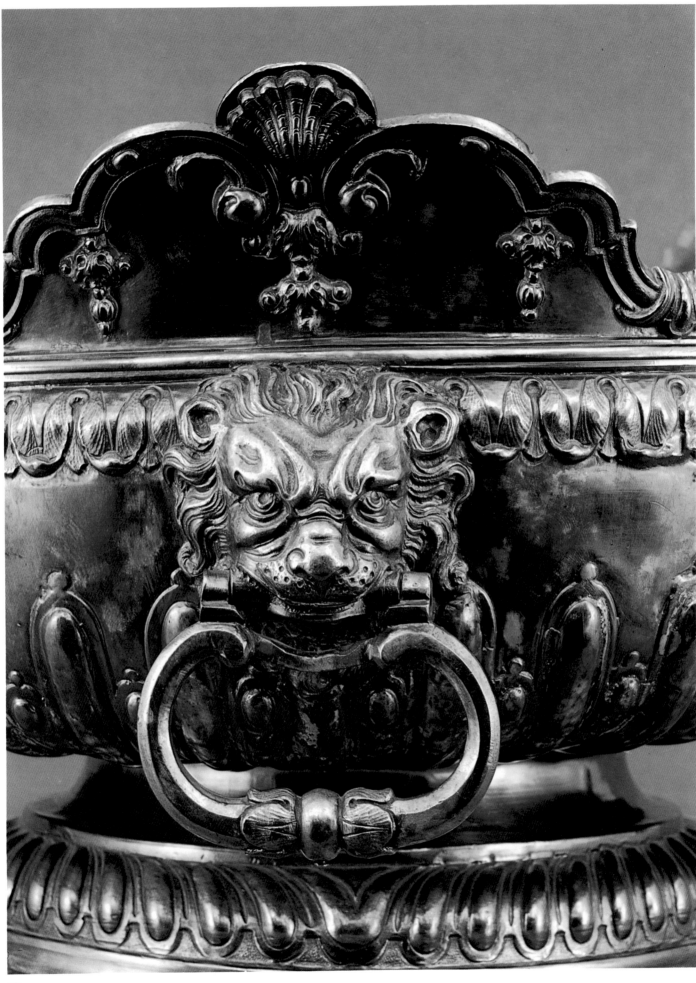

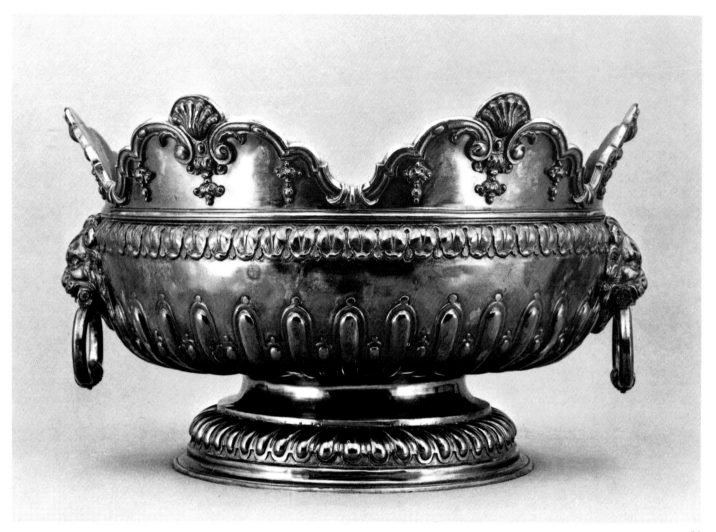

57, 58

GABRIEL SLEATH (1674–1756)

Punch bowl. London hall-mark for 1710–11

Cast in silver, chased. Diameter 42.5 cm

Transferred from the Winter Palace. Inventory No. 7022

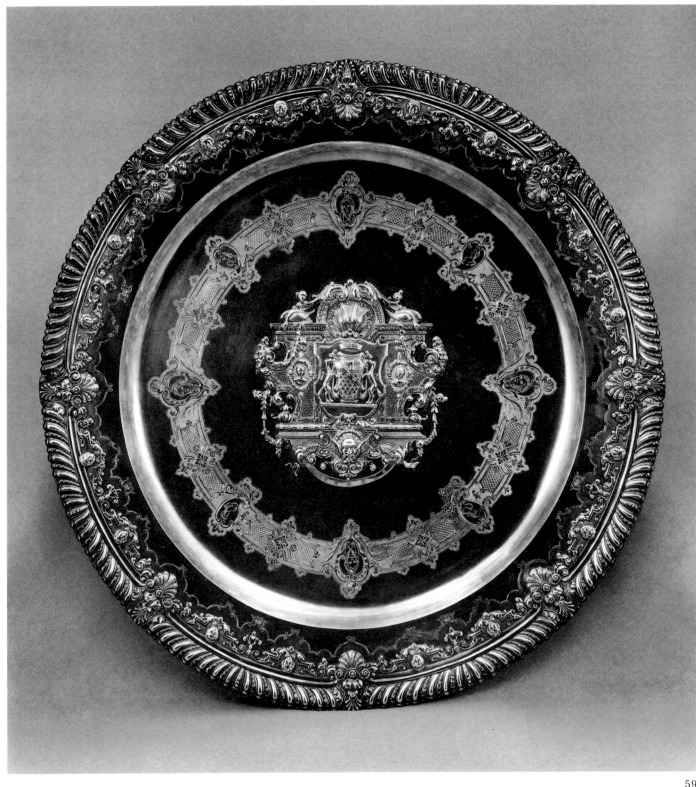

59

PAUL DE LAMERIE (active in the first half of the 18th century)

Basin. London hall-mark for 1726–27

Engraved, on the back, the monogram: *H*

Chased silver. Diameter 66 cm

Acquired in 1925 from the V. Shuvalova collection in Leningrad.
Inventory No. 13483

On the bottom, in the centre of the basin, is an applied shield
emblazoned with arms of Baron Stroganov, executed from a design
by the herald master Count F.M. Santi (active in Russia from 1724).
The same shield can be observed on a Lamerie basin of 1723
(see Hayward 1959, pls. 62–63).
The manner of decoration is similar in both pieces. The Hermitage
basin was probably ordered when the title of baron was conferred
on the Stroganovs.

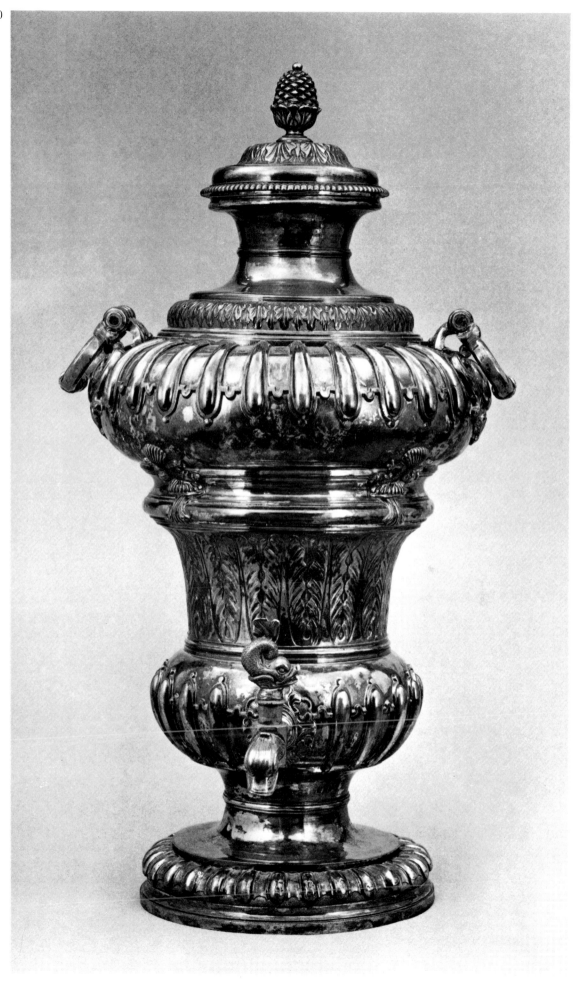

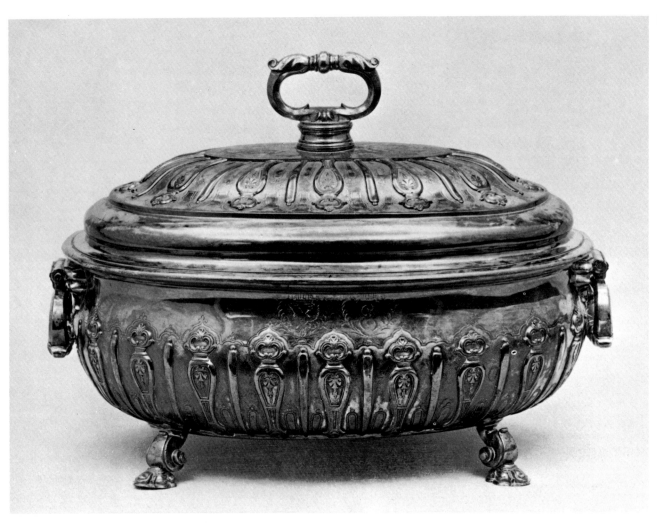

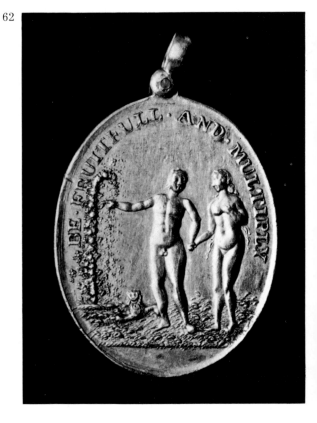

62

60

PAUL DE LAMERIE (active in the first half
of the 18th century)

Wine fountain. London hall-mark for 1720–21

Cast in silver, chased. Height 70 cm
Transferred in 1762 from the Winter Palace. Inventory No. 7025

61

SIMON PANTIN (c. 1680–1728)

Soup tureen and lid. London. C. 1715

Both bowl and lid bear the engraved arms of Catherine I
set in cartouches.

Cast in silver, chased. Height 29 cm
Transferred in 1762 from the Winter Palace. Inventory No. 7035
Part of the so-called English service.

Medal of the Beggars' Benison Club. First half
of the 18th century

Struck in silver, gilded. 28×35 mm (oval), 15.96 gm

Acquired in 1937 from the D. Burylin collection
of Masonic insignia. Inventory No. 178

A rare medal with a loop for suspension.
Obverse. Adam and Eve, a flowering vine and a lion.
Leg. BE.FRUITFULL.AND.MULTIPLY.
Reverse. Venus and Adonis. *Leg.* LOSE.NO.OPPORTUNITY.

64, 65

Medal of the Gormogon Society. 18th century

Struck in silver. 42×75 mm (oval), 26.82 gm

Transferred from the Winter Palace. Inventory No. 16134

Medal with a decorated loop for suspension. One of four known
examples of its kind.
Obverse. A figure representing the mythical 1st Emperor
of China — "the universal head" of the Order of the Gormogons.
Leg. C.Q.KY.PO.OECUM.VOLG.ORD.GORMOGO. (Chin Quan
Kypo Oecumenical Volgee of the Order of the Gormogons).
Below, in a decorated cartouche, the legend: AN: REG: XXXIX.
Reverse. The disc of the sun with the face of a man and radiating
beams. *Leg.* UNIVERSUS.SPLENDOR.UNIVERSA.
BENEVOLENTIA. At the bottom, on an ornamental tablet,
the legend: AN: INST 8799.
The Society or Order of the Gormogons was founded in 1724
by members of Masonic lodges, favouring the restoration
of the Stuarts.

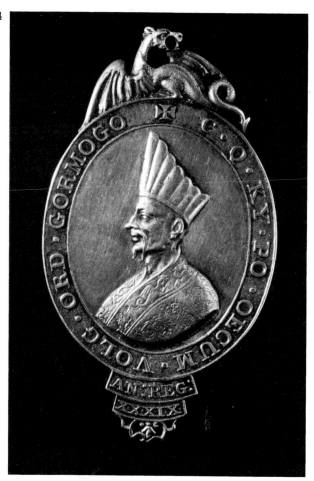

64

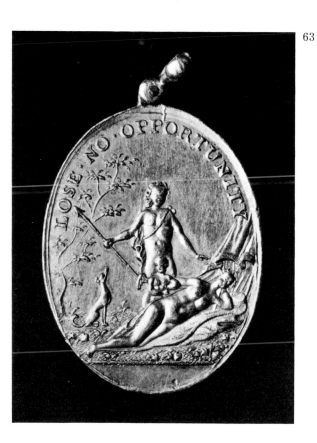

63

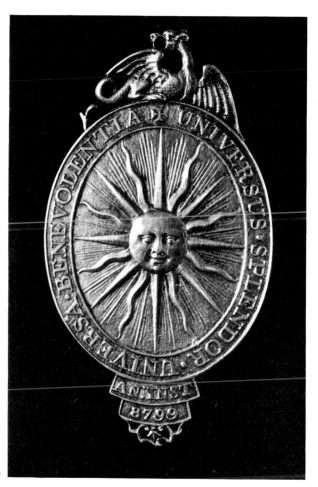

65

Turnip watch on a châtelaine. London. Mid-18th century

Signed on the mechanism: *Jos Dudds London 3101*

Chased gold, lapis lazuli, rubies and marcasite. Length 26 cm

Transferred from the Winter Palace.
Recorded in the inventory of 1789. Inventory No. 2026

66

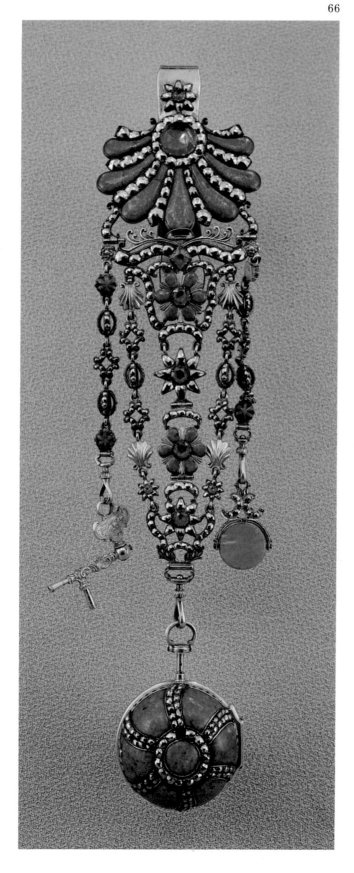

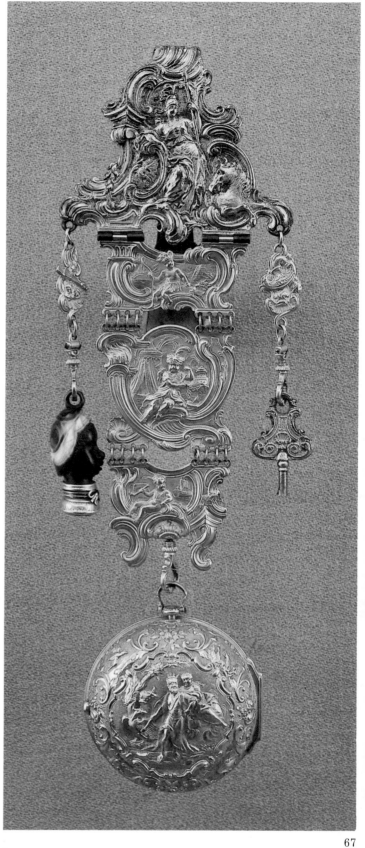

67

67

Turnip watch on a châtelaine. London. Mid-18th century

Signed on the face of the dial: *Hen: Thornton. London 1730*

Chased gold, decorated with a pendant in three-layered agate.
Length 30 cm

Transferred from the Winter Palace.
Recorded in the inventory of 1789. Inventory No. 2048

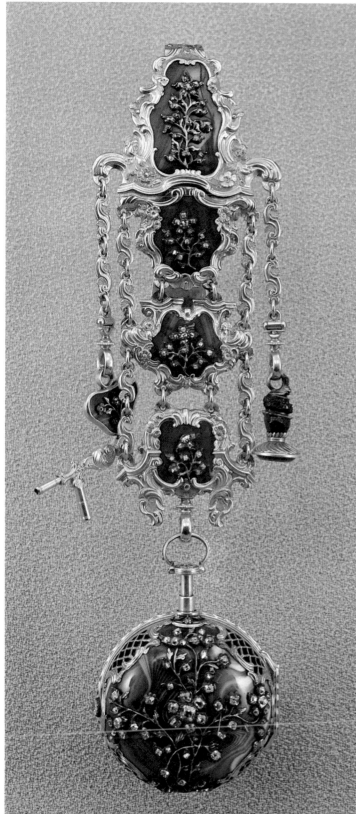

68

Turnip watch on a châtelaine. London. 1740s

Chased gold set with diamonds and rubies. Length 21.7 cm

Inscribed on the case: *W 1 No. 1139.* Signed on the mechanism and dial: *Quare Horseman London*

Transferred from the Winter Palace. Inventory No. 4303

Published for the first time.

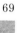

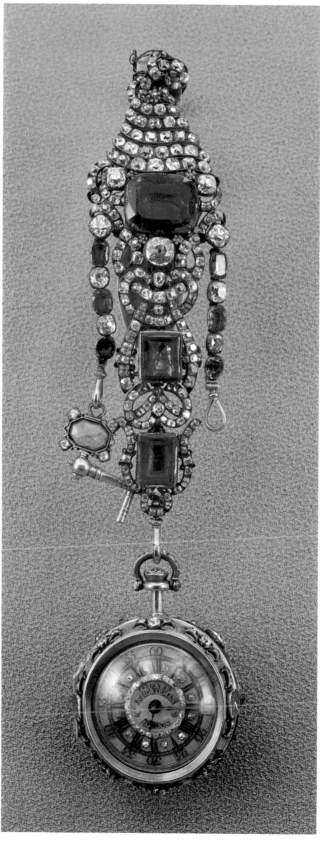

68

THOMAS TEARLE (active in the first half of the 18th century)

Turnip watch on a châtelaine. London. 1752–53

Signed on the dial and mechanism: *C. Cabrier. London 6900*

Agate mounted in chased gold set with diamonds. Length 19.8 cm

Transferred from the Winter Palace. Inventory No. 4310

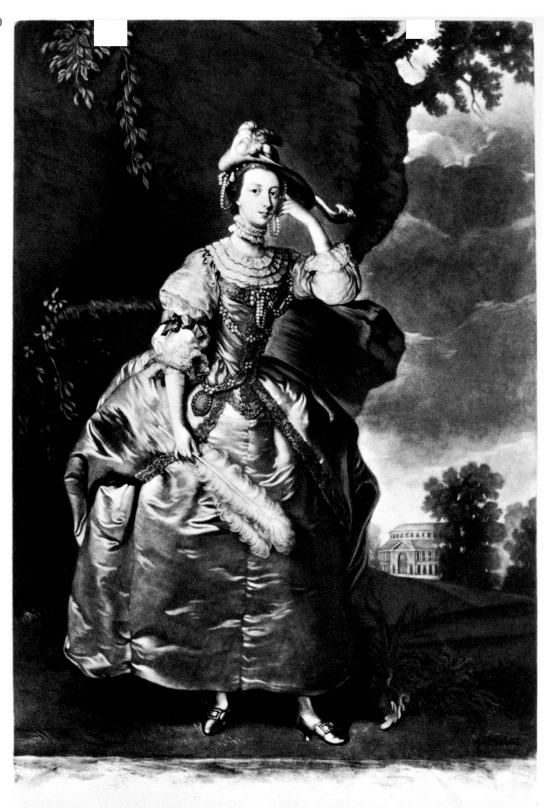

70

JAMES MacARDEL (1728/29 (?)–1765)

Portrait of Mary, Duchess of Ancaster. 1757

From the original of Thomas Hudson

Mezzotint. 50.3×35 cm. First state of three
(Smith 1884, vol. II, p. 836; Dukelskaya 1963, No. 42)

Acquired before 1817. Inventory No. 34049

Mary, Duchess of Ancaster (?–1793), was the mistress of Queen
Charlotte's wardrobe. Renowned as a trend-setter in fashion.

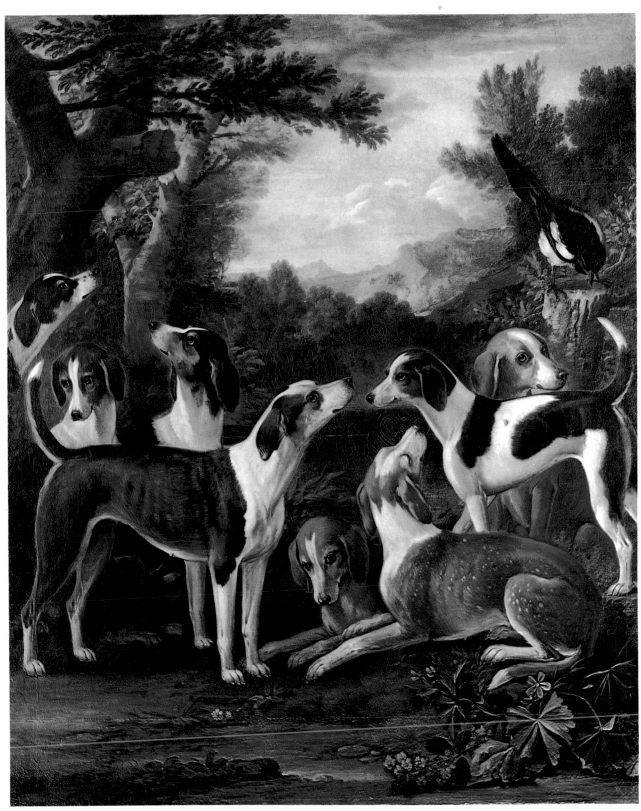

71

JOHN WOOTTON (*c.* 1686–1765)

Hounds and a Magpie

Oil on canvas. 152×128 cm

Signed, on the right: *John Wootton pinx.*

Transferred in 1958 from the Gatchina Palace near Leningrad.
Acquired in 1779 with the Robert Walpole collection
(Houghton Hall, Norfolk). Inventory No. 9781

In a description of the Houghton Hall collection, it was noted that
the picture hung in the Breakfast Room. William Byrne made an
engraving of it for the *Set of Prints Engraved after the Most Capital
Paintings in the Collection of... the Empress of Russia, Lately in
the Possession of the Earl of Orford* (London, 1788). Amongst the
engravings listed in the first volume (No. 14) there is a description
of the painting: "Painting by Wootton. Engraved by William Byrne.
Portraits of favourite hounds, and a magpie which generally
attended them at chase."

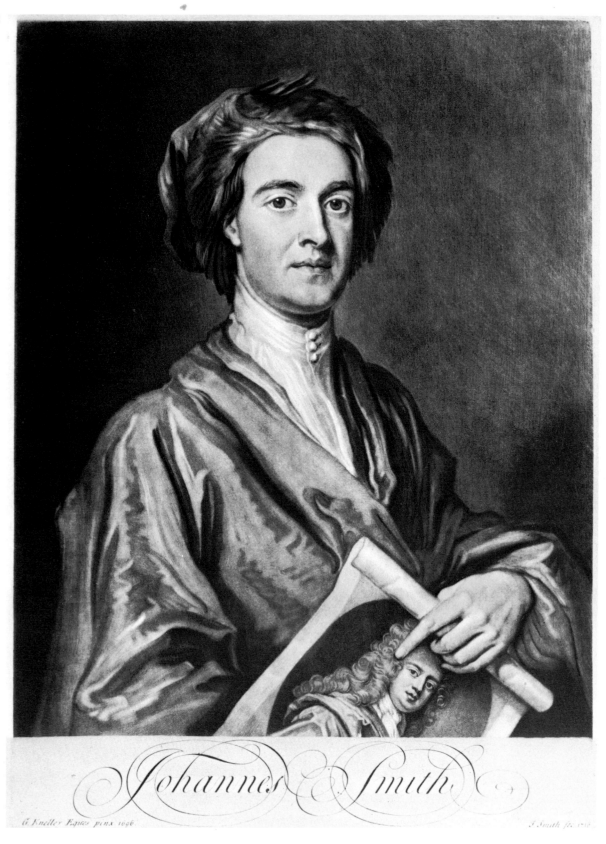

72

JOHN SMITH (1652?–1742)

Portrait of the Engraver John Smith. 1716

From the original of Godfrey Kneller

Mezzotint. 34×25.5 cm. Second state of three (Wessely 1887, Nr. 233; Dukelskaya 1963, No. 51)

Acquired before 1817. Inventory No. 34192

Smith holds the engraving he has made from Kneller's *Self-portrait*
(Kneller granted Smith the privilege of engraving his paintings).

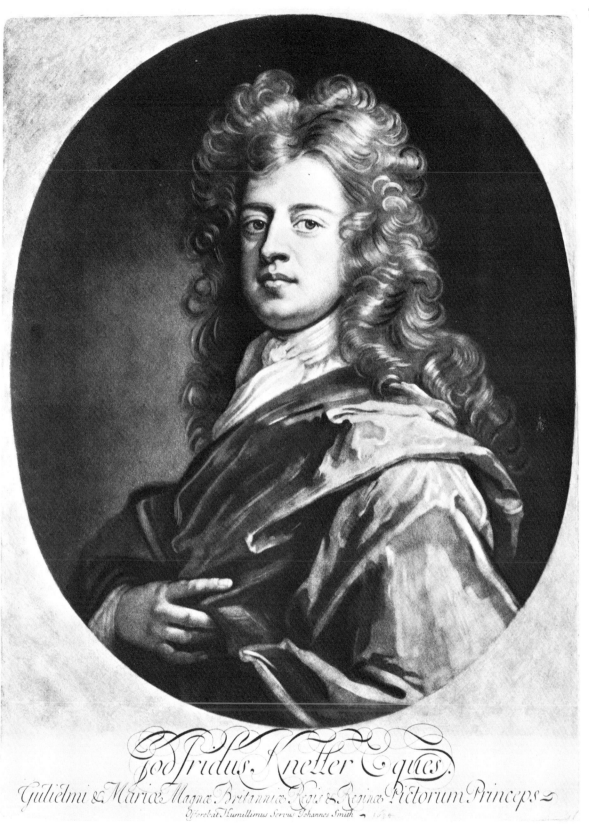

73

JOHN SMITH (1652?–1742)

Portrait of Godfrey Kneller. 1694(?)

Mezzotint. 36×26.8 cm. Second state of three (Wessely 1887, Nr. 153; Dukelskaya 1963, No. 50)

Acquired before 1817. Inventory No. 34193

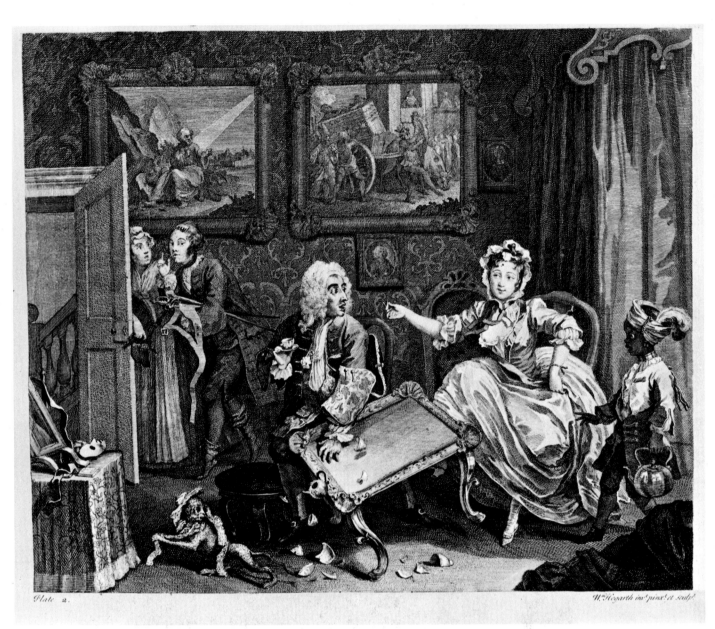

Plate 2.

W. Hogarth inv.t pinx.t et sculp.t

74

WILLIAM HOGARTH (1697–1764)

A Harlot's Progress. Second plate. 1744

Engraving. 60×45 cm. Second state of three
(Dobson 1891, p. 252; Paulson 1965, No. 152)

Acquired before 1817. Inventory No. 32942

The first issue of the engravings was executed and published by
Hogarth in 1732. Vertue wrote: "*A Harlot's Progress* has captivated
the Minds of most People persons of all ranks & conditions from the
greatest quality to the meanest" (Paulson 1971, vol. I, p. 284).
On 8 November 1744 Hogarth announced in *Daily Advertiser* that
due to public demand a second edition would be issued, and that, to
distinguish this edition, in the centre of each print, beneath
the engraving, there would be a cross.

WILLIAM HOGARTH (1697–1764)

The Four Times of the Day. A series of four prints: Morning, Noon, Evening, Night. 1738

Engraving and etching. 49×39.5 cm.
Second state of three (Dobson 1891, p. 262;
Paulson 1965, Nos. 152–155; Paulson 1971,
vol. I, pp. 398–404)
Acquired before 1837

The originals were painted by Hogarth around 1736 as a result of commission from Jonathan Tyers to decorate a pavilion in the Vauxhall pleasure gardens. Hogarth advertized subscriptions to his engravings at the start of 1738 in the *London Daily News*: "Mr. Hogarth Proposes to Publish by Subscription, Five large Prints from Copper-Plates... after his own Paintings, viz. four representing, in a humorous Manner, Morning, Noon, Evening, and Night; and the fifth, a Company of Strolling Actresses dressing themselves for the Play in a Barn. Half a Guinea to be paid at the Time of Subscribing, and Half a Guinea more on the Delivery of the Prints. The Pictures, and those Prints already engrav'd, may be view'd at the Golden Head in Leicester Fields, where Subscriptions are taken in. — Note, After the Subscription is over, the Price will be rais'd to five Schillings each Print; and no Copies will be made of them (Paulson 1965, p. 178).
On 4 May, the *London Daily Post* informed the subscribers that Hogarth had just finished his work on the prints: "Mr. Hogarth hath just published at 1.5 s. a Set of Five Prints" (Paulson 1965, p. 178).
Whilst at work on this series, Hogarth was aided by Bernard Baron.

75

I. **Morning**

Inventory No. 33054

The scene depicts Covent Garden in London. On the right is the façade of Inigo Jone's Church of St. Paul burned down in 1795 and rebuilt by Thomas Hardwick. In front is the notorious Tom King's Coffee House. Its position in the picture is different from the one that it actually occupied, i.e. on the opposite side of the square. The house in the background is somewhat reminiscent of a stern and belonged to Admiral Edward Russell.

76

II. **Noon**

Inventory No. 33055

In the background is the church of St. Giles-in-the-Fields. Paulson suggests that it also depicts Hog Lane, an area of Soho colonized by French émigrés. On the right is a Catholic church.

77

III. **Evening**

Inventory No. 33056
Engraved by Bernard Baron

The scene is laid north of London on the bank of the New River. In the background is the building of Sadler's Wells Theatre.

78

IV. **Night**

Inventory No. 33057

A London street near Charing Cross with its bronze equestrian statue of Charles I. The character in the foreground is a drunken Freemason. He is believed to be a portrait of Thomas de Veil, the Bow Street Magistrate. He was so corrupt and so strict in his condemnation of drunkenness that on one occasion a mob set fire to his house (a large fire burning on the horizon hints at this fact). Fielding used him as a model for Justice Squeezum in his comedy *The Coffee House Politician, or the Justice Caught in His Own Trap*. The oak boughs on the barber's sign and candles on the window-sills show that it is 29 May, the anniversary of the Restoration in 1660.

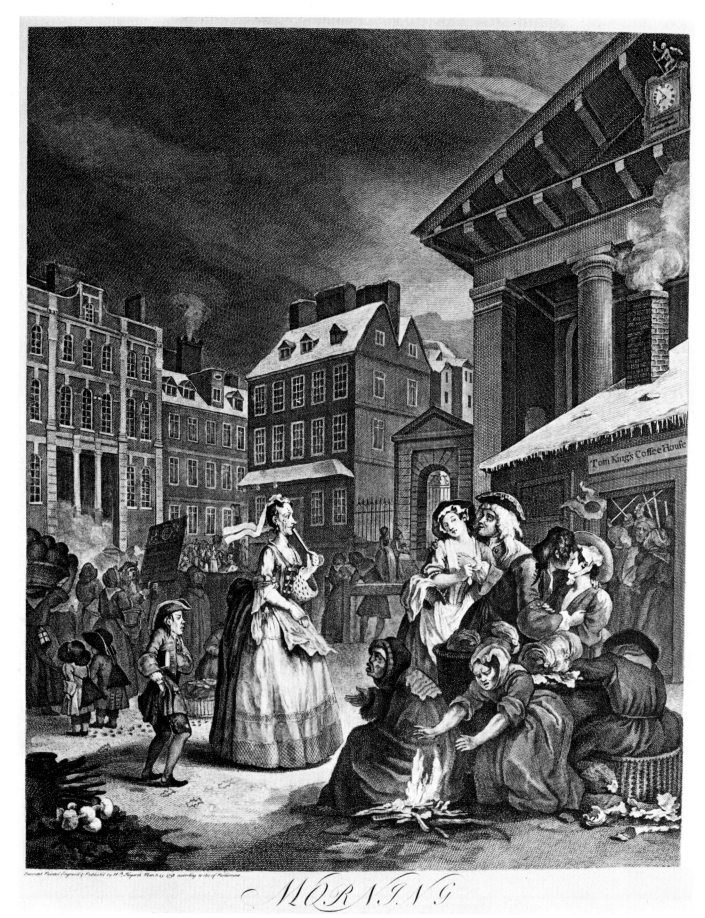

Invented Painted Engraved & Published by W. Hogarth March 25, 1738 according to Act of Parliament.

MORNING

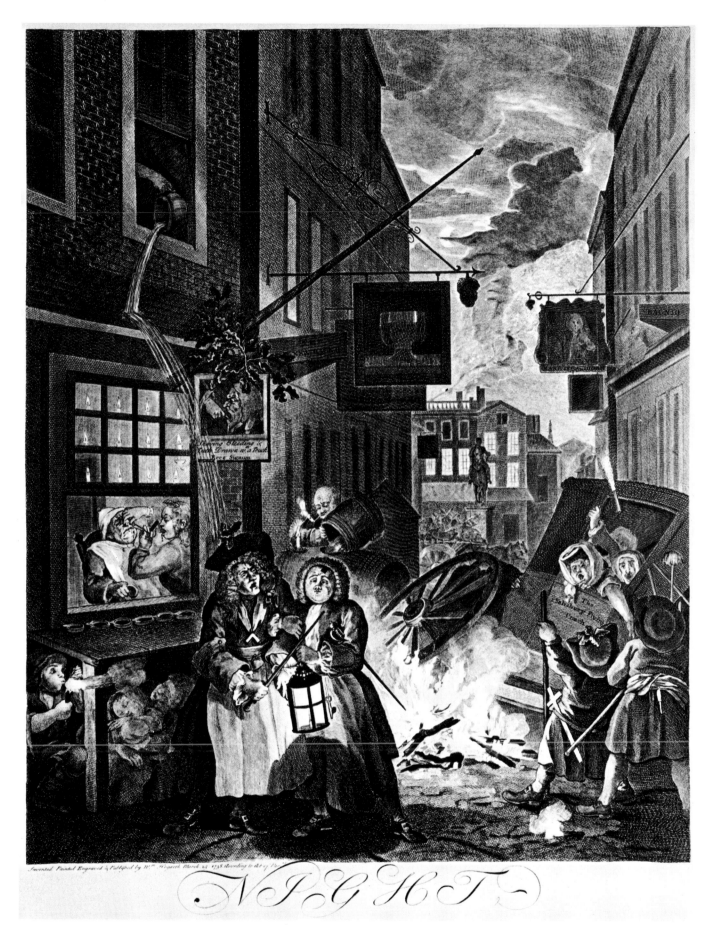

N I G H T

78

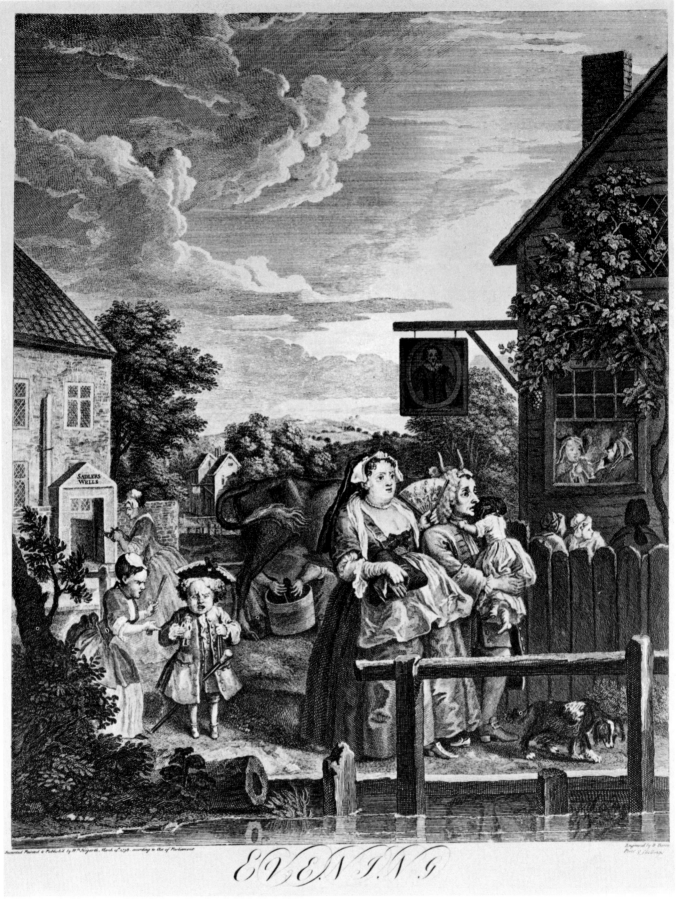

Invented Painted & Publish'd by Wm Hogarth, March 25 1738. according to Act of Parliament

Engraved by B Baron
Price 1 Shilling

E V E N I N G

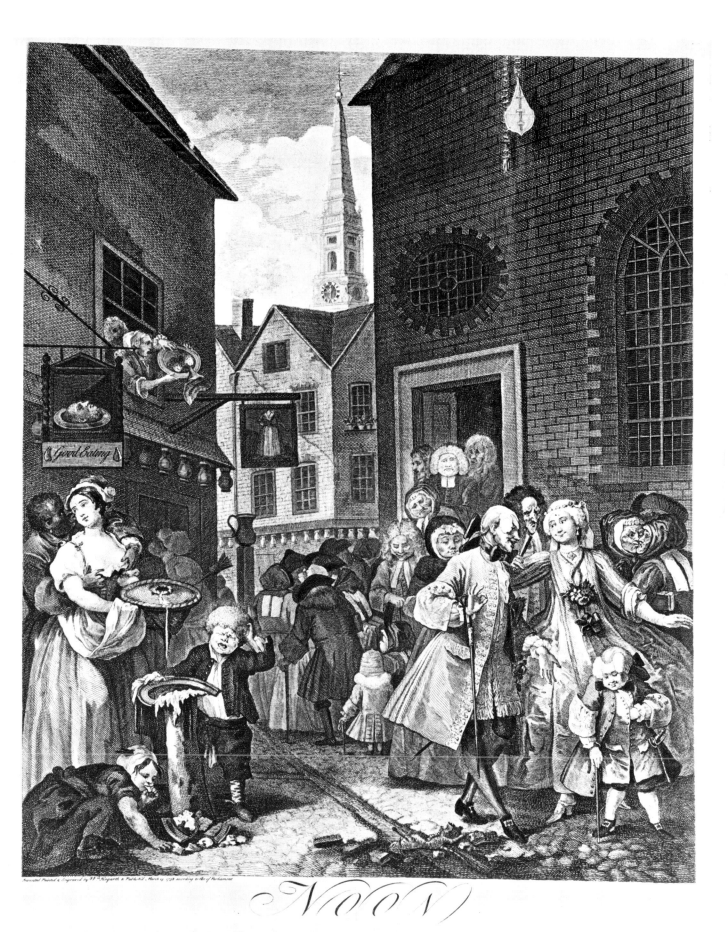

Good Eating

Invented Printed & Engraved by Wm Hogarth & Publish'd, March 25. 1738 according to the Act of Parliament

NOON

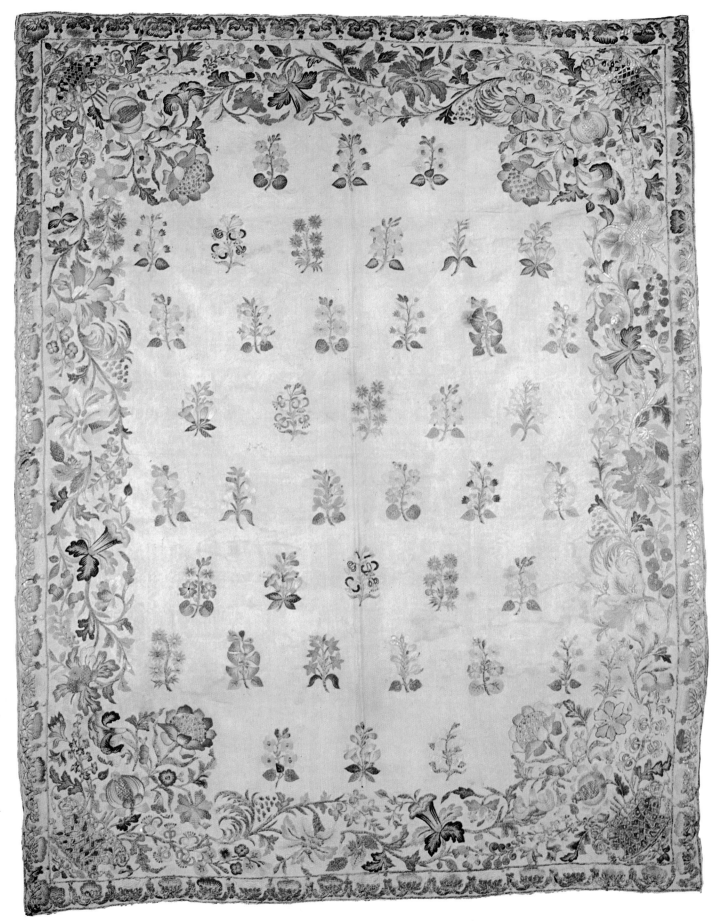

79

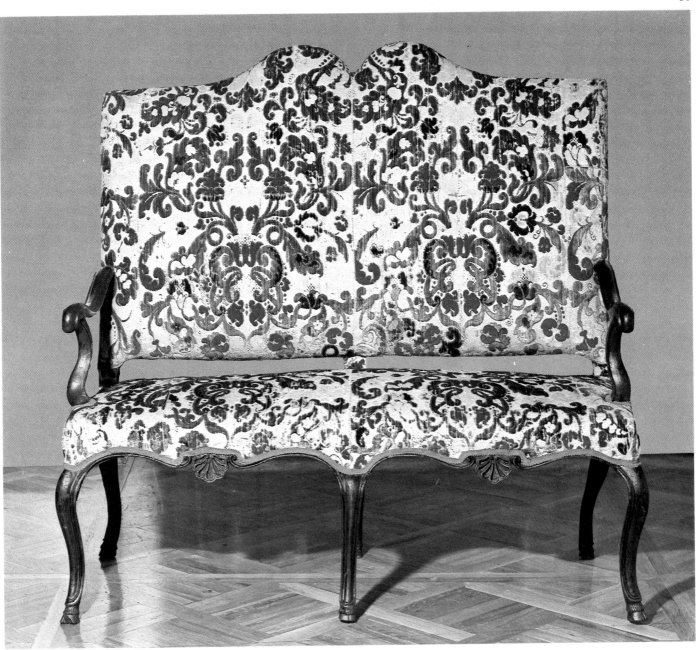

79

80

Table cloth. First third of the 18th century

Satin, long and short stitch, couched work. 98×127 cm

Transferred in 1933 from the Stieglitz School Museum
in Leningrad. Inventory No. 2229

English decorative needlework of the first half of the 18th century
is characterized by a rich floral border framing a central square.
The form of these items reflects the influence of Oriental art
which was a consequence of the enormous influx of luxury
articles from India and China since the late 17th century.
Similar examples may be found in the Victoria and Albert Museum
(see *Guide to English Embroidery*, London, 1970, No. 59) and
in the Untermyer collection (*English and Other Needlework
Tapestries and Textiles in the Irwin Untermyer Collection*,
Cambridge, 1960, p. 126).

Published for the first time.

Sofa. First quarter of the 18th century

Carved walnut, covered in velvet
with a silk-thread design. Height 128 cm

Transferred in 1930 from the Winter Palace.
Inventory No. 1884

The style of English furniture of the 1720s and '30s is generally
called the Queen Anne style. Its ruling principle was simplicity
and comfort.
The high straight back of the Hermitage sofa and the cabriole
legs are typical of furniture of this style. Characteristic too,
is a scallop shell motif on the frame.
Similar sofas are to be seen in the Victoria and Albert Museum.

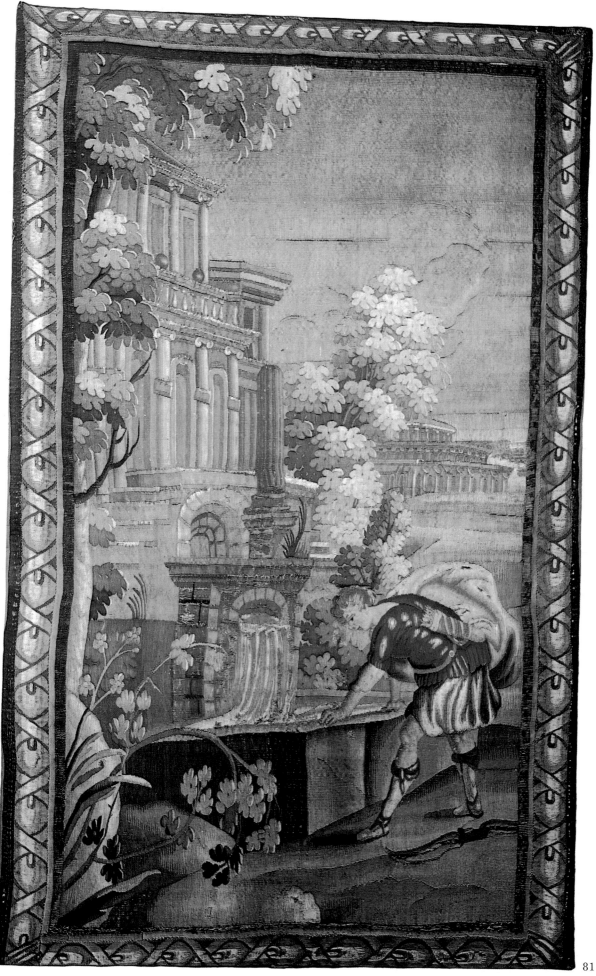

81

Tapestry: Narcissus at the Source.

From the series *Ovid's
"Metamorphoses"*. 18th century

Wool, silk, hand-woven. 194×125 cm

Acquired in 1936. Inventory No. 15630

Several sets of tapestries on subjects
from Ovid's *Metamorphoses* were
produced in an unknown workshop in
the 18th century. The distinguishing
feature of these tapestries is the narrow
border decorated with a geometrical
design recalling a rod interwoven
with ribbon.

The Hermitage tapestry is a simplified
version of the subject based on the myth
of Narcissus, a motif repeatedly used
in this workshop.

Published for the first time.

82

**Tapestry with an architectural
landscape.** 18th century

Wool, silk, hand-woven. 193×93 cm

Acquired in 1936. Inventory No. 15631

Fragment of a tapestry *The Muse* from
the series *Ovid's "Metamorphoses"*.
A similar tapestry in a private collection
in England was published by
H.G. Marilier (*English Tapestries of the
Eighteenth Century*, London, 1930,
p. 87, pl. 35).

Published for the first time.

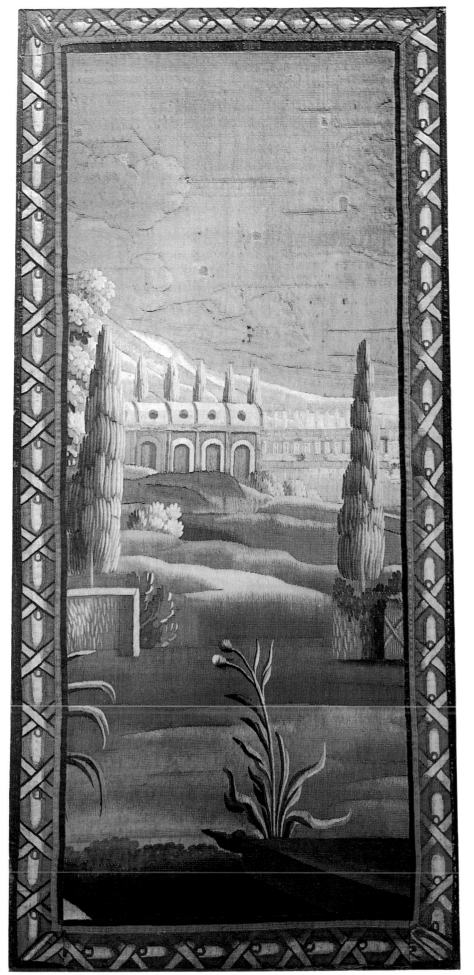

82

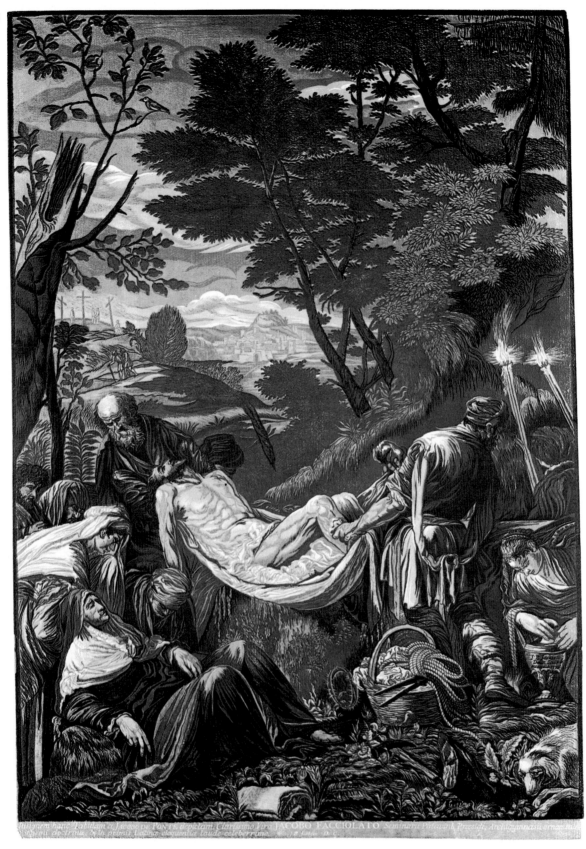

JOHN BAPTIST JACKSON (1700/1–*c.* 1777)

The Entombment. 1739

From the original of Jacopo Bassano

Chiaroscuro woodcut. Print from four blocks. 45.4×38.6 cm
(Nagler 1828, No. 5; Kainen 1962, No. 19; Dukelskaya 1970, No. 3)

Acquired before 1817. Inventory No. 7294

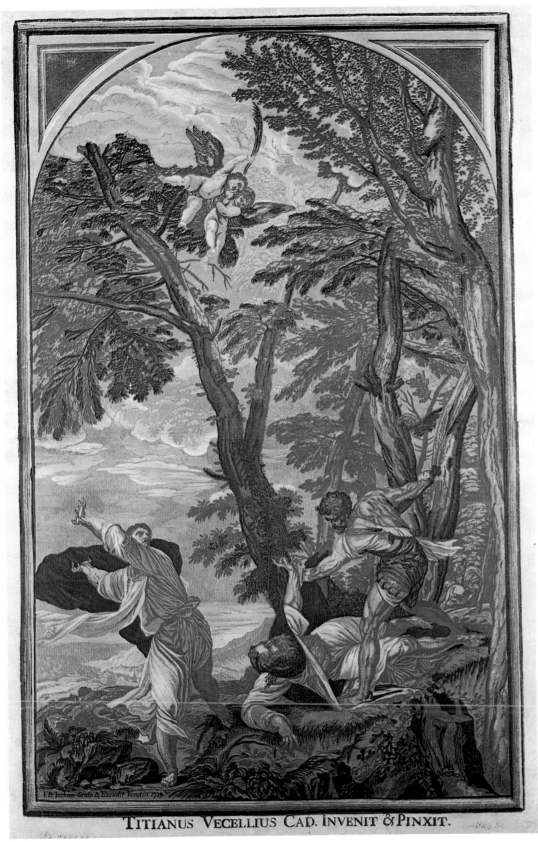

TITIANUS VECELLIUS CAD. INVENIT & PINXIT.

JOHN BAPTIST JACKSON (1700/1–c. 1777)

The Death of St. Peter the Martyr. 1739

From the lost original by Titian

Chiaroscuro woodcut. Print from four blocks.
Heightened with white. 54×34.6 cm (Nagler 1828, No. 10;
Kainen 1962, No. 16; Dukelskaya 1970, No. 6)

Acquired in 1939 from the S. Yaremich collection
in Leningrad. Inventory No. 368359

The engravings, *The Entombment* and *The Death of St. Peter the Martyr*, belong to a set consisting of seventeen coloured xylographs from paintings by outstanding Venetian masters — Bassano, Titian, Veronese and Tintoretto. The set was produced by Jackson in Venice between 1739 and 1743. "In this Work may be seen", he wrote in the *Essay*, "what engraving on Wood will effectuate, and how truly the Spirit and Genius of every one of those celebrated Masters are preserved in the Prints."

AUGUSTINE COURTAULD (active in the first half of the 18th century)

Centrepiece. London hall-mark for 1741–42

Silver, chased and engraved, crystal. Height 30 cm

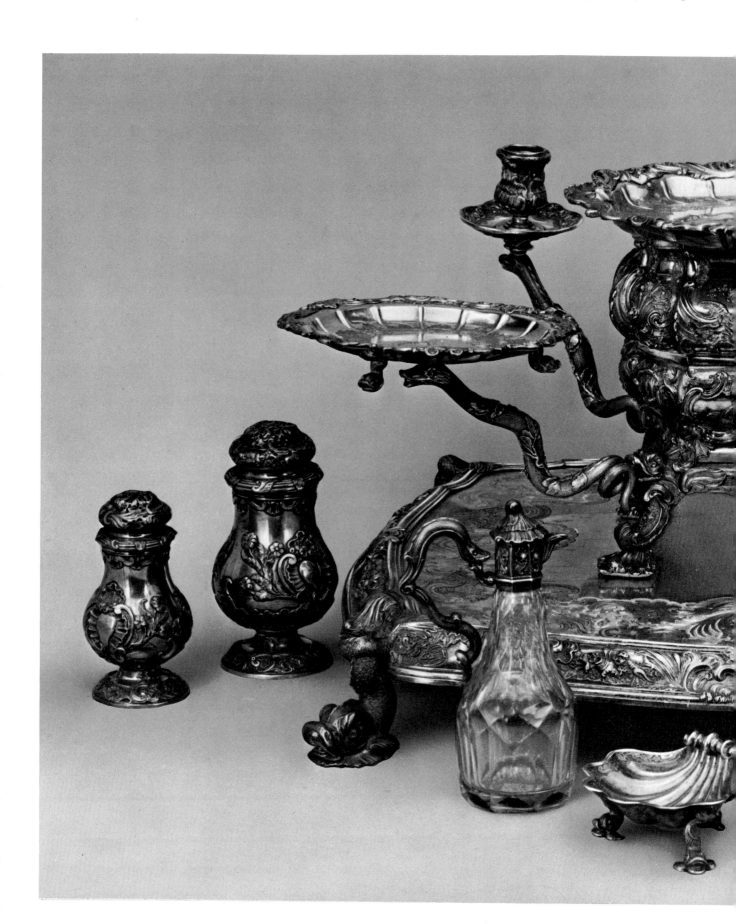

Acquired in 1922 from the Yusupov collection in Petrograd.
Inventory No. 13429

The centrepiece is an exceptionally rare example of its kind in
English silverware of the time.

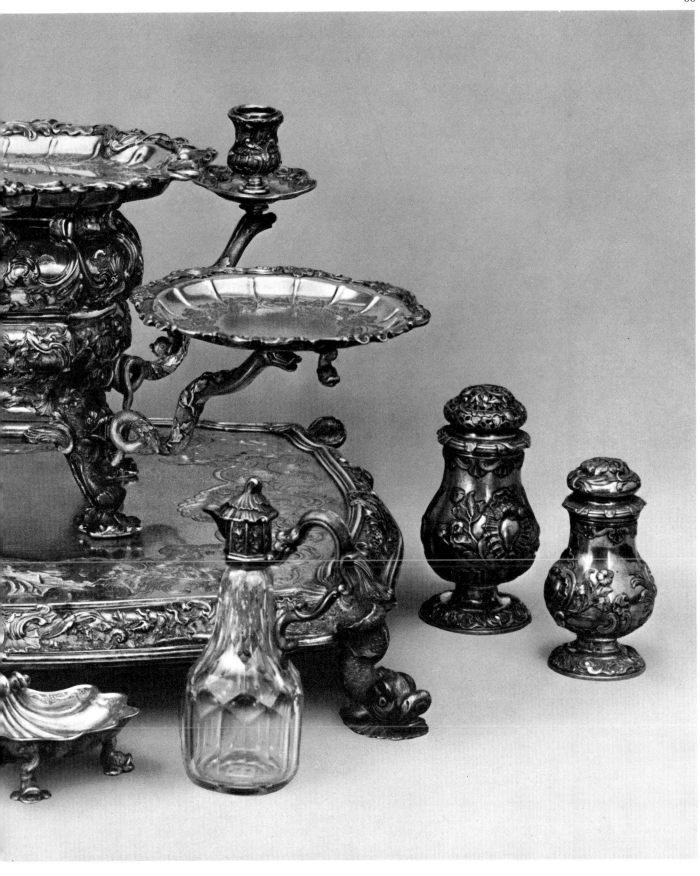

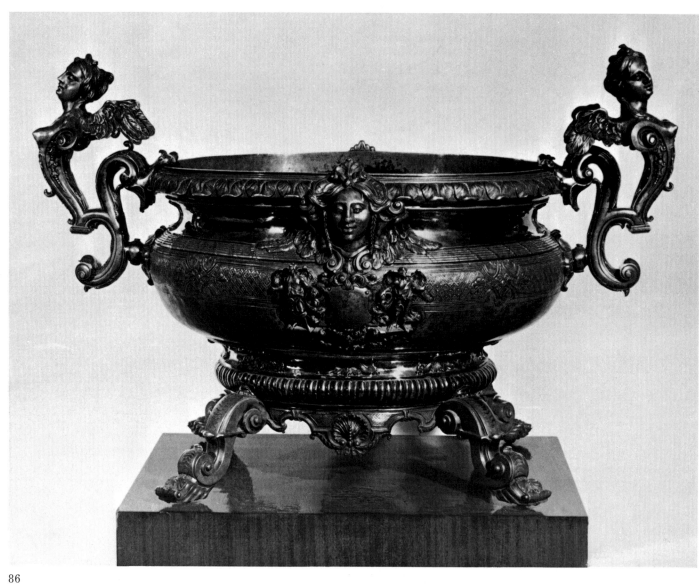

86

86, 87

PAUL DE LAMERIE (active in the first half
of the 18th century)

Wine cooler. London hall-mark for 1720–21

Cast in silver, chased. Length 132 cm

Acquired in 1741. Inventory No. 7040

The body of the cooler bears the arms of Nicholas Leake, 4th Earl
of Scarsdale. At some later date, attempts were made to remove
the arms eventually covered over with a small shield.
The cooler was brought to Russia as a part of the so-called
Augsburg service, which belonged to Duke Biron.

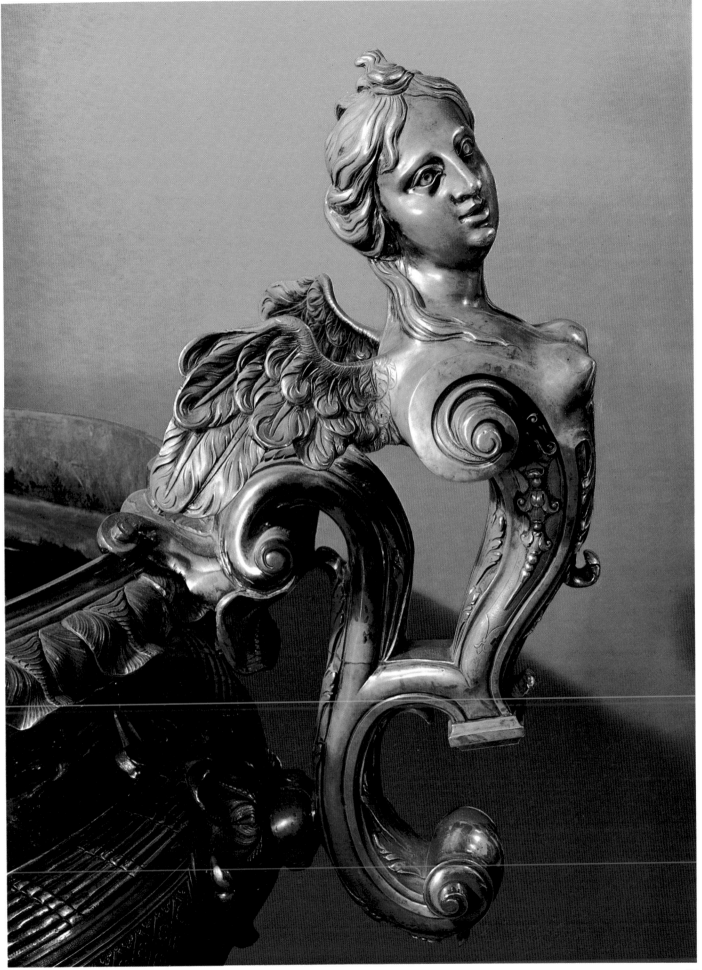

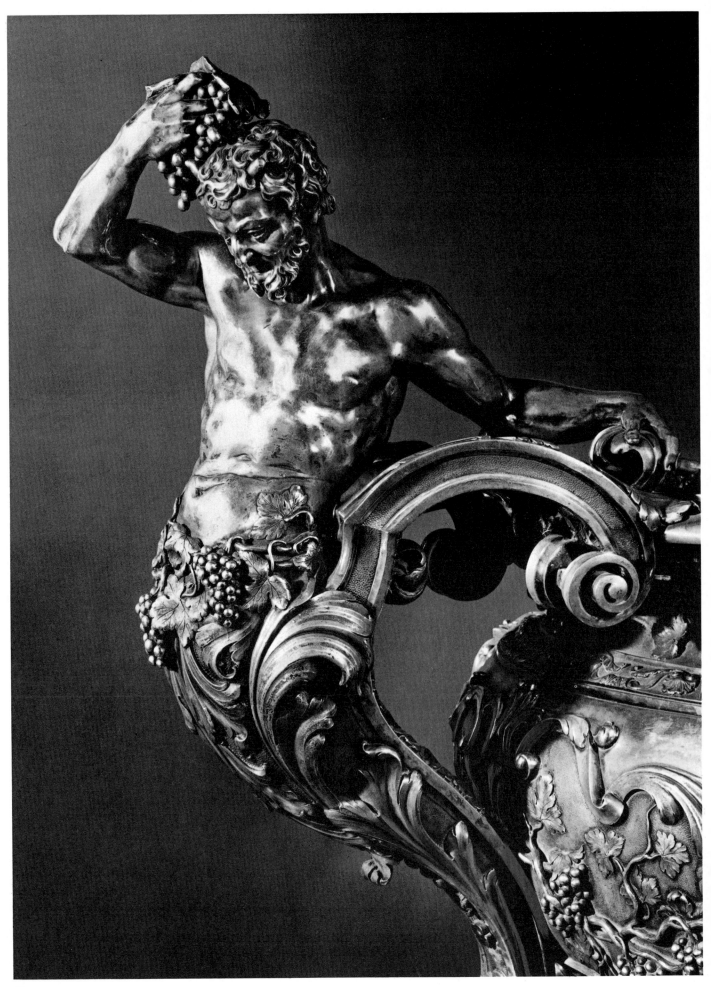

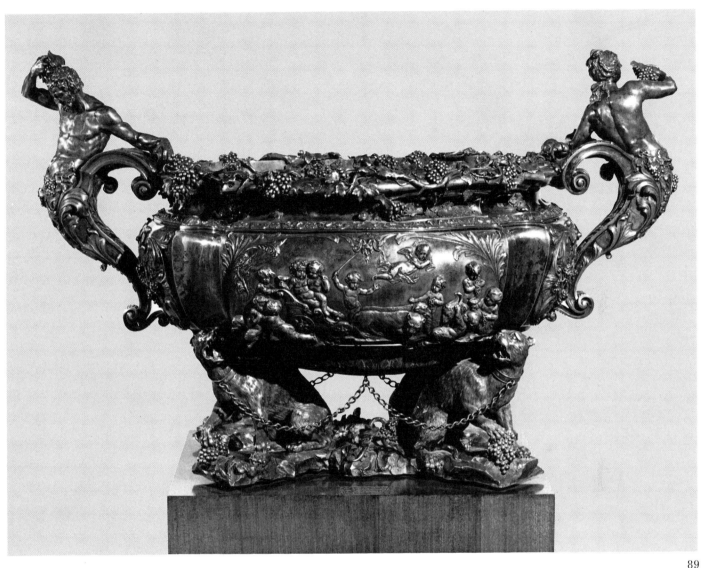

88–90

CHARLES KANDLER (active in the first half
of the 18th century)

Wine cooler. London hall-mark for 1734–35

Cast in silver, chased. Length 155 cm

Transferred from the Winter Palace. Inventory No. 7041

Work on the cooler was initiated by the banker and silversmith
Henry Jerningham, who drew a design of it in 1730, which was
engraved by George Vertue. Wax models were made by the sculptor
John Michael Rysbrack.

In 1735 Jerningham asked the permission of Parliament to use
the wine cooler as a prize in lotteries organized to raise money
for building a bridge over the Thames at Westminster Abbey.
In 1737 it was won by William Battin of East Marden in Sussex.
Soon afterwards the cooler arrived in Russia and may have been
acquired for Empress Anna. In 1741, on the orders of Empress
Elizabeth, the cooler became the property of the State. In 1881,
after interest in the cooler had been revived by the English art
historian Wilfred Cripps, a galvanoplastic copy was made
for the Victoria and Albert Museum.

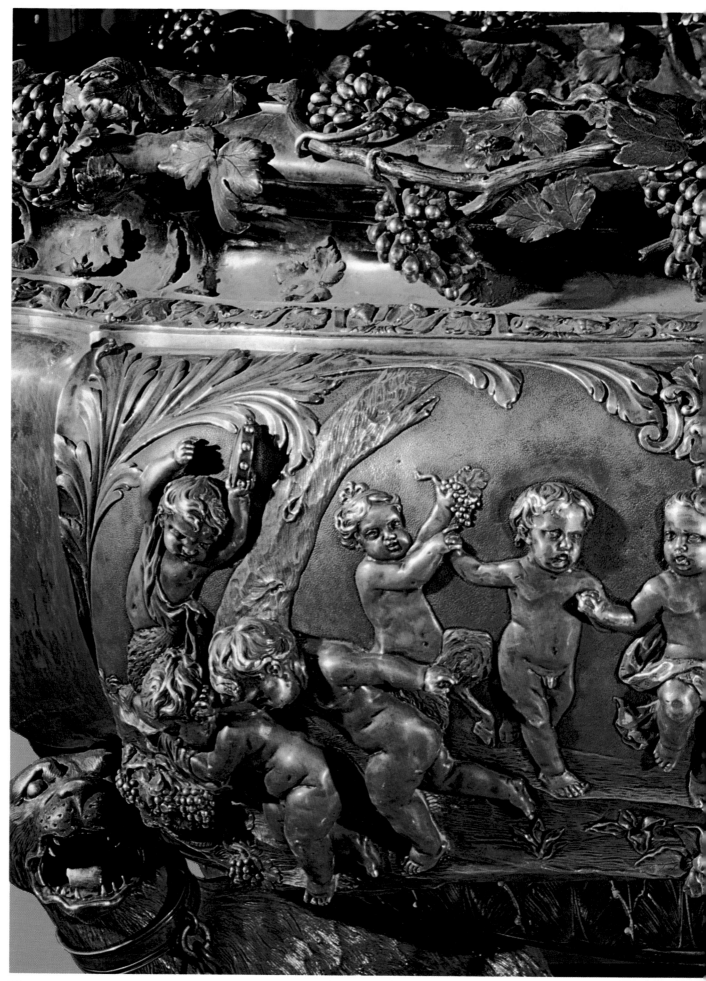

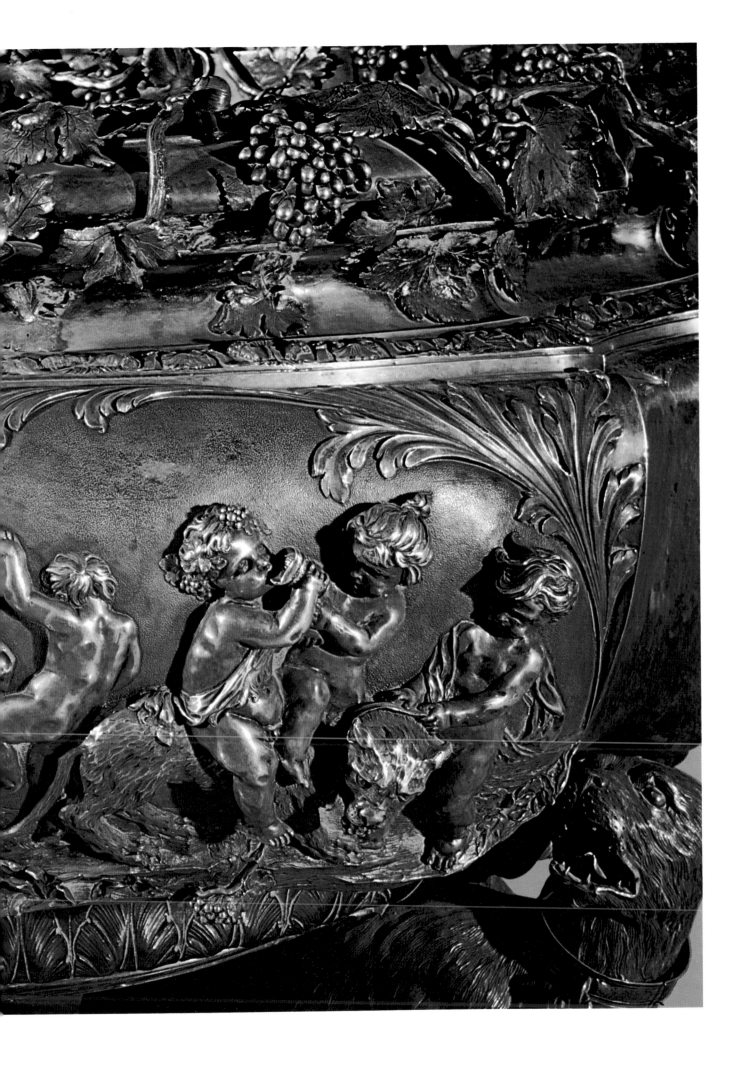

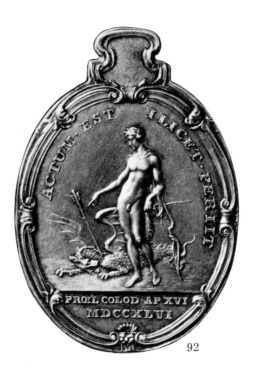

91

92

91, 92

RICHARD YEO (*c.* 1720–1779)

Service medal commemorating the Battle of Culloden. 1746

Struck in silver. 38×54 mm (oval), 36.85 gm

Acquired before 1850. Inventory No. 7540

The medal has an ornamental border and a loop for suspension. In the Hermitage piece the loop has not been pierced.

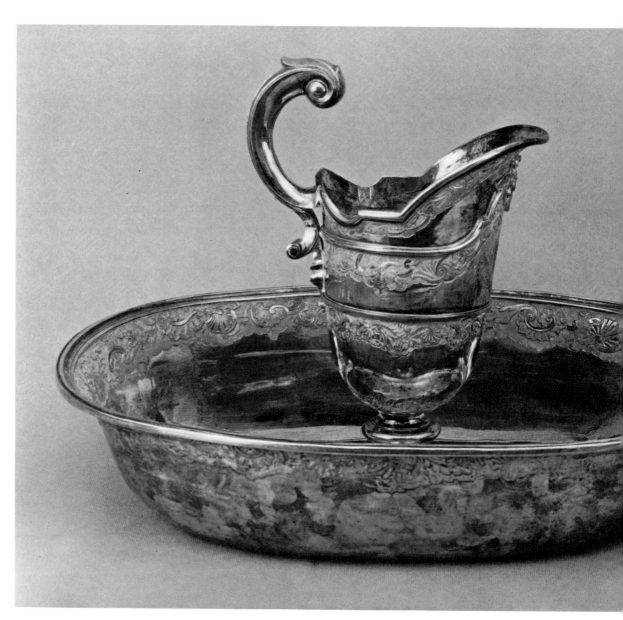

Obverse. Head of Duke of Cumberland.
Leg. CUMBERLAND. Bottom left: YEO. F. (artist's signature).
Reverse. Apollo, laureate, leaning upon his bow, points to the Dragon wounded by his arrow.
Leg. ACTUM.EST ILICET. PERIIT. At the bottom: PRŒL: COLOD. AP XVI MDCCXLVI. The medal commemorates the Duke of Cumberland's victory over the Scottish Jacobites led by Prince Charles Edward and Lord Murray.

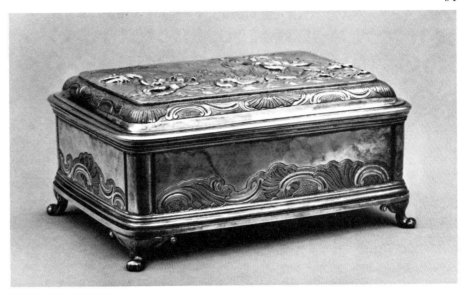

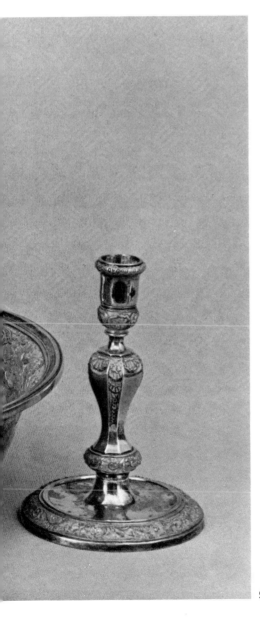

93

Ewer, basin and candlestick. 1730s

Chased silver. Height of ewer 25.5 cm; length of basin 38 cm; height of candlestick 13.6 cm

Acquired in 1922 from the Altenburg collection in Petrograd. Inventory Nos. 13764–13766

The ewer, basin and candlestick form part of a twenty-four piece toilet set which belonged to Duke Biron. Almost all the pieces bear his coat-of-arms. The set was produced between 1718 and 1738 by the London craftsmen Paul de Lamerie, Peter Archambo, Augustine Courtauld, Simon Pantin, George Johnson and Edward Vincent.

94

AUGUSTINE COURTAULD (active in the first half of the 18th century)

Casket. London hall-mark for 1741–42

Chased silver. Height 9.8 cm

Acquired in 1908 from the collection of Grand Prince Alexei Alexandrovich in St. Petersburg. Inventory No. 438

93

SAMUEL WOOD (c. 1704–1794)
WILLIAM CRIPPS (?–1767)

Centrepiece. London hall-mark for 1745–46

Chased silver, wood. Height 28.5 cm

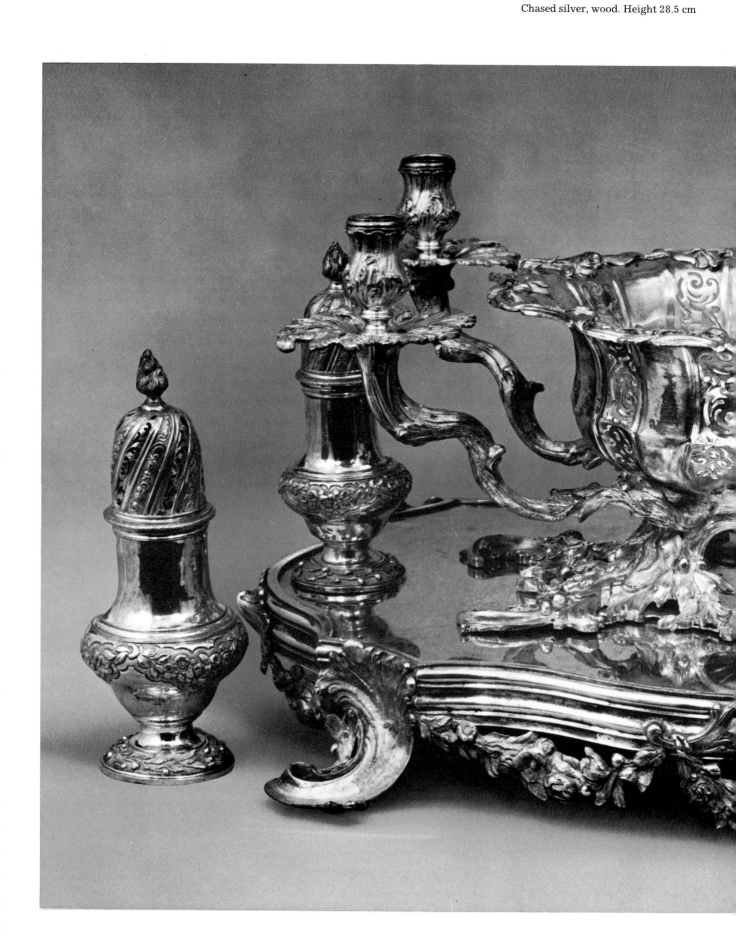

The pepperpots bear the mark of the maker Wood, and the body,
that of Cripps. The stand bears the stamp of the St. Petersburg
Assay Office and the assay-master Ivan Frolov.
Acquired in 1762. Inventory No. 7042
The stand possibly produced in St. Petersburg.

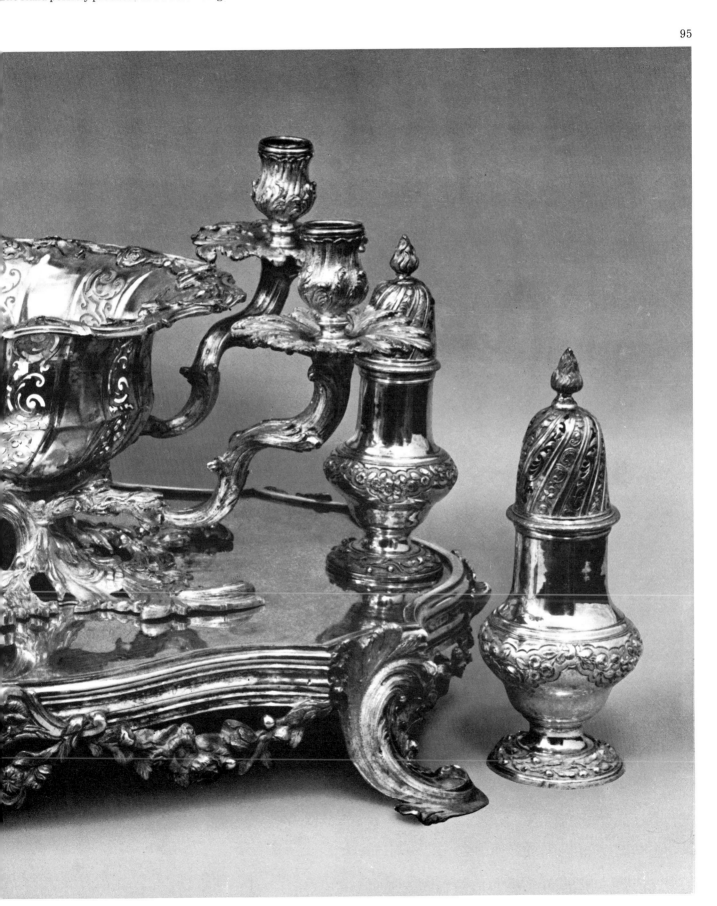

96

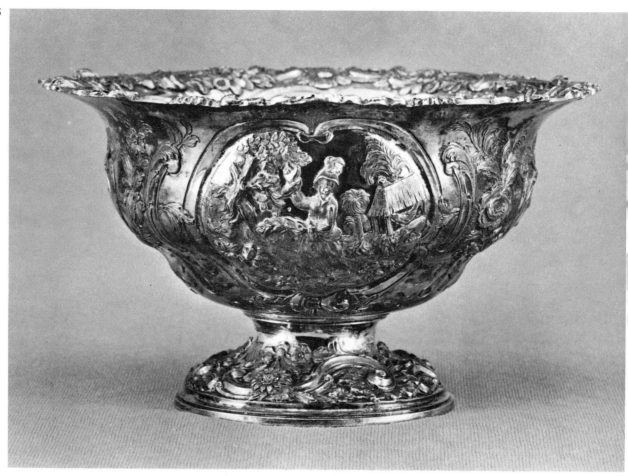

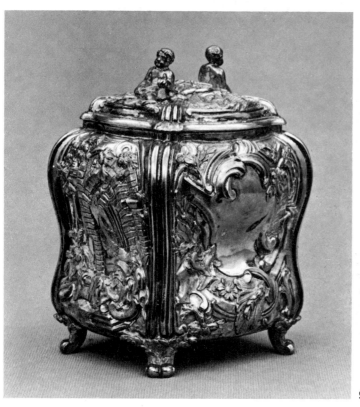

97

96

FULLER WHITE (?–1775)
Rinsing bowl. 1758–59
Chased silver. Height 10.5 cm
Inventory No. 7128
Part of the so-called Oranienbaum service.

97

THOMAS HEMMING (?–1795/1801)
Tea-caddy. 1750–51
Chased silver. Height 13.2 cm
Inventory No. 7129
Part of the so-called Oranienbaum service.

FULLER WHITE (?–1775)

Tea-pot. 1757–58

Chased silver, wooden handle. Height 17 cm
Inventory No. 7127
Part of the so-called Oranienbaum service.

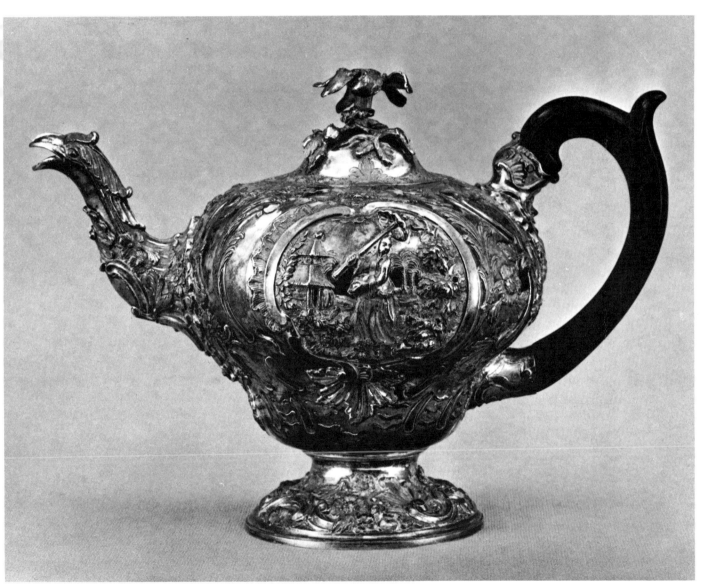

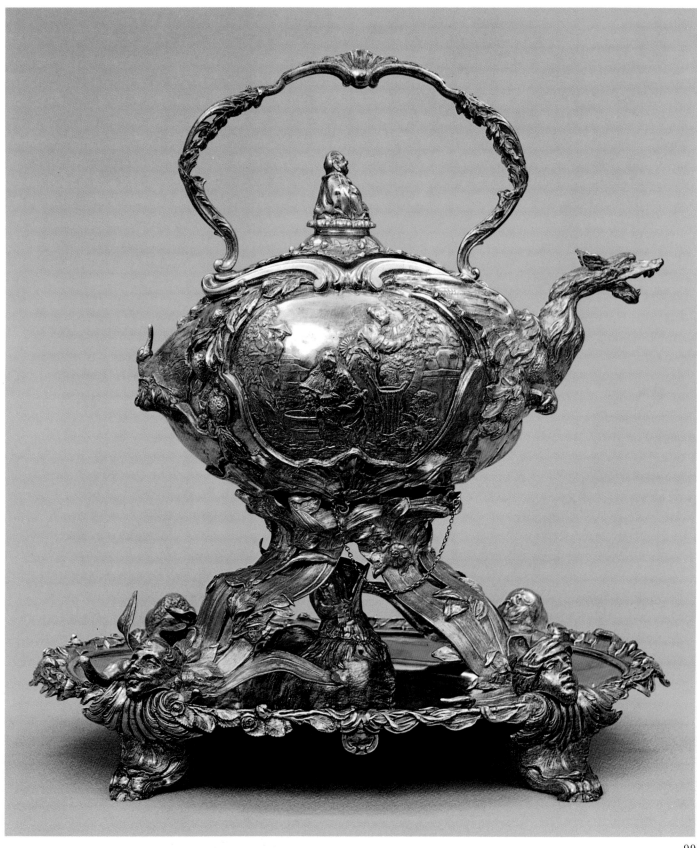

99, 100

NICHOLAS SPRIMONT (1718–1770)

Tea-kettle, stand and burner. London hall-mark for 1745–51

Cast in silver, chased. Height 39.5 cm

The tea-kettle bears the stamp of the St. Petersburg Assay Office dated 1792 and the stamp of the assay-master Nikifor

Moshchalkin. The date letter on the tea-kettle corresponds to the years 1750–51, and on the burner, to 1745–46.

Transferred in 1792 from the Oranienbaum Palace. Inventory No. 7125

Part of the tea and coffee set of the so-called Oranienbaum service. It consisted of seven pieces produced by Nicholas Sprimont, Thomas Hemming and Fuller White in 1745–58.

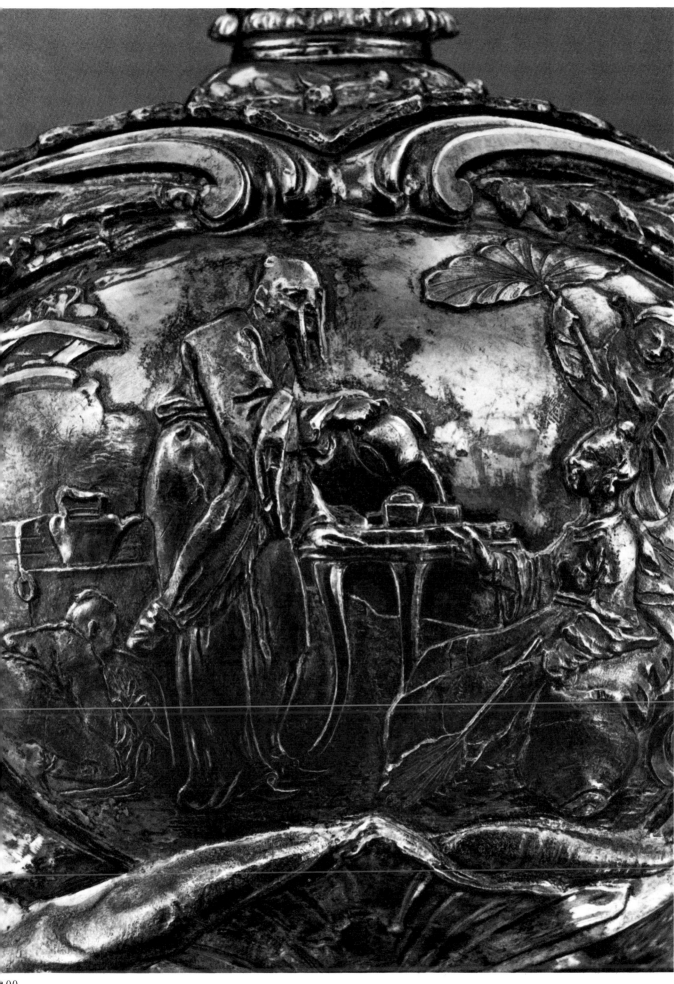

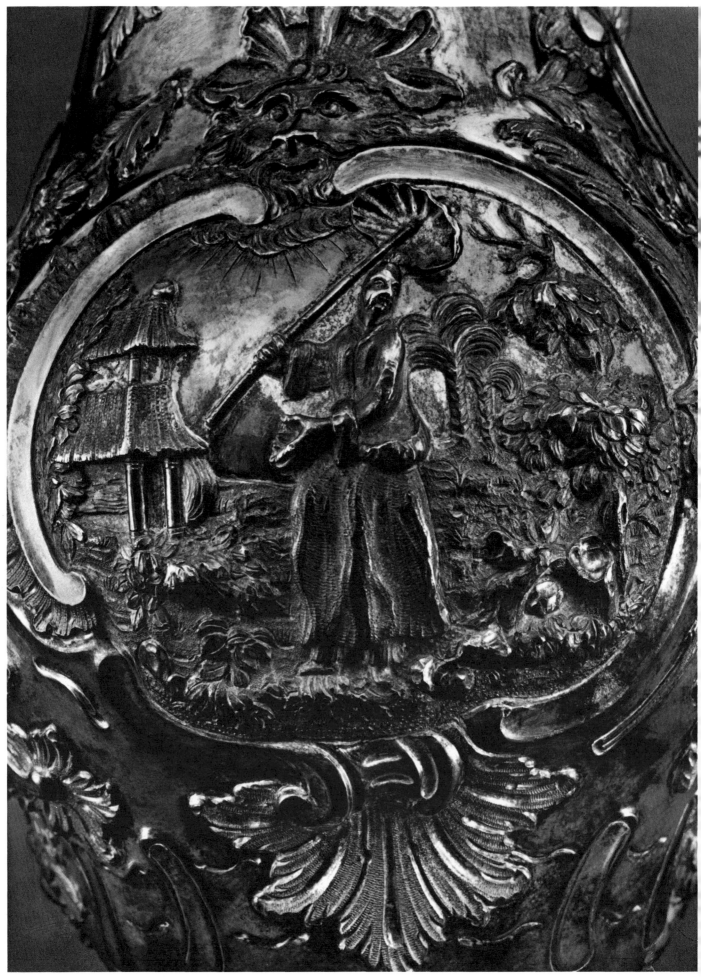

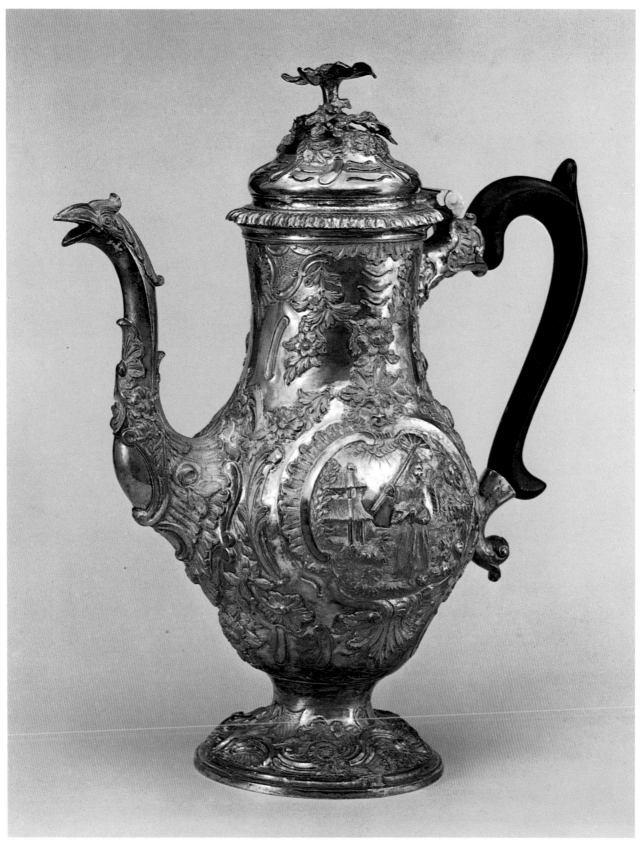

102

101, 102

FULLER WHITE (?–1775)

Coffee-pot. 1756–57

Chased silver, wooden handle. Height 28.5 cm

Inventory No. 7126

Part of the so-called Oranienbaum service.

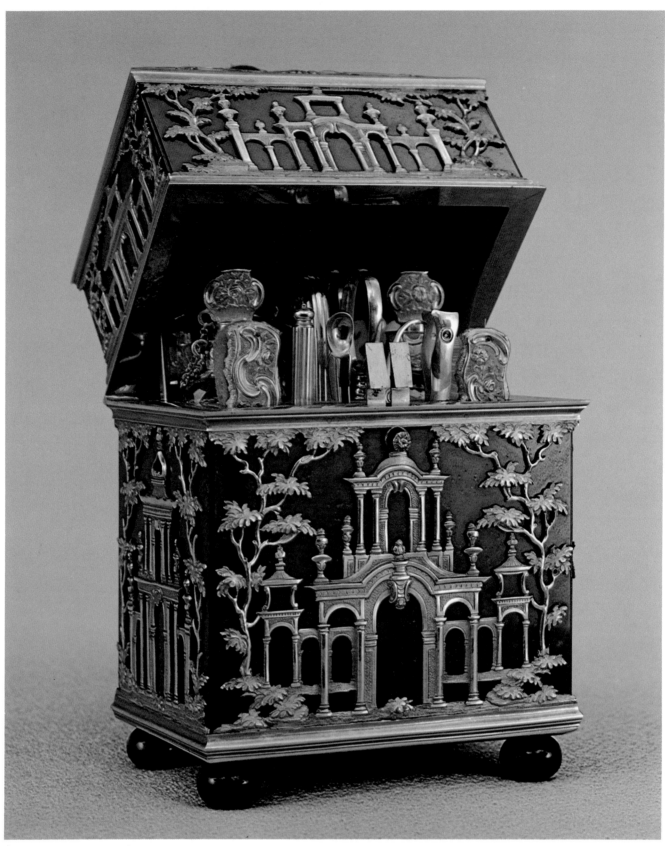

104

103

Necessaire. Mid-18th century

Chased gold, bloodstone. Height 12.7 cm

Transferred from the Winter Palace. Recorded in the inventory
of 1789. Inventory No. 1811

The 1859 inventory says that "the necessaire was a gift presented
to Empress Catherine on her name-day".
The tablet in the necessaire bears an inscription in Russian with
congratulations and wishes to the Empress.

104

Notebook and pencil. Mid-18th century

Shagreen mounted in gold set with bloodstones.
The pencil bears a seal in cornelian. Length 14 cm

Transferred from the Winter Palace. Recorded in the inventory
of 1789. Inventory No. 1351
Published for the first time.

105

Necessaire. Mid-18th century

Shagreen mounted in gold. Length 9.5 cm

Transferred from the Winter Palace. Recorded in the inventory
of 1789. Inventory No. 1374

105

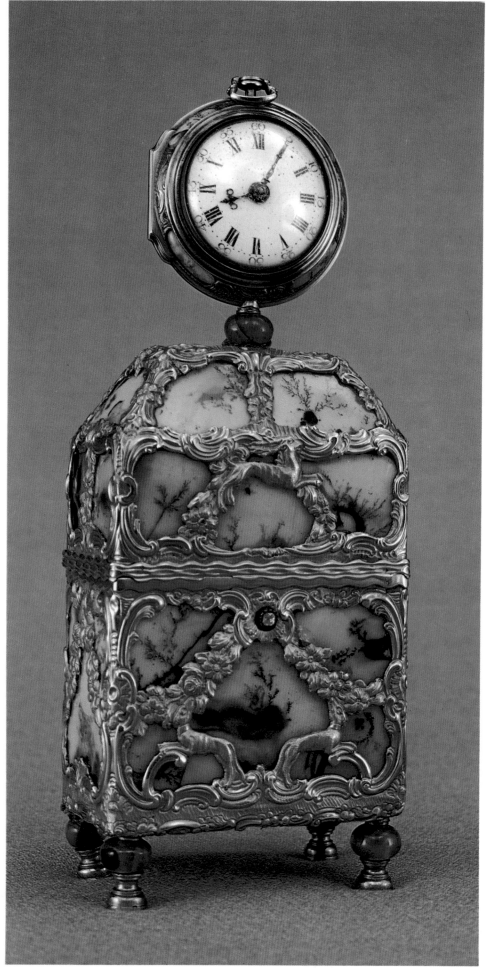

Necessaire with clock.
London. Mid-18th century

Moss agate mounted in chased
gold set with diamonds.
Height 14.5 cm. Signed on
the mechanism: *Dan^e Platiel*

Transferred from
the Winter Palace.
Recorded in the inventory
of 1789. Inventory No. 2005

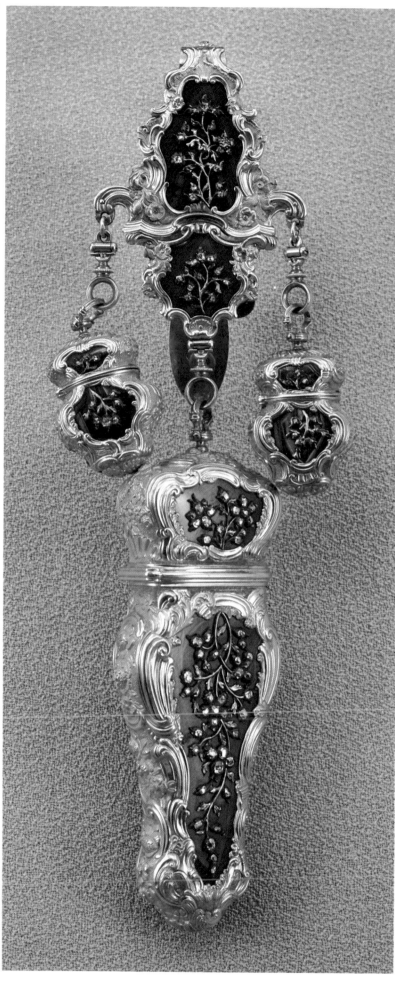

107

THOMAS TEARLE (active
in the first half of the 18th century)

Necessaire on a châtelaine.
London hall-mark for 1752–53

Banded agate mounted in chased gold
set with diamonds. Length including
the châtelaine 19.5 cm

Transferred from the Winter Palace.
Inventory No. 4312

Published for the first time.

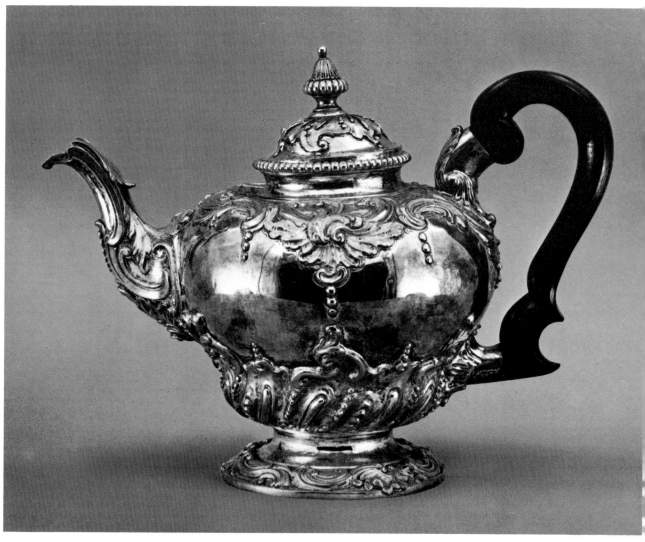

108

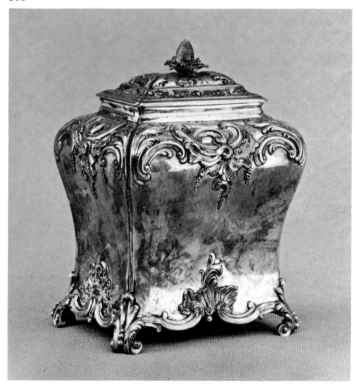

108

SAMUEL COURTAULD (1720–1765)

Tea-pot. London hall-mark for 1757–58

Chased silver. Height 15.5 cm
Acquired in 1762. Inventory No. 7049

109

PIERRE GILLOIS (active in the second
half of the 18th century)

Tea-caddy. 1757–58

Chased silver. Height 13 cm
Acquired in 1762. Inventory No. 7043
The caddy, as well as the coffee-pot and tea-pot
by Samuel Courtauld (inventory Nos. 7046 and 7049),
was part of a travelling set.

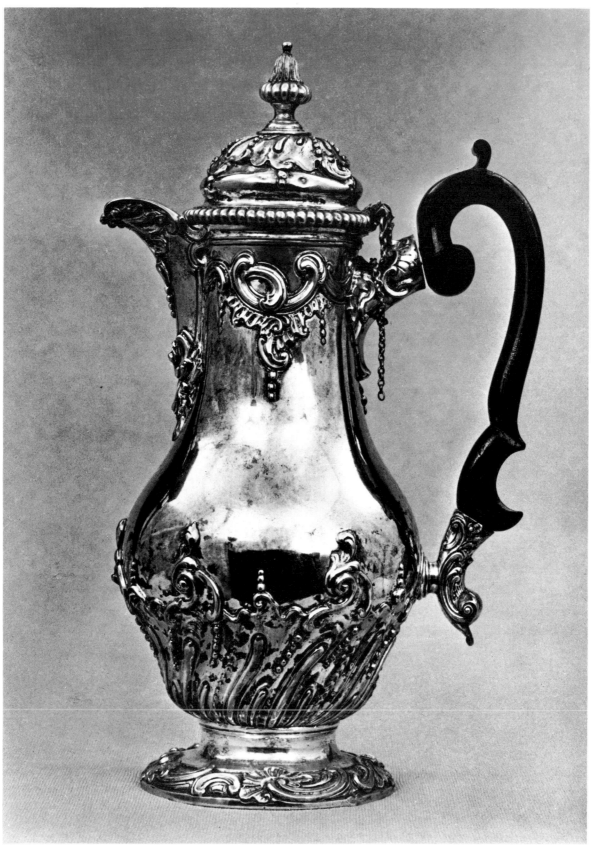

110

110

SAMUEL COURTAULD (1720–1765)

Coffee-pot. 1757–58

Chased silver. Wooden handle. Height 26 cm

Acquired in 1762. Inventory No. 7047

The Hermitage has a companion coffee-pot with
a silver handle (inventory No. 7046).

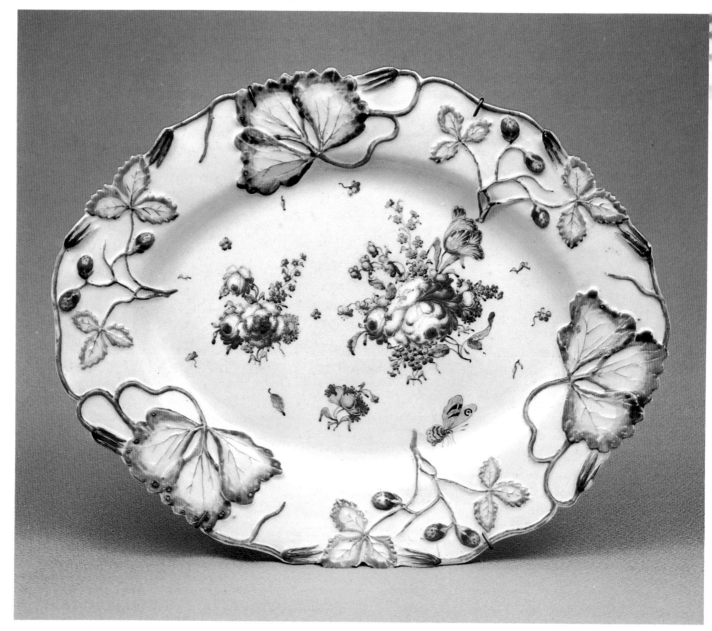

111

Dish. Longton Hall. *C.* 1775

Unmarked

Porcelain painted in colours. 20.4×23.4 cm

Acquired in 1918 from the A. Dolgorukov collection
in Petrograd. Inventory No. 20900

Amongst the items produced at Longton Hall, the plates and dishes
moulded in relief with foliate designs were especially important.
A plate with the same foliate pattern on the border as the Hermitage
dish but with a different painted design in the centre, was put up
for auction at Christie's on 28 October 1968 (lot 73). A plate similar
to this one, is reproduced by Honey (1928, pl. 48).

**Tea-pot in the form
of two scallop shells.**
Whieldon. *C.* 1750

Unmarked

Agateware, pewter lid.
Height 13.7 cm

Transferred in 1928 from
the Leningrad City Museum.
Formerly in the Anichkov Palace
in St. Petersburg.
Inventory No. 14219

Similar tea-pots in the form of
scallop shells produced at the
Whieldon factory, are mentioned
by Hayden (1912, p. 188).
A tea-pot like the one in the
Hermitage is in the Victoria and
Albert Museum (see Rackham
1928–30, vol. II, No. 249).

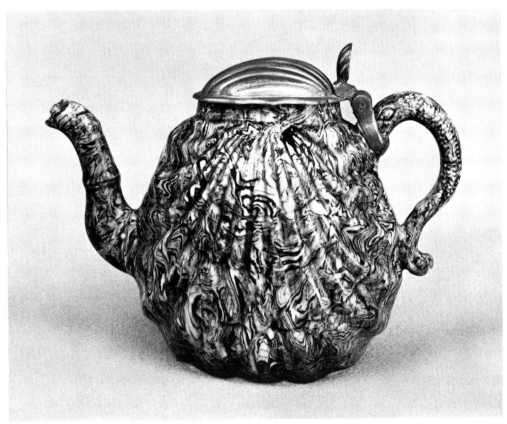

112

113

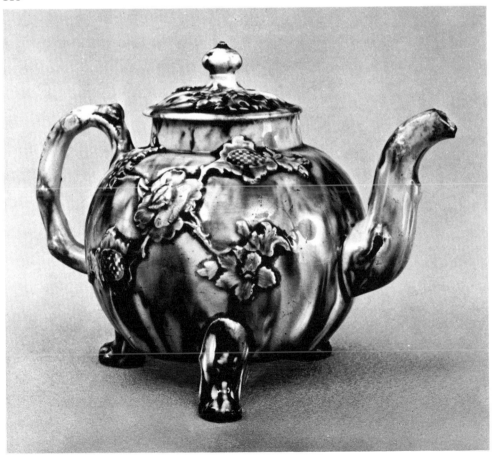

113

Tea-pot and cover.
Whieldon–Wedgwood. *C.* 1755

Unmarked

Porcelain with relief ornament
under a tortoise-shell glaze.
Height 12.6 cm

Transferred in 1919 from
the Museum of the Society
for the Encouragement of Arts
in Petrograd (*Catalogue* 1904,
p. 245, No. 14).
Inventory No. 19056

Similar tea-pots are reproduced
by Corely & Schwartz
(1965, fig. 2)
and Mankowitz & Haggar
(1957, pl. 108B).

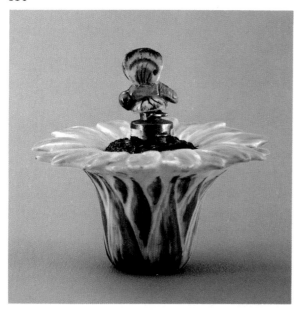

114

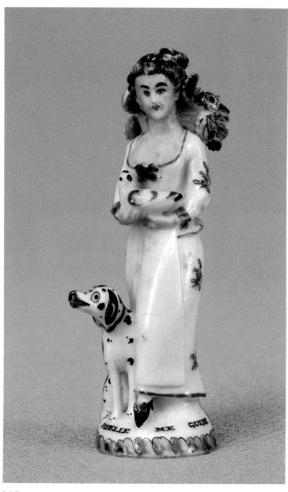

115

Scent-bottle: Sunflower. Chelsea. *C.* 1760

Unmarked. On the neck is a narrow strip
of white enamel inscribed: *Odoriferant.*

Porcelain painted in colours and mounted in gold. Height 4.7 cm

Acquired in 1918 from the A. Dolgorukov collection
in Petrograd. Inventory No. 18575

115

Scent-bottle: Young Woman with a Dog.
The Girl-in-a-Swing factory. *C.* 1753–54

Unmarked. Inscribed around the edge of the base:
Fidelle me guide

Porcelain painted in colours. Height 6.8 cm

Acquired in 1925 from the Yusupov collection
in Leningrad. Inventory No. 19301

In the catalogues of the Schreiber collection (Rackham 1928–30,
vol. I, No. 245, pl. 24) and the Untermyer collection (Hackenbroch
1957, fig. 169, pl. 71), a similar bottle is thought to have been
produced in Chelsea and dates from around 1760. Lane (1961,
pl. 35 f) attributes it to the Girl-in-a-Swing factory, which was also
in Chelsea, and dates it earlier — c. 1753 or 1754.

116

Summer. From The Seasons of the Year set.
Chelsea. *C.* 1755

After the model by Joseph Willems

Unmarked

Porcelain painted in colours. Height 31.5 cm

Acquired in 1925 from the State Museum Fund.
Inventory No. 16414

A similar figure of Ceres personifying summer, is reproduced by
Lane (1961, pl. 11), who thinks it to be the work of the modeller
Joseph Willems.

117

Sweet jar: The Abduction of Europa. Chelsea. *C.* 1755

Unmarked. Inscribed on the ribbon: *Caprice amoureux*

Porcelain painted in colours and mounted in gold;
lid of moss agate. Height 5.2 cm

Acquired in 1925 from the Yusupov collection
in Leningrad. Inventory No. 19390

A similar sweet jar, depicting Venus and Cupid, also with a gold
mount and agate lid, is illustrated in the catalogue of the Untermyer
collection (Hackenbroch 1957, fig. 225, pl. 68).

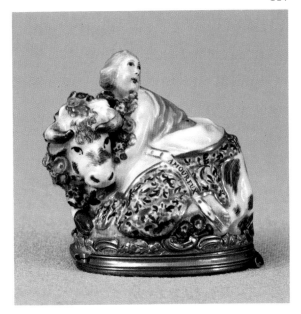

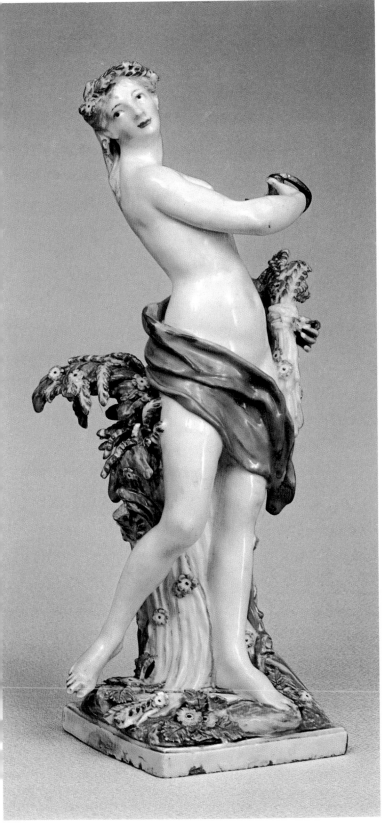

116

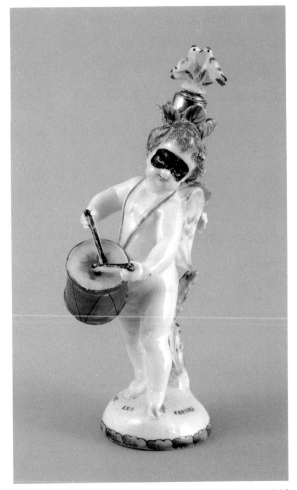

118

118

Flask: Cupid as a Drummer. Chelsea. 1753–54

Porcelain painted in colours. Height 9 cm

Acquired in 1925 from the Yusupov collection
in Leningrad. Inventory No. 18582

(a) **Binding of Sir Thomas Smithe's Voiage and Entertainment in Rushia,** London, 1605 (top centre)

By Francis Bedford (1779–1885)

Marocain, with gold tooling. 15×20.5 cm

On the title page, the binder's label: *Bound by F. Bedford*

Inventory No. 66051

A rare publication from the book collection of Prince A. Lobanov-Rostovsky.

(b) **Binding of John Tradescant, Museum Tradescantianum . . . ,** London, 1656 (bottom right)

By Robert Riviere (1808–1882)

Marocain, with gold tooling. 9.5×15 cm

Binder's label on the fly-leaf: *Bound by Riviere*

Inventory No. 19165

A rare publication from the book collection of Prince A. Lobanov-Rostovsky.

(c) **Binding of Beauplan, Description d'Ukraine . . . ,** Rouen, 1660 (top left)

By William Pratt (active in the second half of the 18th century)

Leather in the manner of imitation marble. 14.5×18.5 cm

Binder's label on the fly-leaf: *Bound by W. Pratt*

Inventory No. 65657

Spine panelled, inlaid. A rare publication from the book collection of Prince A. Lobanov-Rostovsky.

(d) **Binding of Caferino Zeno, Dei commentarie del viaggio in Persia . . . ,** Venetia, 1558 (bottom left)

By Christian Kalthoeber

Leather, with gold tooling. 9.5×14.5 cm

Binder's label on the fly-leaf: *Bound by C. Kalthoeber, London*

Inventory No. 57287

Spine panelled. Edges gilded. A rare publication from the book collection of Prince A. Lobanov-Rostovsky.

(e) **Binding of Tables by the Late Mr. Gay . . . ,** Newcastle, 1779 (top right)

By Ramage

Leather, with gold tooling. 9.5×15.5 cm

Binder's name on the fly-leaf: *Bound by Ramage London*

Inventory No. 158315

Binding decorated with fine linear and dotted tooling. Spine panelled. Edges gilded.

120

120

Binding of M. Overbeck, Reliquiae antiquae urbis Romae...,
3 vols., Amstelaedami, 1708

Leather, with gold tooling. 54×39 cm

Inventory No. 25384

Binding in honey-coloured leather decorated with the arms of
Queen Anne (1655–1714) in the centre of each cover. At the corners
of the central panel formed by a double border are the Royal
monogram and a crown. Fly-leaf of white paper. Edges plain.
Referred to in C. Davenport, *English Heraldic Bookstamps*
(London, 1909, p. 52).

121

121

Binding of an album of Hogarth's prints,
s.l., s.a. Mid–18th century

Leather, with gold tooling. 61×47 cm

Inventory No. 32940

The panelled spine of this superb binding bears the eight-fold repetition of the crown of the Prince of Wales.

SECOND HALF OF THE EIGHTEENTH CENTURY

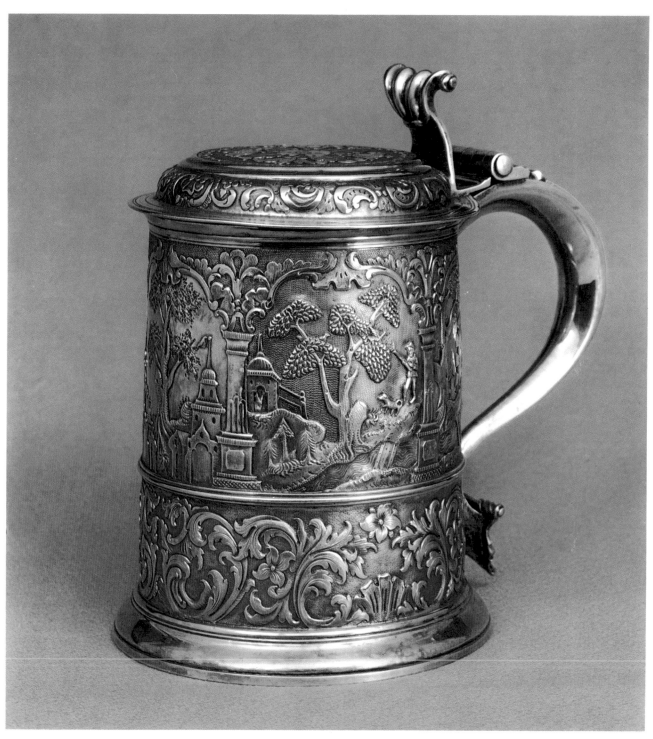

122

CHARLES WRIGHT (?–1815)

Tankard. London hall-mark for 1776–77

Silver, chased and gilded. Height 21 cm

Acquired in 1925 from the Ye. Shuvalova collection
in Leningrad. Inventory No. 13789

Published for the first time.

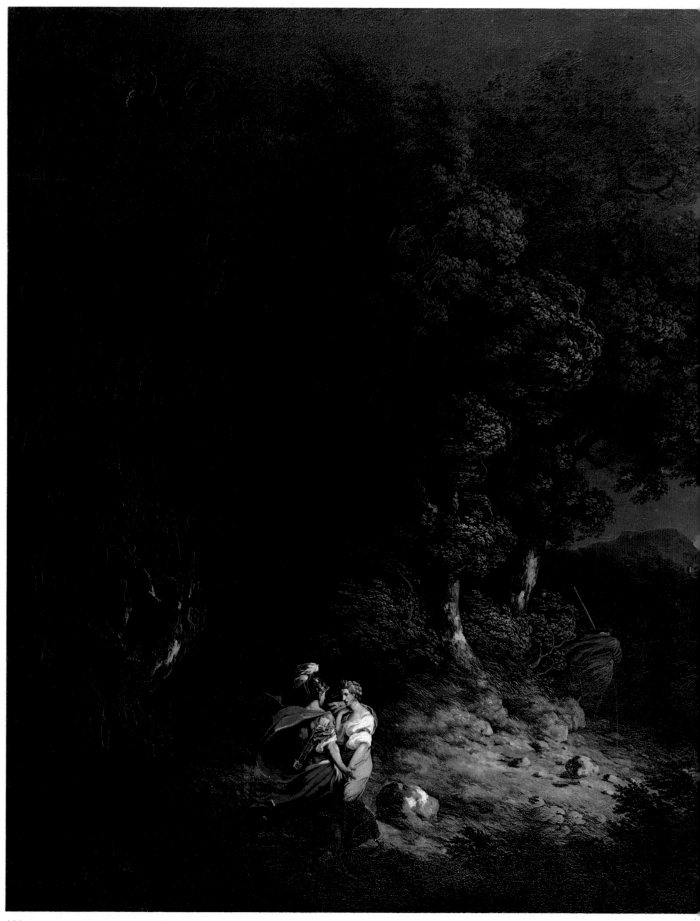

123

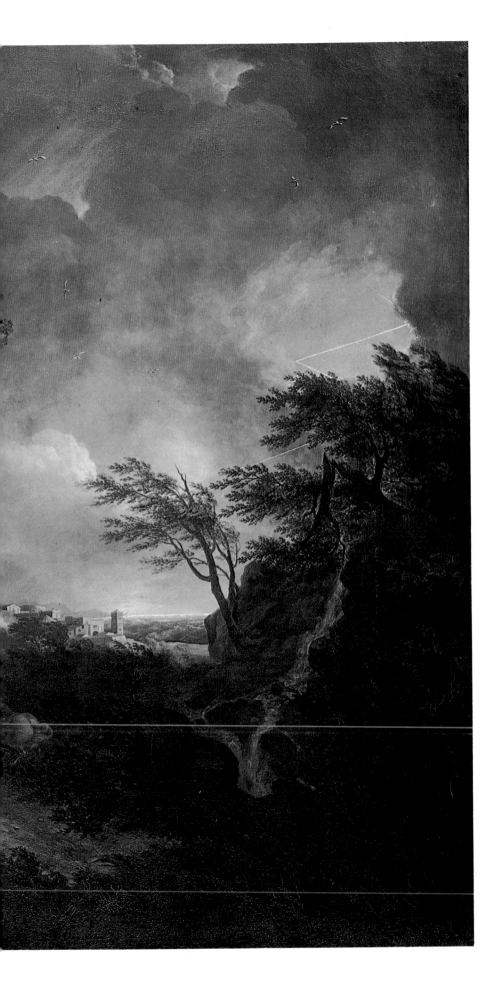

THOMAS JONES
(1743–1803)

**Landscape with Dido
and Aeneas.** 1769

Oil on canvas. 137.5×193.5 cm

Signed and dated, bottom right:
Tho: Jones pt 1769

Transferred before 1838 from
the Gatchina Palace near
St. Petersburg. Originally
acquired in 1792 with
the G. Potiomkin collection
in St. Petersburg.
Inventory No. 1343

Subject borrowed from Canto IV
of Virgil's *Aeneid.*
Figures painted
by John Mortimer.
According to Williamson
(1904, p. 7), in the figure
of Aeneas Mortimer painted
himself.

JOSHUA REYNOLDS
(1723–1792)

**The Continence
of Scipio.** 1788–89

Oil on canvas. 239.5×165 cm
(unfinished)

Acquired in 1792 with
the G. Potiomkin collection
in St. Petersburg.
Commissioned in 1788
by Prince Potiomkin.
Inventory No. 1347

The subject is borrowed
from Titus Livius (XXV, 50).

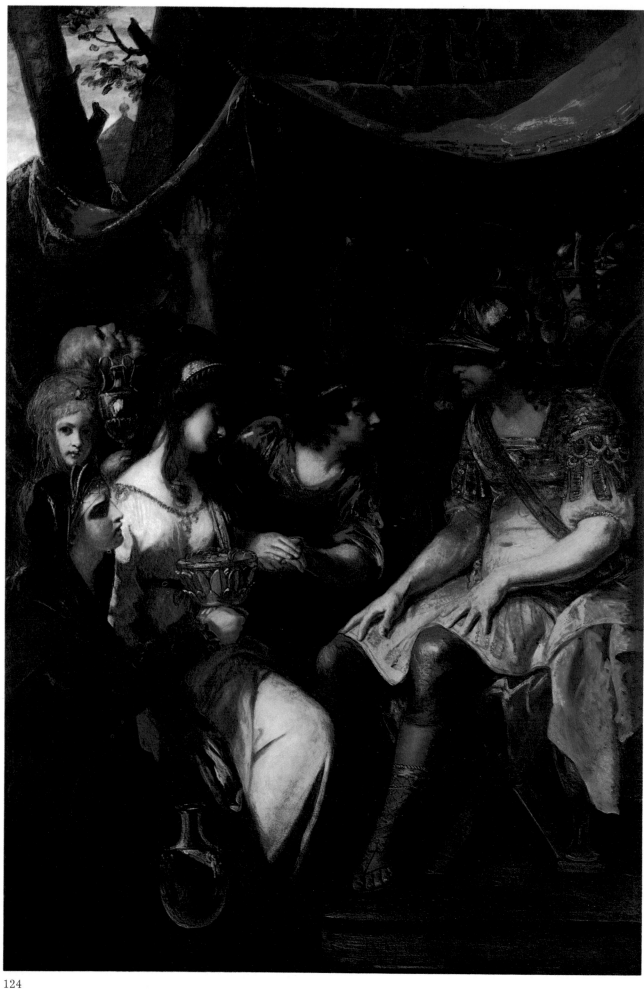

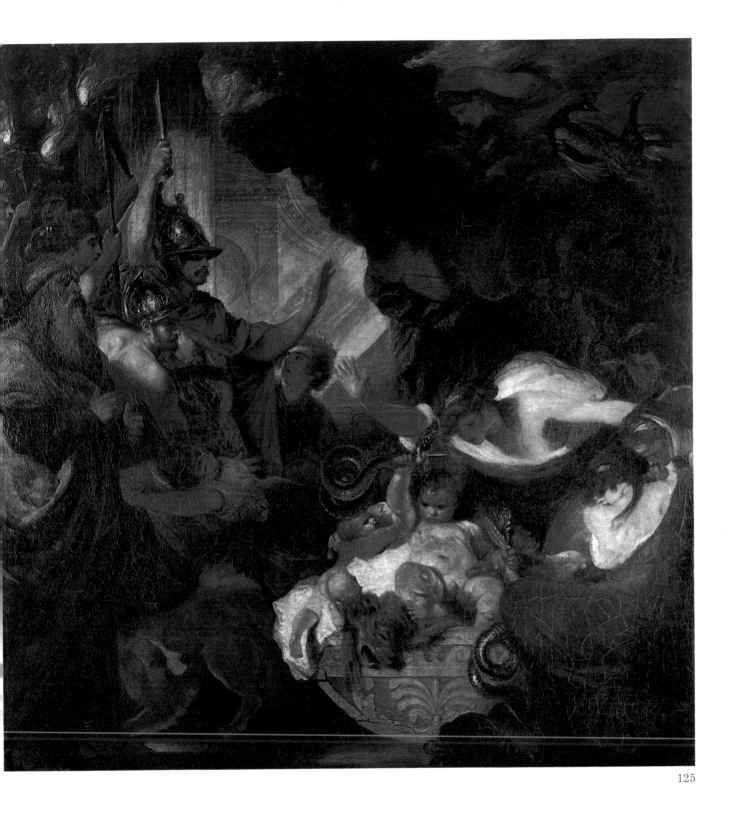

125

JOSHUA REYNOLDS (1723–1792)

The Infant Hercules Strangling the Serpents. 1786–88

Oil on canvas. 303×297 cm

Acquired in 1789. Commissioned in 1785 by Catherine II
through the agency of the English ambassador in St. Petersburg,
Lord Carysfort. Inventory No. 1348

The subject is borrowed from *The First Nemean Ode* of the Greek
poet Pindar. Reynolds explained his choice of the subject in a letter
to Prince Potiomkin in this way: ''J'ai choisi le trait surprenant
de la valeur d'Hercules encore enfant, parce que le sujet fait
allusion (au moins une allusion éloignée) à la valeur non enfantine
mais si connue de l'empire Russe'' (see Trubnikov 1913, p. 41).

Some of the figures in the painting portray actual people.
Reynolds's famous friend Dr. Samuel Johnson is represented as
Tiresuis and the face of the woman standing behind Amphitrion
recalls the actress Sarah Siddons.

There is a series of paintings by Reynolds of Hercules with the
serpents. We know of one Reynolds's drawing for the picture
The Infant with Serpents (the collection of Mrs. R.A. Lucas) on
which there is an inscription obviously made in a 19th century
hand: ''First idea of the Infant Hercules.'' Two sketches in pencil
and Indian ink in the British Museum also depict the infant with
serpents, but these are not so close to the picture as the drawing in
the Lucas collection. A sketch of the entire composition in grisaille
came up for auction at Charles Sedelmayer's in Paris in 1907.

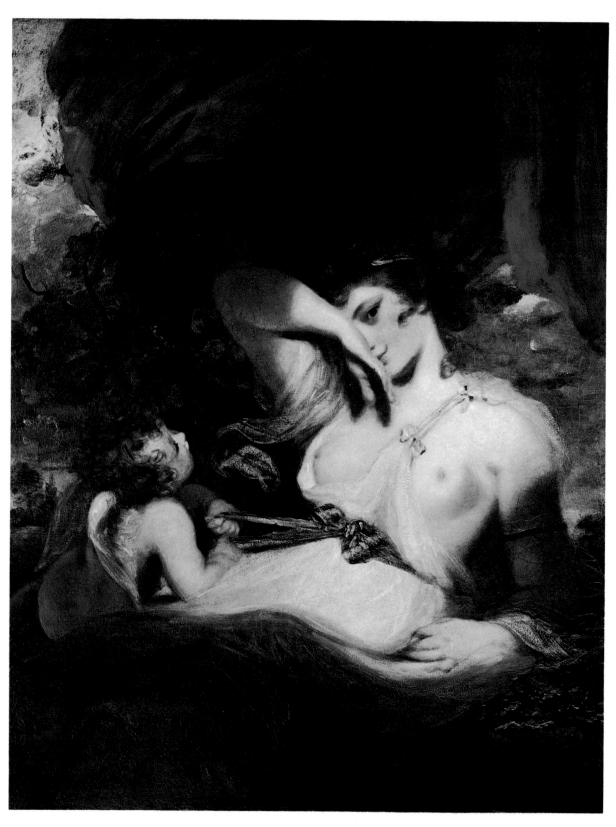

126, 127

JOSHUA REYNOLDS (1723–1792)

Cupid Untying the Girdle of Venus. *C.* 1788

Oil on canvas. 127.5×101 cm

Acquired in 1792 with the G. Potiomkin collection
in St. Petersburg. Prince Potiomkin acquired it in 1788
from Reynolds through the agency of the English ambassador
in St. Petersburg, Lord Carysfort. Inventory No. 1320

This is a replica of the *Snake in the Grass*, painted in 1784
(the National Gallery in London). Other replicas are to be seen
in the Soane Museum in London and in the collections of Lords
Wimborne and Burton.

It has not been possible to ascertain who was the model for
Reynolds's Venus, or "nymph" as the painter himself called her. In
his notes on sitters for 1784, Reynolds observed that a Miss Wilson
posed for his nymph, but as there are several nymphs in Reynolds's
work at the time, we cannot presume that it was in fact Miss Wilson.
On the other hand, in two pictures painted in 1783 and 1784, *The
Sylvan Nymph and the Faun* and *Lady Hamilton as a Bacchante*,
Lady Hamilton is unquestionably the sitter. This allows us to
suppose that the Hermitage painting depicts the same model.

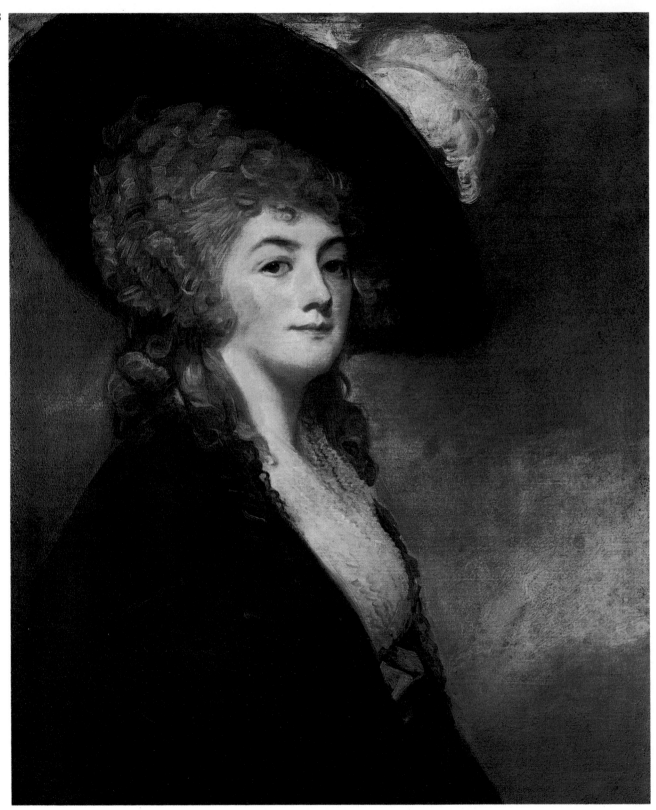

128

GEORGE ROMNEY (1734–1802)

Portrait of Harriet Greer. 1781

Oil on canvas. 76×64 cm

Inscribed and dated, on the back, in ink: *Painted by Romney 1781*

Acquired in 1912 from the A. Khitrovo collection in St. Petersburg in accordance with the owner's bequest. Previously in the Crawford collection, later in the Newland collection in England and then purchased by Charles Sedelmayer. Inventory No. 3511

129

JOHN HOPPNER (1758–1810)

Portrait of Richard Brinsley Sheridan

Oil on canvas. 77×64 cm (on the right there is an extention of the canvas measuring 8 cm across at the top and 12 cm at the bottom)

Acquired in 1912 from the A. Khitrovo collection in St. Petersburg in accordance with the owner's bequest. Inventory No. 3510

130

Richard Brinsley Sheridan (1751–1816) was a famous
English playwright.
The picture entered the Hermitage as a portrait of Sheridan.
However, the identity of the subject is a matter of conjecture.
The various attested portraits of Sheridan by Reynolds and
Hoppner have little in common with the Hermitage picture.
The portrait which comes closest to it, is an engraving
by Bolt of 1791 in which the writer is portrayed against
the background of the Houses of Parliament.

BENJAMIN WEST (1738–1820)

**Portrait of George, Prince of Wales,
and His Brother Henry Frederick.** 1778

Oil on canvas. 240.5×166 cm

Signed and dated, on the wall to the right: *Painted
by B. West. Historical Painter to His Majesty London 1778*
Transferred in 1831 from the English Palace at Peterhof.
Commissioned in 1778 by Catherine II
for the Chesmensky Palace. Inventory No. 9527

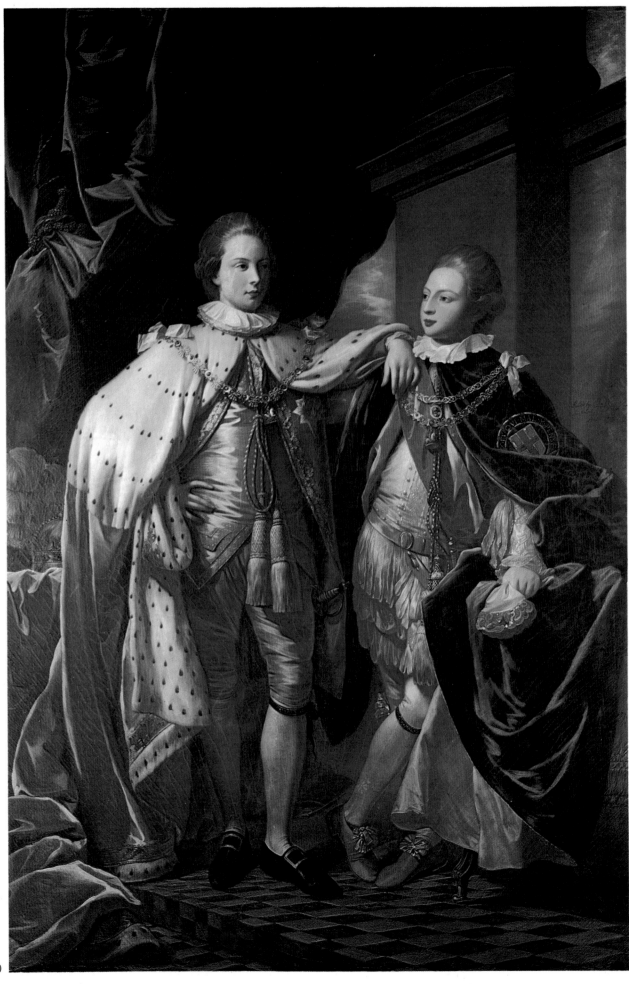

130

THOMAS GAINSBOROUGH (1727–1788)

Portrait of a Lady in Blue. 1770s

Oil on canvas. 76×64 cm

Acquired in 1912 from the A. Khitrovo collection
in St. Petersburg in accordance with the owner's bequest.
Inventory No. 3509

In William Armstrong's monograph *Gainsborough* (1898), the *Lady in Blue* was already described as a work by Gainsborough

belonging to Alexei Khitrovo. In an article by P. Veiner (1912) devoted to the Khitrovo collection, the *Lady in Blue* was first identified as *Portrait of the Duchess of Beaufort*, but the writer produced no evidence for this assumption. Nevertheless, beginning with the 1916 Hermitage catalogue, this name was given in all the Museum publications. In Ellis Waterhouse's major book on Gainsborough (1958), the picture is called *Portrait of a Lady in Blue*. The stylistic peculiarities of the painting, and the dress and coiffure of the model support the date suggested by Veiner.

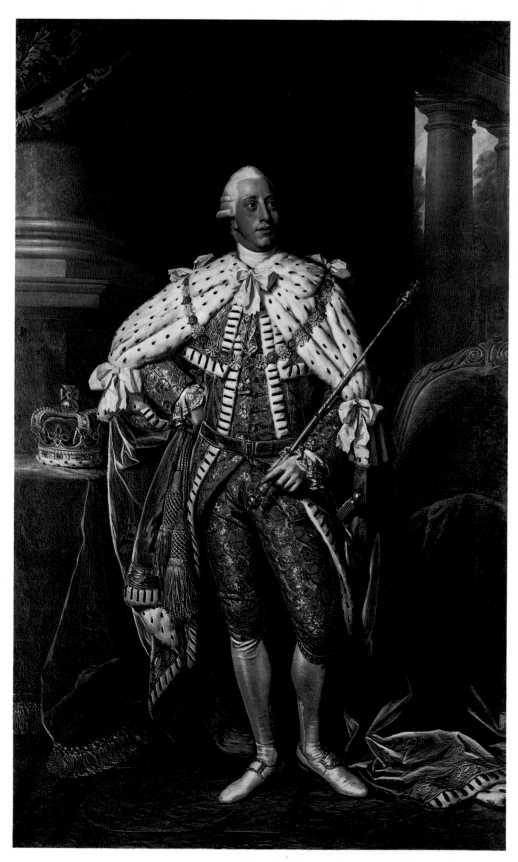

132

NATHANIEL DANCE (1735–1811)

Portrait of King George III

Oil on canvas. 241×148.5 cm

A companion painting to the portrait of Queen Charlotte Sophia
(the Hermitage, inventory No. 9565)

Transferred in 1931 from the English Palace in Peterhof together
with the companion portrait. Commissioned in 1788 by Catherine II
for the Chesmensky Palace. Inventory No. 4469

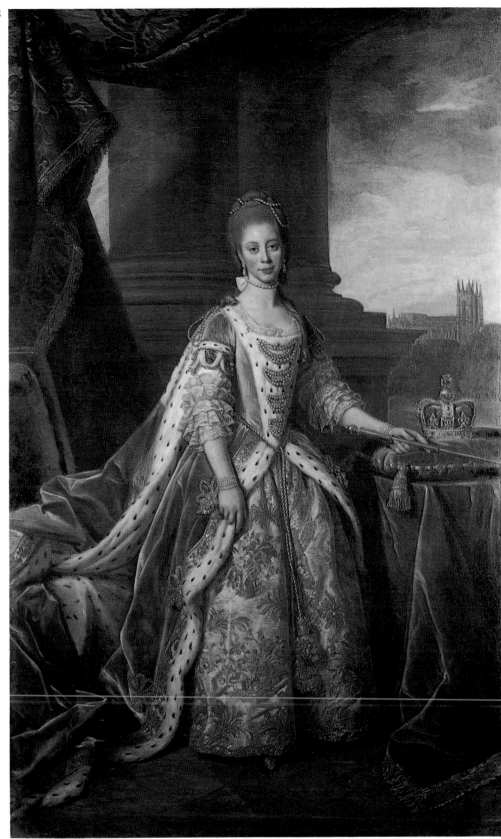

133

NATHANIEL DANCE (1735–1811)

Portrait of Queen Charlotte Sophia. 1773–74

Oil on canvas. 238×146 cm

Inventory No. 9565

Charlotte Sophia (1744–1818) was a niece of Duke of
Mecklenburg-Strelitz; after 1761, wife of George III.

134

JOSEPH NOLLEKENS (1737–1823)

Laughing Child. Second half of the 18th century

Signed, on the back: *Nollekens*[F.t]

Marble. Height 27 cm

Acquired before 1859. Inventory No. 296

Published for the first time.

134

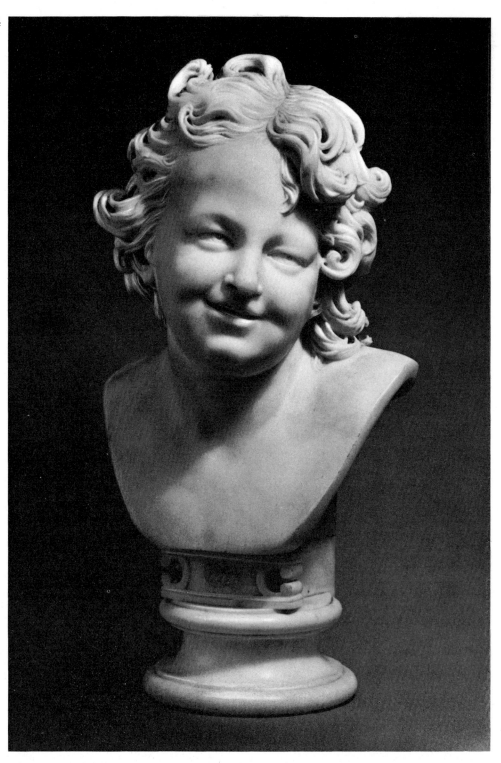

135

JOSEPH NOLLEKENS (1737–1823)

Portrait of Charles Fox. 1791

Signed and dated, on the back: *Nolle Kens F.ᵗ London, 1791*

Marble. Height 56 cm

Transferred in 1852 from the Tauride Palace in St. Petersburg. Originally purchased by Catherine II in 1791. Inventory No. 13

Charles James Fox (1749–1806) was an English statesman. Catherine II requested the portrait of Fox after a speech he made in Parliament opposing Pitt's plan to send the English fleet into the Baltic Sea and force Russia to give up the territories won in the Russo-Turkish war which had just ended. "His eloquence saved both his country and Russia from a war which would have been unjustifiable and senseless," wrote Catherine (see "A. Khrapovitsky The Diary of 1782–93", *Russky arkhiv*, 1901, 16 April 1791).

Earl Fitzwilliam allowed the Russian ambassador Count Semion Vorontsov to take over the commission for the marble bust of Fox which had just been fulfilled by Nollekens. The bust was taken to Russia and placed in the Hermitage. For the Cameron Gallery Edme Gastecloux made a bronze cast which was placed between the busts of Demosthenes and Cicero. An intaglio in cornelian was made from the marble original by Karl Leberecht.

Nollekens portrayed Fox several times. Another marble replica can be seen in the National Portrait Gallery in London.

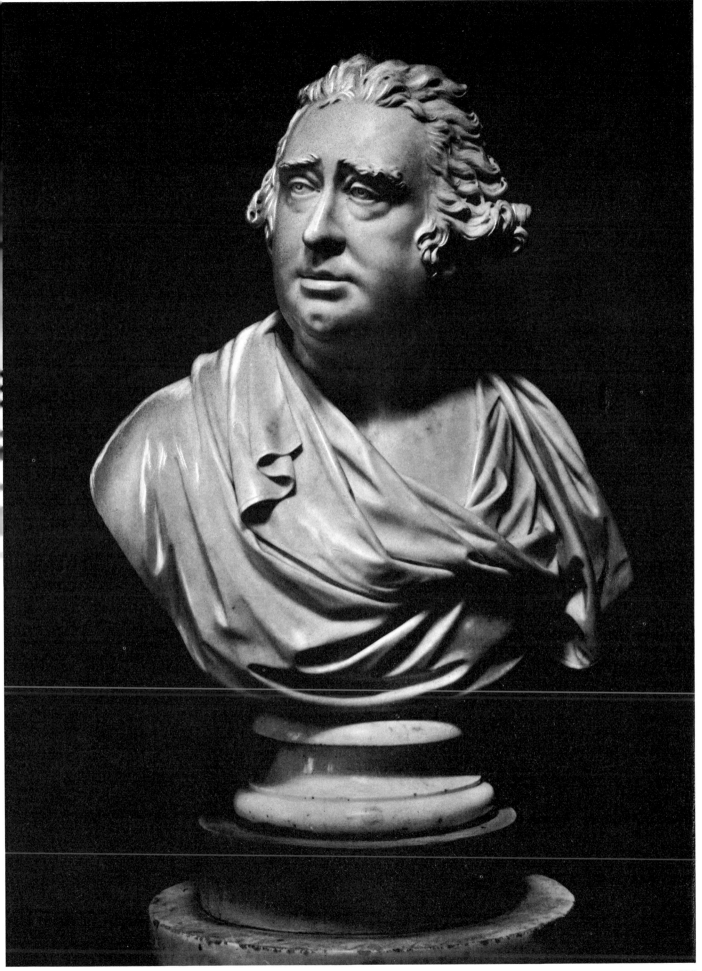

136

JOSEPH WRIGHT OF DERBY (1734–1797)

**Firework Display at the Castel Sant'Angelo
in Rome (La Girandola).** 1778

Oil on canvas. 162.5×213 cm

Transferred in 1920 from the English Palace
at Peterhof. Purchased from the artist in 1779
together with the companion painting
The Eruption of Vesuvius (the Pushkin Museum
of Fine Arts in Moscow). Inventory No. 1315

The canvas depicts a firework display organized
annually on the eve of St. Peter's Day in Rome.
After 1774, Wright painted the companion pictures
La Girandola and *The Eruption of Vesuvius* many
times. To the present time, we know of eight
pictures representing *The Eruption of Vesuvius*
and three of *La Girandola*.
The sale of the pictures to Russia would appear to
have improved the artist's financial state and his
reputation. On this subject, Wright wrote to the
collector Daniel Dolby in 1773 that the Empress
of Russia had purchased from him two pictures,
The Eruption of Vesuvius and *La Girandola*,
and has paid him 500 guineas for them which
he considered a good price and a great honour.

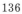

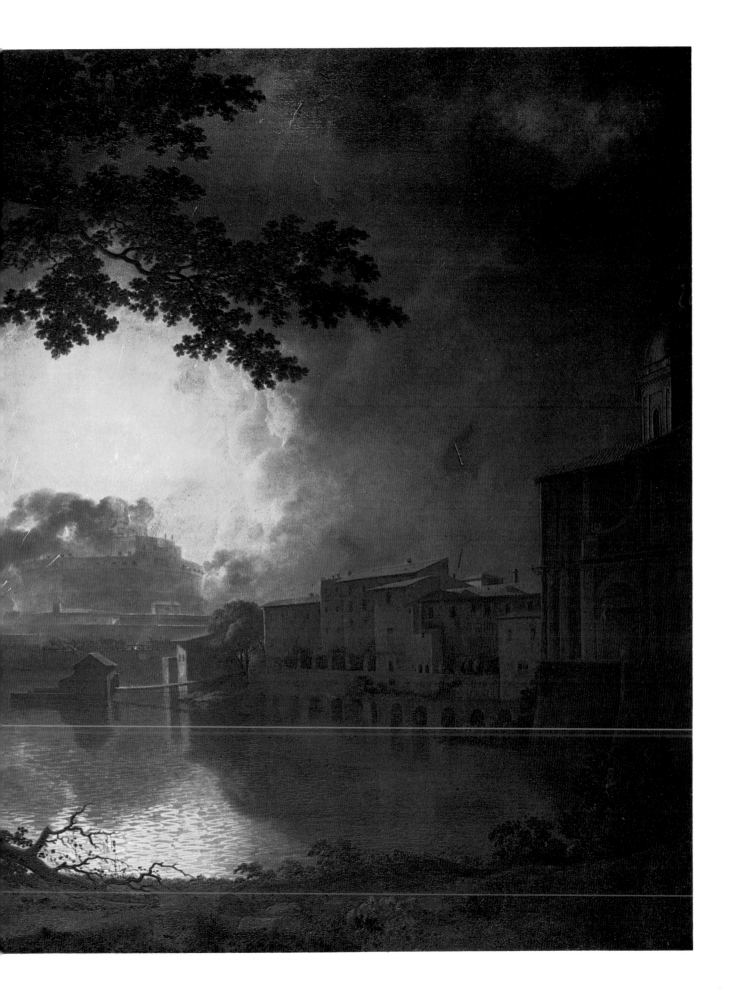

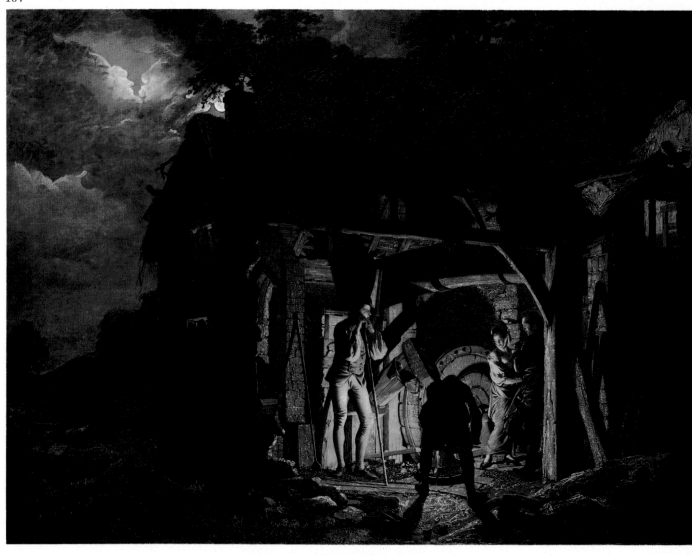

137, 138

JOSEPH WRIGHT OF DERBY (1734–1797)

An Iron Forge Viewed from Without. 1773

Oil on canvas. 105×140 cm

Signed and dated on the hammer, at the foot
of the canvas: *J. Wright pinxit 1773*

Acquired in 1774 or 1775 for Catherine II,
apparently through the agency of the Russian consul Baxter
and the engraver P. Burdett. Inventory No. 1349

In 1772 and 1773 Wright painted several pictures on the subject of
the smithy (*An Iron Forge* and *The Blacksmith's Shop*). According
to Benedict Nicholson (1968), three other paintings on the same
subject, besides the one in the Hermitage, have survived. These are
in the collections of Mr. and Mrs. Paul Mellon (*The Blacksmith's
Shop*) Earl Mountbatten of Burma (*An Iron Forge*) and in an

unknown private collection. One other composition — *The
Blacksmith's Forge* — is known only from the engraving.
Wright's notebook gives a full description of the artist's treatment
of *An Iron Forge*: "Two men forming a bar of iron into a horse shoe
from whence the light must proceed. An idle fellow may stand by
the anvil in a time-killing posture, his hands in his bosom, or
yawning with his hands stretched upwards, & a little twisting of his
body. Horse shoes hanging upon the walls, and other necessary
things faintly seen, being remote from the light. Out of this room
shall be seen another, in wch a farmer may be shoeing a horse by
the light of a candle. The horse must be saddled and a traveller
standing by. The servant may appear with his horse in hand, on
wch may be a portmanteau. This will be an indication of an
accident having happened, and show some reason for shoeing the
horse by candlelight. The moon may appear and illuminate some
part of the horses if necessary" (Bemrose 1885). This plan was
partially adopted in the Hermitage painting.

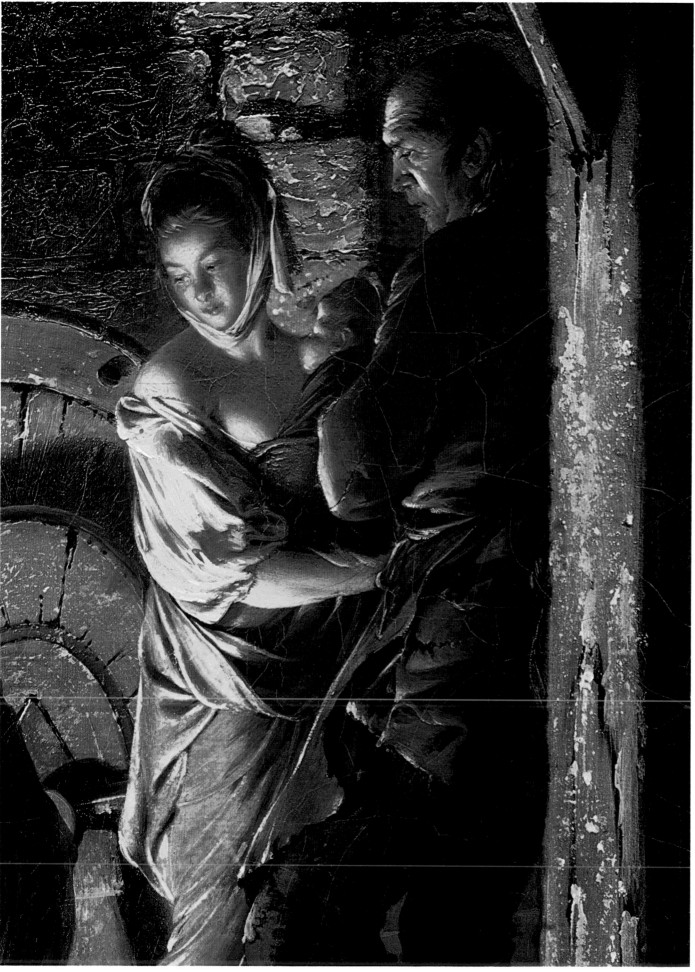

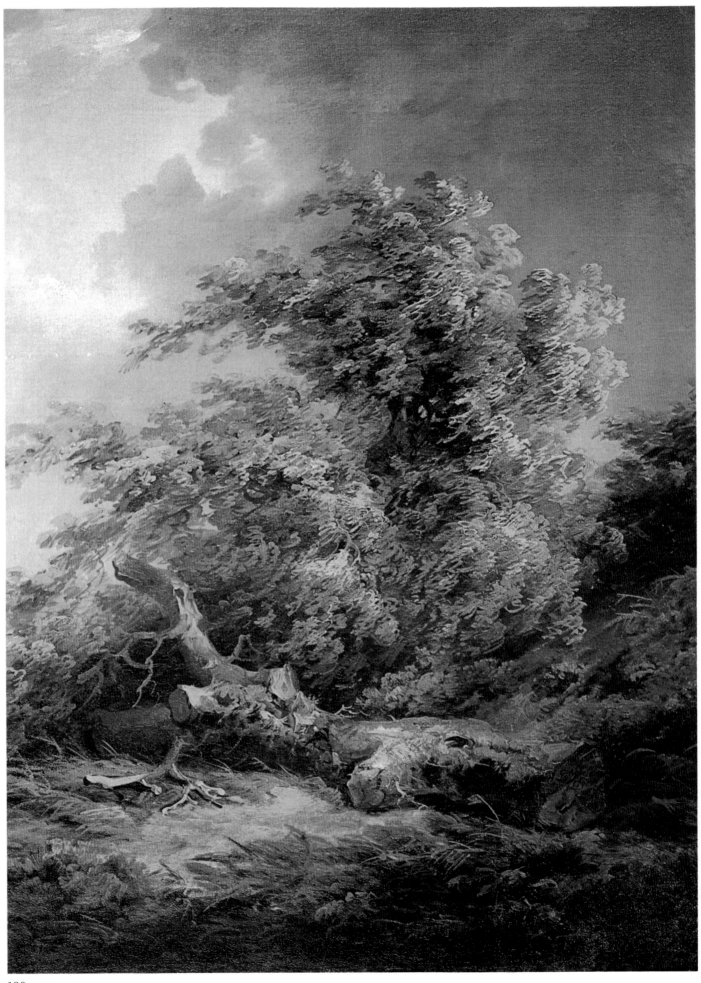

139

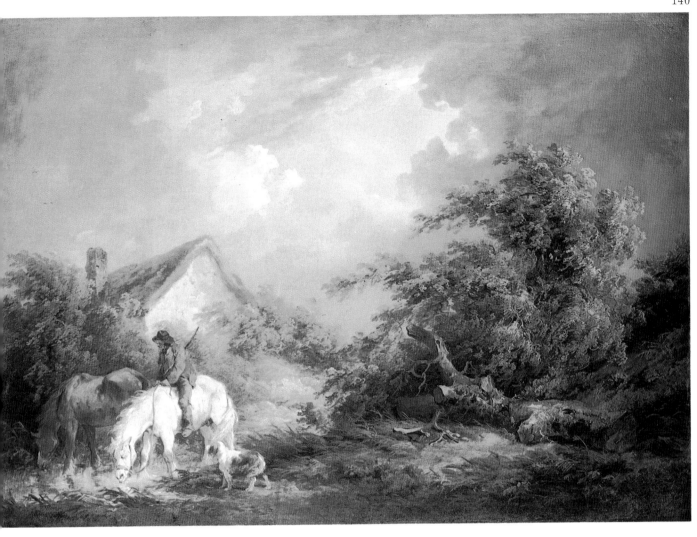

139, 140

GEORGE MORLAND (1763–1804)

The Approach of the Storm. 1791

Oil on canvas. 85×117 cm

Signed and dated, to the right, on the trunk of a tree:
G. Morland, 1791

Acquired in 1919 from the Versen collection in Petrograd.
Possibly purchased by Count Versen in the 1860s.
Inventory No. 5834

The portrayal of a landscape before a storm was attempted
by Morland several times (the Art Gallery at Wolverhampton,
private collections).

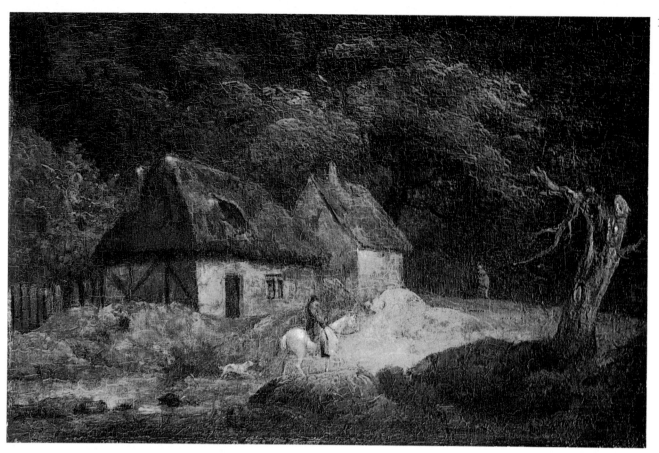

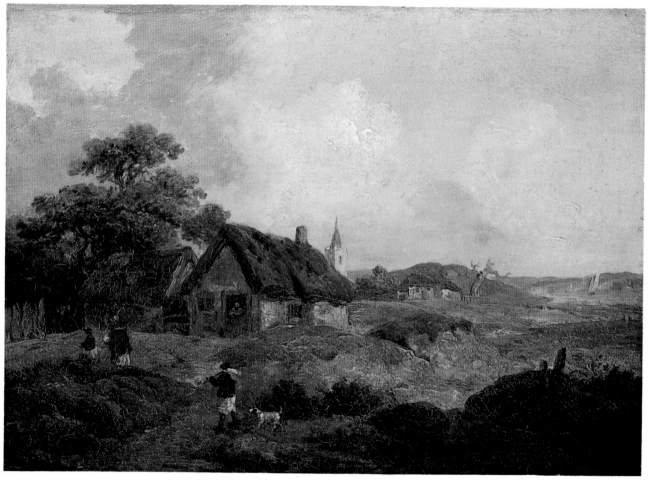

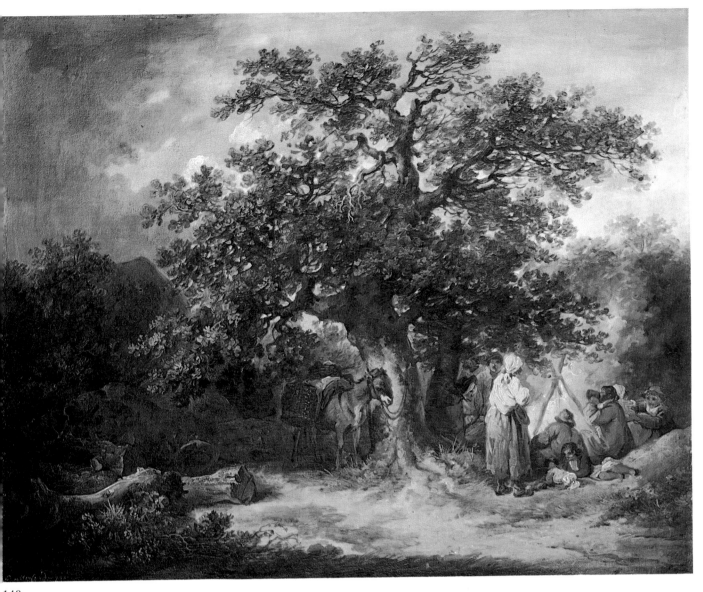

143

141

GEORGE MORLAND (1763–1804)

A Village Road. *C.* 1790

Oil on wood. 19×27.5 cm

Signed, bottom right: *G. Morland*

Acquired in 1925 from the State Museum Fund.
Inventory No. 5840

A similar painting *Stormy Landscape with Rider* came up
for auction at N.V. Bukowski's in Stockholm
in February 1935 (lot 13).

142

GEORGE MORLAND (1763–1804)

A Country Scene. *C.* 1790

Oil on canvas. 20×28.5 cm

Signed, to the right, on the stone: *G. Morland*

Acquired in 1925 from the State Museum Fund.
Inventory No. 5841

143

GEORGE MORLAND (1763–1804)

Gypsies. *C.* 1790

Oil on canvas. 35.5×47 cm

Signed, bottom left: *G. Morland*

Acquired in 1920 from the State Museum Fund.
Inventory No. 5833

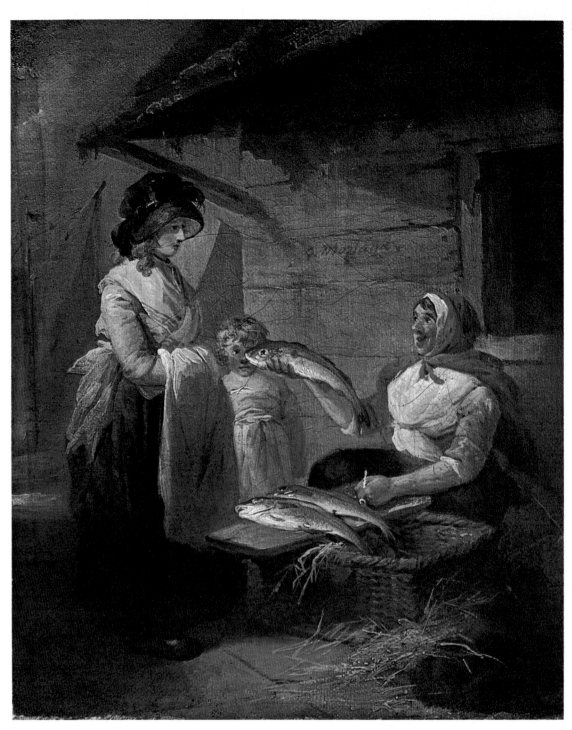

144

GEORGE MORLAND (1763–1804)

Woman Selling Fish

Oil on canvas. 31×25.5 cm

Signed on the wall: *G. Morland*

Acquired in 1923 from the State Museum Fund.
Inventory No. 7198

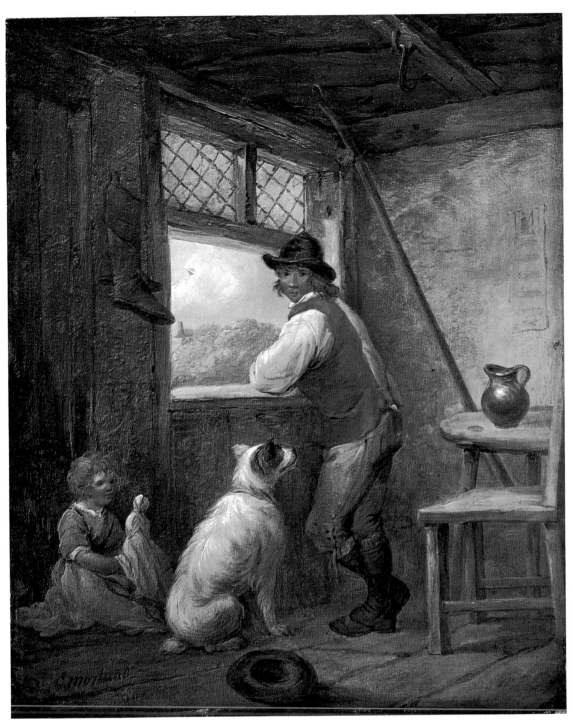

145

GEORGE MORLAND (1763–1804)

Peasant at a Window

Oil on wood. 30×25 cm

Signed, bottom left: *G. Morland*

Acquired in 1925 from the State Museum Fund.
Inventory No. 5839

The figure standing at the window is possibly Morland's
servant Gibbs who posed several times for the artist.

146, 147

CHARLES WHITE (?–1780)

Flowers and Birds. 1772

Oil on canvas. 57.5×95.5 cm

Signed and dated, to the left, on the window-box:
C. W. 1772.

Transferred in 1922 from the Petrograd Academy of Arts.
Before 1882 in the collection of N. Kushelev-Bezborodko
in St. Petersburg. Inventory No. 3784

148

WILLIAM MARLOW (1740–1813)

A Seaside View

Oil on canvas. 65×83 cm

Signed, bottom right: *Marlow*

Transferred in 1907 from Peterhof where it was housed
in the Hermitage Pavilion. Originally purchased
not later than 1797. Inventory No. 1319

In the Hermitage inventory of paintings of 1797
the picture was attributed to the Vernet school.

149

WILLIAM HASTIE (1755–1832)

Project for a country house. Façade. 1794

Pen and ink, wash. 56×142 cm
Signed, bottom right: *William Hastie*
Acquired in 1794. Inventory No. 23295
The project consists of four sheets: the plan of the first
and second storeys, façade and section.
The building is conceived on the lines of neo-Palladian
buildings of the 18th century comprising a central
block and four wings connected to it by galleries.

150

WILLIAM HASTIE (1755–1832)

Project for a house in the pseudo-Gothic style. 1794

Pen and ink, wash. 32×45 cm
Acquired in 1794. Inventory No. 3153
A page from an album, the first sheet of which
bears an inscription in Hastie's hand.
The album contains 57 sheets.
Published for the first time.

151, 153

CHARLES CAMERON (1746–1812)

**Design for a door in the Agate Pavilion
at the Thermae.**
Variants of decoration. 1780–85

Watercolour, pen and ink, wash. 39.5×52.6 cm
Signed: *Cameron*
Acquired in 1822 with Charles Cameron's papers,
purchased in England from the heirs of the architect.
Inventory No. 11046

152

CHARLES CAMERON (1746–1812)

**Designs for a boudoir in the Agate Pavilion
at the Thermae.** Cross-section. 1780–85

Watercolour, pen and ink, wash. 39.9×60.1 cm
Acquired in 1822 with Charles Cameron's papers
purchased in England from the heirs of the architect.
Inventory No. 11012
The Agate Pavilion or the Agate Suite — the rooms
of the second storey of Cameron's Thermae — was
constructed alongside the Yekaterininsky Palace
at Tsarskoye Selo from 1780 to 1785.

149

150

154

CHARLES CAMERON (1746–1812)

Design for a staircase at the Thermae. Cross-section. 1780–85

Watercolour, pen and ink, wash. 63.5×45 cm

Acquired in 1822 with the papers of Charles Cameron purchased
in England from the heirs of the architect. Inventory No. 10990
The staircase connects the first storey of the Thermae —
the so-called Cold Baths — with the second, the Agate Pavilion.

155

CHARLES CAMERON (1746–1812)

**Design for a ceiling in the Lyonnaise Drawing Room
of the Yekaterininsky Palace (designed by Bartolommeo Francesco
Rastrelli) at Tsarskoye Selo.** Final variant. 1779–82

Watercolour. 46.4×58.6 cm

Acquired in 1822 with the papers of Charles Cameron purchased
in England from the heirs of the architect. Inventory No. 11061

156

CHARLES CAMERON (1746–1812)

**Design for a stove in the Arabesque Room
of the Yekaterininsky Palace (designed by Bartolommeo Francesco
Rastrelli) at Tsarskoye Selo.** Front view. 1779–82

Watercolour, pen and ink, wash. 47.7×33.9 cm

Acquired in 1822 with the papers of Charles Cameron purchased
in England from the heirs of the architect. Inventory No. 11087

157

CHARLES CAMERON (1746–1812)

Designs for stoves (?)

Watercolour, pen and ink, wash. 55.5×49.2 cm

Acquired in 1822 with the papers of Charles Cameron purchased
in England from the heirs of the architect. Inventory No. 11065

№ 2 въ овалную
комнату

№ 3. № 4.

№ 4. Дверь въ первую
агатную комнату
2 Двери

№ 3. Дверь во вторую
агатную комнату
2 Двери

1. Сажень.

2. Сафени.

155

156

157

ADAM MENELAWS (1756–1831)

**Project for the Krasnoselskiye Gates
in the Alexandrovsky Park at Tsarskoye Selo.** 1820s

Watercolour, pen and ink, pencil. 68×56 cm

Acquired in 1894 through the agency of E. Gartier.
Inventory No. 12912

Published for the first time.

159

ADAM MENELAWS (1756–1831)

**Project for a farm in the Alexandrovsky Park
at Tsarskoye Selo.** 1818

Watercolour, pen and ink, wash. 60×96 cm

Acquired in 1894 through the agency of E. Gartier.
Inventory No. 12955

In 1818 to 1822 a farm was constructed to replace the wooden cattle
yard. The style of the farm blended with other pseudo-Gothic
buildings constructed by Menelaws.

160

ADAM MENELAWS (1756–1831)

Project for the White Tower at Tsarskoye Selo. 1821

Watercolour, pen and ink, wash. 66×54.6 cm

Acquired in 1894 through the agency of E. Gartier.
Inventory No. 12908

Published for the first time.

161

ADAM MENELAWS (1756–1831)

**Landscape in the Alexandrovsky Park
at Tsarskoye Selo.** After 1828

Watercolour over pencil. 35.5×50.5 cm

Acquired in 1894 through the agency of E. Gartier.
Inventory No. 12963

The attribution to Menelaws was made by Militsa Korshunova
by analogy with his signed drawings in the Hermitage collection.
The architect sketched one of the most picturesque corners
of the Alexandrovsky Park on the banks of Vittolovo Pond.
In the background we can see the Chapelle, a decorative
building in the pseudo-Gothic style, constructed after
Menelaws's design between 1825 and 1828. This single view left
to us by the architect bears witness to the high quality of his
graphic technique.

159

161

164

162, 163

ALEXANDER COZENS (*c.* 1717–1786)

Studies of Skies

Grey wash and black ink on yellowish paper. 12×14.9 cm

Acquired in 1896 from the A. Lobanov-Rostovsky collection
in St. Petersburg. Inventory Nos. 41571, 41583

The studies form part of a collection of 25 of Cozens's drawings
pasted to the sheets of an album bound in leather, with the title
Skies impressed on the spine, and the heading on the title page:
Studies of Skies by Alexander Cozens. In each of the studies,
Cozens treats the effect of sunlight at different times of the day.
The album also contains sketches (mythological scenes, landscapes,
studies of pets) and bears the signature: *J. Hubert Fonthill 1785*,
which appears twice. The album seems to have belonged to the
Swiss artist Jean Hubert. It is quite possible that the album of
drawings was presented to Hubert by the owner of Fonthill William
Beckford, who was a friend of the Hubert family and of Cozens and
his father. We know that in 1785 Hubert took part in the exhibition
at the Royal Academy and that he was staying in England.

164

GEORGE MORLAND (1763–1804)

Landscape with Wayfarers

Watercolour. 15.8×19.8 cm

Acquired in 1966 from a private collection
in Leningrad. Inventory No. 45880

The manner of execution, the application of colours, the colour
range and the depiction of the figures all point to Morland.
From the composition and watercolour technique it is
possible to conjecture that the drawing dates from the last
years of the artist's life when he had settled in a coastal town
near the Isle of Wight.

165

GEORGE MORLAND (1763–1804)

Morning. 1790

Coloured etching. 45×57 cm

Acquired before 1817. Inventory No. 139245

THOMAS ROWLANDSON (1757–1827)

Gossiping Women

Watercolour, pen and ink. 13.5×9.7 cm

Acquired in 1928 from the Grizar collection
in St. Petersburg. Inventory No. 27435

167

THOMAS ROWLANDSON (1757–1827)

The Art of Scaling. 1792

Coloured etching with acquatint. 32×38 cm
(Grego 1880, vol. I, p. 221; Dukelskaya 1966, pl. 50)

Engraved by Samuel Alken

Acquired in 1815. Inventory No. 81768

Joseph Grego, in his monograph on Rowlandson,
dates the caricature to 1787 (?)

168

THOMAS ROWLANDSON (1757–1827)

The Chase. 1793

Coloured etching. 45.5×56 cm (Dukelskaya 1966, pl. 9)
Acquired in 1815. Inventory No. 81670

THOMAS ROWLANDSON (1757–1827)

The Dinner. 1787

Coloured etching. 44×55 cm (Dukelskaya 1966, pl. 10)
Acquired in 1815. Inventory No. 81668

HENRY BUNBURY (1750–1811)

A Sunday Evening. 1772

Etching. 23×28 cm (George 1938–52, No. 5048;
Dukelskaya 1966, p. 22, pl. 115)

Engraved by James Bretherton

Acquired before 1817. Inventory No. 82119

A SUNDAY EVENING.

170

171

SATURDAY NIGHT; or, a COBLER SETTLING the WEEK'S ACCOUNT with his WIFE.

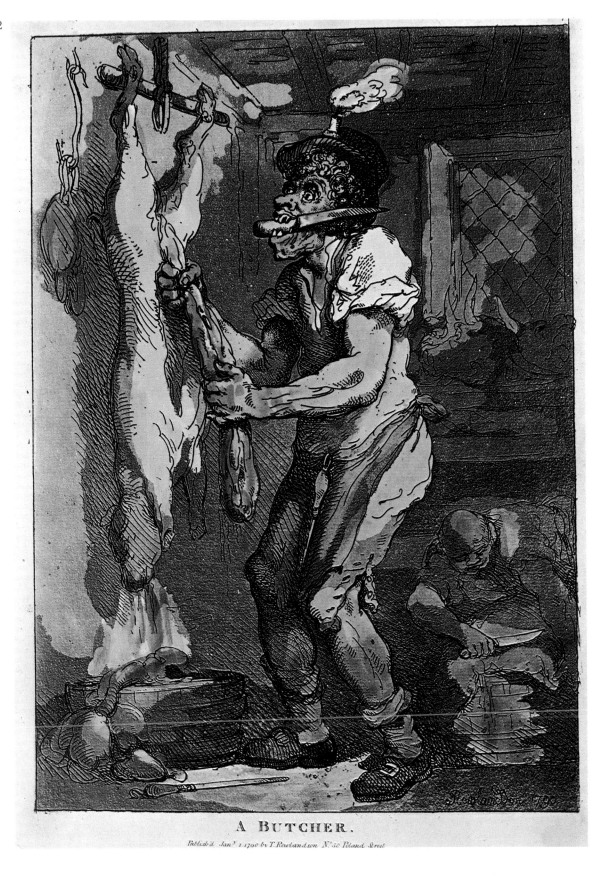

A BUTCHER.

Publish'd Jan.ʳ 1 1790 by T. Rowlandson N.ᵒ 50 Poland Street

171

172

The GOUT.

The FALL of Icarus.

In former days the Poet sings,
An Artist skill'd and rare;
Of **Wax** and **Feathers** form'd his Wings
And made a famous pair.——

With which from Precipice or Tower
From Hill or highest Trees,
When work'd by his mechanic power
He could descend with ease.——

Why **T—p—e** then wants such a store
You surely ask in vain?——
A moment of reflection more
Will make the matter plain.

With Plumes & **Wax** & such like things
In quantities not small
He tries to make a pair of Wings
To ease his *sudden Fall*!

173

JAMES GILLRAY (1756–1815)

The Gout. 1799

Coloured etching. 27×36 cm (Wright & Evans 1851, No. 454;
George 1938–52, No. 9448; Dukelskaya 1966, pl. 65)

Acquired in the second half of the 19th century.
Inventory No. 299802

174

JAMES GILLRAY (1756–1815)

The Fall of Icarus. 1807

Coloured etching. 36×24.5 cm (Wright, pp. 346–347;
Wright & Evans 1851, No. 334; George 1938–52, No. 10721)

Acquired in the second half of the 19th century.
Inventory No. 300260

Caricature of Lord Temple, Vice-President of the Board
of Trade and joint Paymaster-General in Grenville's
ministry, who was accused of appropriating large
quantities of office materials.

175

JAMES GILLRAY (1756–1815)

Attitude! Attitude Is Every Thing! 1805.
A sheet from the series *Elements of Skateing*

From the drawing of John Sneyd

Coloured etching. 26×35.5 cm (Wright, p. 326;
Wright & Evans 1851, No. 540; George 1938–52, No. 10474)

Acquired in the second half of the 19th century.
Inventory No. 300103

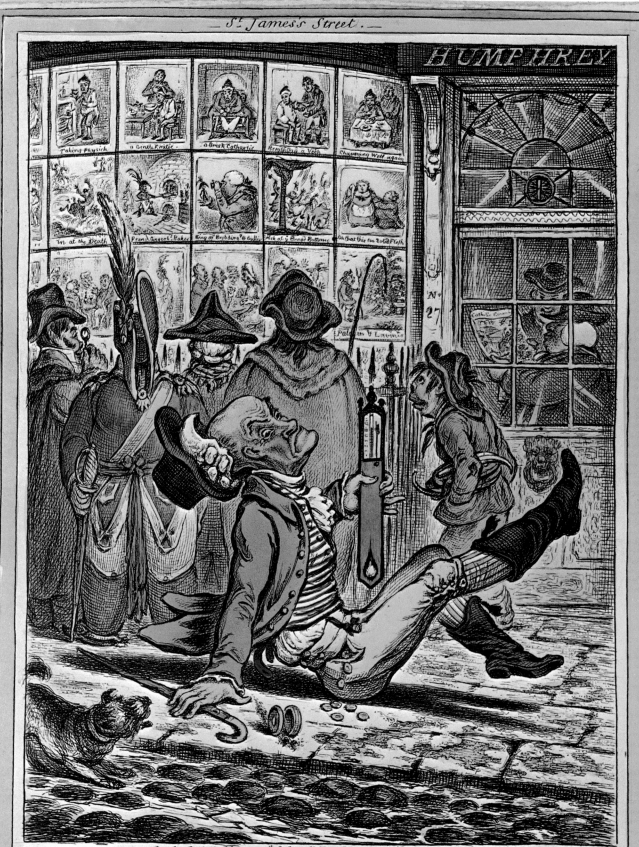

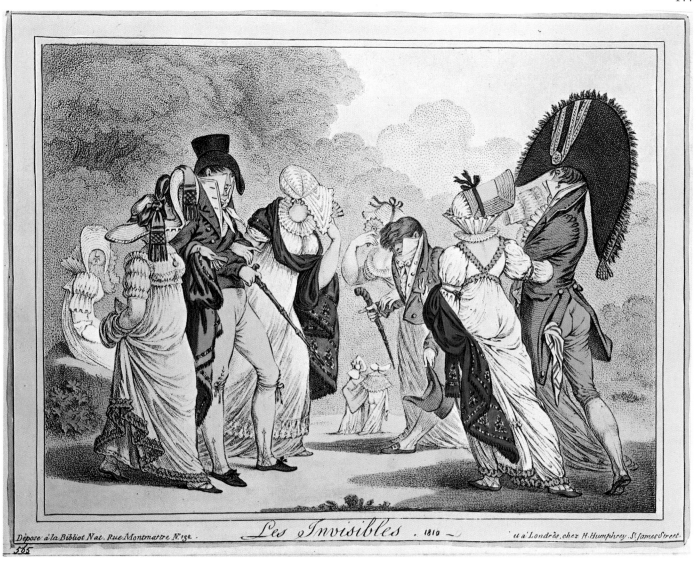

Les Invisibles . 1810 ~

Déposé à la Bibliot Nat. Rue Montmartre N.132 .

et à Londres, chez H. Humphrey. St James Street.

565

176

JAMES GILLRAY (1756–1815)

Very Slippy-Weather. 1808

From the drawing of John Sneyd

Coloured etching. 26.5×20.5 cm (Wright & Evans 1851, No. 559; George 1938–52, No. 11100)

Acquired in the second half of the 19th century. Inventory No. 300191

Depicts the shop of Mrs. Humphrey on St. James's Street. The window displays Gillray's caricaturies for which Mrs. Humphrey received the sole rights in 1791.

177

JAMES GILLRAY (1756–1815)

Les Invisibles. 1810

Coloured etching. 24×32 cm (Wright, p. 369; Wright & Evans 1851, No. 568; George 1938–52, No. 11612)

Acquired in the second half of the 19th century. Inventory No. 330316

Les Invisibles and its companion piece, *La Valse*. *Le Bon Genre* (1810), were issued in London and Paris. Both are etched copies of French engravings.

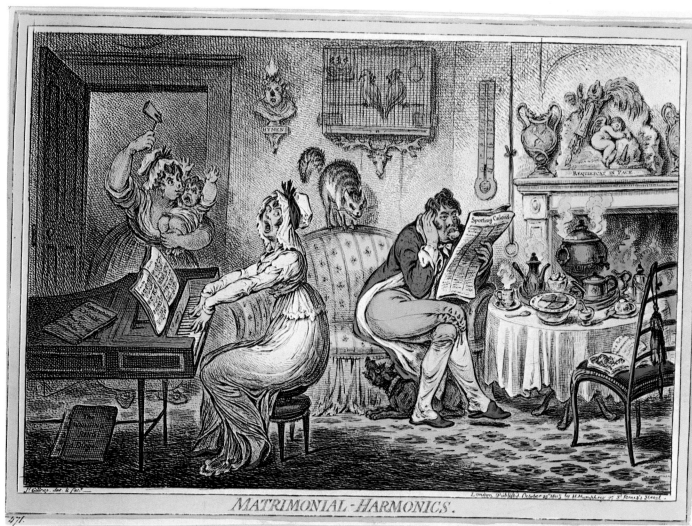

MATRIMONIAL-HARMONICS.

178

178, 179

JAMES GILLRAY (1756–1815)

Matrimonial-Harmonics. 1805

Coloured etching. 25.5×37 cm (Wright, pp. 325–326;
Wright & Evans 1851, No. 539; George 1938–52, No. 10473)

Acquired in the second half of the 19th century.
Inventory No. 300092

REQUIESCAT IN PACE

Sporting Calendar

The Art of Tormenting

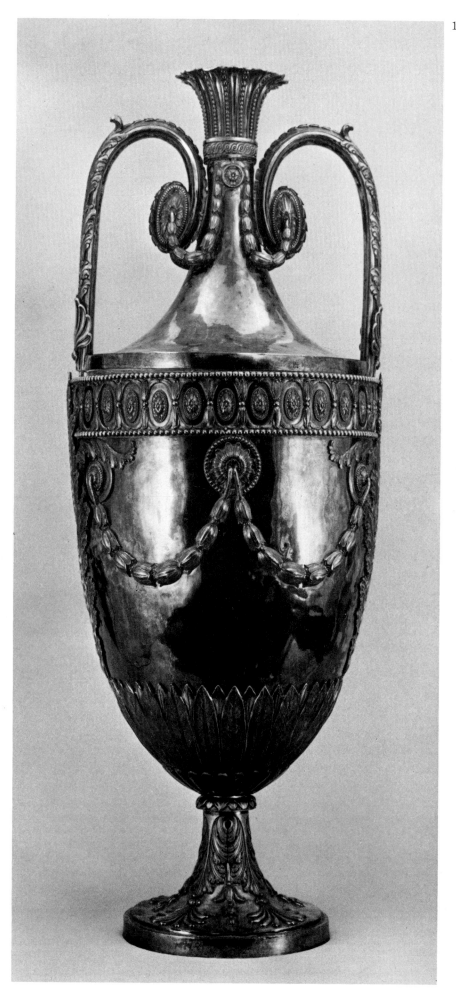

180

ANDREW FOGELBERG
(active from 1773 to 1800)

Vase. London hall-mark for 1770–71

Chased silver. Height 88.5 cm

Transferred after 1797 from
the Tauride Palace in St. Petersburg.
Inventory No. 7160

The Hermitage also possesses a companion
vase (inventory No. 7161). Both vases were
purchased along with a wine cooler by
Philip Rollos from the Duchess of Kingston
by Catherine II, and presented
to Prince Potiomkin.

ase-censer. Beginning of the 19th century

methystine quartz, ormolu and marble.
eight 42 cm
cquired in 1915 from
e State Museum Fund. Inventory No. 1561
ublished for the first time.

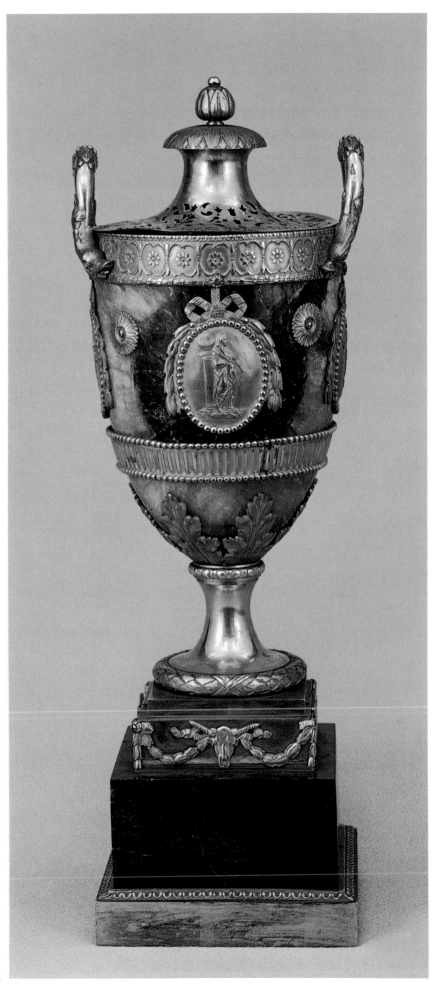

182

182, 183

Dressing commode. 1760s or 1770s

Lemon wood, thuja and other woods, inlaid with ivory,
ormolu trimmings. Height 102 cm

Acquired in 1927 from the M. Musin-Pushkin collection
in Leningrad. Inventory No. 4

The decoration of the commode combines elements typical of
furniture in the Louis XVI style (the pattern of inlay in the central
oval), and of English furniture of the 1760s and '70s. The inlay,
framing the central composition, features English ornamentation
of the kind shown in the furniture guide produced by Thomas
Chippendale the Younger in 1779. The front door of the cabinet
hides the three drawers of the commode. Furniture of this type
was made by John Linnell and George Cobb. Similar pieces
can be seen in the Victoria and Albert Museum and in private
collections in England.

Published for the first time.

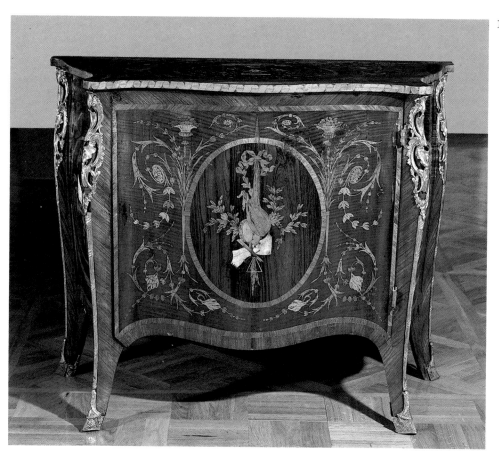

183

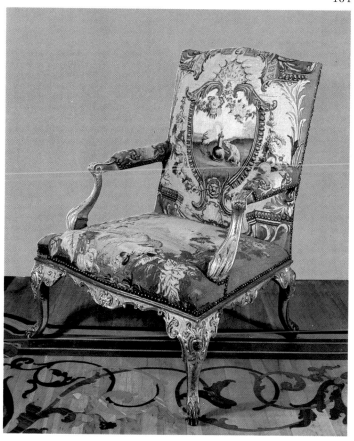

184

Armchair. Mid-18th century

Carved wood, gilded and covered in needlework.
Height 95 cm

Transferred in 1933 from the Stieglitz School Museum.
Inventory No. 1538

The armchair is in the so-called French style,
but alongside features typical of the French rococo,
the craftsman incorporated elements characteristic
of English furniture: cabriole legs and the tall straight
back directly adjoined to the seat.
The armchair is upholstered in 18th century needlework
produced at the Soho factory. It depicts scenes from
La Fontaine's fables.
Published for the first time.

THE ANGLERS DELIGHT
Containing Rules, and observations, calculated to form the compleat Fisherman

186

185

Cloth depicting the Siege of Gibraltar.
Last quarter of the 18th century

Linen thread, design printed from engraved copper block.
104×68 cm

Inscribed, on the left: *The glorious Defence of Gibraltar
and Destruction of the Flouting Batteries
by the Heroic Elliot and his Brave Garrison*;
on the right: *Your Fame Inglorious France and Spain
Sunk by Brave Elliots Coup de Main. 1782*

Transferred in 1934 from the Ivanovo Regional Art Museum.
Inventory No. 14563

In the 18th century printed textiles with subject scenes became
very popular in England. In this example from the Hermitage,
the cloth depicts the final stage in "the Great Siege" (1779–83)
during which the Spaniards tried unsuccessfully to gain back
Gibraltar seized by the British in 1704.

186

Handkerchief depicting a fishing scene.
Last quarter of the 18th century

The design drawn and engraved by W. Sherwin.
Red printed linen. 66×71 cm

Signed: *W. Sherwin Delin et Sculp.*
Transferred in 1923 from the Stieglitz School Museum
in Petrograd. Inventory No. 4032

The handkerchief is an unusual kind of advertisement produced
by an English firm dealing in the sale of fishing tackle. Around a
central medallion, there are representations of different fish and
a guide to the times of year that they should be caught and which
baits should be used. The top and sides give information about
the various kinds of bait. At the bottom is the name of the shop.
These kinds of handkerchiefs decorated with subject scenes became
very popular in England in the late 18th and early 19th centuries,
especially after the introduction of techniques for the production
of printed textiles.

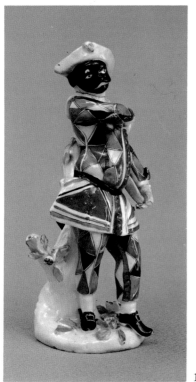

187

Harlequin.
The Bow factory.
C. 1755

Unmarked

Porcelain painted in
colours. Height 13.1 cm
Acquired in 1919 from
the V. Argutinsky-
Dolgoruky collection
in Petrograd.
Inventory No. 6903

A figure similar to this
Harlequin, came up for
auction at Christie's
on 20 May 1963
(lot 140, pl. 13).

187

188

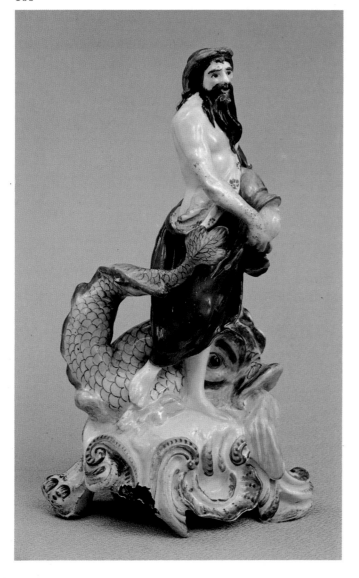

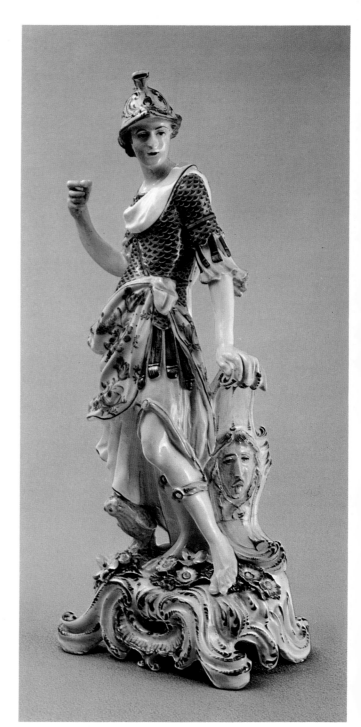

189

188

Water. The Bow factory. *C.* 1760

Unmarked

Porcelain painted in colours. Height 21 cm

Acquired in 1921 from the A. Obolenskaya-Hersdorf
collection in Petrograd. Previously in the collection
of A. Saltykova. Inventory No. 20890

The set *The Four Elements* came up for auction at Christie's on
4 March 1968 (lot 90, pl. facing p. 25) and on 19 April 1971
(lot 212, pl. 13). The bases in the figures of this set are higher than
in the Hermitage one.

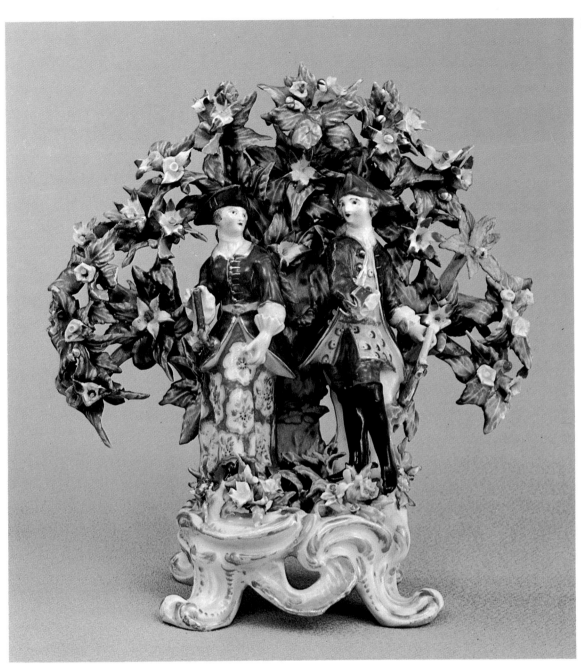

189

Minerva. The Bow factory. *C.* 1760

Unmarked

Porcelain painted in colours. Height 33 cm

Acquired in 1919 from the Versen collection
in Petrograd. Inventory No. 20895

The letter *T* has been impressed on the inside of the base. The same
letter *T* — the mark of the repairer Tebo — occurs in other replicas
of this model. It has been suggested that Tebo was not only
a repairer, but also made figures. For analogies see: Lane 1961
(colour plate C) and Rackham 1928–30 (vol. I, No. 55, pl. 1).

190

Boscage: Sporting Group. The Bow factory. *C.* 1765

Unmarked. Smudged blue sign under a glaze

Porcelain painted in colours. Height 21 cm

Acquired in 1918 from the A. Dolgorukov collection
in Petrograd. Inventory No. 20888

English porcelain factories produced so-called boscage groups in
which the figures are set against a background of flowering shurbs
and dense foliage. The subject of the "sporting group" is rare for
the Bow factory. A similar piece came up for auction at Christie's
on 15 June 1970 (lot 107, pl. IV).

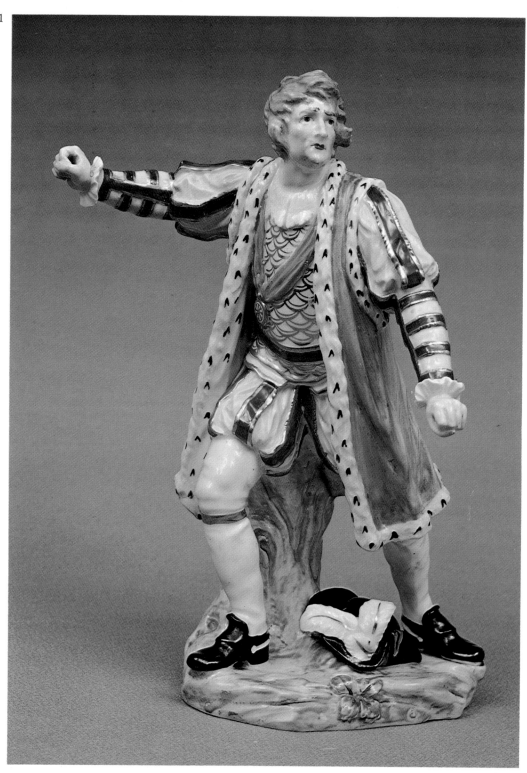

191

David Garrick as Richard III. Chelsea-Derby. *C. 1775*

After a model by John Bacon (?)

Unmarked

Porcelain painted in colours. Height 29.1 cm

Acquired in 1921 from the F. Uteman collection in Petrograd.
Formerly in the collection of S. and V. Yevdokimov
in St. Petersburg (*Catalogue* 1898, p. 84, No. 278).
Inventory No. 20894

The model is based on an engraving by John Dickson made after a
picture by Nathaniel Dance. The example in the Victoria and Albert
Museum is reproduced in the catalogue of the Schreiber collection
(Rackham 1928–30, vol. I, No. 342, pl. 39). Although it too derives
from the same engraving and was produced at the same date, it is
markedly different from the one in the Hermitage, and is probably
the work of some other modeller. The Hermitage figure of Garrick
was published by Roda Soloveichik in *Reports of the Hermitage*
(vol. XVIII, 1960, pp. 40–42) and also in *Musée de l'Ermitage.
Les Arts appliqués de l'Europe occidentale. XII^e–XVIII^e siècles*,
Leningrad, 1974, N° 134.

An Allegory of Music. Chelsea-Derby. *C.* 1775

Unmarked. Incised figure: *216*, and triangle

Porcelain painted in colours. Height 23 cm

Acquired in 1923 from the collection of E. and M. Oliv
in Petrograd. Inventory No. 19872

A group of figures similar to this one is reproduced in the catalogue
of the Schreiber collection (Rackham 1928–30, vol. I, No. 356), in
which there is mention that the figure, made from the same model,
was in a sale of Chelsea-Derby porcelain held on 5 May 1778.

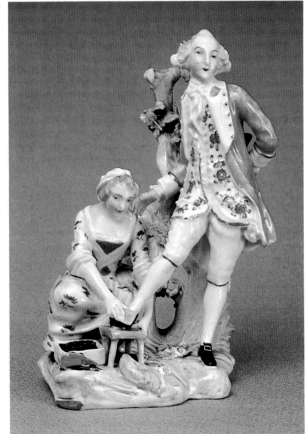

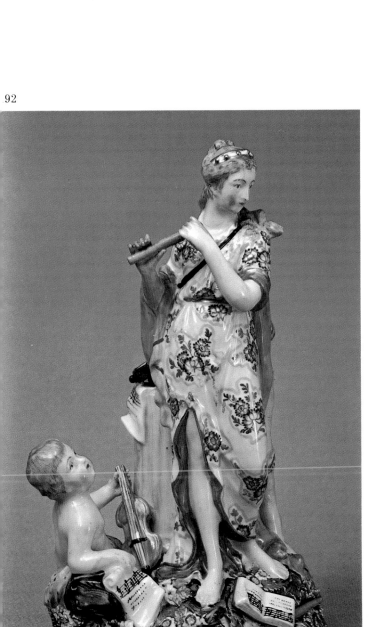

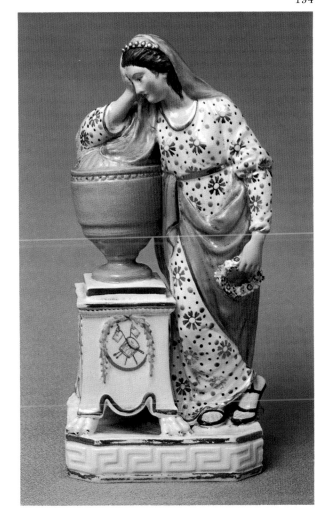

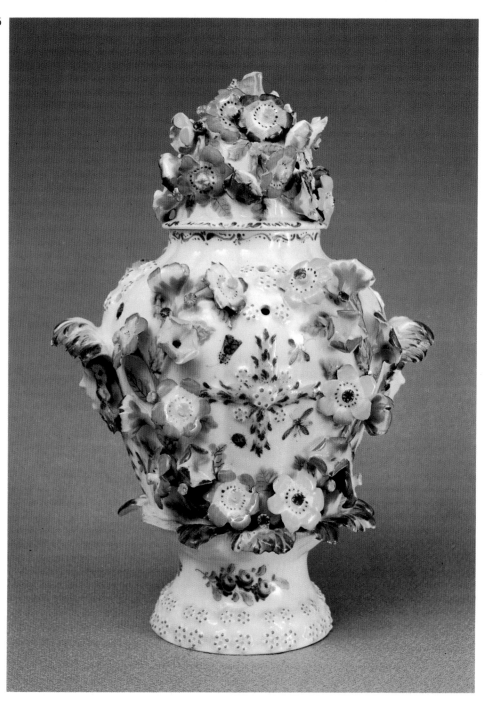

193

The Shoe-black. Chelsea-Derby. *C.* 1775–80

Unmarked

Porcelain painted in colours. Height 17 cm

Acquired in 1921 from the V. Argutinsky-Dolgoruky
collection in Petrograd. Inventory No. 19871

Barrett & Thorpe (1971, pp. 53–54) mention that in the 1830s
copies of figures and groups produced in the 18th century
in the Chelsea-Derby period were made. *The Shoe-maker*
(pl. 131) and probably its companion piece *The Shoe-black*,
were amongst these. Both 19th century copies have high,
pierced bases. As Barrett & Thorpe suggest, the 18th century
figures, from which the 19th century copies were made,
are extremely rare. The Hermitage group was published
by Lisenkov (1964, fig. 47).

194

Andromache Weeping over the Ashes of Hector.

Chelsea-Derby. *C.* 1775–80

Unmarked. Incised figures: *No. 100, 2;*
and the figure *5* in red.

Porcelain painted in colours. Height 22.5 cm

Came in 1963 as a gift from Mrs. Irene Butler
(Auckland, New Zealand). Inventory No. 26726

A similar figure was published by Thorpe (1968), who writes
that the figure of Andromache grieving for Hector was
mentioned in the records of the sale of Chelsea-Derby
porcelain on 17 April 1780. The same figure is reproduced
by Mankowitz & Haggar (1957, pl. 29).

ase-censer and lid. Derby. C. 1765

nmarked

orcelain painted in colours. Height with lid 24.1 cm

cquired in 1925 from the State Museum Fund.

nventory No. 19866

similar censer (the so-called "frill"-vase) is reproduced

y Barrett & Thorpe (1971, pl. 76) and Hannover

925, vol. III. pl. 781).

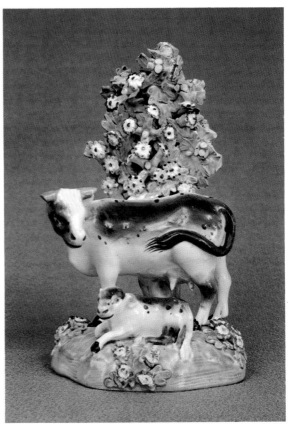

A Cow and Her Calf. Derby. C. 1763–65

Unmarked. Figures in red: *23* and *13*

Porcelain painted in colours. Height 15.5 cm

Transferred in 1919 from the Museum of the Society

or the Encouragement of Arts in Petrograd. Formerly

n the G. Davies collection. Inventory No. 20885

A similar group is reproduced by Savage (1961, pl. 141).

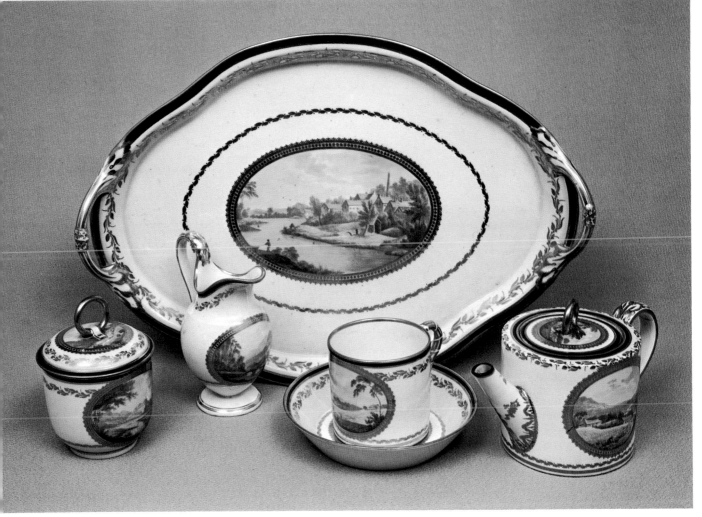

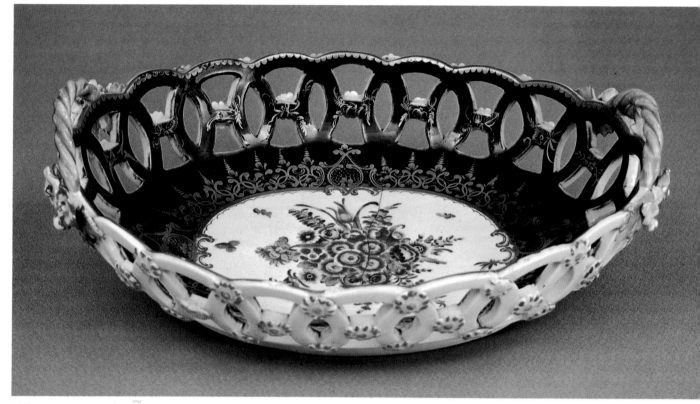

198

197

Solitaire set. Derby. *C.* 1790–94

Blue underglaze marks on all pieces: *D* under a crown.
Inscribed in blue, on the tray: *At Malton Yorkshire*;
on the tea-pot: *Near Caernavon in Wales, On the Isle
of Wight* and *Near Breadsall. Derbyshire* (on the lid);
on the sugar bowl: *Ulles water. Northumberland
and In Dove Dale. Derbyshire* (on the lid); on the milk jug:
Keswick Lake. Cumberland; on the cup: *Near Breadsall.
Derbyshire*; on the saucer: *On the Manifold. Staffordshire*

Porcelain painted in colours. Tray 38.3×27 cm.
Height: 10.5 cm (tea-pot), 10.9 cm (sugar bowl),
12.1 cm (milk jug), 6.7 cm (cup); diameter of saucer 13.7 cm

Acquired in 1918 from the A. Dolgorukov collection
in Petrograd. Inventory Nos. 19028–19032

In Olivar Daydi's book (1957, vol. II, pl. 128) there is a reproduction
of a similar service in the Victoria and Albert Museum depicting
landscapes painted by Zachariah Boreman. The technique of
painting is close to that of the Hermitage service.

198

Basket. Worcester. *C.* 1770

Mark under a glaze: a crescent in blue

Porcelain painted in colours. 27×21.5 cm

Acquired in 1921 from the State Museum Fund.
Inventory No. 20899

Pieces with similar painted design are reproduced by Hobson
(1910, pl. VI).

199

Winter. From The Seasons of the Year set. Plymouth. *C.* 1770

Unmarked

Porcelain painted in colours. Height 14.3 cm

Transferred in 1919 from the Museum of the Society
for the Encouragement of Arts in Petrograd (*Catalogue* 1904,
p. 250, No. 62), formerly in the G. Stetiner collection.
Inventory No. 20889

Charleston (1965, p. 150) mentions two sets produced in Plymouth,
in which the figures of children personified parts of the globe and
the seasons of the year. The figure of the boy (*Winter*) is reproduced
by Honey (1928, pl. 87c) and Rackham (1928–30, vol. I, No. 699,
pl. 78). An example of the same figure came up for auction at
Christie's on 13 November 1972 (lot 58, pl. facing p. 20).

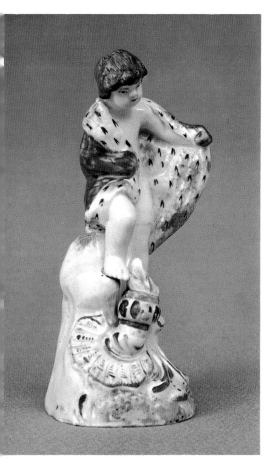

Basket with lid and stand. Worcester. *C.* 1765–70

Mark in blue under a glaze: *W*

Porcelain painted with cobalt. Height of basket 13 cm;
stand 26.1×21.3 cm

Transferred in 1926 from the Stieglitz School Museum
in Leningrad. Formerly in the Vorontsov collection.
Inventory No. 20771

A similar basket is reproduced by Watney (1963, pl. 37b) and
Hannover (1925, vol. III, pl. 811). A basket in the same form, but
with different painted design, was put up for auction at Christie's
on 13 November 1972 (lot 106, pl. facing p. 38).

200

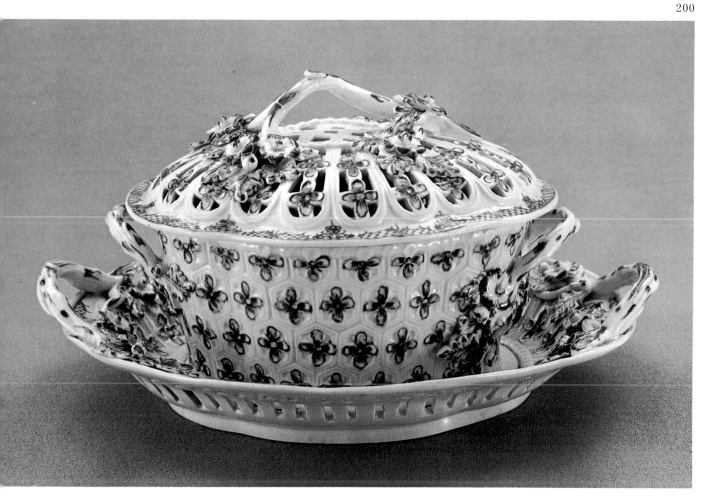

Sugar bowl and lid. Worcester. *C.* 1775

Porcelain painted in colours. Height 11.3 cm

Transferred in 1919 from the Museum of the Society
for the Encouragement of Arts in Petrograd (Catalogue 1904,
p. 247, No. 36). Formerly in the G. Stetiner collection.
Inventory No. 20875

A similar sugar bowl but with different painted design came
up for auction at Christie's on 19 February 1968
(lot 257, pl. XI). The same bowl formed part of a fluted tea
and coffee set which came up for auction at Christie's
on 22 May 1972 (lot 161, pl. 6).

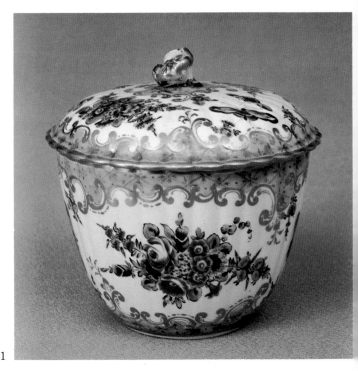

201

202

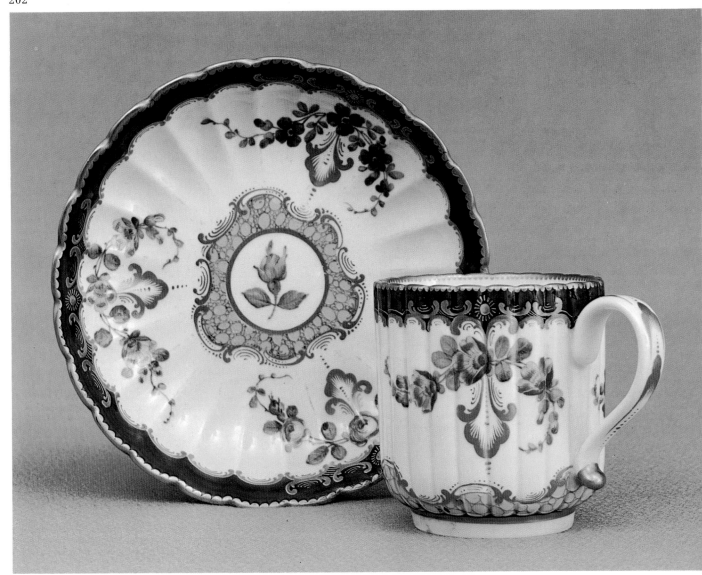

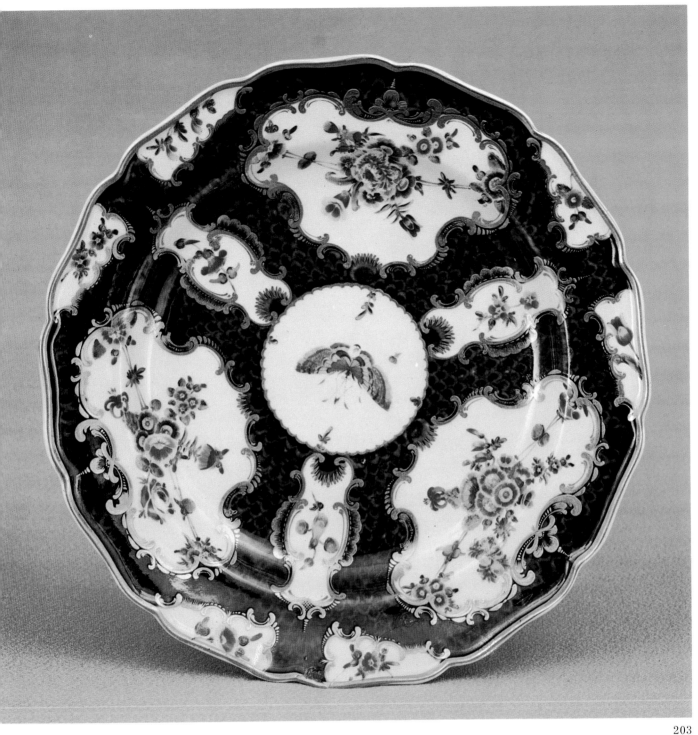

203

202

Cup and saucer. Worcester. *C.* 1775

Mark in blue under the glaze in the pseudo-Oriental style

Porcelain painted in colours. Height of cup 7 cm.
Diameter of saucer 14.2 cm

Transferred in 1919 from the Museum of the Society
for the Encouragement of Arts in Petrograd. Formerly
in the G. Stetiner collection. Inventory No. 19002

A cup and saucer in the same shape but with different painted
design formed part of a fluted tea and coffee service which was
put up for auction at Christie's on 22 May 1972 (lot 161, pl. 6).

203

Plate. Worcester. *C.* 1770

Mark in blue under the glaze in the pseudo-Oriental style

Porcelain painted in colours. Diameter 22.5 cm

Acquired in 1921 from the F. Uteman collection
in Petrograd. Inventory No. 19042

Similar plates are reproduced by Hobson (1910, pl. XCV)
and Olivar Daydi (1957, vol. II, colour plate VII).

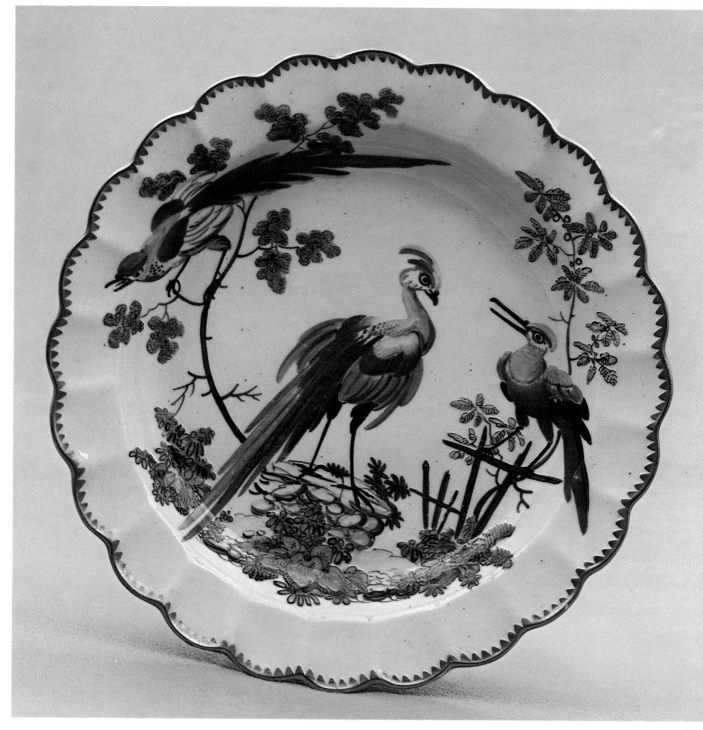

204

Side plate. Worcester. *C.* 1770

Unmarked

Porcelain painted in colours. Diameter 17 cm

Transferred in 1919 from the Museum of the Society
for the Encouragement of Arts in Petrograd (*Catalogue* 1904,
p. 248, No. 41). Formerly in the G. Stetiner collection.
Inventory No. 19003

Painted in the workshop of James Giles.
A plate with similar form and painted design is reproduced
by Barrett (1966, pl. 71).

JAMES COX (active in the second half of the 18th century)

Turnip watch. London. 1775

Signed on the dial and mechanism: *James Cox London 1775 N 9745*

Silver, engraved and painted with transparent enamel. Diameter 11.3 cm

Transferred in 1925 from the Stieglitz School Museum in Leningrad. Inventory No. 11271

205

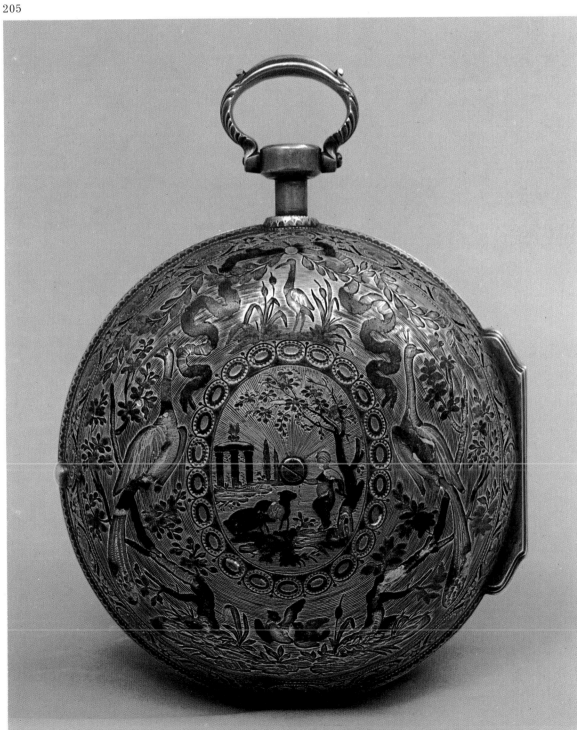

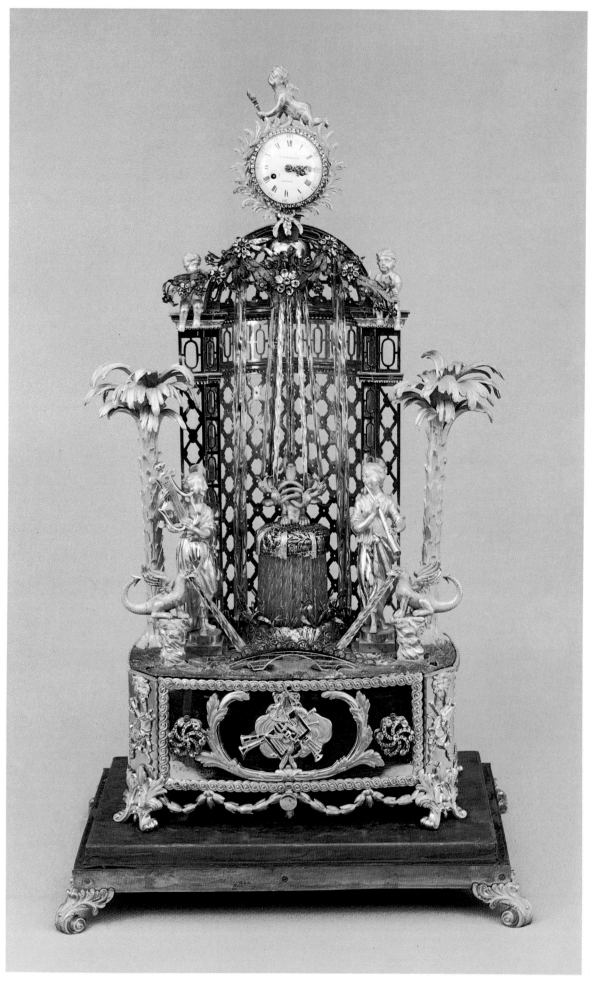

PETER TORKLER
(active in the second half
of the 18th century)

**Table clock:
Pavilion and Fountain.**

London. 1780s
Ormolu, crystal. Height 52 cm

Transferred in 1931 from the
Museum of the Revolution in
Leningrad. Before 1920
in the Winter Palace.
Inventory No. 2003

The mechanism operating
the chime and the action
of the fountain are in the base,
on the outward side of which
there are rosettes of strass
concealing the slot
for the key.

207

JAMES COX
(active in the second half
of the 18th century)

**Table clock with lion
and rhinoceros.** 1770s

Ormolu, agate, coloured glass.
Height 53 cm

Signed on the dial:
Cox, Jas. London

Transferred in 1859 from
the Winter Palace.
Inventory No. 6422

The chime mechanism is
concealed in the base shaped
like a casket in agate.
Rosettes in strass hide
the slot for the key on the
outward side.

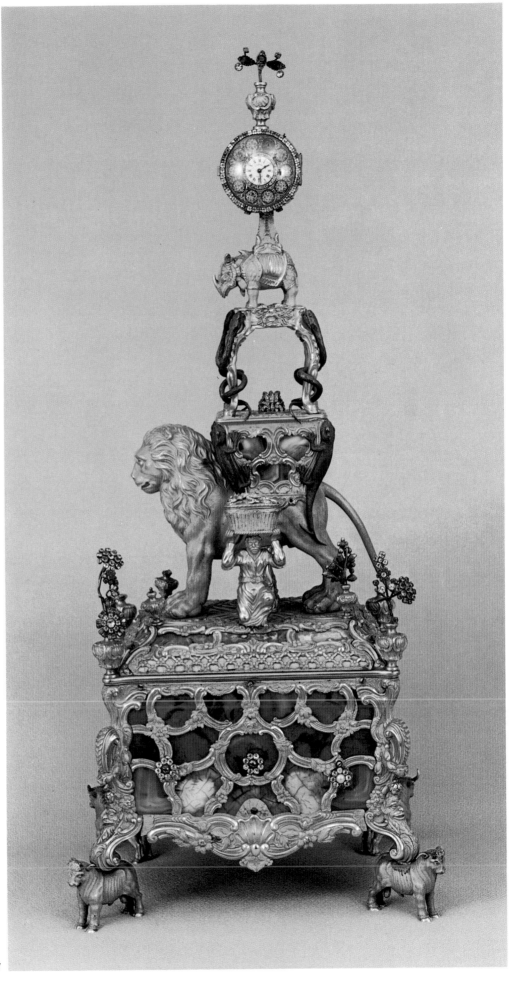

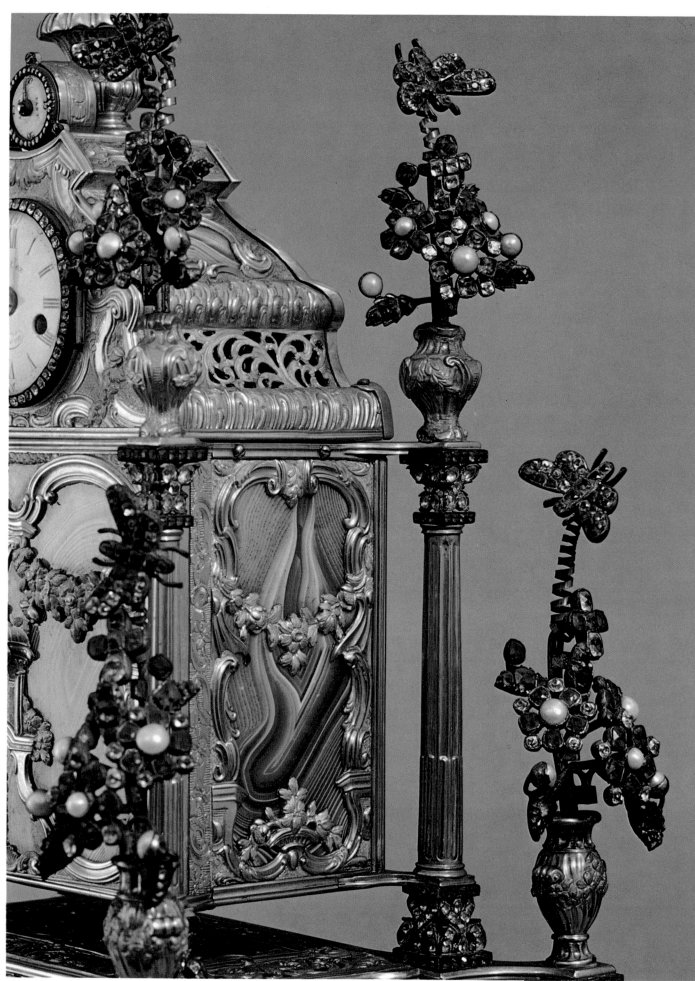

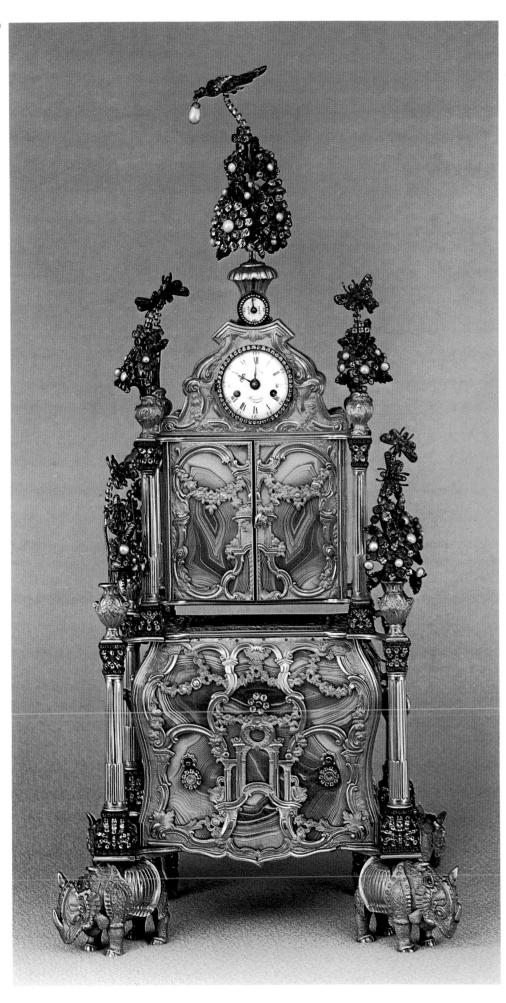

208, 209

JAMES COX
(active in the second half
of the 18th century)

**Dressing-table clock mounted
on rhinoceroses.** London. 1772

Signed on the dial:
Jas Cox 1772

Chased gold, pink agate,
coloured glass. Height 38.7 cm

Transferred from
the Winter Palace.
Recorded in the inventory
of 1789. Inventory No. 2003

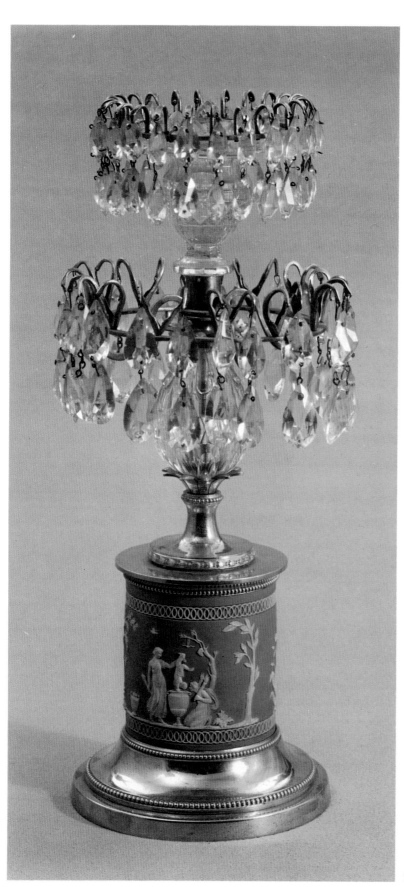

210

Girandole. Late 18th century

Crystal, ormolu, faïence painted in colours.
Height 34 cm

Transferred in 1859 from the Winter Palace.
Inventory No. 5901

Published for the first time.

211

Girandole. Late 18th century

Crystal, ormolu, jasperware. Height 87 cm

Acquired in 1932 from the State Museum Fund.
Inventory No. 5901

The support for the girandole was probably
produced by Josiah Wedgwood.

Published for the first time.

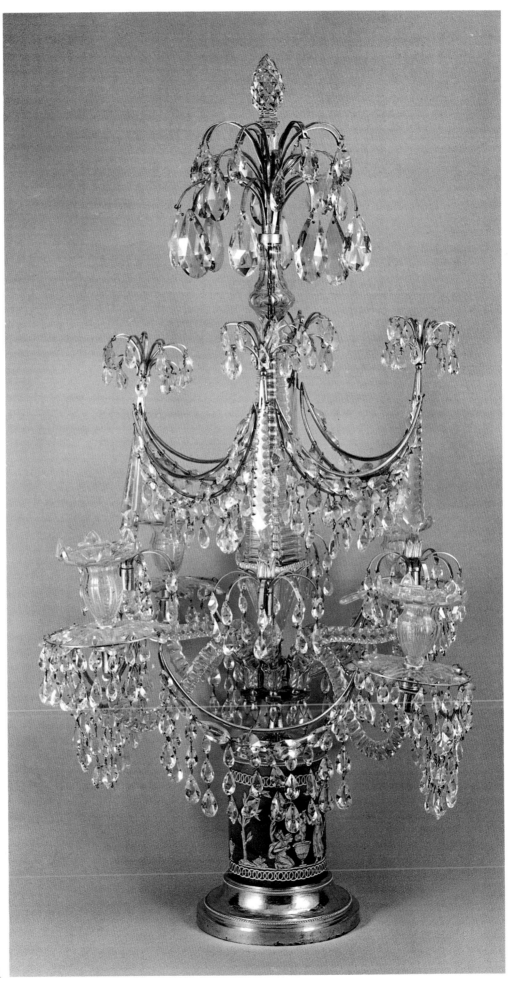

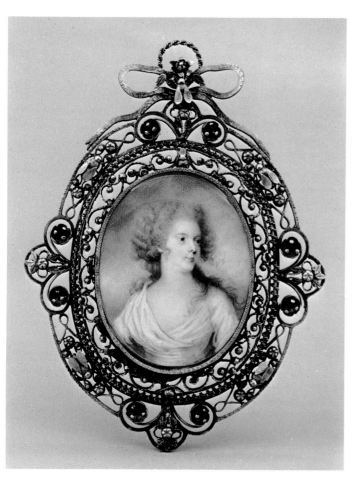

212

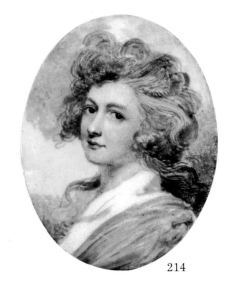

214

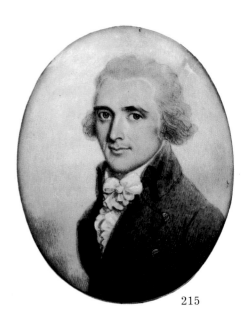

215

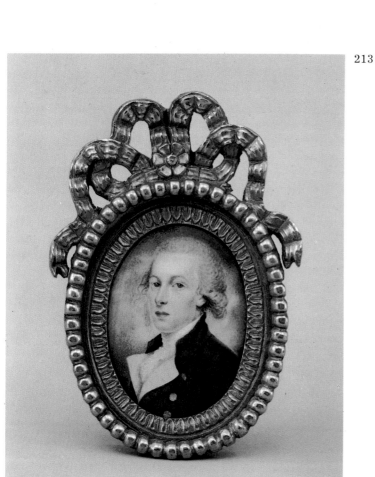

213

212

ANDREW PLIMMER (1763–1837)

Portrait of a Young Woman

Gouache and watercolour on ivory. 6.8×5.6 cm

Acquired before 1917. Inventory No. 278

Formerly ascribed incorrectly to the French miniaturist Georges Lerois (1739–1778). Identified as the work of Andrew Plimmer in the 1830s.

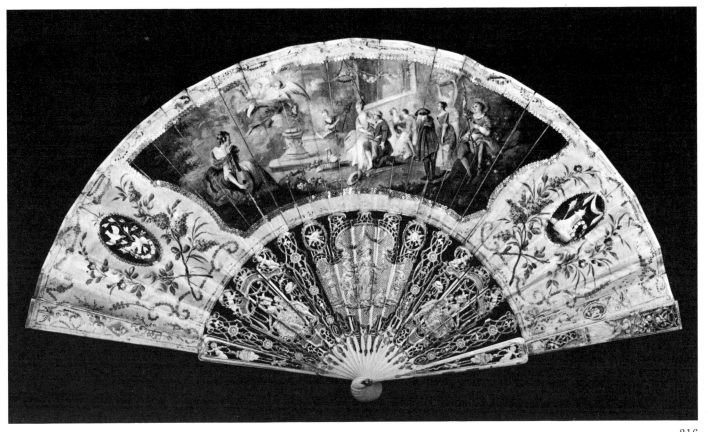

216

213

UNKNOWN PAINTER OF THE LATE 18TH CENTURY

Portrait of a Young Man in a Wig. 1780s

Gouache on ivory. 3.8×2.9 cm

Acquired in 1924 from the collection
of L. and E. Kochubei in Leningrad. Inventory No. 1855
Published for the first time.

214

GEORGE ENGLEHEART (1752–1829)

Portrait of Princess Gagarina

Gouache and watercolour on ivory. 4.6×3.7 cm
Acquired in 1950 from a private collection. Inventory No. 2838
Published for the first time.

215

ANDREW PLIMMER (1763–1837)

Portrait of a Man in a Blue Frock Coat

Gouache on ivory. 6.9×5.7 cm
Acquired in 1970 from a private collection. Inventory No. 2988

216, 217

Fan. 1780s

Carved ivory, silk, gold foil, painted. Length 28.3 cm
Transferred in 1928 from the City Museum in Leningrad.
Inventory No. 9910

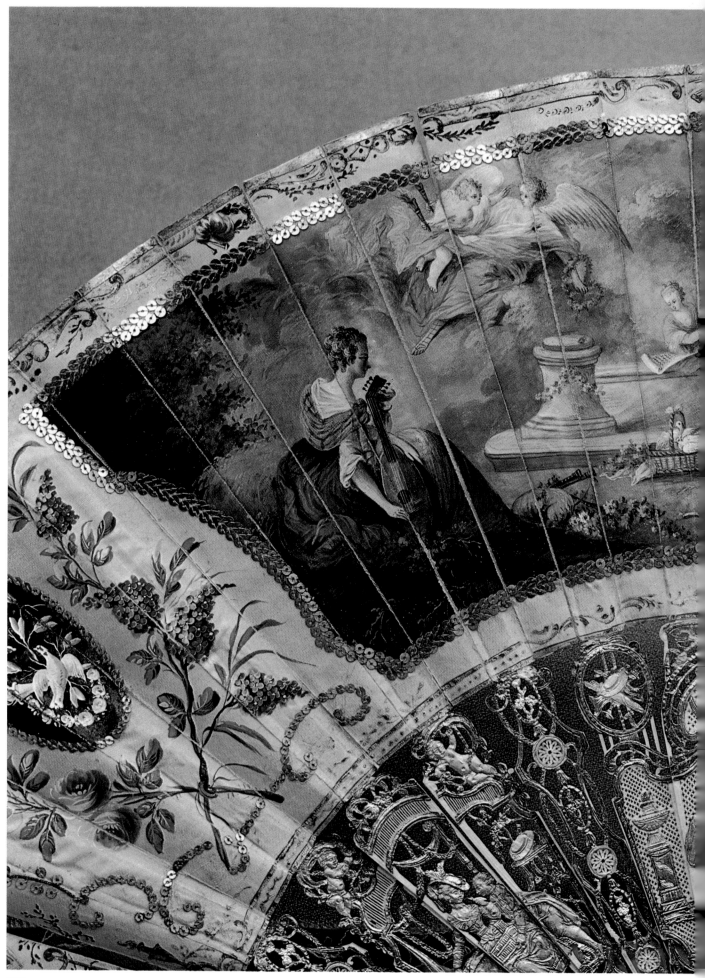

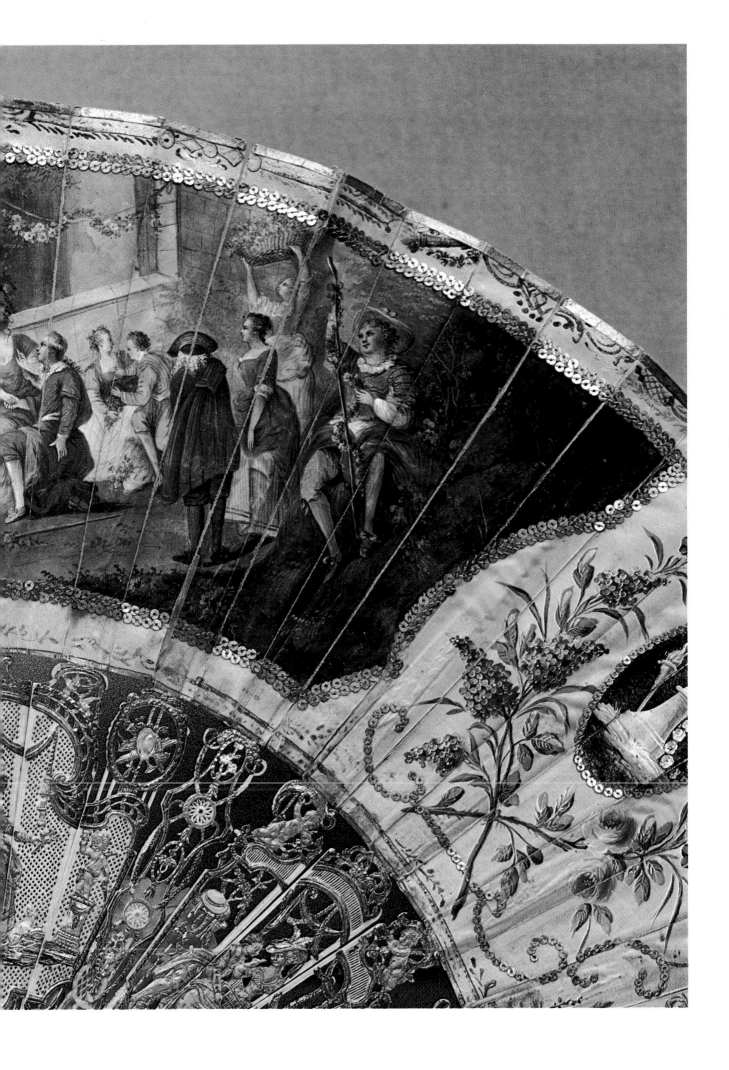

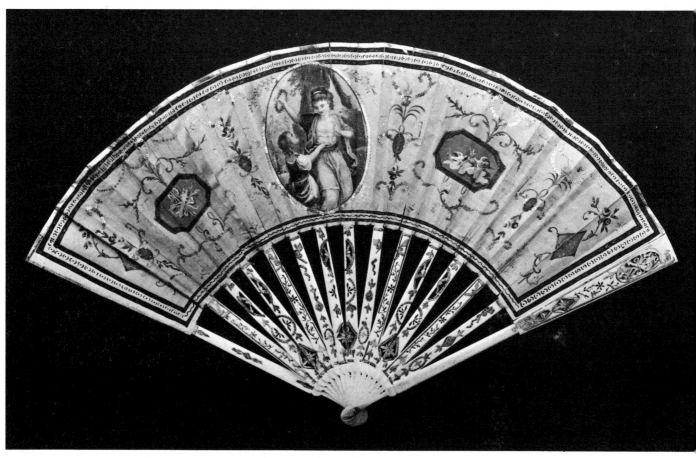

218

218, 219

Fan. 1780s

Carved ivory, silk, foil, painted. Length 20 cm

Transferred in 1929 from the City Museum in Leningrad.
Inventory No. 10571

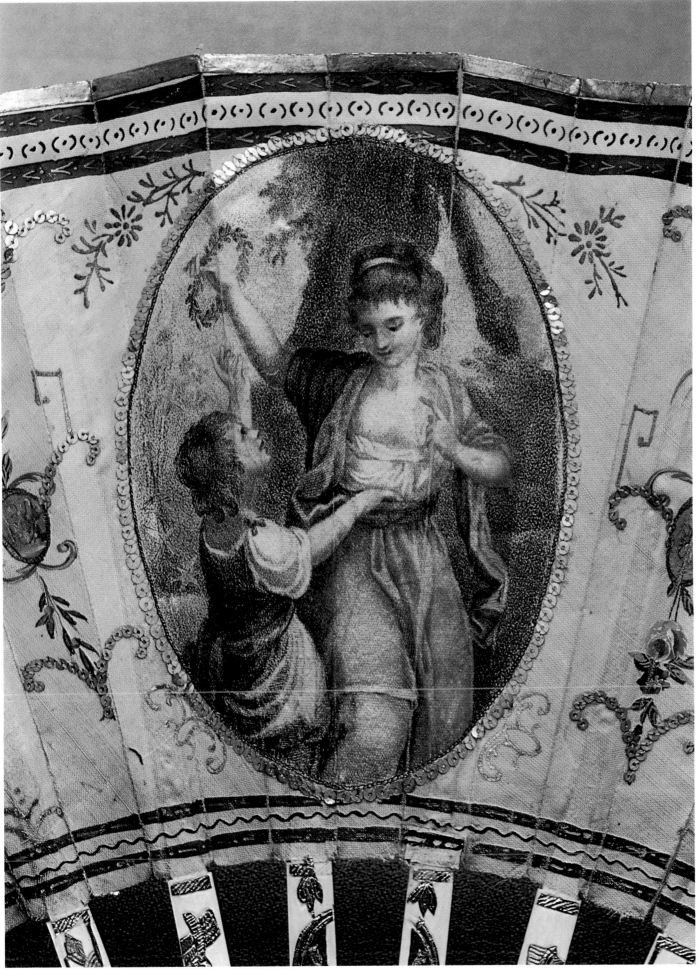

**Engraved gems by Charles Brown
and William Brown**

In the Hermitage there are over 200 engraved gems by
Charles and William Brown, which makes up almost a half
of their entire output (the remaining pieces are scattered
about other collections or else lost. We know of the existence
of these lost intaglios from the impressions made by James
Tassie in London). From 1786 onwards, on the orders of
Catherine II, regular purchases and shipments of cameos
and intaglios by the Brown brothers were dispatched from
London to St. Petersburg through the agency of Weitbrecht,
bookseller to the Imperial Court. Documents surviving in
the Central Historical Archives in Leningrad and the State
Archives of Old Acts in Moscow make it possible to follow
in detail the history of the purchases. Whilst fulfilling the
orders of the Russian Court, the Browns, who had been
regular and established contributors to the exhibitions
of the Society of Artists of Great Britain and the Royal
Academy, in the period between 1786 and 1796, did not
display a single gem in London.
William and Charles Brown engraved on the coloured
minerals all kinds of historical and mythological scenes,
portraits and representations of animals. The artists
produced several gems recalling events from Russian
history, in particular cameos celebrating the Russian
victories in the war with Turkey. Having thus applied
themselves to the treatment of a wide variety of genres
typical of glyptic art, and having drawn on a rich store of
technical devices for engraving which had been developed
over the centuries, the Browns showed themselves to be
receptive artists in tune with the spirit of their time and
able to find in their art a language capable of expressing
it. Although the Browns spent many years fulfilling
commissions from abroad, and although they are less
well known in Britain than other gem engravers of the
time, the unique character of their work was defined
essentially by the traditions of English culture of the last
third of the 18th century.

220

WILLIAM BROWN (1748–1825)

Intaglio: Head of Hygeia. Before 1785

Signed: *W. BROWN INVT*

Cornelian. 2.6×2.2 cm

Impressions: Raspe 1791, No. 4116

Acquired in 1787. Inventory No. 3698

The intaglio was produced before 1785, since in that year a cast
made of it was included in the second part of Tassie's manuscript
catalogue which had been compiled by that time (Hermitage
Archives, I, 6, "c", No. 32). The Hermitage also possesses a cameo
of the same subject produced by the Browns (inventory No. 1776,
see Kagan 1975, No. 82).

CHARLES BROWN (1749–1795)

Intaglio: Mars and Bellona. *C.* 1785

Signed: *C. BROWN INVT*

Cornelian. 36×30 cm

Impressions: Raspe 1791, No. 7281

Acquired in 1787. Inventory No. 3946

In the first inventory of cut gems in the Hermitage, dating from the
late 18th century (Hermitage Archives, I, 6, "c", No. 2), the intaglio
was called *Mars and Venus*. The same name was given by Raspe,
Dalton, Forrer and Maximova. The name *Mars and Bellona* occurs
on the bill presented by Weitbrecht for payment. This bill which
was based on the original bill from the Browns is preserved in
the Central Historical Archives in Leningrad (fund 468, inventory I,
part 2, item 3902, p. 73).
A version of this composition, also produced by Charles Brown,
belonged to the Prince of Wales (Raspe 1791, No. 7282).
Using classical models, the engraver was, however, not aiming
merely at producing faithful copies. In contrast with gems of the
classical era, these are notable for their size, crowded composition
freely incorporating elaborate details, and the harmonious
combination of deep relief and fine engraving, which results in a
superb interplay of light and shade. The intaglios are also striking
for their remarkable purity of line which seems to reconcile the
opposing trends of the Baroque and Classical styles characteristic
of English art at this time. In 1784 the intaglio was exhibited
at the Royal Academy of Arts (Graves 1905–6, vol. 1, p. 306).

CHARLES BROWN (1749–1795)

WILLIAM BROWN (1748–1825)

Intaglio: The Death of Socrates

Signed: *BROWN*

Chalcedony. 1.9×2.7 cm

Acquired in 1791. Inventory No. 4072

This intaglio together with two others in the Hermitage by the
Browns — *The Death of Seneca* and *The Murder of Archimedes* —
form a set. *The Death of Socrates* was undoubtedly produced under
the influence of the paintings of Jean-François Pierre Peyron and
Jacques Louis David, put on display at the same time at the Paris
Salon in 1787. The Browns may have seen these canvases during
their stay in Paris in 1788 or in engraved reproductions.
The figure of Socrates is borrowed from the composition by David
with its famous gesture of the left hand and Criton's hand on his
knee. However, the couch on which Socrates is sitting is shown
foreshortened, with its edge to the viewer, as in the Peyron
painting. In this way the engravers were able to create their own
arrangement for the remaining parts in accordance with the laws
of pyramidal composition.

229

229

WILLIAM HARRIS (active in the last quarter
of the 18th century)

Intaglio: Bust of a Woman in a Veil

Signed: *HARRIS*

Cornelian. 2.2×1.6 cm

Acquired in 1873 with the L. Perovsky collection.
Inventory No. 3964

230

ROBERT PRIDDLE (active in the second half
of the 18th century)

Intaglio: Leda and the Swan

Signed: *PRIDDLE Sc*

Cornelian. 2.5×2.8 cm

Acquired in 1964 with the collection of G. Lemlein
in accordance with the owner's bequest.
Inventory No. 12725

One of the few known works of this gem engraver (reproduced in
the Forrer Dictionary 1904–30, vol. IV, p. 690). The composition
of the intaglio, which was a variant of the gem on the same theme
by Edward Burch (Lippold 1922, Taf. CXXXVII), derives from
Michelangelo's lost cartoon.

230

231

RICHARD YEO (c. 1720–1779)

Intaglio: Diana with a Bow

Signed: *YEO*

Cornelian. 2.4×1.9 cm

Acquired in 1887 from the V. Miatlev collection.
Inventory No. 4288

231

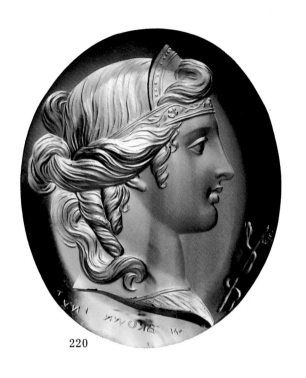

220

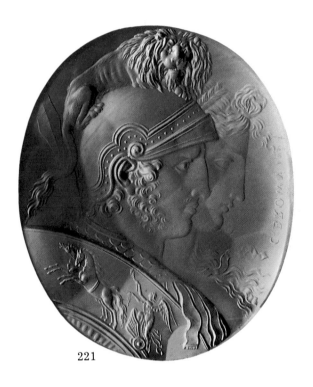

221

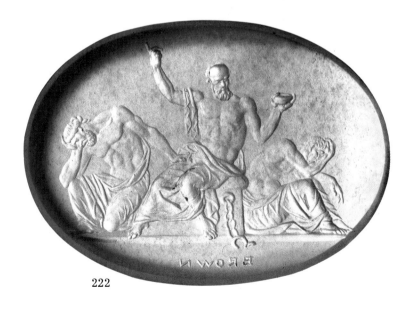

222

223

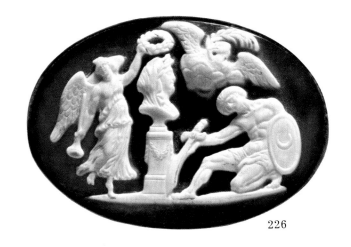

226

224

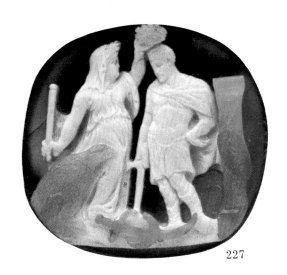

227

225

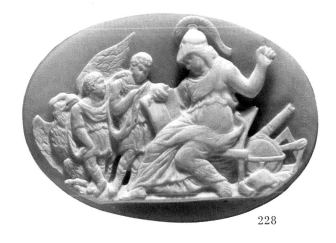

228

223

CHARLES BROWN (1749–1795)
WILLIAM BROWN (1748–1825)

Cameo: A Tiger

Signed: *BROWN*

Two-layered variegated agate. 17×22 cm

Acquired in 1796. Inventory No. 1785

The cameo was mentioned in Weitbrecht's bill presented for payment in June 1796 under No. 10, as "Un tigre — pierre tâchetée", and is included in the group of cameos executed from antique models (Central Historical Archives in Leningrad, fund 468, inventory I, part 2, item 4031, p. 4791). However, its comparison with a contemporary engraving by James Morphey from a picture by James Northcote, an exponent of sporting painting, shows that it was this engraving that served as a model for the gem. Whilst not aiming at a naturalistic effect in rendering the striped colouring of the beast, the carvers skilfully conveyed the iridescent quality of the prowling beast's skin.

224

WILLIAM BROWN (1748–1825)

Intaglio: The Abduction of Europa. *C.* 1783

Signed: *BROWN INV^T*

Cornelian. 2.1×3 cm

Impressions: Raspe 1791, No. 1170

Acquired in 1786. Inventory No. 3731

The Abduction of Europa was one of the first gems produced by the Browns to arrive at the Hermitage.
In 1783 the intaglio was exhibited at the Royal Academy of Arts (Graves 1905–6, vol. 1, p. 314). Raspe (1791, No. 1770) calls this gem an outstanding work of the new glyptic art.

225

CHARLES BROWN (1749–1795)

Intaglio: A Horse Frightened by a Lion

Signed: *C. BROWN F.*

Cornelian. 2.4×2.9 cm

Impressions: Raspe 1791, No. 13234

Acquired in 1791. Inventory No. 3953

The intaglio reproduces from William Wollett's engraving the central group in George Stubbs's painting of the same name. Charles Brown also made a slightly larger replica (Raspe 1791, No. 13233). In 1774 one of these two gems was put on display at the Royal Academy of Arts in London (Graves 1905–6, vol. I, p. 306). The composition by Stubbs, the chief representative of the so-called sporting genre, was used in many forms of art. Stubbs himself transferred it to a plaque issued by the Wedgwood factory. Edward Burch, the older contemporary of the Browns, was the first English gem cutter to engrave Stubbs's picture (Raspe 1791, No. 13235).

226

CHARLES BROWN (1749–1795)
WILLIAM BROWN (1748–1825)

Cameo: Catherine II Crowning Prince Potiomkin with Laurels. 1789

Signed: *BROWN*. Inscribed at the top: *OCZAKOW*

Three-layered sardonyx. 2.5×2.6 cm

Acquired in 1791. Inventory No. 1125

The cameo was produced to commemorate the taking of Ochakov on 6 December 1788 by Russian troops commanded by Potiomkin during the Turkish campaign.

227

CHARLES BROWN (1749–1795)

Cameo: Allegory of the Defeat of the Turkish Fleet. 1791

Signed: *C. BROWN F^T*

Sardonyx. 3.5×5.1 cm

Acquired in 1791. Inventory No. 1104

The cameo is a companion piece to No. 228.

The cameo was produced to commemorate the victory of the Russian fleet in the war with Turkey (1787–91). It depicts a Turk on his knees presenting his sword at the foot of a pedestal supporting a bust of Catherine II.

228

CHARLES BROWN (1749–1795)
WILLIAM BROWN (1748–1825)

Cameo: Catherine II Instructing Her Grandsons. 1790–91

Signed: *BROWN*

Two-layered onyx. 3.1×4.5 cm

Acquired in 1791. Inventory No. 1124

The cameo is a companion piece to No. 227.

Catherine II is depicted as Minerva with a book in her hand. The attributes of her scholarship are to be seen in the globe, the quadrant and the telescope. Near Catherine stands Konstantin and behind him, Alexander.
Sketches for both cameos, sent to Catherine II for approval in 1790, are in the Archive of Old Acts in Moscow (fund 1293, inventory 30, item 107, p. 136).

EDWARD BURCH (1730–1814)

Intaglio: Head of Sappho

Signed: *BURCH*

Sardonyx. 1.8×1.5 cm

Impressions: Raspe 1791, No. 10211

Acquired before 1794. Inventory No. 3958

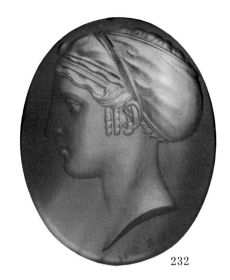

232

The intaglio was produced not later than 1786 since a cast was made from it, which was recorded in the third part of the manuscript catalogue of the Tassie collection, dating from this year (Hermitage Archives, I, 6, "c", No. 32). The Hermitage possesses a replica of the intaglio in cornelian by Burch himself (inventory No. 12465). The intaglio follows an engraved stone by Giovanni Pichler (H. Rollet, *Die drei Meister der Gemmoglyptik: Antonio, Giovanni und Luigi Pichler*, Wien, 1874, S. 37, Nr. 208), which in its turn, copies a classical bust in the Vatican. After Burch, this gem was repeated in England by William and Charles Brown, William Barnett, twice by William Lane, and by Edward Burch the Younger. However, the closest copy of Burch's work was the intaglio by his pupil Nathaniel Marchant (see Lippold 1922, Taf. CLV, 8).

233

EDWARD BURCH (1730–1814)

Intaglio: Sacrifice to Minerva

Signed: *BURCH F.*

Chalcedony. 2.3×1.9 cm

Impressions: Cades, No. 336

Acquired before 1794. Inventory No. 3956

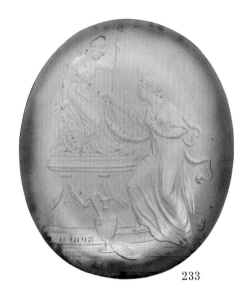

233

The intaglio notable for its unusual composition was produced before 1769, and in that year Burch made an impression of it which was put on display at the Tenth Exhibition of the Society of Artists of Great Britain (Graves 1907, p. 43). A cast of the intaglio is also to be found in the collection of Tommaso Cades (T. Cades, *Impronte Gemmarie*, No. 336 — the number according to the set in the Department of Classical Studies at the Hermitage).

234

EDWARD BURCH (1730–1814)

Intaglio: Dionysiac Bull

Signed: *BURCH*

Cornelian. 4×1.9 cm

Acquired before 1794. Inventory No. 3957

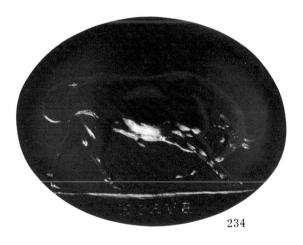

234

The intaglio is based on the classical gem by Hyllus (Cabinet de Médailles, Bibliothèque Nationale, Paris), which was popular in the 18th century due to the numerous casts and engravings made from it. There is one other similar intaglio produced by Burch, which in its details is closer to the original (see Raspe 1791, No. 13106).

235

NATHANIEL MARCHANT (1739–1816)

Intaglio: Head of Antinous (?)

Signed: *MARCHANT*

Sard. 2.8×2.2 cm

Impressions: Cades, No. 370

Acquired in the 18th century. Inventory No. 3981

The intaglio was made after a classical coin.

236

BRAGG (active at the end of the 18th and beginning of the 19th centuries)

Intaglio: Diana and a Dog

Signed: *BRAGG INT*

Sard. 2×1.5 cm

Acquired at the beginning of the 19th century.
Inventory No. 3695

237

UNKNOWN ENGRAVER OF THE SECOND HALF OF THE 18TH CENTURY

Intaglio: Portrait of Isaac Newton

Cornelian. 27×20 cm

Acquired in 1964 with the collection of G. Lemlein
in accordance with the owner's bequest.
Inventory No. 12735

Iconographically, the intaglio repeats the profile portrait of Newton without a wig and with a comet in the background, which was common in English glyptic art from the end of the 17th century. The early examples are portrait intaglios in the British Museum (see Dalton 1915, No. 1105) and in the Hermitage (inventory No. 4042, Maximova 1926, p. 18). Later pieces are known from the casts of James Tassie (Raspe 1791, Nos. 14316–14328). Most characteristic and popular among Newton's portraits of this type is a medallion produced by the Wedgwood factory in 1773 after a model by William Hackwood (R. Reily, G. Savage, *Wedgwood. The Portrait Medallions*, London, 1973, p. 258). This portrait was engraved in stone by Marchant, Birch and others.

238

NATHANIEL MARCHANT (1739–1816)

Intaglio: Profile of a Woman

Signed: *MARCHANT*

Chalcedony. 2.5×1.8 cm

Impressions: Cades, No. 390

Acquired in 1861. Inventory No. 4126/22

The intaglio depicts the head of a caryatid from the Villa Albani in Rome.

239

UNKNOWN ENGRAVER OF THE SECOND HALF OF THE 18TH CENTURY

Intaglio: Portrait of Elizabeth Hartley, an Actress of the Covent Garden Theatre

Cornelian. 28.5×24 cm

Acquired in the early 19th century. Inventory No. 11388

Among the gem casts made by James Tassie there are three identical portraits of the famous actress: two of them signed, one by Richard Deen (Raspe 1791, No. 14662) and the other by Nathaniel Marchant (Raspe 1791, No. 14663), and the third, anonymous one (Raspe 1791, No. 14664). The Hermitage intaglio is another replica of the same portrait which can be traced to one common source — probably an engraved portrait of the actress, who repeatedly served as a model, in her tragic roles, for Joshua Reynolds, Angelica Kauffmann, Gavin Hamilton and other English painters.

240

NATHANIEL MARCHANT (1739–1816)

Intaglio: Bacchus and Ariadne

Sardonyx. 2.4×2.4 cm

Acquired at the end of the 18th century. Inventory No. 9333

The engraver's replica of an oval signed gem now in the British Museum (Dalton 1915, No. 700, pl. XXV). In this composition, Nathaniel Marchant imitated a fragment of a marble relief from the Herculaeneum showing the seated Bacchus (now in the National Museum of Naples). Then, taking as a starting point the surviving details of the hands holding a vessel and part of a thyrsus, he made a free reconstruction of the lost figure of a woman (a nymph or Ariadne). An intaglio *Bacchus and Bacchante* from the antique fragment was exhibited by Marchant at the Royal Academy in 1783 (Graves 1905–6, vol. V, p. 181).

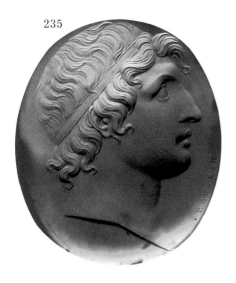

235

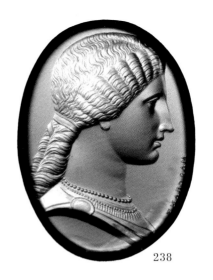

238

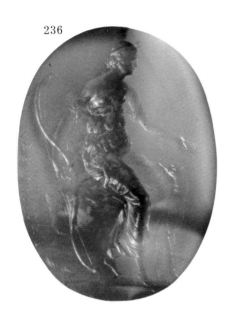

236

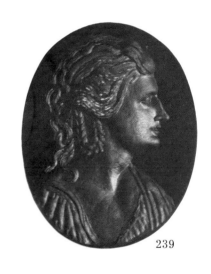

239

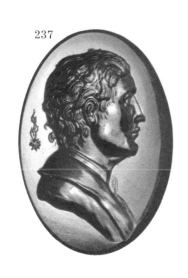

237

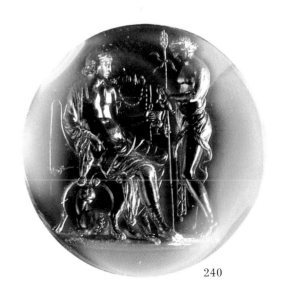

240

Cabinet for gem casts

Made by Roach after the design of James Wyatt (1748–1813)

Satin wood, palm, ebony, stained maple, thuja,
inlaid and carved. Height 232 cm

Acquired at the beginning of the 1790s. Inventory No. 344

One of a set of cabinets intended to house fifteen thousand casts and
the same number of glass copies of engraved gems from the famous
European collections, which in the 1780s and early 1790s James
Tassie was assembling for Catherine II in London. It was specified
in the order received by Tassie in 1781 that the casts were to be
supplied to Russia in special cabinets (Raspe 1786, p. 25).
The cabinets were produced by Roach after a design by one of the
foremost architects of the time James Wyatt. In the spring of 1783,
the first set of impressions was ready. On 14 March Tassie sent a
letter to George III in which he asked permission to display a set
of casts, showing the origin, progress and present state of gem
engraving before being put on public display and sent to Russia
(J.M. Gray, *James and William Tassie*, Edinburgh, 1894, p. 17).
A public viewing of the casts and the cabinet was arranged at
the beginning of April, and a curious record of this event survives
in the form of a letter from a certain Samuel Curwen published by
M.P. Macquoid (*A History of English Furniture*, London, 1904,
p. 220): "1783, April 5th. Called at Mr. Jassey's to have a sight of
the curious cabinet of satin-wood, inlaid and decorated with many
devices, figurative etc., on front and sides. Its contents rows of
drawers containing impressions of intaglios, cameras, seals etc.,
to the number of more than six thousand, duplicated, to be sent to
the Empress of Russia" (the author of the letter obviously meant
Tassie for Jassey and cameos for cameras).
In June 1783 the cabinet and casts arrived at Tsarskoye Selo.
Subsequently, similar cabinets of casts were dispatched to Russia.
Another cabinet, presented by Catherine II to her heir Paul, was set
in the Palace at Pavlovsk (see *The Art Treasures of Russia*, vol. III,
1903, p. 215, fig. 335 — in Russian) where it remained until the War
of 1941–45. Most likely, the cabinets arrived in Russia without legs.
The legs must have been added when the cabinets were installed.
In their details, the cabinets slightly differ from one another. Only
the early cabinets were inlaid with white enamel medallions set
in bronze frames. These were casts from Tassie's workshop,
for the storage of which the cabinets were also intended. Later,
when the casts were transferred to other cases, the cabinets were
drastically altered (fortunately, one of them still bears the ivory
plate with the inscription: *Roach, Cabinet Maker, London*).
The cabinet shown here is the only one to have survived in its
original form and internal arrangement (200 flat numbered
drawers). It is probably one of the later cabinets since decoration
in the form of medallion casts is absent.

241

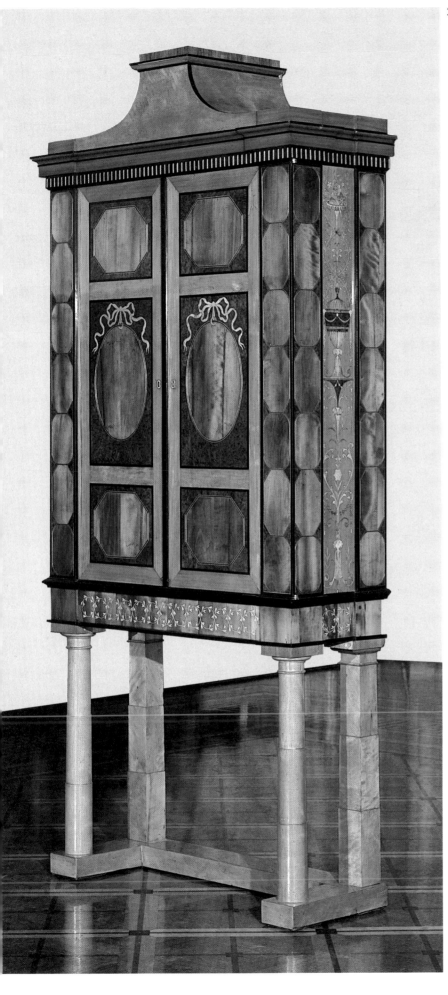

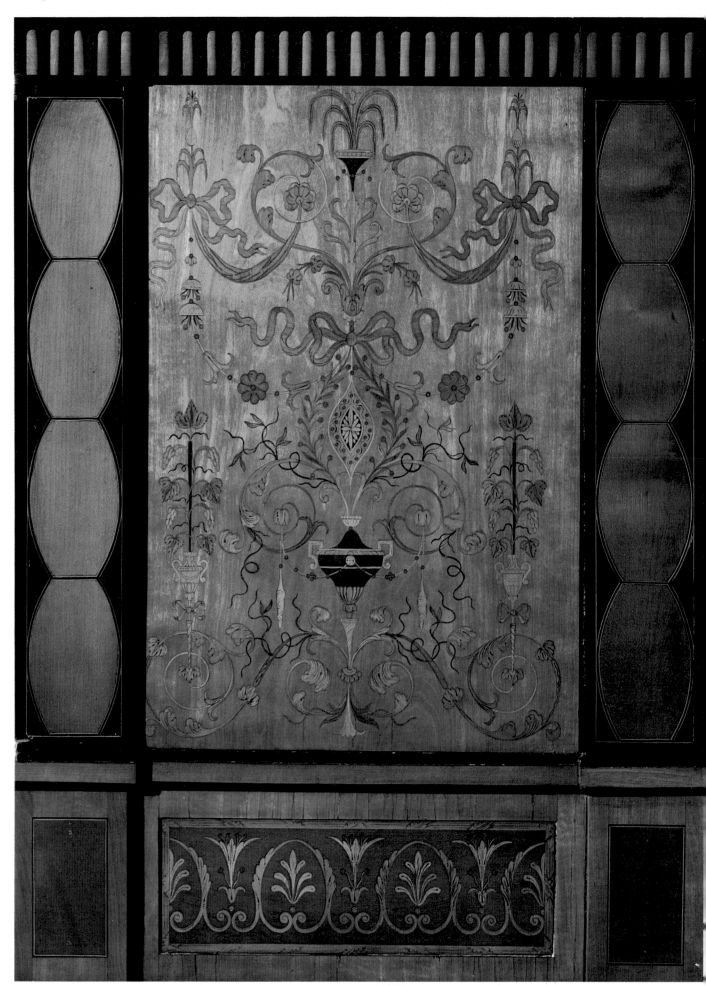

243

Cabinet for gem casts. Last quarter of the 18th century

By Roach

Satin-wood, palm-wood, ebony, stained maple, thuja,
inlaid and carved. Height 128 cm

Acquired in the mid-1780s. Inventory No. 342

The cabinet was intended to hold a small independent collection of
casts from engraved gems. It is possible that Catherine II presented
it to Count Lanskoi. This assumption is based on the fact that in
1781 Catherine II sent Tassie an advance for not one, but two
collections of casts (Central Historical Archives in Leningrad,
fund 468, inventory I, part 2, item 3896, p. 194). When Lanskoi died
three years later, the Empress obtained his collection, which
appears to have included "the English casts" (*ibid.*, item 46, p. 187).

This exceptionally fine little cabinet, entirely different in its
proportions and shape, shows the use of the same decorative devices
as in the cabinets of the main collection, either slightly modified or
repeated. They have in common similar motifs in marquetry and the
characteristic upper inlaid frieze beneath an entablement, creating
the illusion of fluting. On the corner uprights and the door panels
there are green wood mountings which are an effective background
for the inlaid design and white relief. Many features of the finish on
the inside and outside of the cabinet as well as the choice of woods,
are persuasive evidence for concluding that this cabinet was also
the work of Roach.

Both cabinets are superb examples of English furniture
of the last quarter of the 18th century — the period which has
earned the name "the satin-wood" era.

Published for the first time.

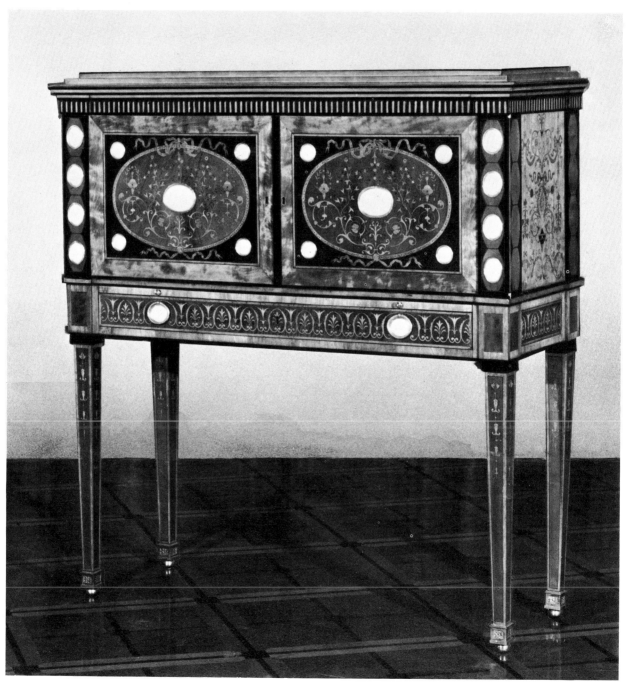

244

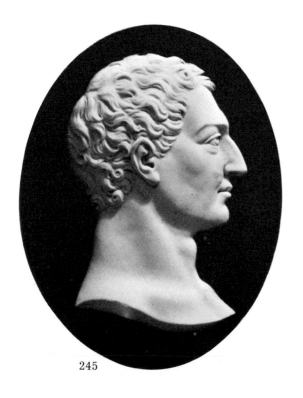

245

246

245

Medallion bearing the portrait of George Washington.
Wedgwood. 1778–79

Inscribed, under the portrait: *WASHINGTON.*
Mark: *Wedgwood & Bentley*

Blue solid jasper, bronze. 9.1×7.6 cm

Acquired in 1939 from a private collection.
Inventory No. 25486

The medallion was produced on the lines of the medal issued in
Paris in 1777. Recorded in the Wedgwood and Bentley catalogue
of 1779; published by Mankowitz (1953, p. 253). A similar medal
is reproduced by Reilly & Savage (1973, pp. 331–332, pl. XVa).

246

Medallion bearing the portrait of Priestley.
Wedgwood. 1778

After the model of Hackwood

Inscribed, under the portrait: *PRIESTLEY.*
Mark: *Wedgwood*

Green dip jasper. 8.7×7 cm

Acquired in 1918 from the A. Dolgorukov collection
in Petrograd. Inventory No. 19804

A medallion similar to the one in the Hermitage is reproduced
in the catalogue of the Sixth Wedgwood International Seminar
(1961, No. 155).

247

Vase. Wedgwood. *C.* 1770–75

Unmarked

Basalt ware painted with encaustic. Height 22 cm

Acquired in 1919 from the A. Rudanovsky collection
in Petrograd. Inventory No. 19080

The use of red colour and encaustic painting is occasionally to be
found on vases in black basalt. Similar articles are reproduced
in the works of Savage (1961, pl. 75) and Kelly (1970, pp. 45–47).

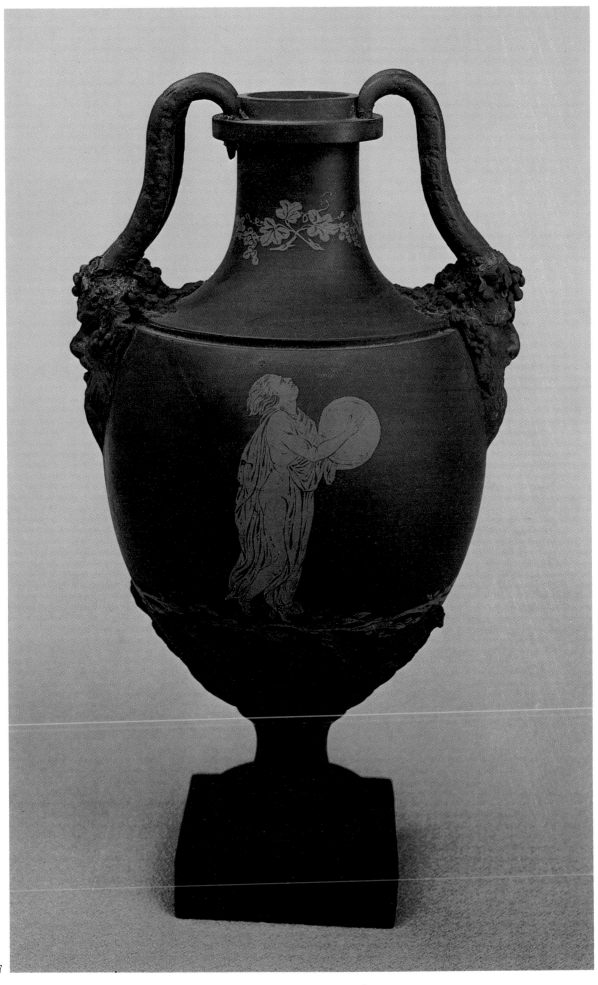

248

Ruin of a classical column. Wedgwood. 1780s

Mark: *Wedgwood*

Blue solid jasper. Height 18.5 cm

Acquired in 1920 from the Commission for the Preservation
of Works of Art and Antiquities. Inventory No. 19070

Similar models of ruined classical columns are reproduced
by Kelly (1970, p. 55).

249, 250

A pair of medallions, War and Peace. Wedgwood. Late 1770s

Marks: *Wedgwood*

Blue solid jasper. Diameter 28.7 cm and 28.3 cm

Acquired in 1918 from the A. Dolgorukov collection
in Petrograd. Inventory Nos. 19063, 19067

The figure of the woman depicted on the medallion is similar to
those of Thalia and Terpsichore on the relief *The Nine Muses*
by John Flaxman (see Corely & Schwartz 1965, fig. 38). From
the modelling of the figures, it is possible to assert that it was also
John Flaxman who produced the Hermitage medallion.

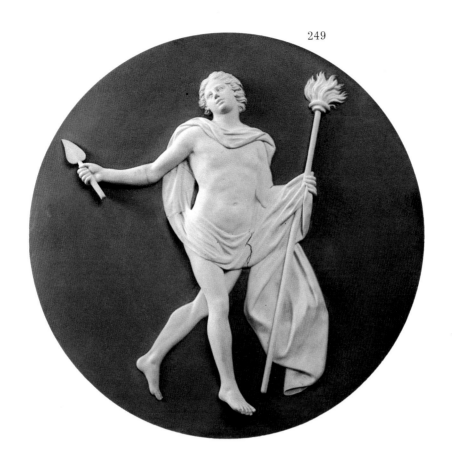

249

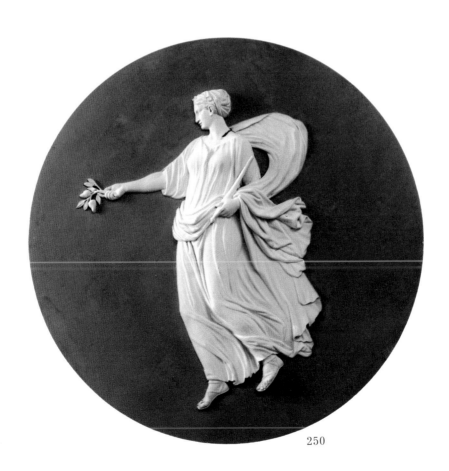

250

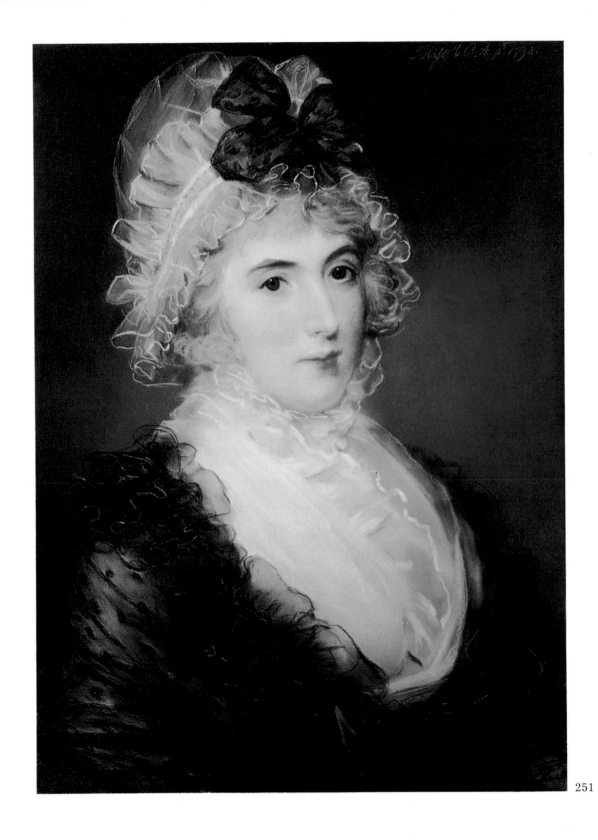

251

251

JOHN RUSSELL (1745–1806)

Portrait of Janet Grizel Cuming. 1794

Signed and dated, top right: *J. Russell R.A. pt 1794*

Pastel on paper mounted on canvas. 59×44 cm

Acquired in 1935 from a private collection in Leningrad.
Formerly in the collection of A. Khitrovo in St. Petersburg.
Inventory No. 42323
As we can see from the two tabs pasted to the back of the mounting
board, the subject is the eldest daughter of the Scottish landowner
George Chalmers of Pittencrieff, and the wife of the Edinburgh
banker Thomas Cuming Earnside. At the time the pastel drawing
was done, Janet Grazel was thirty-six.

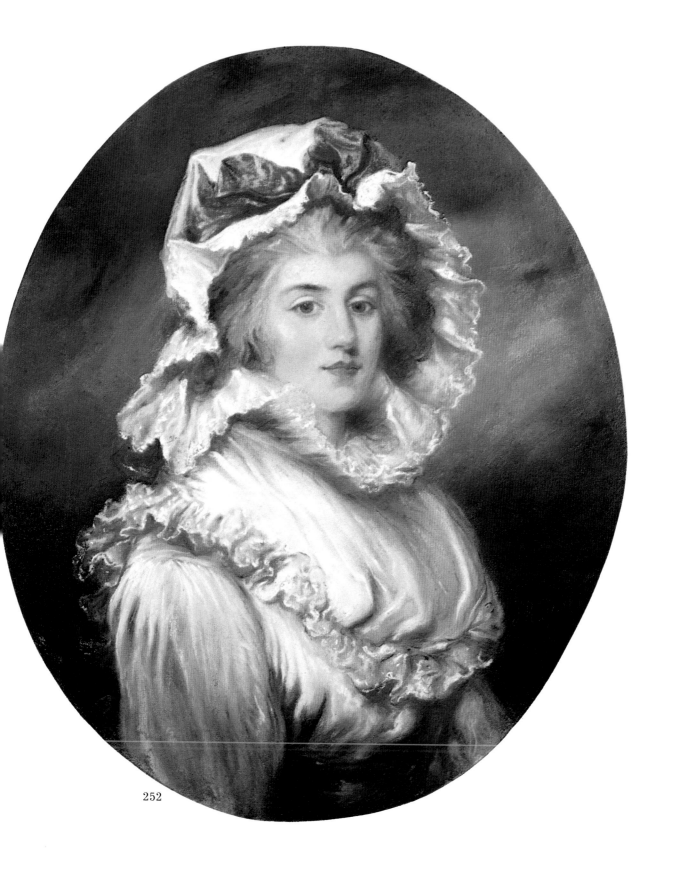

252

252

JOHN RUSSELL (1745–1806)

Portrait of a Young Girl in a Hood

Signed, bottom right: *J. Russell*

Pastel on paper mounted on canvas. 72×55 cm (oval)

Acquired in 1925 from the State Museum Fund.
Inventory No. 27314

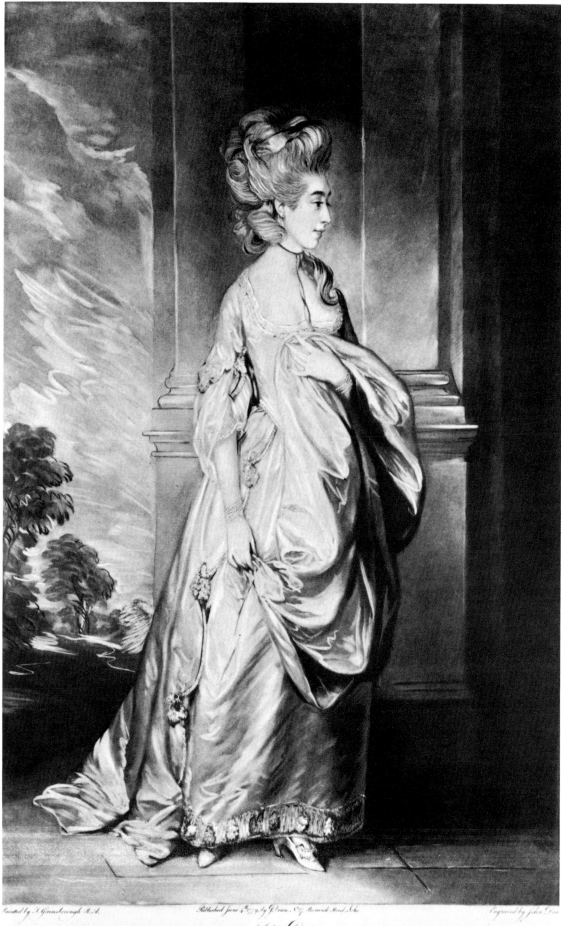

Painted by T. Gainsborough R.A. Published June 4th 1779 by J. Dean, No 7 Berwick Street Soho Engraved by John Dean

Mrs Elliot.

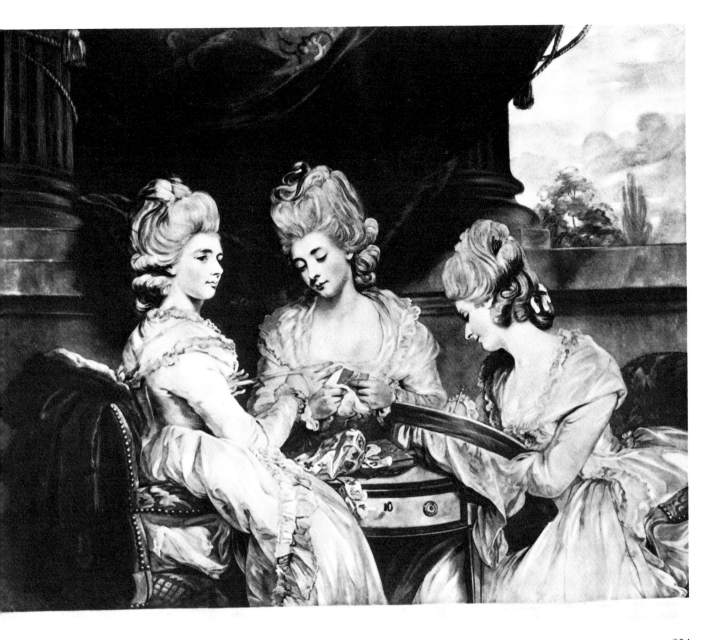

254

253

JOHN DEAN (*c.* 1750–1798)

Portrait of Mrs. Elliot. 1779

From the original of Thomas Gainsborough

Mezzotint. 61.3×38 cm. Second state of two
(Smith 1884, vol. I, No. 162; Dukelskaya 1963, No. 33)

Acquired before 1817. Inventory No. 138516

254

VALENTINE GREEN (1739–1813)

Portrait of Ladies Waldegrave. 1781

From the original of Joshua Reynolds

Mezzotint. 63×38 cm. First state of four
(Smith 1884, vol. II, No. 591; Dukelskaya 1963, No. 18)

Acquired before 1817. Inventory No. 33153

The daughters of Earl James Waldegrave, grand-nieces
of Horace Walpole.

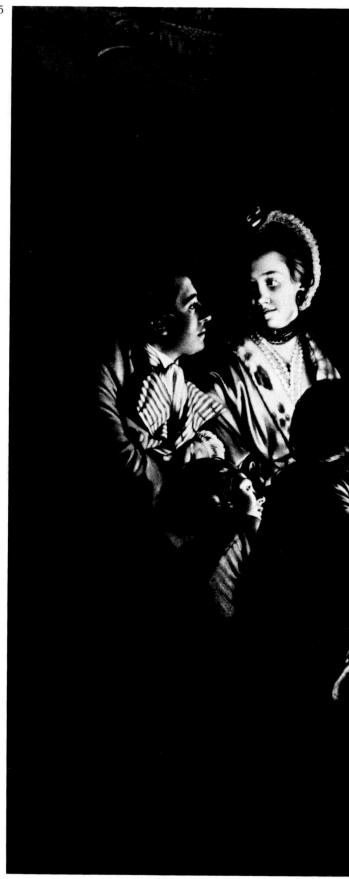

255

VALENTINE GREEN (1739–1813)

An Experiment on a Bird in the Air Pump. 1796

From the original of Joseph Wright

Mezzotint. 48×58.3 cm. Proof before signature and
inscription. (This state is not given in the Smith 1884
catalogue; see Dukelskaya 1963, No. 20.)

Acquired before 1817. Inventory No. 34060

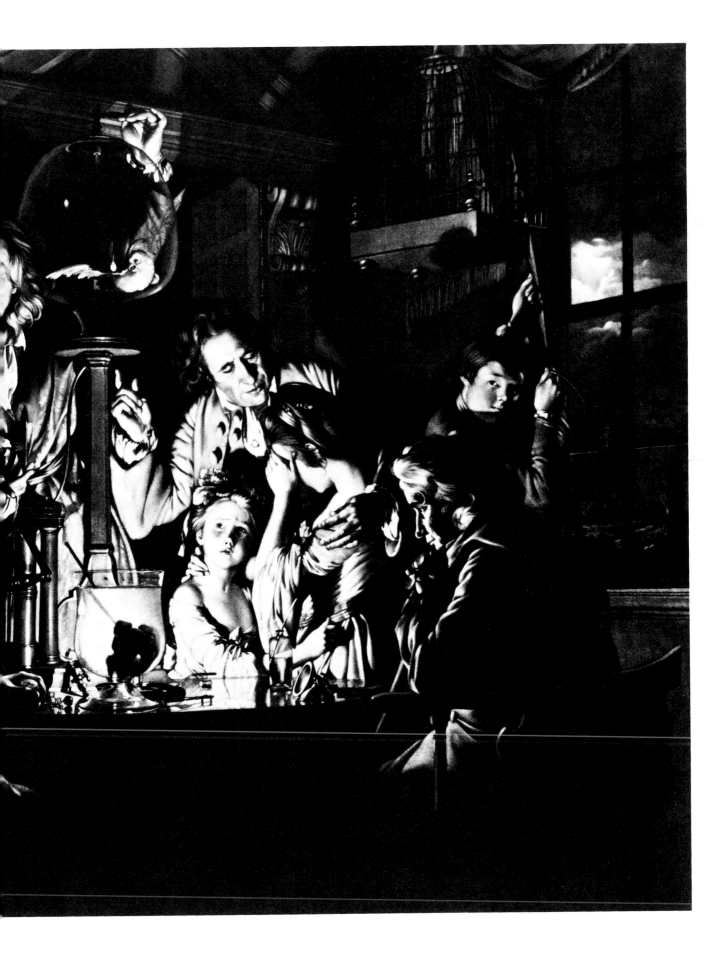

COL. TARLETON.

256

JOHN RAPHAEL SMITH (1752–1812)

Portrait of Colonel Tarleton. 1782

From the original of Joshua Reynolds

Mezzotint. 64.3×39.5 cm. Second state of three
(Smith 1884, vol. III, No. 1305; Dukelskaya 1963, No. 57)

Acquired before 1817. Inventory No. 33210

Banastre Tarleton (1754–1833) distinguished himself in the war
against America (1776–81). In 1787 he published *A History
of the Military Campaign in the Southern Provinces.*

257

VALENTINE GREEN (1739–1813)

Portrait of Emily Mary, Countess of Salisbury. 1781

From the original of Joshua Reynolds

Mezzotint. 63×38 cm. First state of two
(Smith 1884, vol. II, No. 583; Dukelskaya 1963, No. 17)

Acquired before 1817. Inventory No. 33160

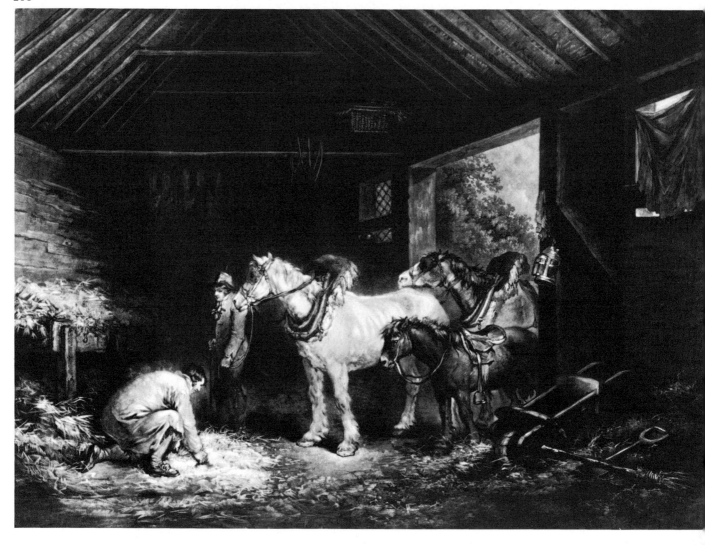

258

WILLIAM WARD (1766–1826)

The Farmer's Stable. 1792

From the original of George Morland

Mezzotint. 58.5×86 cm. Second state of three
(Frankau 1904, p. 190, No. 110; Dukelskaya 1963, No. 62)

Acquired before 1817. Inventory No. 141140

259

RICHARD EARLOM (1743–1822)

A Blacksmith's Shop. 1771

From the original of Joseph Wright

Mezzotint. 60.5×42.6 cm. First state of two
(Smith 1884, vol. I, No. 260; Wessely 1886, Nr. 122;
Dukelskaya 1963, No. 35)

Acquired before 1817. Inventory No. 138665

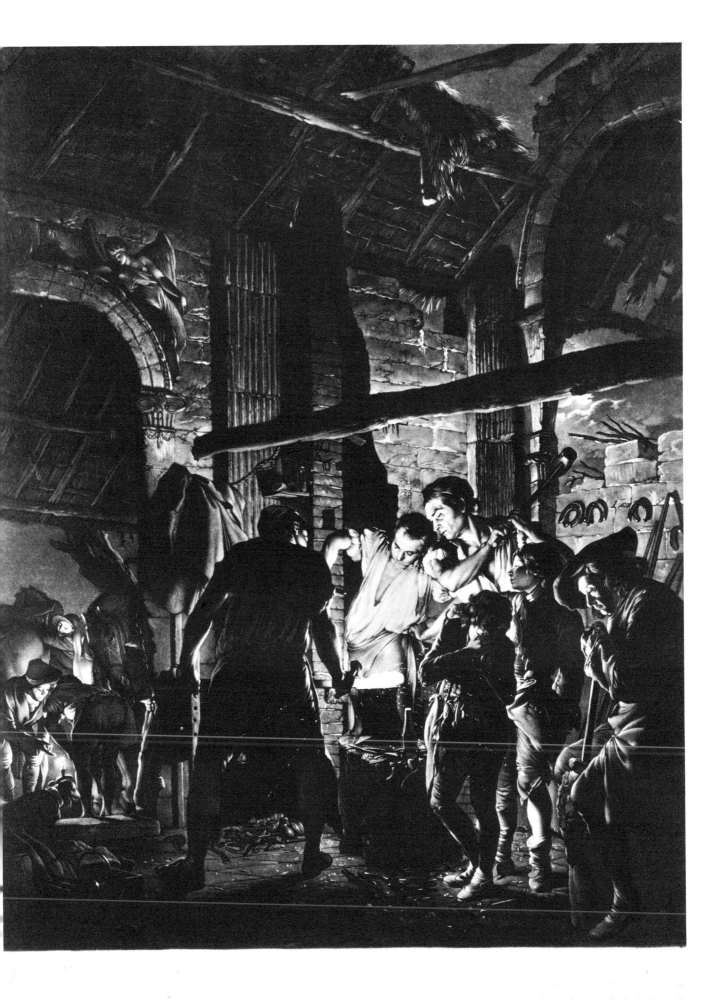

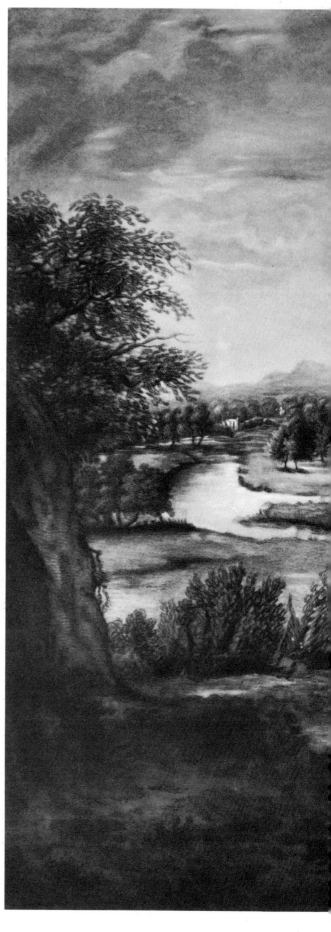

260

JOHN JONES (c. 1745–1797)

View from Richmond Hill. 1796

From the original of Joshua Reynolds

Mezzotint. 50.2×57.2 cm

Acquired before 1817. Inventory No. 33176

The engraving was published in 1800 by Jones's widow.
It depicts a view of the Thames valley.
On the left is the villa of the poet Alexander Pope.

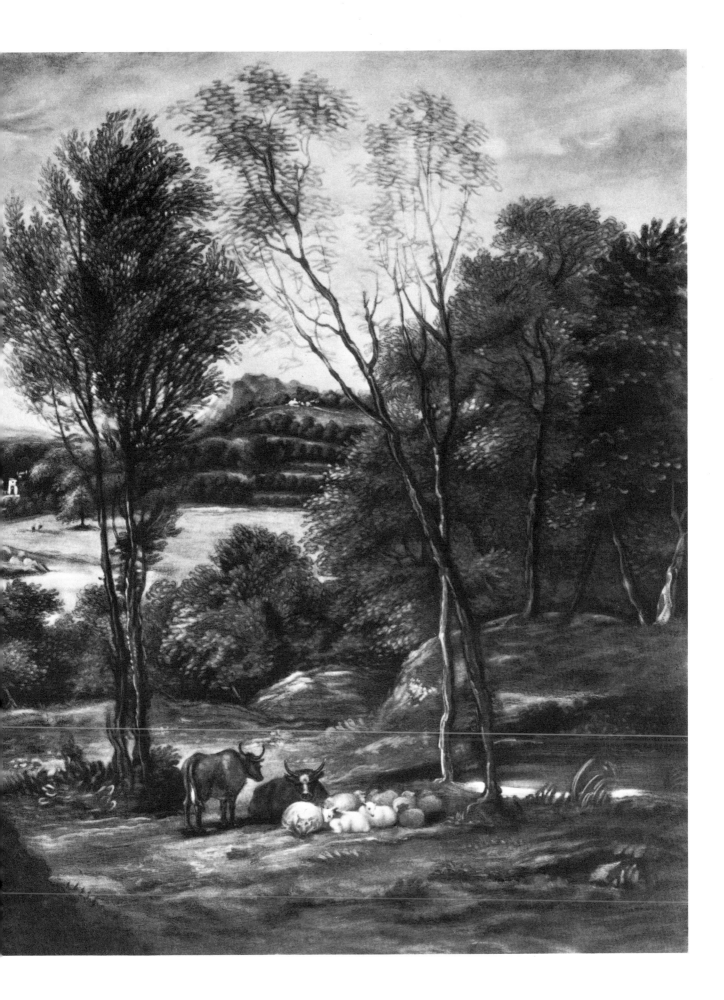

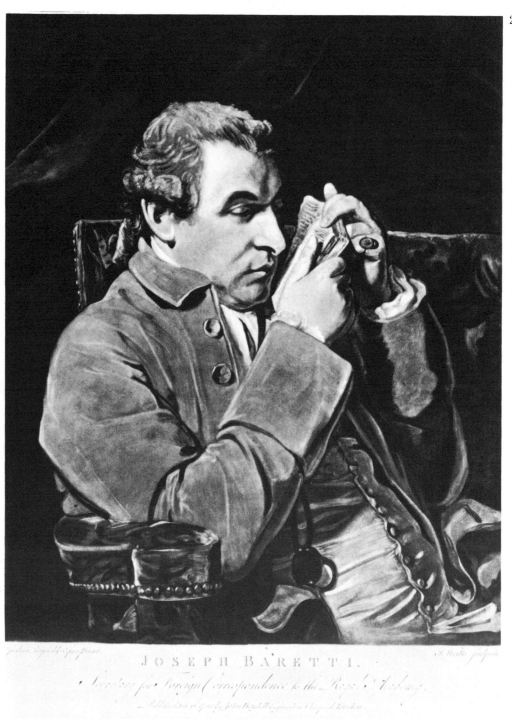

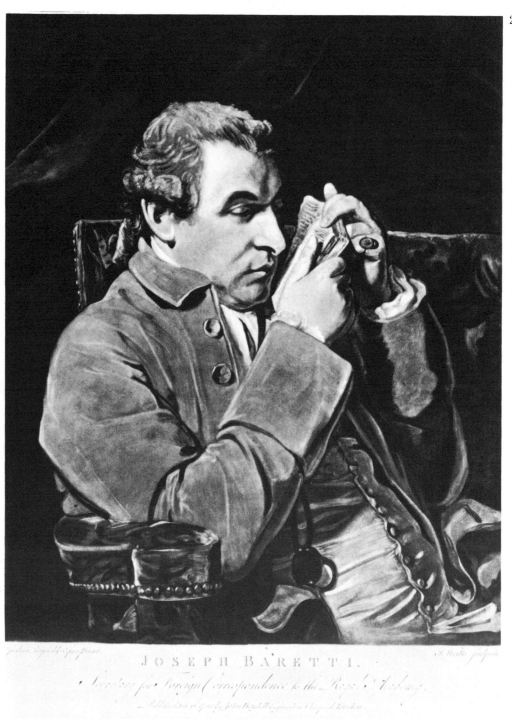

JOSEPH BARETTI.

261

261

JOHN WATTS (active from the 1760s to 1780s)

Portrait of Joseph Baretti. 1780

From the original of Joshua Reynolds

Mezzotint. 45.3×32.5 cm. Second state of two
(Smith 1884, vol. IV, No. 1567; Dukelskaya 1963, No. 63)

Acquired before 1817. Inventory No. 139868

Joseph Baretti (*c.* 1716–1789) was a writer and friend of Samuel
Johnson, secretary for foreign correspondence at the Royal
Academy of Arts in London.

262

JOHN RAPHAEL SMITH (1752–1812)

Portrait of Lady Caroline Montague (Winter). 1777

From the original of Joshua Reynolds

Mezzotint. 51×36.5 cm. Second state of two
(Smith 1884, vol. III, No. 1284; Dukelskaya 1963, No. 52

Acquired before 1817. Inventory No. 33202

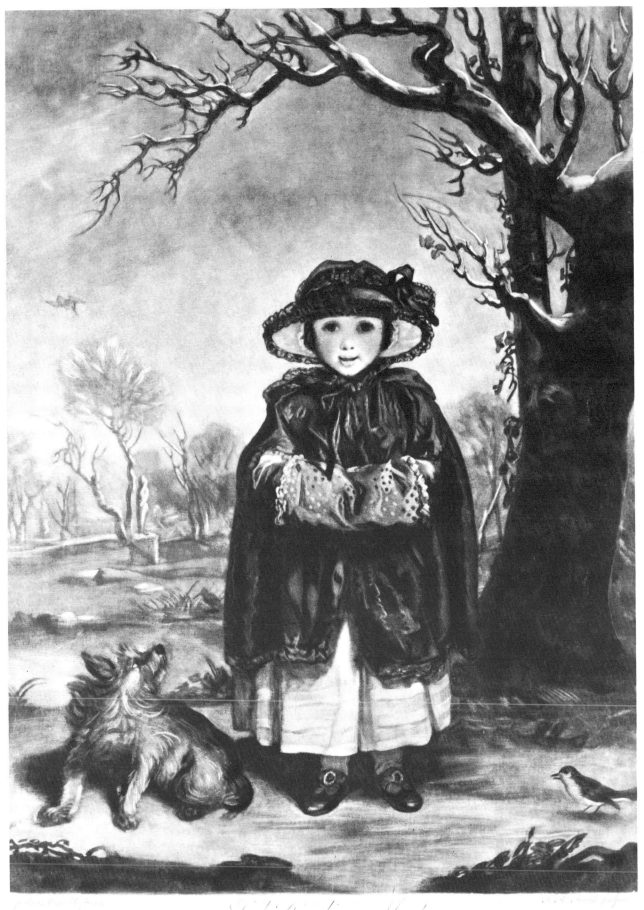

Lady Caroline Montagu

Daughter of his Grace the Duke of Buccleugh

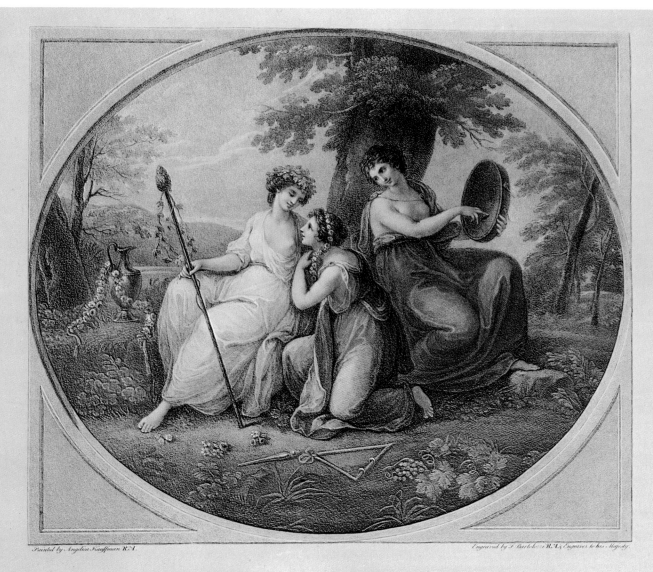

BACCHANALIANS. Les BACCHANTES.

From an Original Painting of the same size by Signora Angelica Kauffman in the possession of Charles Boddam, Esq.

Painted by Angelica Kauffman R.A. *Engraved by F. Bartolozzi R.A. Engraver to his Majesty*

Published as the Act directs 12 July 1786 by T. M. Diemar, N.14 Sloane, London

263

263

FRANCESCO BARTOLOZZI (1727–1815)

Les Bacchantes. 1786

From the original of Angelica Kauffmann

Coloured stipple engraving. 35.5×40 cm (oval)
(Baily 1907, p. 58 — mentioned only as a print in bistre)

Acquired in 1938. Inventory No. 355178

264

FRANCESCO BARTOLOZZI (1727–1815)

Portrait of Miss Farren. 1792

From the original of Thomas Lawrence

Stipple engraving. 55.4×36.2 cm. Third state of five
(Baily 1907, p. 60; O'Donoghue 1908, vol. II. No. 39;
Dukelskaya 1963, No. 3)

Acquired in 1965 from the A. Dolivo-Dobrovolsky collection
in Leningrad. Inventory No. 388818

Elisabeth Farren (c. 1759–1829), later Countess of Derby,
was one of the finest comedy actresses of her time. Performed at
the Haymarket and Drury Lane.
The engraving is thought to have been begun by Bartolozzi's pupil,
Charles Knight, since the first prints, dated 1791, are signed by him.

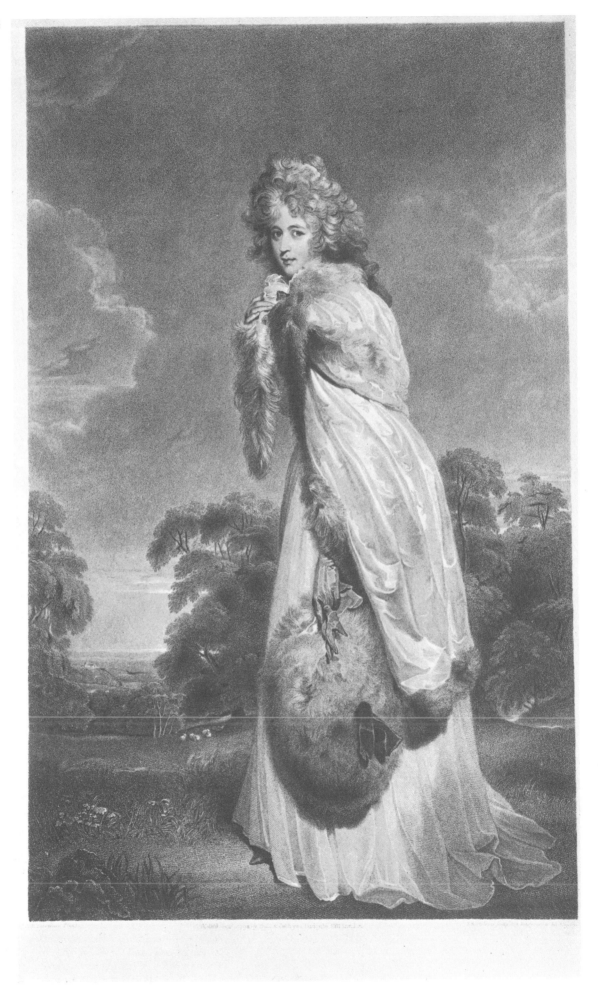

Bright Jols all cheering Beams illume the Day
The Dews exhald from off the spangled Spray:
Now Coveys to the silent stubbles fly,
And fearful Hares amidst Brake and Thistles lie.

SHOOTING.

Plate II.ᵈ

Engraved after an Original Picture in the Possession of M.ʳ Bradford

Published by Tho.ˢ ____ N.ᵉ ____ Fleet Street, London, as the Act directs. ____ Aug. ____

265

WILLIAM WOLLETT (1735–1785)

Shooting. 1769

From the original of George Stubbs

Engraving and etching. 44.2×53.3 cm. Second state of two
(Nagler 1828, Bd. 22, S. 84, Nr. 84; Dukelskaya 1963, No. 10)

Acquired before 1817. Inventory No. 233394

Second of the four plates comprising the set *Hunting*.

266

WILLIAM WOLLETT (1735–1785)
WILLIAM ELLIS (1747–*c.* 1810)

Solitude. 1778

From the original of Richard Wilson

Engraving and etching. 44.3×55.7 cm. Second state of three
(Nagler 1828, Bd. 22, S. 80, Nr. 18; Dukelskaya 1963, No. 11)
Acquired before 1817. Inventory No. 140100

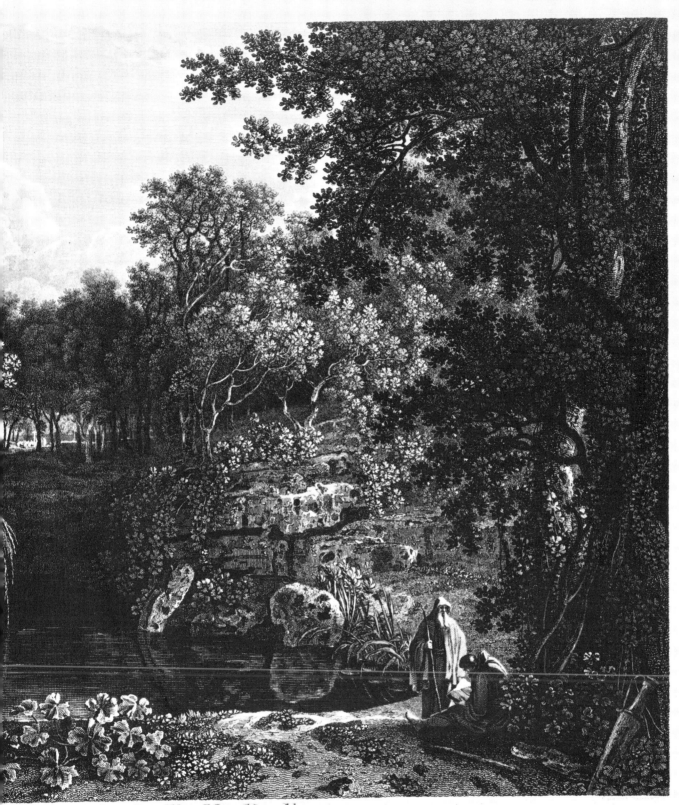

SOLITUDE.

p Beaumont, Bar.ᵗ this PLATE is Dedicated.

a Ver. ine Eng.ᵈ humble Servant William Woollett

rom the original Picture in the possession of M.ʳ J.ᵈ Tedpe

This are the haunts of Meditation, those
The same, where ancient bards the inspiring breath
Estatic felt, and to this world untaxed

Thomson Summer v.

Publish'd by _____ according to act of Parliament

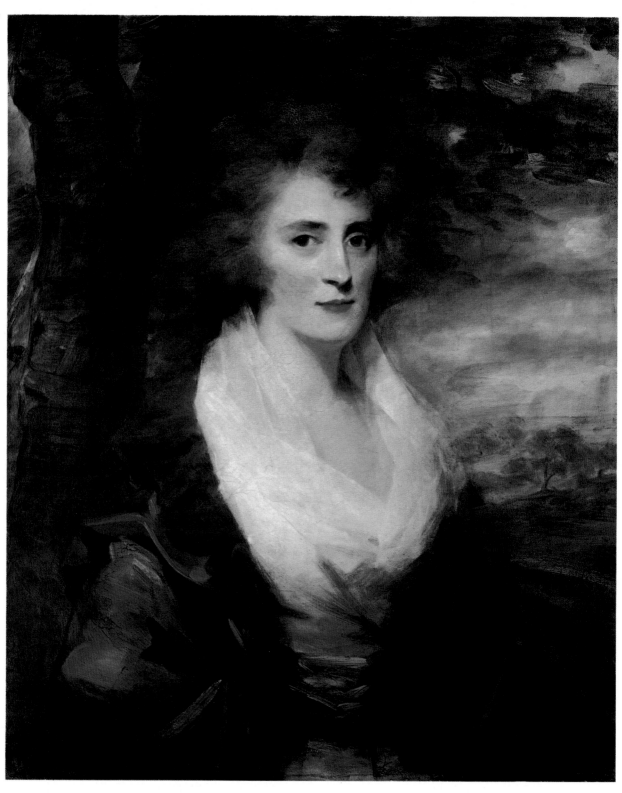

267

HENRY RAEBURN (1756–1823)

Portrait of Eleanor Bethune. 1790s

Oil on canvas. 76×64 cm

Acquired in 1912 with the A. Khitrovo collection
in St. Petersburg in accordance with the owner's bequest.
Inventory No. 3512

268

JOHN OPIE (1761–1807)

Portrait of Francis Winnicombe. 1796

Oil on canvas. 92×71 cm

Acquired in 1912 with the A. Khitrovo collection
in St. Petersburg in accordance with the owner's bequest.
Inventory No. 3514

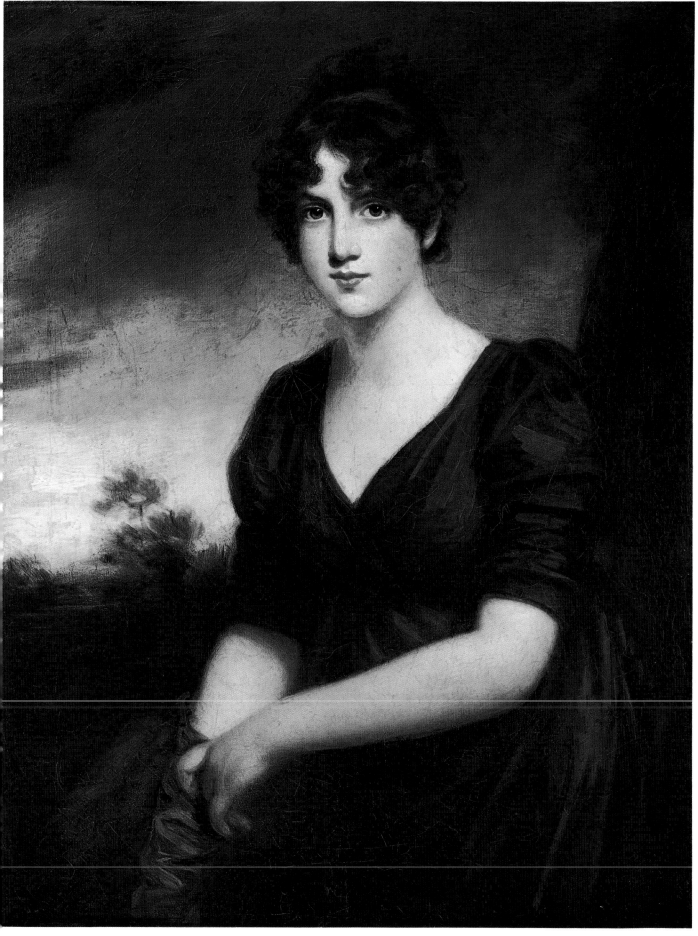

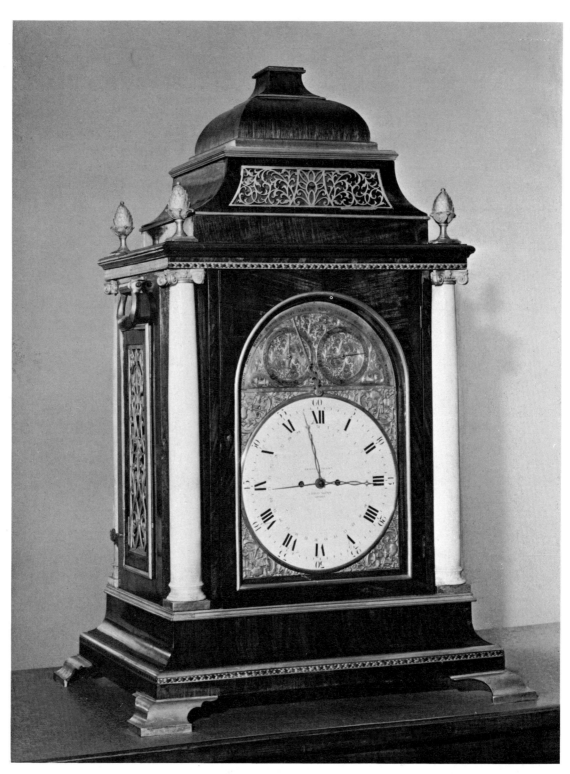

269

D. DUBOIS (active in the late 18th century)

Table clock. Late 18th century

Ebony, thuja, ormolu, coloured marble. Height 120 cm

Beneath the dial, an enamel shield, signed: *D.F. Dubois London*

Acquired in 1938 from the State Museum Fund. Inventory No. 911

Behind the glass face, there is a chased bronze plate depicting
the interior of a building.

270

Officer's dress sabre. Birmingham. 1799

From the workshop of John Wooley

Burnished steel, iron, gilded, etched and engraved, ivory.
Total length 95 cm, length of blade 82 cm

The blade bears the letters *GR*, and, in an oval frame,
the inscription: *J. Wooley A.Cº. Cast steel, Warranted.*

Facts about the acquisition of the sabre are lacking.
Inventory No. 2709

As indicated in the manuscript catalogue of the Tsarskoye Selo
armoury collection (1849–61), the sabre belonged to Alexander I.

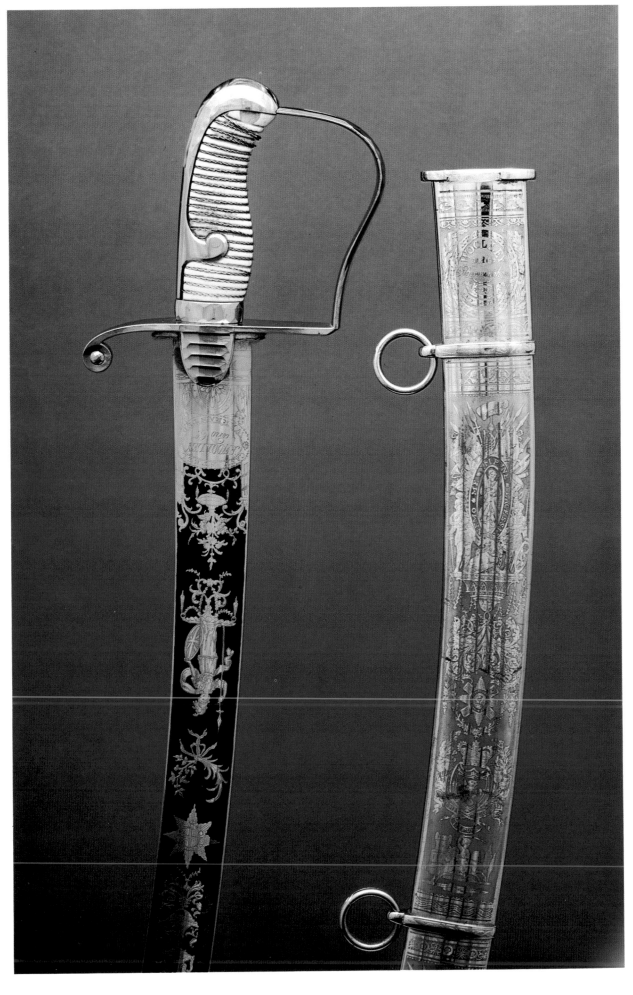

271

271, 272

Chair. Third quarter of the 18th century

Satin-wood painted in oils, woven bull-rush seat.
Height 95 cm

Acquired in 1923 from the collection of E. and M. Oliv
in Petrograd. Inventory No. 284

The chair was produced under the influence of similar
examples published in George Hepplewhite's *Guide*.
This is evident from the contours of the back, the rosette,
garland and bead ornamentation. In the centre of the back
is a medallion depicting Hymen.
Similar chairs are in the Victoria and Albert Museum
and in private collections in England.

27:

273

Settee. Third quarter of the 18th century

Wood painted in oils, covered in
contemporary rep needlework. Height 95 cm

Acquired in 1923 from the collection of E. and M. Oliv
in Petrograd. Inventory No. 1895

The settee is of double-chair form. The arm rests joined to the front
legs by means of curved uprights, and the back consisting of oval
shields, are characteristic of furniture by George Hepplewhite.
In the centre of the back are the stylized arms of the Prince
of Wales. This motif, corresponding to pl. No. 6 in Hepplewhite's
Cabinet-makers and Upholsterers Guide of 1788, was often
adapted by English craftsmen.

Published for the first time.

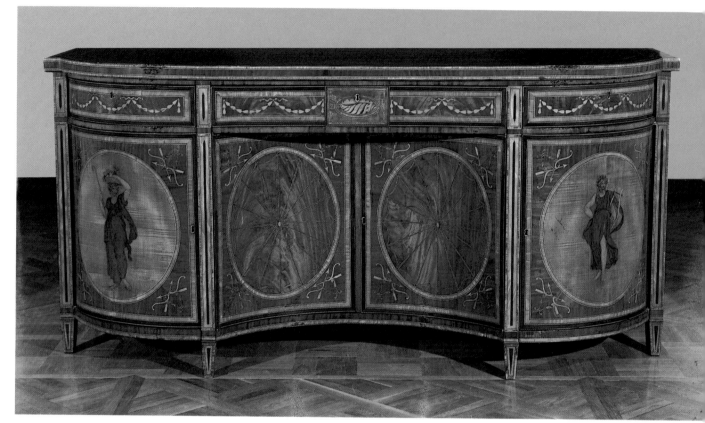

274

Dressing commode. Third quarter of the 18th century

Lemon, sycamore, thuja and other woods. Marquetry.
Height 95 cm

Transferred in 1931 from the combined collection
of the Yekaterininsky and Pavlovsk Palaces.
Inventory No. 1825

In Thomas Sheraton's *The Cabinet Maker's and Upholsterer's
Drawing-book* of 1791, we find examples of furniture with a
"serpentine" front. The Hermitage dressing commode is such
an instance. Typical also are the oval medallions with geometric
patterns or female figures playing musical instruments,
for which the designs were often made by Angelica Kauffmann
and Michelangelo Pergolesi.

275, 276

Pembroke table. Last quarter of the 18th century

Satin-wood painted in oils. Height 73 cm,
width 91 cm, depth 45.5 cm

Transferred from the Winter Palace. Inventory No. 5346

Pembroke folding tables on high legs, which stood in the space
between windows replaced console tables and were very popular
in the second half of the 18th century. Similar oval-topped tables
can be found amongst the furniture designs of Robert Adam,
George Hepplewhite and Thomas Sheraton. But the character of
the ornamental painting on the frame and on the legs, consisting
of garlands of leaves with beads and flowers, makes it possible
to date the Hermitage table around 1790 — a period when the
influence of Sheraton's designs was felt particularly strongly.

275

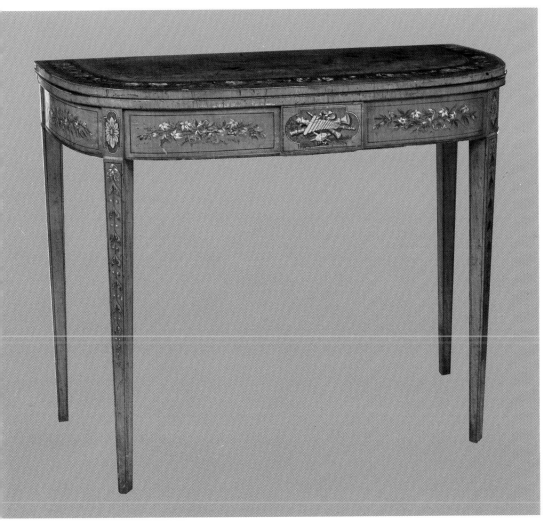

276

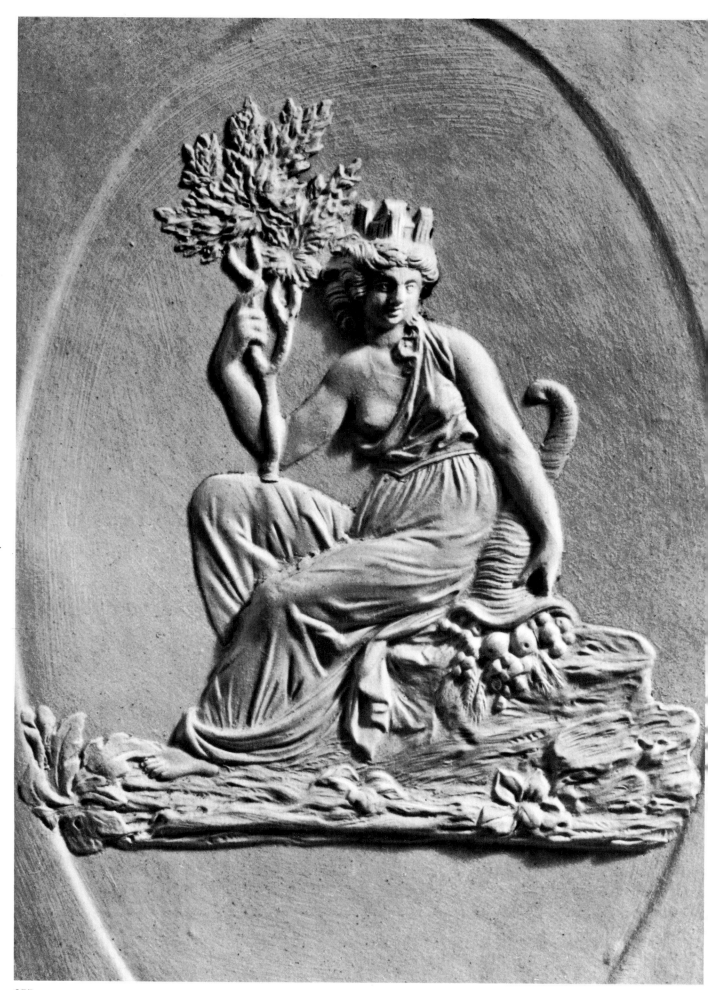

277

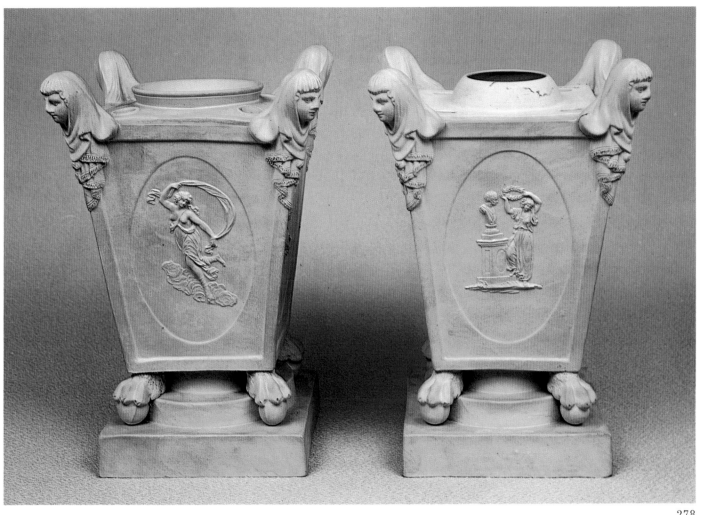

278

277, 278

A pair of boughpots. Turner. 1780s

Impressed mark: *Turner*

Caneware. Height 18.8 and 18.7 cm

Transferred in 1919 from the Museum of the Society
for the Encouragement of Arts in Petrograd (*Catalogue* 1904,
p. 247, Nos. 26, 27). Formerly in the collection of G. Stetiner.
Inventory Nos. 19074, 19075.

A similar boughpot (one of a pair) is reproduced in the magazine
Antiques (April 1968, p. 457). Boughpots of this type in basalt
ware came up for auction at Christie's on 26 January 1970
(No. 124, pl. facing p. 24).

Pieces from the "Green Frog" service.
Wedgwood. 1773–74

Creamware painted in colours

Transferred in 1912 from the English
Palace at Peterhof

The service was commissioned by Catherine II from
Wedgwood in 1770 through Baxter, the Russian consul in
London. There were protracted negotiations about the price
of the service. Work was begun in the summer of 1773 and
continued until the beginning of 1774. It arrived in Russia
at the end of the summer of 1774.

Catering for 50 persons and consisting of 952 pieces,
the service was intended for the "La Grenouillère" Palace

(after 1780, this became the Chesmensky Palace). Each piece
of the service depicts a green frog emblazoned on a shield,
a kind of emblem of this palace. An inscription on the case
of wine glasses reads:

"This Table and Dessert Service, consisting of 952 Pieces,
and ornamented in Enamel, with (above) 1244 real Views
of Great Britain, was made at Etruria in Staffordshire
and Chelsea in Middlesex, in the Years 1773 & 1774,
at the Command of that illustrious Patroness of the Arts,
Catherine II, Empress of all the Russias, by
Wedgwood & Bentley."

The catalogue of the service was prepared by Wedgwood's
associate Bentley, in French, moreover each piece was
numbered to correspond with the entries in the catalogue.

279

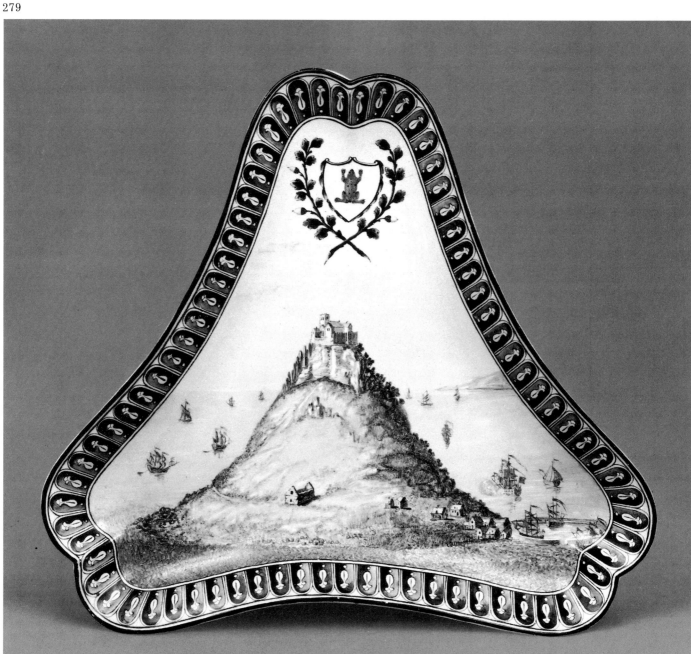

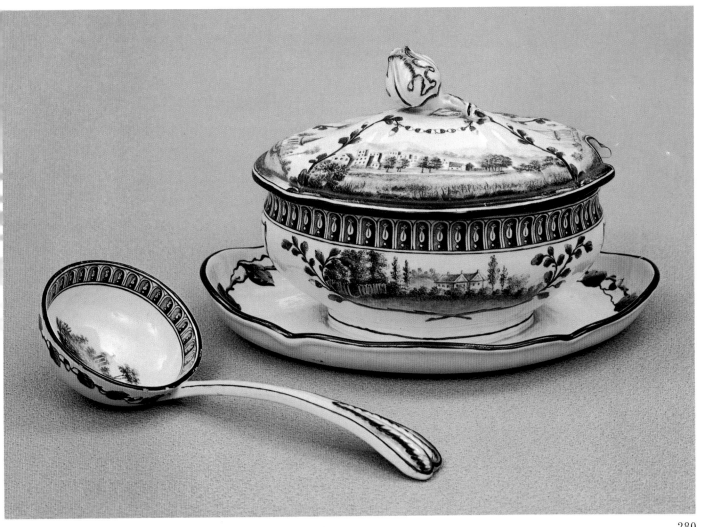

279

Triangular dish (stewed-fruit bowl)

Length 28.5 cm

Inventory No. 8502

643. View of Mount St. Michael, Cornwall.

280

Sauce-boat on stand with cover and spoon

Height 11 cm, length 13.5 cm, width 10 cm;
length of spoon 16.5 cm

Mark: *Wedgwood*

Inventory No. 8561

Sauce-boat: 496. View of the Well Walk, Hampstead.
497. View of the Marsh at the bottom of the Heath at Hampstead.
Cover: 956. View near Hampstead.
957. View near London.
Spoon: 608. View of a Temple in Kew Gardens.

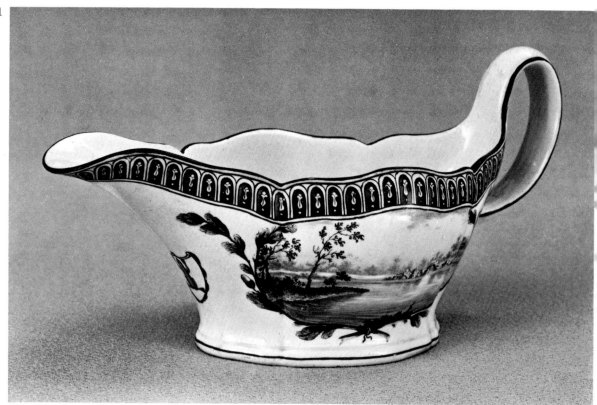

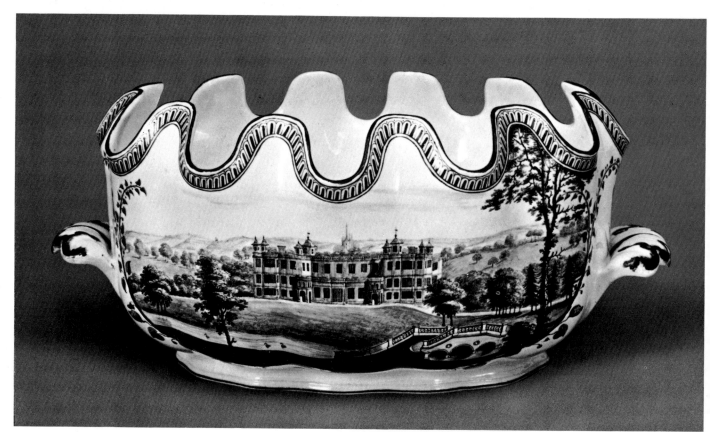

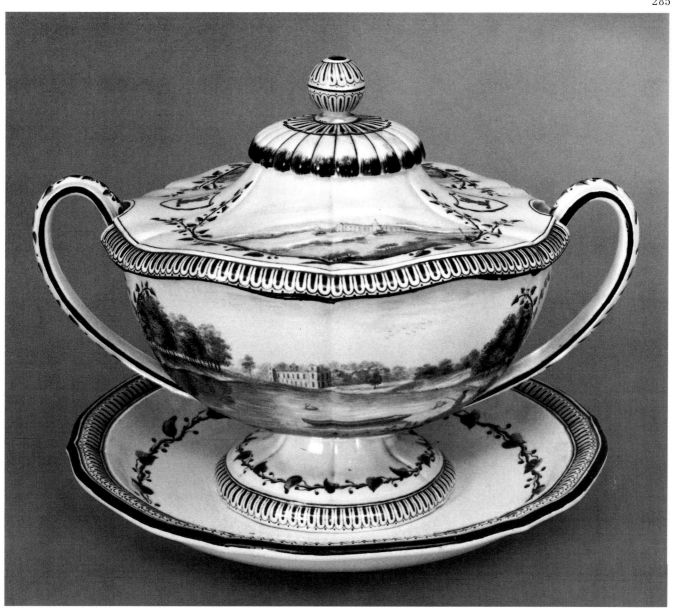

285

Tureen with stand and cover

Tureen: height 17.2 cm, diameter 17.5 cm;
stand: diameter 21.8 cm

Inventory Nos. 8692, 8540

Tureen: 1105. View of Guiting Grange, Gloucestershire.
1106. View of Welbeck, Nottinghamshire.
Cover: 1113. View near Howard Castle, Yorkshire.
1114. View of Temple near the same place.
Stand: 1092. Distant view of Ludlow Church, Shropshire.

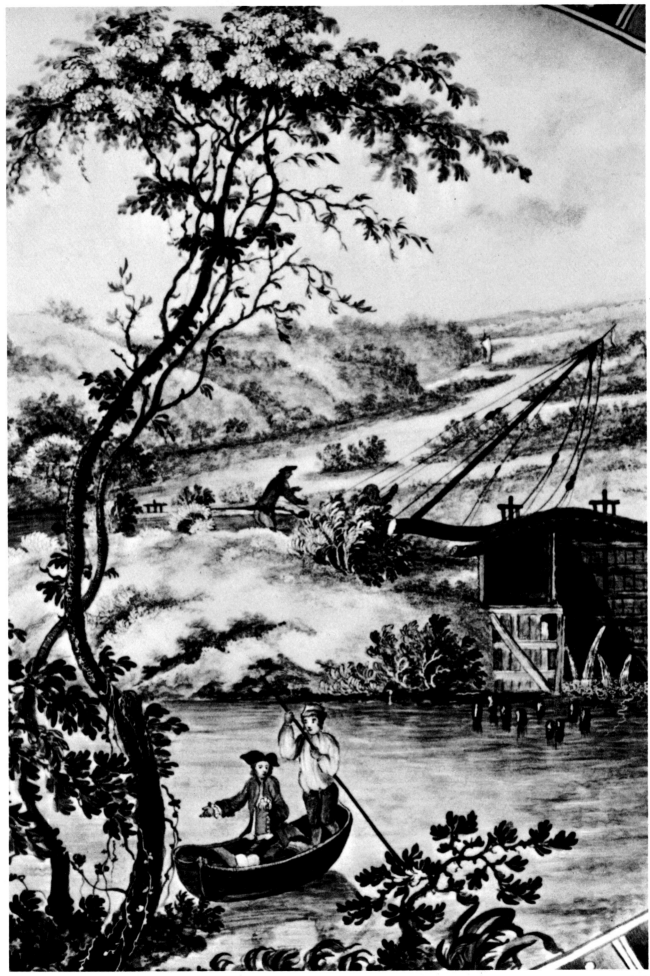

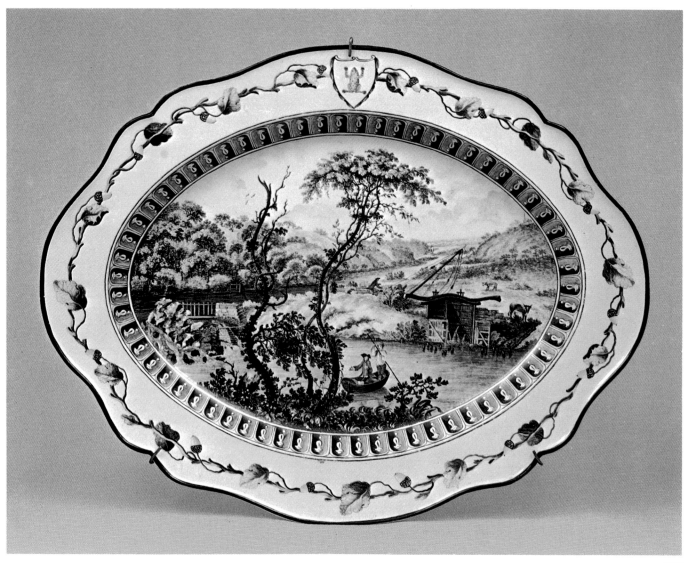

281

Saucer with handle

Height 6.5 cm, length 17.5 cm, width 9 cm

Inventory No. 8566

547. View in Lord Le Despencer's gardens at West Wycombe.
548. View in the gardens at Stow.

282

Glass-cooler

Height 14.5, width 23 cm

Inventory No. 20832

1271. View of Millross Abbey, Scotland.
1272. View of Audley End, Essex.

283, 284

Oval dish

41.5×32 cm

Inventory No. 8630

303. View of the Dunnington Hills,
Derbyshire extending to the River Trent.

286

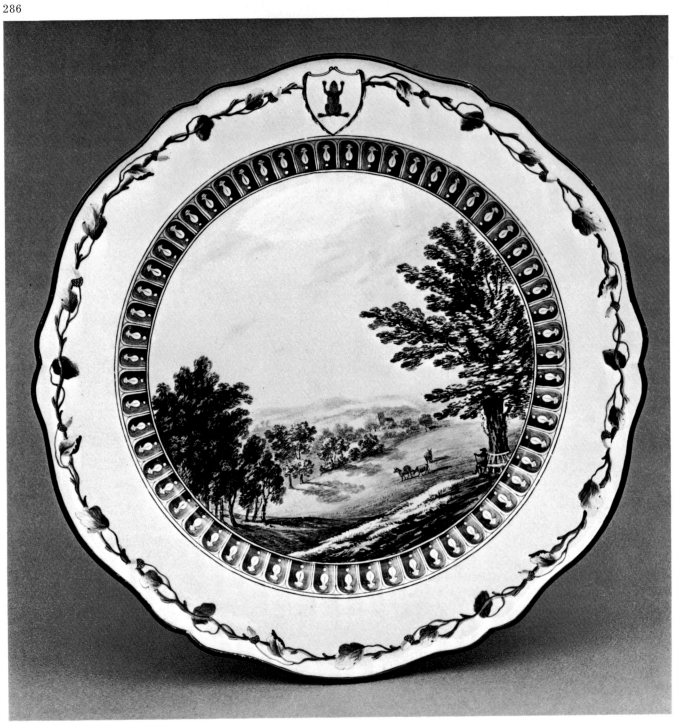

286

Round dish

Diameter 30.5 cm

Inventory No. 8715

316. View at the bottom of the meadow on Broadgate Park, Leicestershire, the property of Lord Stamford.

287

Ice pail with cover

Height 34.5 cm, diameter 23 cm

Inventory No. 8539

Ice pail: 1063. View of Fontaines Abbey, Yorkshire.
1064. View of Harwood, Yorkshire.
Insert: 1073. View in Studley Park.
Cover: 1078. View of Shuckborough, Staffordshire.
1079. Another view of the same place.
1080. Another view of the same place.

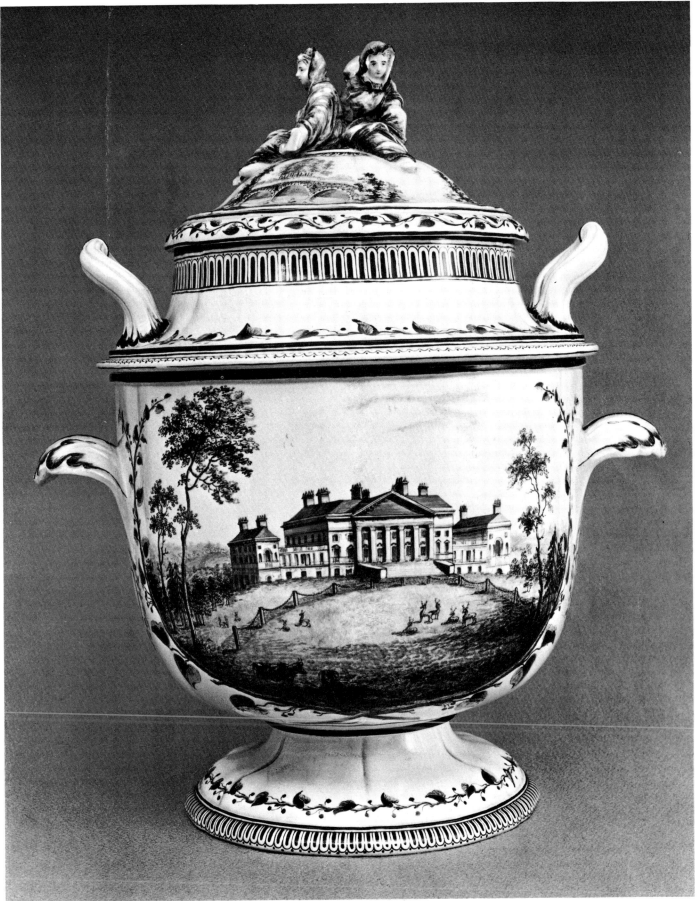

NINETEENTH CENTURY

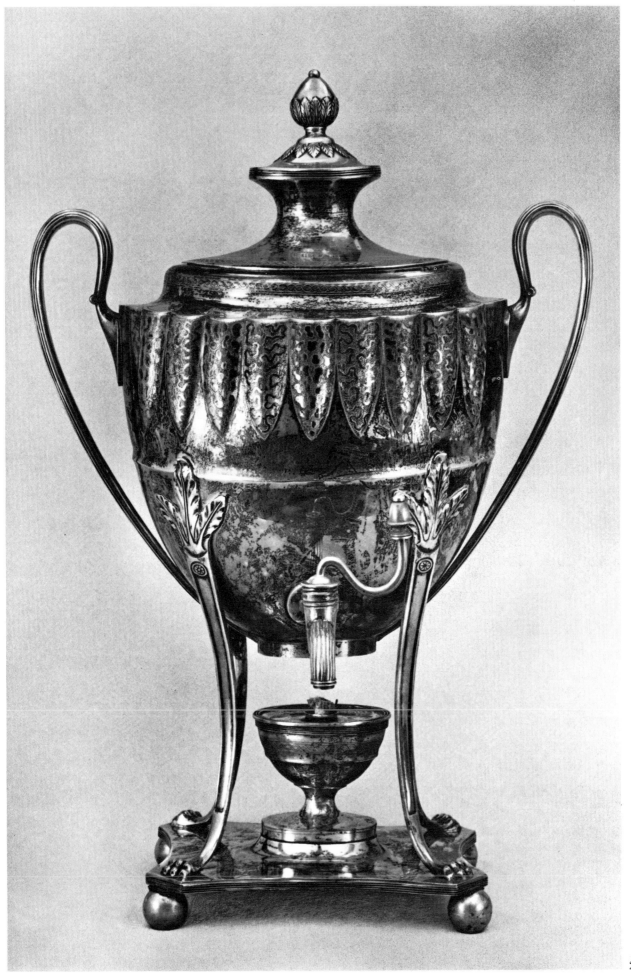

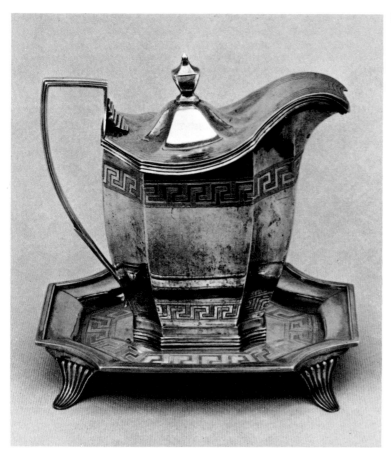

289

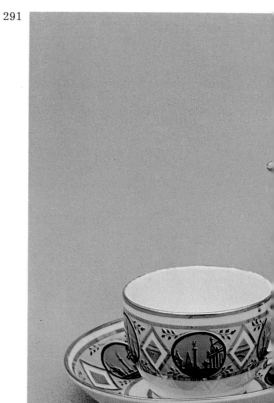

291

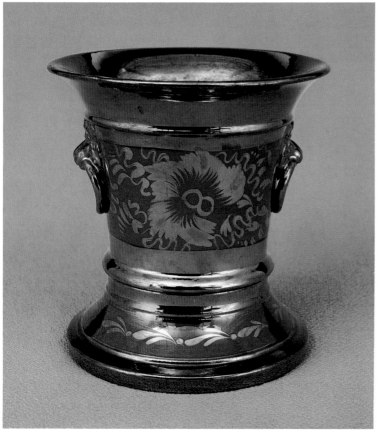

290

288

JOHN ROBINS (?–1831)

Tea-kettle and stand. London hall-mark for 1803–4

Chased silver. Height 53 cm

Acquired in 1925 from the Shakhovskaya collection in Leningrad. Inventory No. 13760

Published for the first time.

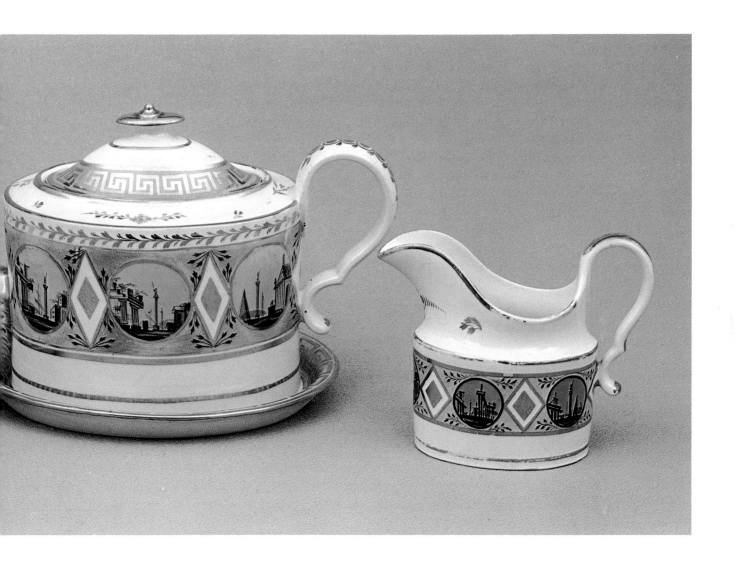

289

JOHN ROBINS (?–1831)

Milk jug and saucer-stand. London hall-mark for 1802–3

Silver, chased and engraved. Height 12.5 cm

Acquired in 1922 from the Yusupov collection
in Petrograd. Inventory No. 13596
Published for the first time.

290

Cache-pot on stand. Staffordshire (?) Early 19th century

Unmarked

Stoneware, lustre-painted and glazed. Height 13 cm

Transferred in 1933 from the Stieglitz School Museum
in Leningrad. Inventory No. 3223 a, b

291

Tea and coffee service. Spode. *C.* 1800

Impressed marks: *Spode*; the figure: *94* (on tea-pot)

Stone china painted in colours. Height of tea-pot 16 cm;
length of stand 20 cm; height of cups 6 cm;
diameter of saucers 13.7 cm

Transferred in 1932 from the Pavlovsk Palace Museum.
Inventory Nos. 24249, 24244, 24246

Spode, like many other English factories, produced, along with the
traditional bone china, other ceramic wares, including so-called
stone china, which was something in between porcelain and faïence.
It was from this ceramic material that the dense, opaque pieces of
the Hermitage service were made.

The decoration of Spode pieces is most varied. The painted design
on the eighteen items making up the Hermitage service consists
of architectural landscapes in medallions set against a coloured
background, which is quite rare for Spodeware.

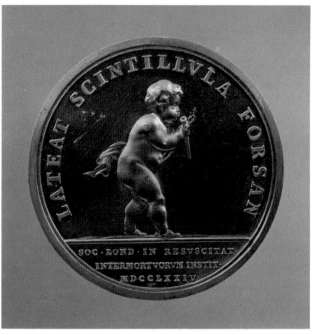

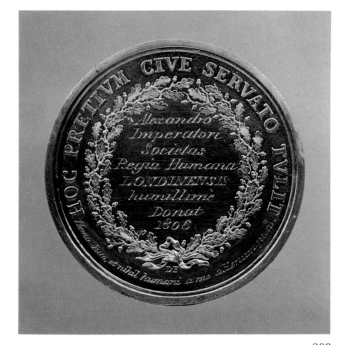

292 293

292, 293

LEWIS PINGO (1743–1830)

Service medal of the London Philanthropic Society. 1806

Struck in gold, engraved. 53 mm, 92.99 gm

Transferred from the Winter Palace in the mid-19th century.
Inventory No. 371

Obverse. A genius of life trying to fan the flame of a dying torch.
Leg. LATEAT SCINTILLVLA FORSAN.
Ex. SOC.LOND.IN.RESVSCITAT. INTERMORTVORVM.INSTIT
MDCCLXXIV.
Reverse. A wreath of oak leaves. *Leg.* HOC. PRETIVM CIVE
SERVATO TVLIT. In the centre, the engraved inscription of eight
lines: ALEXANDRO IMPERATORI SOCIETAS REGIA HUMANA
LONDINIENSIS HUMILLIME DONAT 1806; beneath the wreath:
L.P. (artist's signature); the legend below, along the edge: HOMO
SUM, ET NIHIL HUMANI A ME ALIENUM PUTO.
The London Philanthropic Society awarded the medal to those who,
with no concern for their own lives, had gone to the rescue of people
in danger of drowning. The Hermitage medal was presented to
Alexander I in 1814 in commemoration of the event which occurred
in 1807 (not 1806 as recorded on the medal) near Vilno (see *Case of
Rescusitations by His Imp. Maj. the Emperor of Russia etc.*, London,
1814; *Encyclopaedia Britannica*, N.Y., 1929, vol. XI, p. 876).

294

THOMAS LAWRENCE (1769–1830)

Portrait of Princess Lieven. 1823 (?)

Pencil, and red and white chalk on prepared canvas. 77×64.5 cm

Acquired in 1923 from the Mikhailovsky Palace
in Petrograd. Inventory No. 27319

Darya (Dorothea) Khristoforovna Lieven, née Benkendorf
(1785–1857), was the wife of a Russian ambassador in Berlin
and from 1812, in London. Known for her interest in diplomacy,
for which she earned the nickname "the Sibyl of diplomacy".
The Hermitage sketch is a study for a portrait in oils (the Tate
Gallery). For some reason neither work was collected by the person
who commissioned them in the artist's lifetime or after his death,
and they remained in Lawrence's studio. In 1823 the drawing was
engraved by William Bromley.

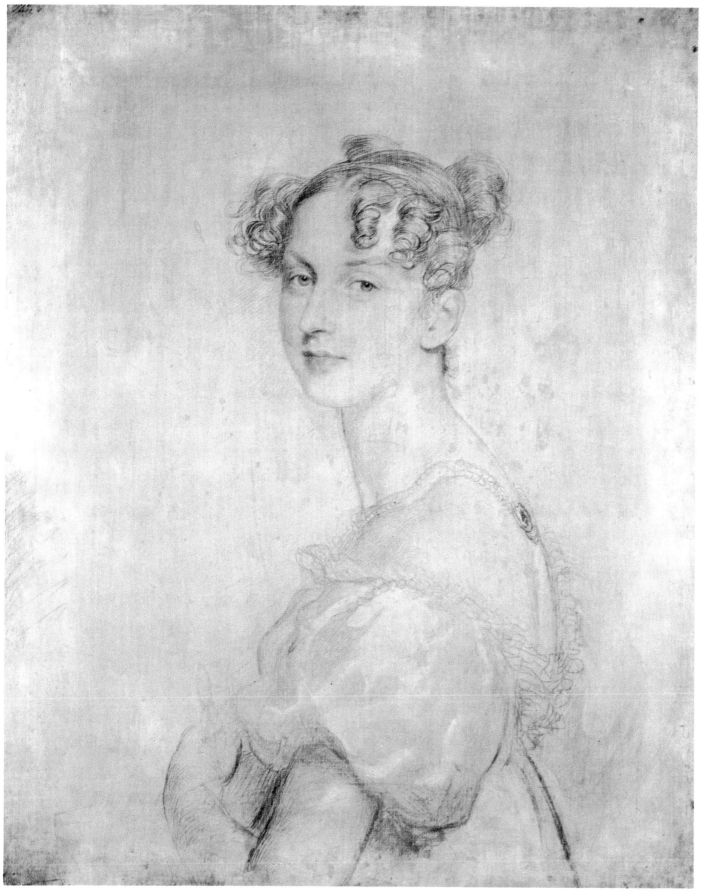

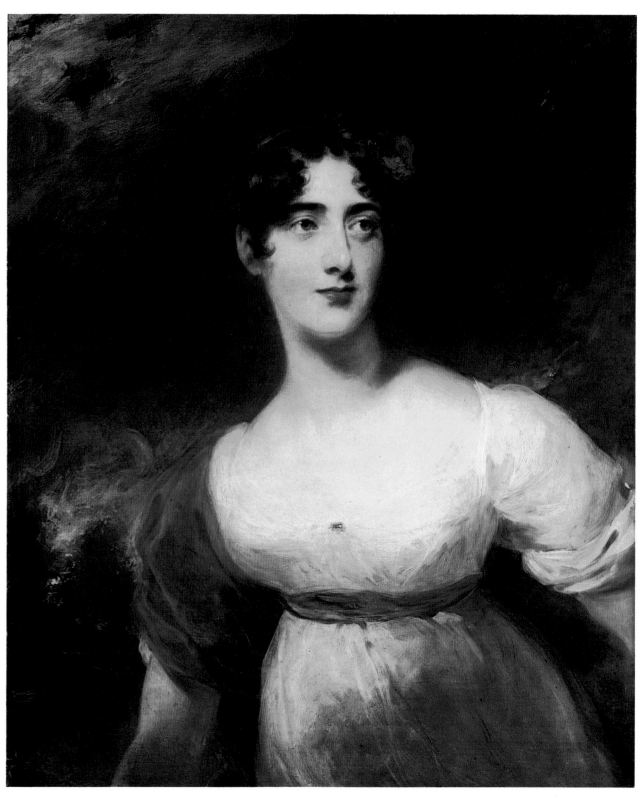

295

THOMAS LAWRENCE (1769–1830)

**Portrait of Lady Emily Harriet Fitzroy,
Later Lady Raglan.** *C.* 1815

Oil on wood. 76×63 cm

Acquired in 1912 with the A. Khitrovo collection
in St. Petersburg in accordance with the owner's bequest.
Formerly the property of the Raglan family. Inventory No. 1513

Lady Emily Harriet Fitzroy (1792–1881), after 1814, was the wife
of Fitzroy-Somerset, later Lord Raglan. In a letter to the Duke
of Kent Lady Emily remarks that Lawrence painted her as she
is when she is expecting the Duke.

Dated on the basis of the stylistic similarity with Lawrence's other
works in this vein, done in the period between 1810 and 1816, such
as the portraits of Viscount Castlereagh (the National Portrait
Gallery) and John Angerstein (the Lloyd collection).

In 1814 Thomas Lawrence made a drawing of Lady Raglan and
her two sisters.

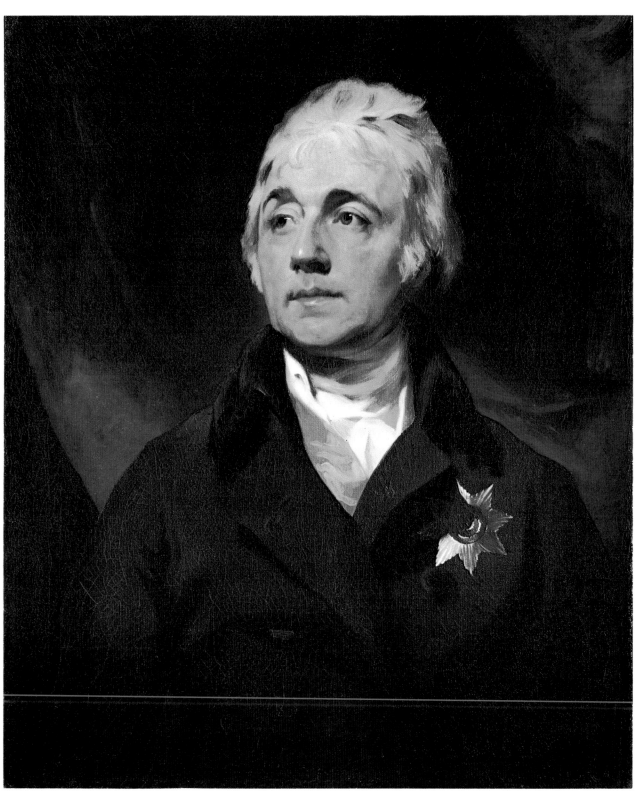

THOMAS LAWRENCE (1769–1830)

Portrait of Count Semion Vorontsov. Before 1806

Oil on canvas. 76.5×64 cm

Acquired in 1900 for the Winter Palace from the heirs
of Count Vorontsov, and then transferred to the Hermitage.
Inventory No. 1363

Count Semion Romanovich Vorontsov (1744–1836) was a celebrated
Russian diplomat; from 1785 to 1806, he was the Russian
ambassador in London.

The portrait was reattributed several times. Lawrence's
authorship is proved not only by the stylistic features of the work,
but also by the fact that in an inventory of pictures in Lawrence's
studio from 14 February 1806 to 18 February 1807, a portrait of
Count Vorontsov appears as No. 158.

A replica of the Hermitage portrait is to be found in the collection
of the Earls of Pembroke and Montgomery, descendants of Count
Vorontsov's daughter, at Wilton — in the catalogue of the exhibition
"The First Hundred Years of the Royal Academy" (1951) it appears
as a work by Thomas Lawrence.

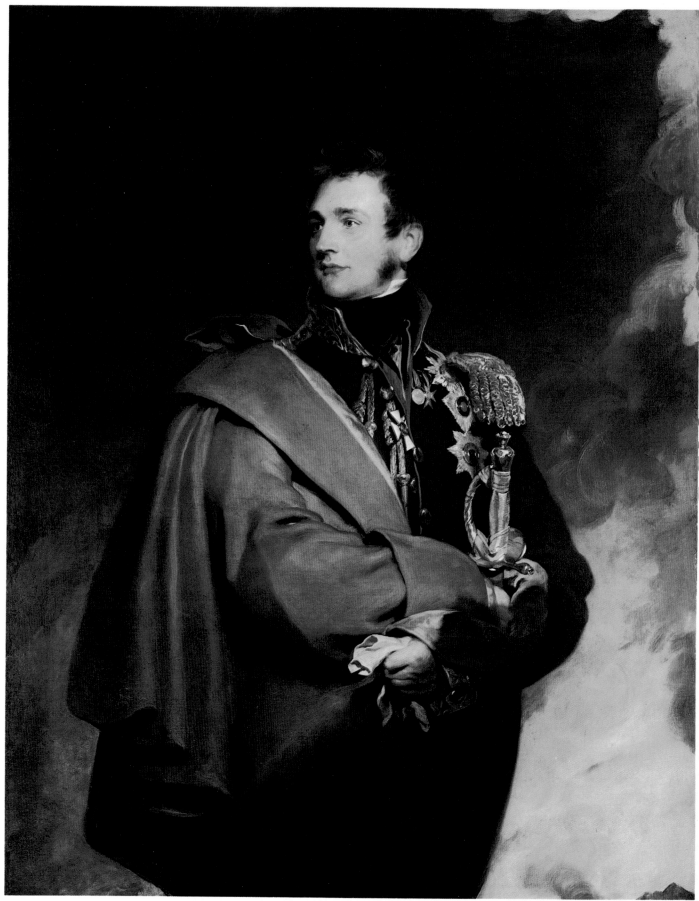

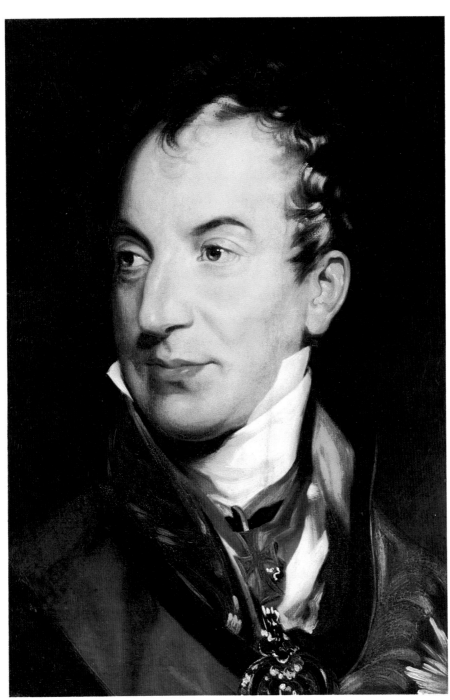

THOMAS LAWRENCE (1769–1830)

Portrait of Count Mikhail Vorontsov. 1821

Oil on canvas. 143×113 cm

Acquired in 1923 from the Vorontsov-Dashkov collection
in Petrograd. Formerly in the Vorontsov Palace in Odessa.
Inventory No. 5846

Count Mikhail Semionovich Vorontsov (1782–1856) was
a Russian military figure and statesman.
The portrait was painted between July and October, 1821, as
testified by a note dated 1821 in the Vorontsov archives: "After
our trip, we returned immediately to Wilton, where we stayed until
the beginning of October. Then we spent fifteen days in London
and it was just at this time that Lawrence finished my portrait."

298

THOMAS LAWRENCE (1769–1830)

Portrait of Prince Metternich. Sketch. 1814–19

Oil on paper mounted on plywood. 51×35 cm

Acquired in 1922 from the collection of Grand Duke
Nikolai Mikhailovich in Petrograd. Inventory No. 5471

Prince Klemens Wenzel Nepomuk Lothar von Metternich
(1773–1859) was an Austrian diplomat and minister, a leading
figure in European politics during the first quarter of the
19th century. One of the architects of the Holy Alliance.
The picture entered the Hermitage as *The Portrait of a Dignitary* by
an unknown English painter of the early 19th century. It is possible
that Princess Lieven brought it to Russia. Princess Lieven was the
wife of the Russian ambassador in London with whom Metternich
corresponded several times in the period from 1818 to 1819.
The sketch in the Hermitage may have been sent by Metternich
as a present to Princess Lieven.

299

299, 300

RICHARD PARKES BONINGTON (1802–1828)

Boats at the Coast. Normandy. *C.* 1825

Oil on canvas. 33.5×46 cm

Transferred in 1929 from the Anichkov Palace in Leningrad.
Until 1869 it belonged to the collection of N. Kushelev-Bezborodko
in St. Petersburg. Inventory No. 5844

Views of Normandy are frequently encountered in Bonington's
pictures from 1820. The scene depicted in the Hermitage painting
is repeated in the landscape *La Côte Normande* of about 1825
(the P. Bureau collection, France).

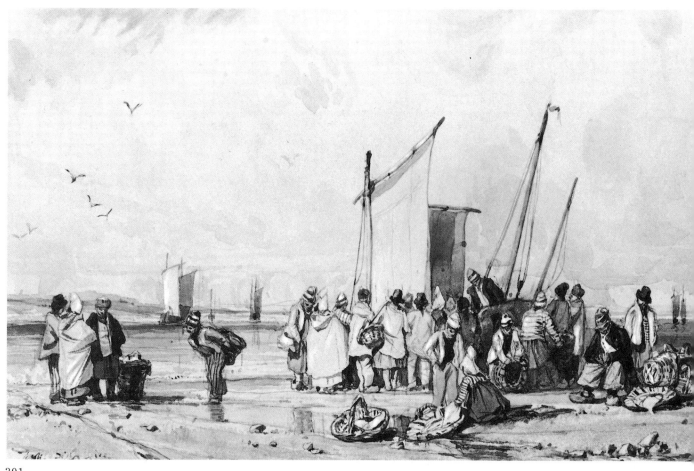

301

302

301

RICHARD PARKES BONINGTON (1802–1828)

Fish-selling on the Coast. *C.* 1828

Signed bottom left: *R P Bonington*

Sepia wash over pencil. 16.7×25.6 cm

Acquired in 1925 from the Shuvalov collection
in Leningrad. Inventory No. 22782

The sheet is similar to the sepia drawings made by the artist
in Brittany and Normandy at various times. It is closest to the
drawings *Return from Fishing* (the Louvre) and *Fishmarket at
Boulogne* (private collection). Since the latter is dated 1828,
there is every reason to assume that the Hermitage sepia
drawing also dates from this time.

302

RICHARD PARKES BONINGTON (1802–1828)

View of Rome. Sketch

Oil on wood. 37.5×56 cm

Acquired in 1931 from the State Museum Fund.
Formerly in the collection of P. Deliarov
in St. Petersburg. Inventory No. 7683

The attribution of the picture has changed several times. It entered
the Hermitage as the work of John Constable. Whilst the 1958
catalogue was being compiled, this attribution was contested.
In 1961 it was published as a work by an unknown English artist
of the early 19th century.
In 1971 the landscape was attributed to Bonington.
In support of this claim we can compare it with Bonington's
pictures *Italian Landscape* (the National Gallery of Scotland,
Edinburgh, catalogue No. 1917), *Estuary with a Sailing Boat*
(the National Gallery of Scotland, Edinburgh, catalogue No. 2165)
and *A View in Normandy* (the Tate Gallery, London,
catalogue No. 5790).

303

WILLIAM ALLAN (1782–1850)

Bashkirs. 1814

Oil on canvas. 43×63 cm

Signed and dated, bottom right, on the stone:
William Allan pinxit 1814

Companion painting to *Frontier Guard*
(the Hermitage, inventory No. 6881)

Transferred in 1918 from the Anichkov Palace
in Petrograd. Inventory No. 9579

It is possible that both pictures were purchased from the artist by
Grand Duke Nikolai Pavlovich (later Nicholas I) who was touring
England and Scotland in 1815.
Bashkirs may have been displayed in 1815 at the Royal Academy
in London under the title *Bashkirs Escorting the Convicts* (No. 147).
However, at the Edinburgh exhibition of the same year which
included a great number of pictures, studies and ethnographical
material brought by Allan from Russia, several pictures with the
same title were put on display. Therefore, it is difficult to identify
the painting with certainty.

304

PATRICK NASMYTH (1787–1831)

Landscape with a Pond

Oil on canvas. 64×79 cm

Acquired in 1915 from the collection of V. Zubrov in Petrograd
in accordance with the owner's bequest. Inventory No. 3490

305

WILLIAM CALLOW (1812–1908)

Harbour at Tréport, Normandy. 1876

Signed and dated, bottom right: *William Callow 1876*

Watercolour over pencil. 42.8×62.8 cm

Acquired in 1938 from a private collection in Leningrad.
Inventory No. 43409

Published for the first time.

306

GEORGE DAWE (1781–1829)

Portrait of Alexander Shishkov. Before 1827

Oil on canvas. 103×78 cm (unfinished)

Acquired in 1923 from the State Museum Fund.
Formerly in the collection of D. Tolstoy in St. Petersburg.
Purchased in London in 1831 at the sale of Dawe's studio.
Inventory No. 5842

Alexander Semionovich Shishkov (1754–1841) was an admiral, man
of letters, President of the Russian Academy of Sciences, Minister
for Education, founder of the literary society "Association of Lovers
of the Russian Word". Left a number of published works, including
Discourse on the New and Old Style of the Russian Language (1803).
George Dawe made a preparatory study in pastels of *The Head
of Alexander Shishkov*, which is in the British Museum.

306

307

GEORGE DAWE (1781–1829)

Portrait of Piotr Bagration. Before 1823

Oil on canvas. 70×62.5 cm

One of the portraits for the 1812 War Gallery
in the Winter Palace. Inventory No. 7818

Prince Piotr Ivanovich Bagration (1765–1812) was an outstanding
Russian general, who was fatally wounded and died in the battle
of Borodino during the war of 1812.
Painted by Dawe from an unknown contemporary portrait
of Bagration. Dated from an engraving issued by Henry Dawe
in London on 1 August 1823.

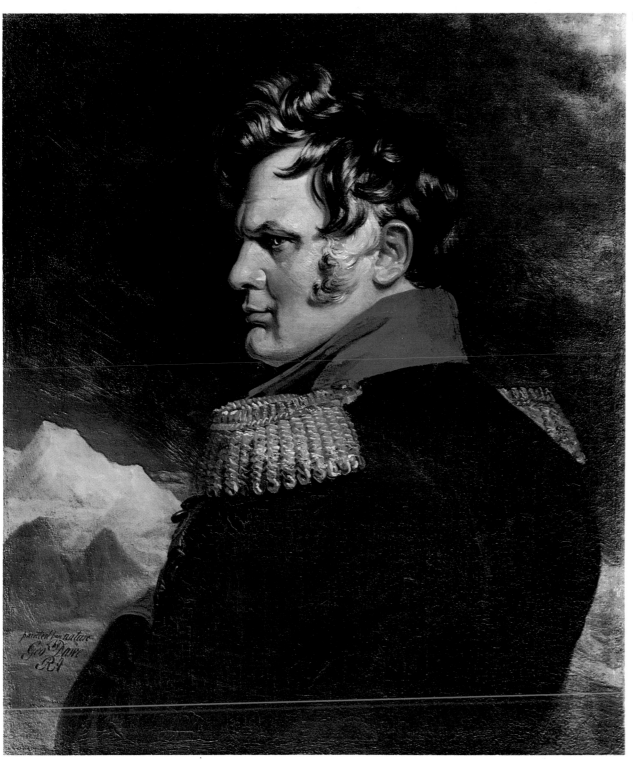

308

GEORGE DAWE (1781–1829)

Portrait of Alexei Yermolov. Before 1824

Oil on canvas. 70×62.5 cm

Signed, bottom left: *Painted from nature geo: Dawe, R.A.*

One of the portraits for the 1812 War Gallery
of the Winter Palace. Inventory No. 7876

Alexei Petrovich Yermolov (1777–1861) was a general who took
part in the campaigns of 1805–7 and 1812–13. From 1818 to 1826,
Commander-in-Chief of the Russian army in the Caucasus.
Dated from an engraving by T. Wright issued in London on
1 October 1824.

309, 310

THOMAS WYON THE YOUNGER (1792–1817)

Waterloo service medal. 1816

Struck in silver. 35 mm, 34.8 gm

Acquired in the mid-19th century. Inventory No. 7920

The medal has a flat steel clip and a steel ring for the ribbon
(which survive on only a few of the known medals).
Obverse. Head of Prince Regent George (after a drawing by Thomas
Lawrence). The legend on the left and right: GEORGE P. REGENT.
Below the neck truncation: T. WYON. JUN:S (artist's signature).
Reverse. Figure of Victory. The legend at the top: WELLINGTON;
in the cartouche: WATERLOO; beneath: JUNE 18. 1815; the legend
on the right, along the edge: T. WYON S. (artist's signature).
Engraved on the edge: WILLIAM MULLER, 1-ST LICHT BATT.
K.G.L. (K.G.L. — King's German Legion).

311, 312

JOHN MILTON (?–1815)

Medal in honour of Count Matvei Platov. 1814

Struck in silver. 48 mm, 80.56 gm

Acquired before 1880. Inventory No. 7703

Obverse. Bust of Platov. *Leg*. HETMAN PLATOFF. On the arm
truncation: I.M. (artist's signature).
Reverse. The legend of four lines: ACRI MILITIA VEXAVIT
GALLOS EQVES METUENDUS HASTA.
Leader of the Don Cossacks, Count Matvei Ivanovich Platov
distinguished himself for exceptional bravery and effective tactic
in the War of 1812 and in the campaigns of 1813–14.

313, 314

THOMAS HALLIDEY (active in the first half
of the 19th century)

Medal in honour of Mikhail Kutuzov. 1813

Struck in silver. 54 mm, 99.66 gm

Acquired before 1856. Inventory No. 7870

Obverse. Head of Kutuzov. *Leg*. CASTRENSIS PRAEFECTVS
PRINCEPS SMOLENCI. MDCCCXIII. On the neck truncation:
HALLIDEY, F. (artist's signature).
Reverse. A laurel wreath; the inscription of two lines: VOTA
PVBLICA.

311

312

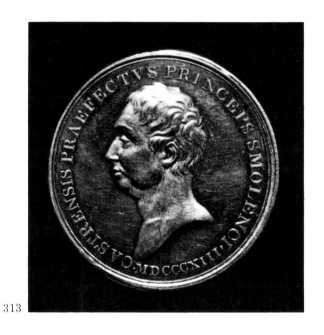

313

314

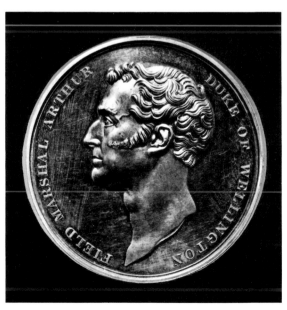

315

316

315, 316

BENEDETTO PISTRUCCI (1784–1855)

Medal in honour of the Duke of Wellington. 1841

Struck in silver. 60 mm, 153.57 gm

Acquired before 1856. Inventory No. 8071

Obverse. Head of Wellington. *Leg.* FIELD MARSHAL ARTHUR
DUKE OF WELLINGTON. On the neck truncation: PISTRUCCI
(artist's signature).
Reverse. Antique helmet, and beneath it thunderbolts. *Leg.* NOVA
CANTAMVS TROPÆA. In the base: AVGVST. 1841. At the left
edge: PISTRUCCI.
The medal was struck to commemorate Wellington's entry into
the Peel ministry.

317

WILLIAM ELMES (active in the first half of the 19th century)

Jack Frost Attacking Bony in Russia. December 1812

Coloured etching. 24×34 cm (George 1938–52, No. 11918)

Acquired in 1941 from the Purchasing Commission.
Inventory No. 356574

Caricature of Napoleon's retreat from Russia in the winter of 1812.

318

is a much colder
experianced
t take care of
give me this
Ft Dennis,
dominion again.

Moscow

Thos Tegg
de.

317

WILLIAM ELMES (active in the first quarter of the 19th century)

The Cossack Extinguisher. November 1813

Coloured etching. 47×33 cm
(George 1938–52, No. 12097)

Acquired in 1941 from the Purchasing Commission.
Inventory No. 149310

The caricature was executed just after Napoleon's defeat by the allied forces in October, 1813 near Leipzig, the town depicted in the background of the sheet in outline.
The Cossack detachments of General Platov took part in the battle.

318

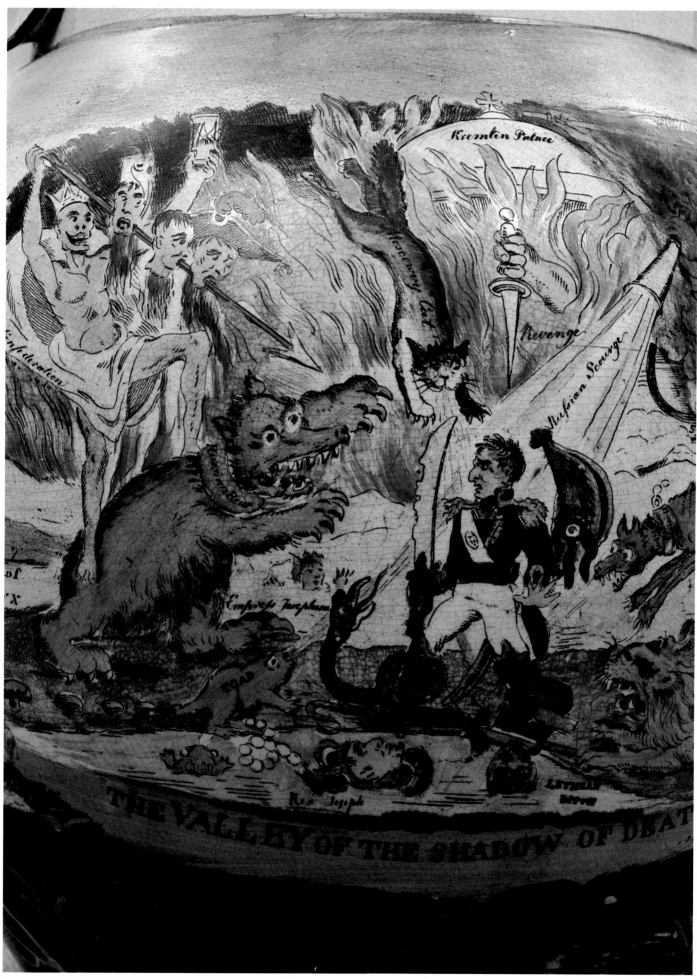

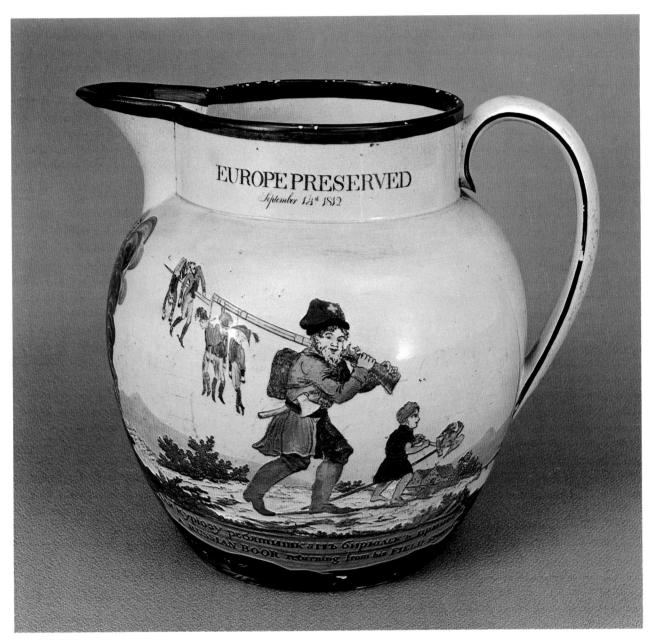

320

319, 320

Jug. Sunderland (?) First quarter of the 19th century

Unmarked

Creamware, coloured transfer design. Height 27 cm

Transferred in 1933 from the Stieglitz School Museum in Leningrad. Inventory No. 3220

The model for the scene represented on one side of the jug was the caricature *The Valley of the Shadow of Death* by the English artist and engraver of the early 19th century, William Elmes (the British Museum). The title is given beneath the picture. On the other side is the reproduction of an etching by an unknown Russian artist of the early 19th century (coloured prints of the etching can be seen in the Hermitage and the Russian Museum in Leningrad), inscribed below with words in Russian, meaning "for the pleasure of the children he brought some bawbles", and in English: *A RUSSIAN BOOR returning from his FIELD SPORTS*. Beneath the pouring lip is a design inscribed: *Conflagration of Moscow seen from the Kremlin on the 14th September 1812*, from a picture by an unknown painter of the early 19th century. The neck bears the inscriptions: *Hourrah your Serene Highness* and *EUROPE PRESERVED September 14th 1812*. The latter probably refers to Fieldmarshal Kutuzov, who for the part he took in the victory over Napoleon, was awarded the title of Serene Prince of Smolensk.

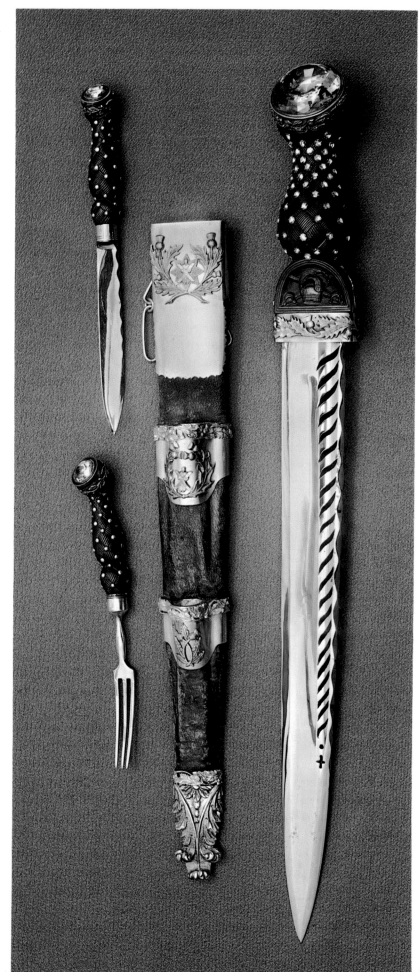

Scottish dagger (dirk). Edinburgh. 1814

By George Hunter

Steel, engraved, chased and polished, silver, ebony, rock crystal. Total length 47 cm, length of blade 32 cm

Inscribed at the base of the blade: *G. Hunter Edin.B*; on the inner side of the mouth of the scabbard, in a frame: *George Hunter A.C°. Army clothers to the king. Edinburgh.* Inventory No. 4888

The dagger formed part of a suit of Scottish national dress, presented to Alexander I during his visit to Great Britain in 1814.
Cl. Blair in *European and American Arms* (London, 1962, No. 188) claims erroneously that the dagger was presented to Nicholas I.

322

Officer's dress sabre. London.
Early 19th century

By Brunn

Steel, burnished, chased and engraved, gilded bronze, ebony, shagreen

Total length 87 cm, length of blade 75 cm

The blade bears the letters *GR* beneath a crown. Inscribed, at the top of the scabbard, in an engraved frame: *Brunn Sword Cutler to the Prince Regent 56 Charing Cross, London.* Inventory No. 2706

Published for the first time.

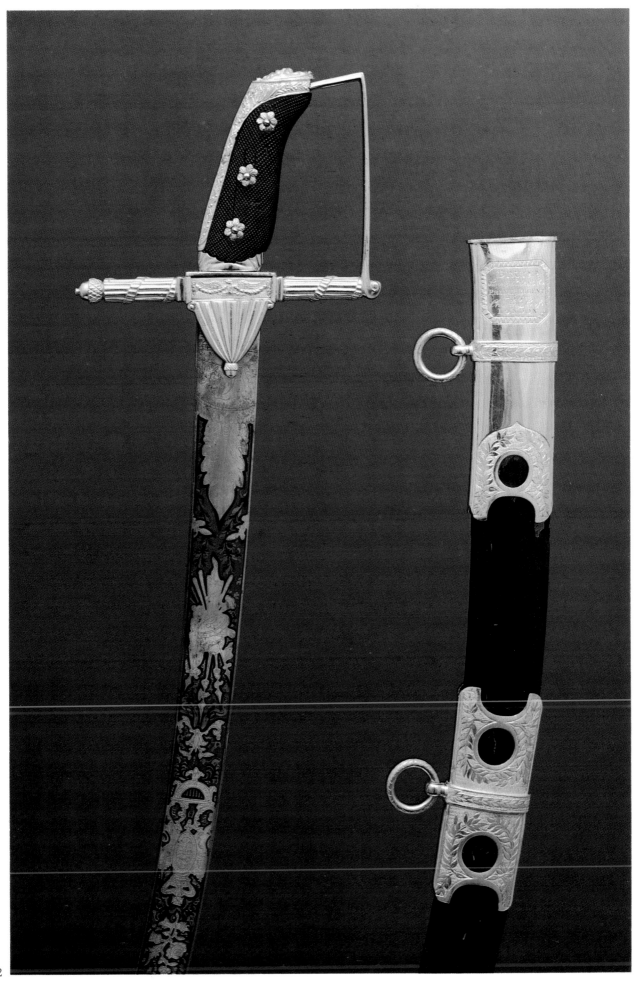

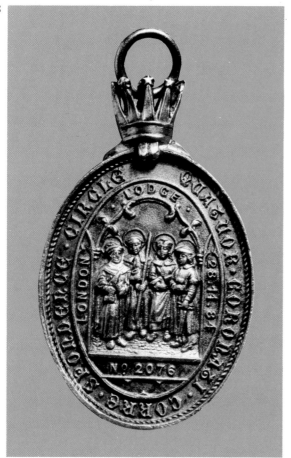

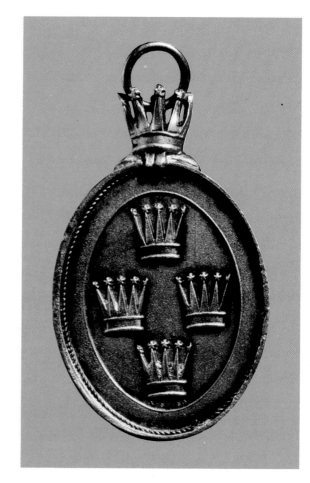

323, 324

GEORGE KENNING (active in the late 19th century)

**Medal of the Correspondence Circle
of the Quatuor Coronati Lodge 2076.** Late 19th century

Struck in silver, gilded. 24×25 mm (oval), 10.16 gm

Acquired in 1937 with the D. Burylin collection
of Masonic insignia. Inventory No. 461

The medal is suspended by a celestial crown and loop.
The accompanying silver bar for the ribbon and a long pin,
probably belong to this medal. Two hall-marks on the reverse:
G.K & S. SILVER. Weight of bar 2.35 gm.

Obverse. A group of four figures, each having a halo about his
head and holding Masonic working tools: gavel, plumb rule, square
and chisel. They represent the protector of the lodge. Along the
rim, the legend in old English lettering: QUATUOR. CORONATI.
CORRE. SPONDENCE. CIRCLE. On the left: LONDON; on the
right: 28. 11. 84; above the group: LODGE; below: N° 2076.
Reverse. Four celestial crowns, one at the top and bottom, and two
between; in the base: KENNING (artist's signature). Engraved on
the bottom edge: BRO.J.I. PËRSITZ (owner's name).

325–327

Honiton lace. Honiton, Devonshire. Mid-19th century

Flax thread woven on bobbins.
6×85 cm; 8×88 cm; 10×100 cm

Acquired after 1917 from the State Museum Fund.
Formerly in the Saxen-Altenburg collection.
Inventory Nos. 122, 128, 130

Honiton in Devonshire was the chief centre of lace production
in England. The method of weaving was derived from Flemish
refugees who settled there in 1567 and 1568. The lace produced
in Honiton and surrounding districts was woven after the designs
of Brussels laces, but with coarser thread. In the 19th century a
particular type of lace very similar to the "Duchesse" guipure
developed in Bruges in Belgium, became common in Honiton.

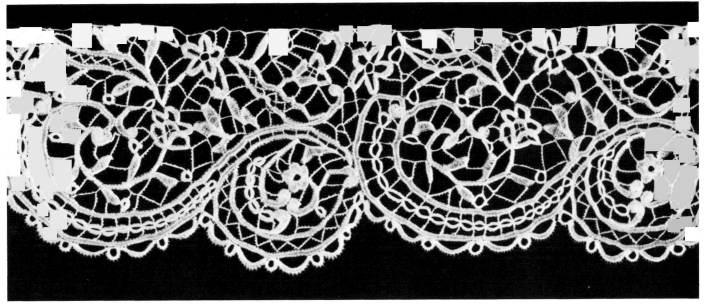

325

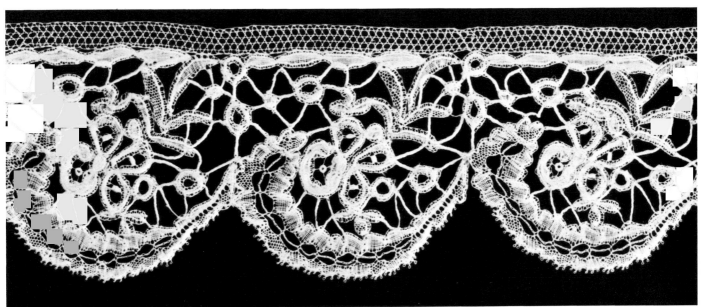

326

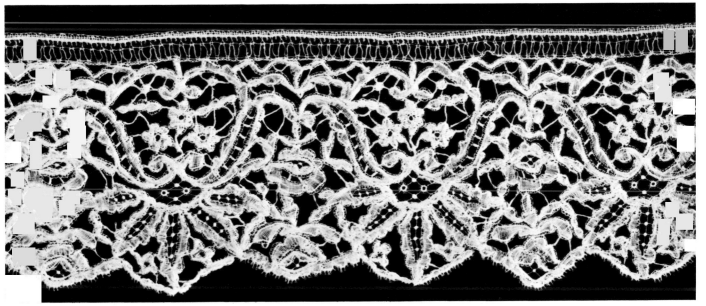

327

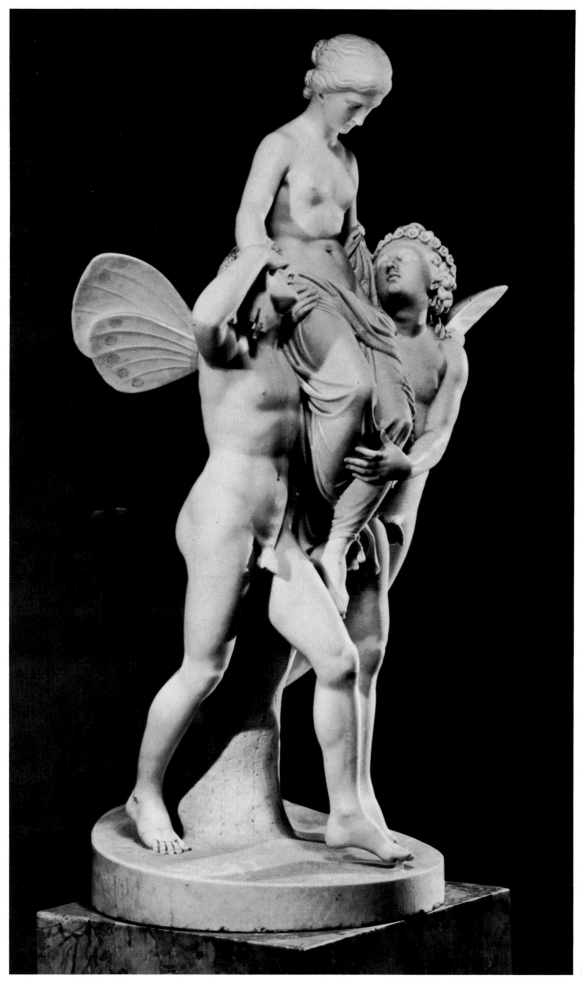

328

328

JOHN GIBSON (1790–1866)

Psyche Carried by the Zephyrs. 1820s

Signed, on the edge of the base:
OPVS IOANNIS GIBSON ROMA.

Marble. Height 132 cm

Transferred in 1926 from the former
Palace of Grand Duke Mikhail Pavlovich
in St. Petersburg. Commissioned
by Alexander I in 1821 (?).
Inventory No. 1132

The first stage in the sculptor's work on the theme
of *Psyche Carried by the Zephyrs* was a sketch of 1816.
From this Gibson made a relief which was put on
display at the Royal Academy in 1816. Then in 1821,
in Rome, he made a model of the sculpture from
which he produced the finished marble for George
Beaumont, which went on display at the Royal
Academy in 1827, and several replicas, including
the one in the Hermitage. In the Palazzo Corsini
in Rome there is thought to be a marble group
commissioned by Giovanni Torlonia. At this
period a relief was also made for the Duke
of Devonshire.

329

JOHN GIBSON (1790–1866)

Cupid as a Shepherd. 1830s

Signed, on the tree stump:
JOANNIS GIBSON ME FECIT ROMAE.

Marble. Height 130 cm

Acquired before 1859. Inventory No. 251

It is possible that the statue was purchased from
the sculptor himself. Gibson produced no less than
eight replicas of the piece. One of these is to be seen
in the Walker Art Gallery in Liverpool.

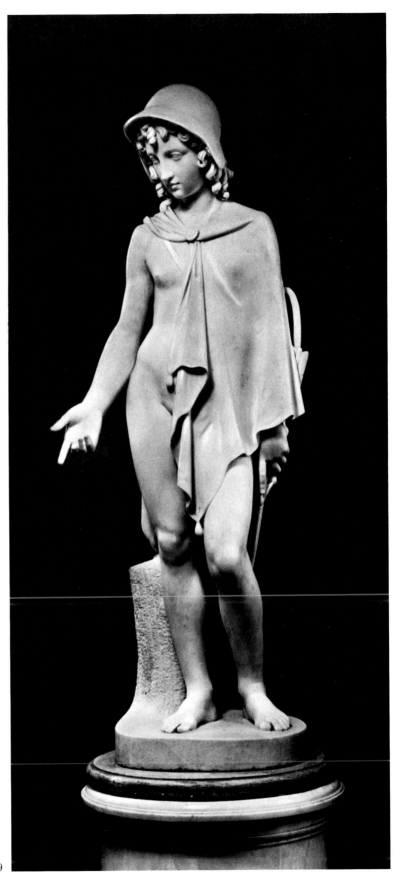

329

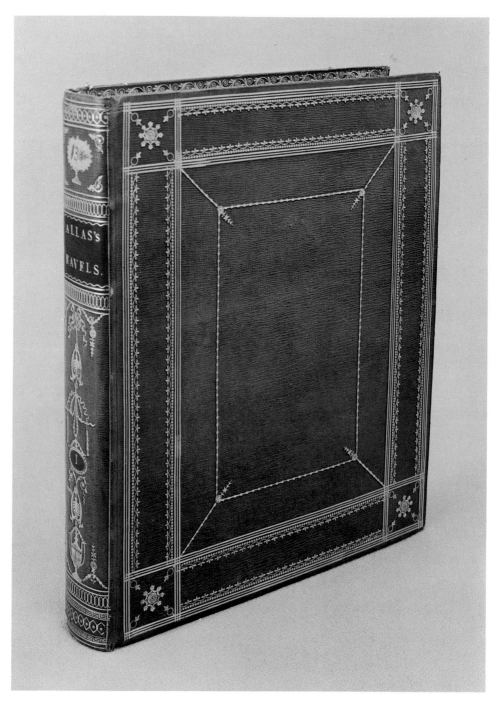

330

330

**Binding of P. Pallas's Travel Through the Southern Provinces
of the Russian Empire in the Years 1793–94,** vol. I, London, 1802

By Charles Meyer (active from 1797 to 1809)

Leather, with gold tooling and inlay. 25.5×30.5 cm

The binder's label on the fly-leaf: *Bound by C. Meyer.
2 Hemmings Row. St. Martins Lane*

Inventory No. 96156

Binding of green leather decorated with gold-stamped borders
and rosettes at each corner. Smooth spine inlaid in red leather.
Fly-leaf of crimson rep.

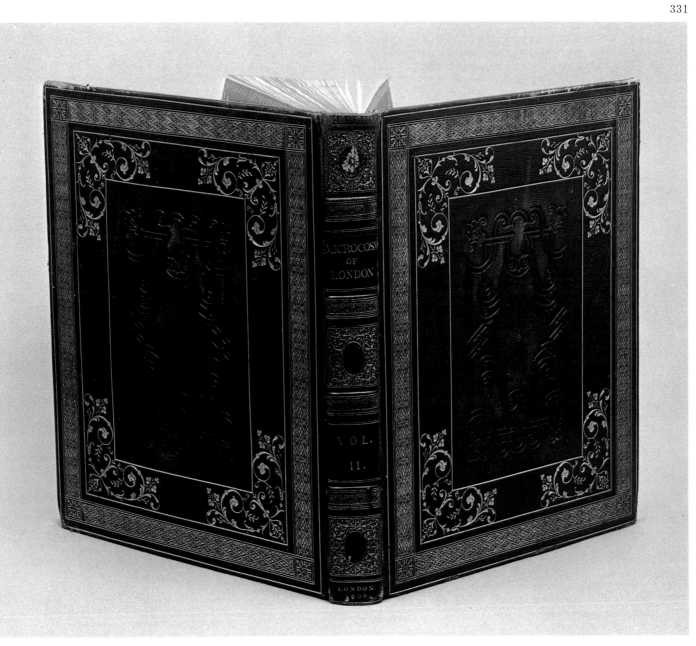

331

Binding of R. Ackermann, The Microcosm of London,
vol. II, London, 1809

By Charles Hering

Leather, with gold and blind tooling. 28×35 cm

The binder's label on the fly-leaf: *Bound by Hering*
9 Newman Street
Inventory No. 444/33–66

Dark-blue binding with a fine design. Central panel imitates
a 16th century style of ornamentation. Fly-leaf of emerald
green moire.

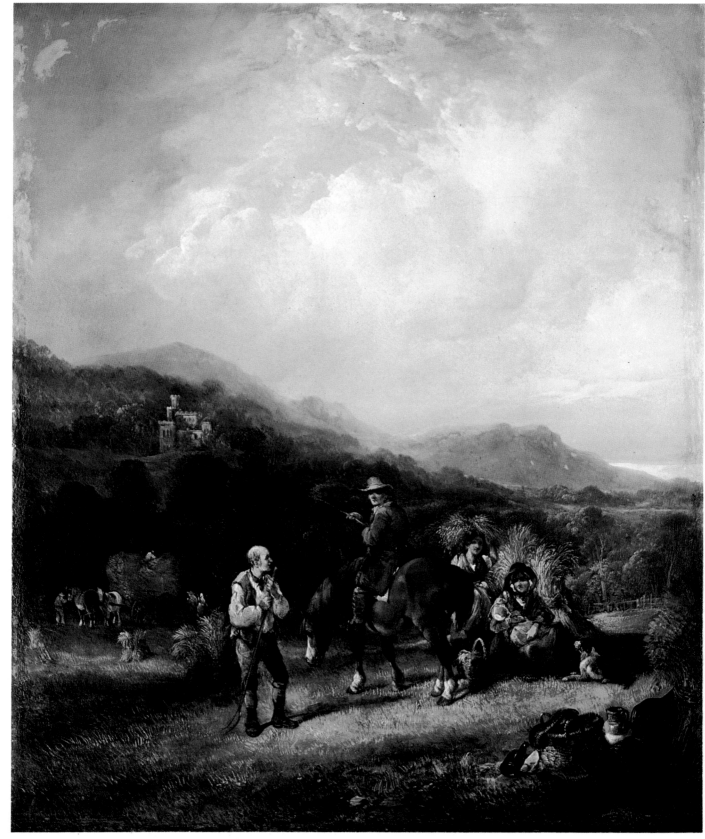

WILLIAM SHAYER THE ELDER (1788–1879)

The Harvest Field

Oil on cardboard. 35.5×30.5 cm

Signed, bottom left: *W. Shayer*. Label on the back:
Shayer Sen. The Harvest Field. A scene in the Isle of Wight.

Acquired in 1948 from a private collection in Leningrad.
Inventory No. 9519

Pictures entitled *The Harvest Field* and *The Harvest Time*, are
frequently encountered amongst Shayer's works (see *Antiques*,
September 1949, p. 152; *Art Digest*, 1 October 1947, p. 3,
and elsewhere).

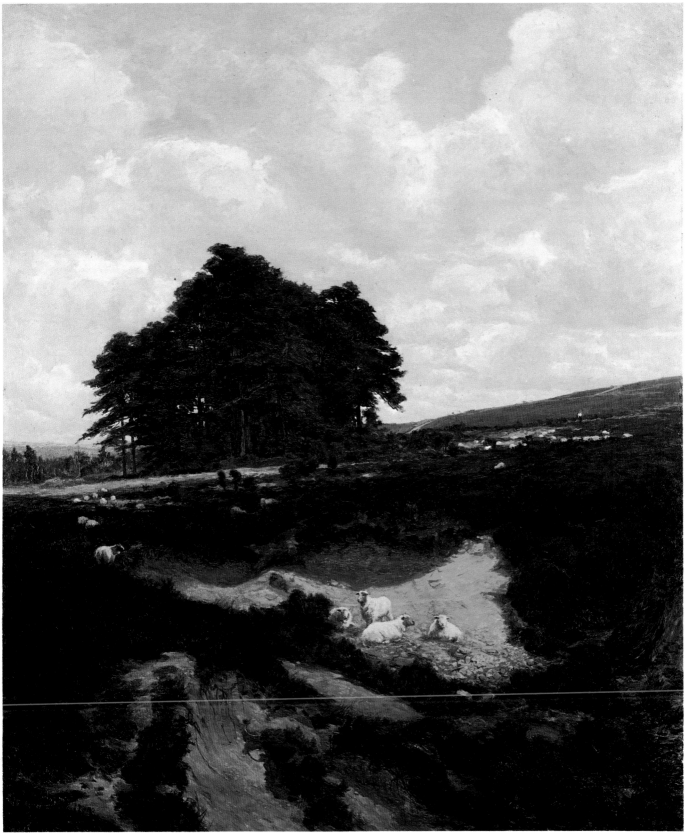

333

FRANK WALTON (1840–1928)

Landscape

Oil on canvas. 76×63.6 cm

Signed, bottom left: *F. Walton*

Transferred in 1948 from the Museum of Modern Western Art in Moscow. Inventory No. 8953

336

ALFRED EAST (1849–1913)

Autumn Landscape. 1901

Signed and dated, bottom left: *A East 1901*

Watercolour and gouache on cardboard. 31×47.8 cm

Acquired in 1937 from the Committee for the Arts
of the USSR. Inventory No. 42916

335

WALTER CRANE (1845–1915)

View near Blythburgh, Suffolk. 1886

Bottom right, inscription, date and monogram:
Blythburgh Sept 86

Watercolour and gouache on cardboard. 26.5×36 cm

Acquired in 1935 from a private collection in Leningrad.
Inventory No. 42165

336

WILLIAM WYLD (1806–1889)

The Crystal Palace in London. 1851

Signed, bottom right: *W. Wyld Londres*

Watercolour. 21.2×30.3 cm

Transferred in 1956 from the Library of the USSR Academy
of Sciences in Leningrad. Inventory No. 46156

The watercolour was apparently done in 1851 at the time that
Joseph Paxton's pavilion was erected on the Thames to house
the World Exhibition in London. Assembled in a few months
from prefabricated sections of glass and metal, the building
came to be known as the Crystal Palace.

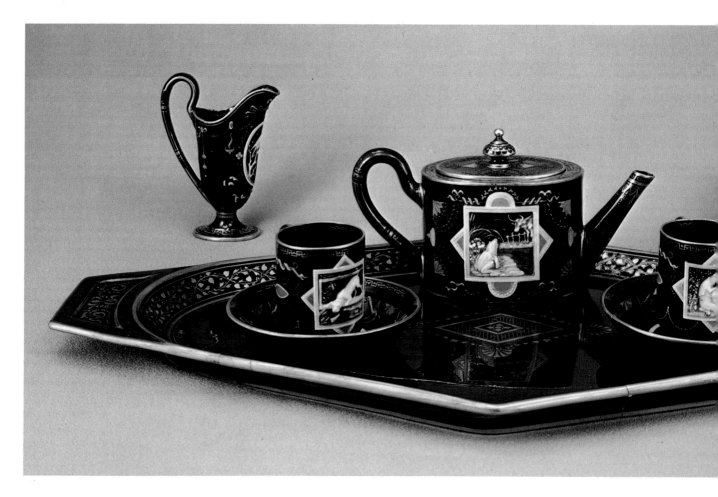

338

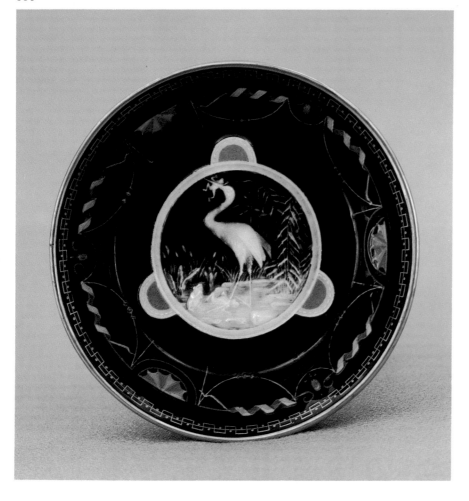

337, 338

Tête-à-tête service. Minton. 1878

Marks impressed and gilded:
Mintons. Paris Exhibition 1878

Some of the pieces have labels
of the trade firm: *T. Goode & Co.,
London*. Porcelain painted under
a glaze and fired.

Pâte-sur-pâte technique

Tray 53×29 cm. Height: 10 cm (tea-pot),
4.3 cm (sugar basin), 12.3 cm (milk jug),
6.3 cm (cups); diameter of saucers 11.3 cm

Transferred in 1929 from
the Anichkov Palace in Leningrad.
Inventory Nos. 23801–23806

Made for the Paris Exhibition of 1878.
The service is decorated with scenes from
La Fontaine's fables. The technique of
pâte-sur-pâte originated in Sèvres and was
then employed in many other factories. It
was introduced at the Minton works by the
modeller and pottery designer Marc-Louis
Solon, who was invited there in 1871.
The Hermitage *tête-à-tête* service appeared
in the catalogue of the exhibition "The
Hermitage: Applied Art of the Late 19th to
the Early 20th Centuries" (Leningrad,
1974, No. 72).

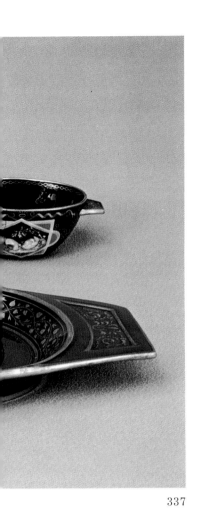

337

Vase. London, Thomas Webb & Sons. *C. 1889*

Mark on the bottom: *Thomas Webb & Sons*. Label: *T. Goode & Co South Audley Street London Grosvenor Square*

Three-layered glass, multiple etching. Height 18.5 cm

Transferred in 1923 from the Stieglitz School Museum in Petrograd. Originally acquired in 1889 at the World Exhibition in Paris. Inventory No. 1347

339

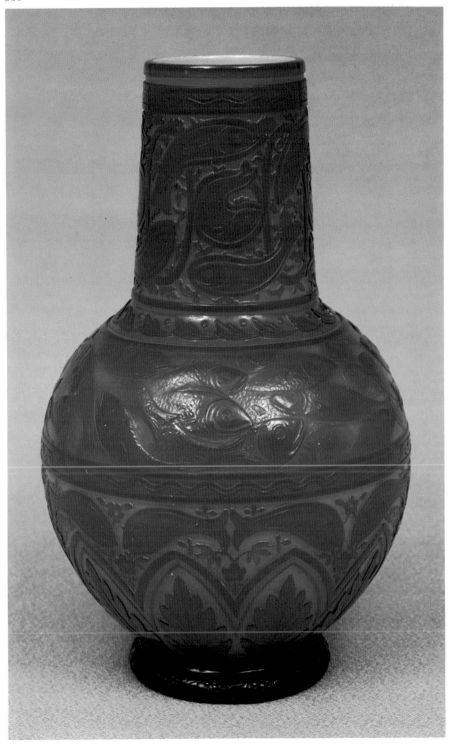

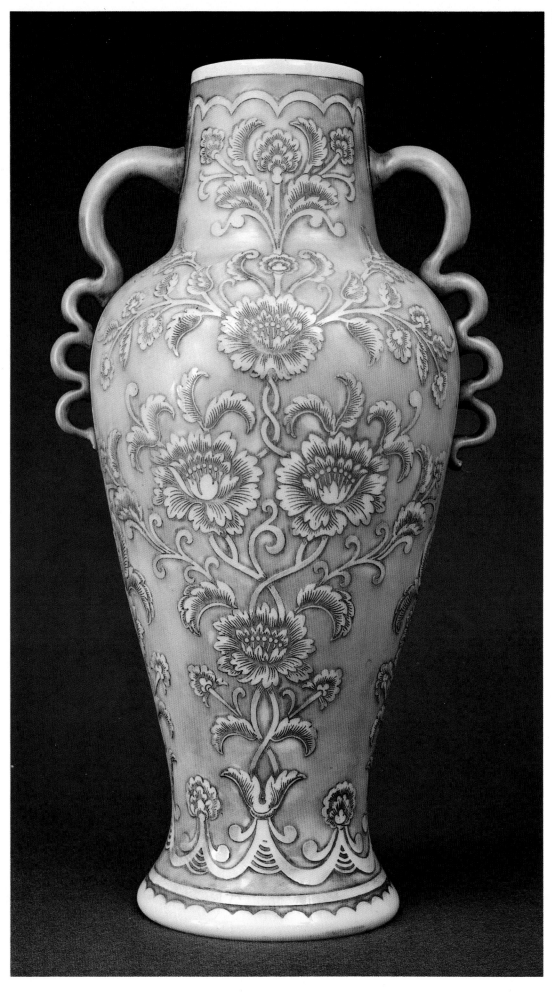

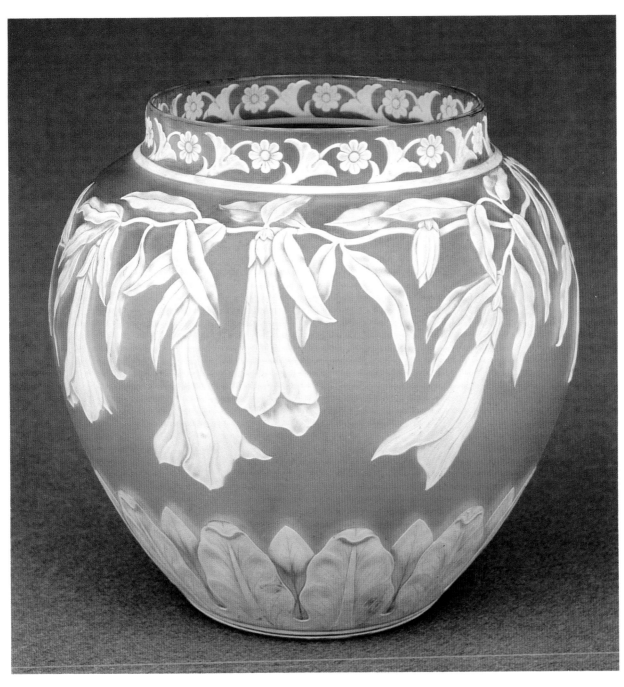

341

Vase. London, Thomas Webb & Sons. *C. 1889*

Mark on the bottom: *Thomas Webb & Sons*. Label: *T. Goode & Co. South Audley Street London Grosvenor Square*

Two-layered glass, etched design in red. Height 30 cm

Transferred in 1923 from the Stieglitz School Museum in Petrograd. Originally acquired in 1889 at the World Exhibition in Paris. Inventory No. 1357

341

Vase. London, Thomas Webb & Sons. *C. 1889*

Label on the bottom: *T. Goode & Co South Audley Street London Grosvenor Square*

Two-layered glass, etched and engraved. Height 16.9 cm

Transferred in 1923 from the Stieglitz School Museum in Petrograd. Originally purchased in 1889 at the World Exhibition in Paris. Inventory No. 1340

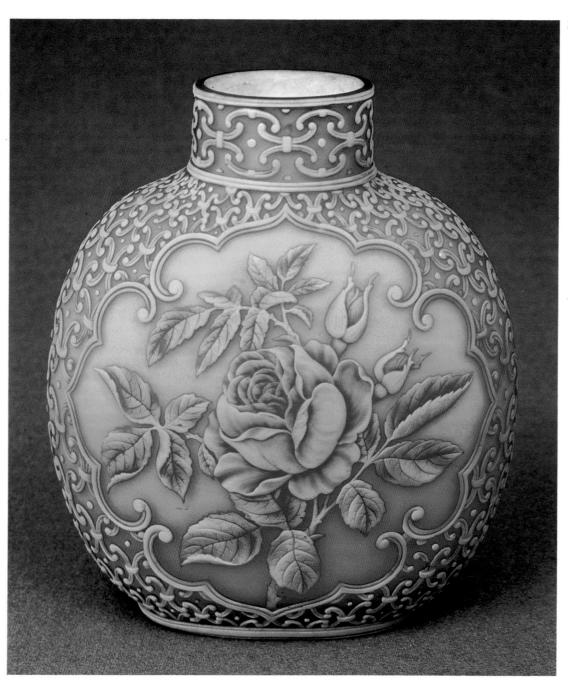

342

Vase. London, Thomas Webb & Sons. *C. 1889*

Label on the bottom: *T. Goode & Co South Audley Street*
London Grosvenor Square

Two-layered glass, etched and engraved. Height 40 cm

Transferred in 1923 from the Stieglitz School Museum in Petrograd.
Originally acquired in 1889 at the World Exhibition in Paris.
Inventory No. 1343

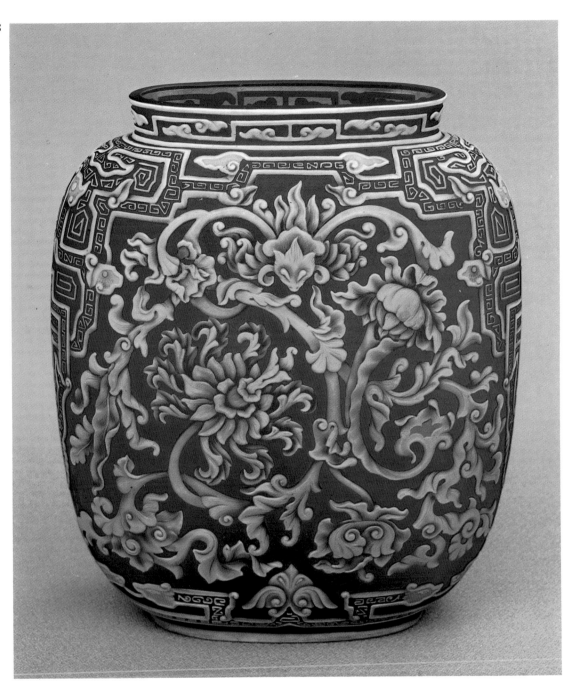

343

Vase. London, Thomas Webb & Sons

Label on the bottom: *T. Goode and Co South Audley Street London Grosvenor Square*

Three-layered glass, etched and engraved. Height 16.7 cm

Transferred in 1923 from the Stieglitz School Museum in Petrograd. Originally acquired in 1889 at the World Exhibition in Paris. Inventory No. 1342

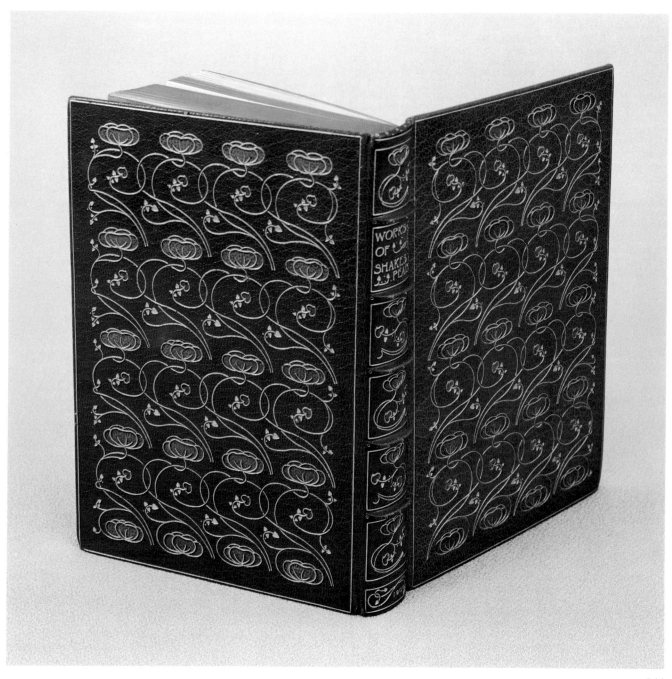

344

Binding of The Complete Works of William Shakespeare,
Oxford, 1900

Leather, with gold tooling and inlay. 13.5×19.5 cm

Inventory No. 150619

Inlaid binding in the Art Nouveau style decorated with a linear
design. Spine panelled, inlaid. Fly-leaf of coloured paper with
a leather border, imitating the design on the spine and covers.

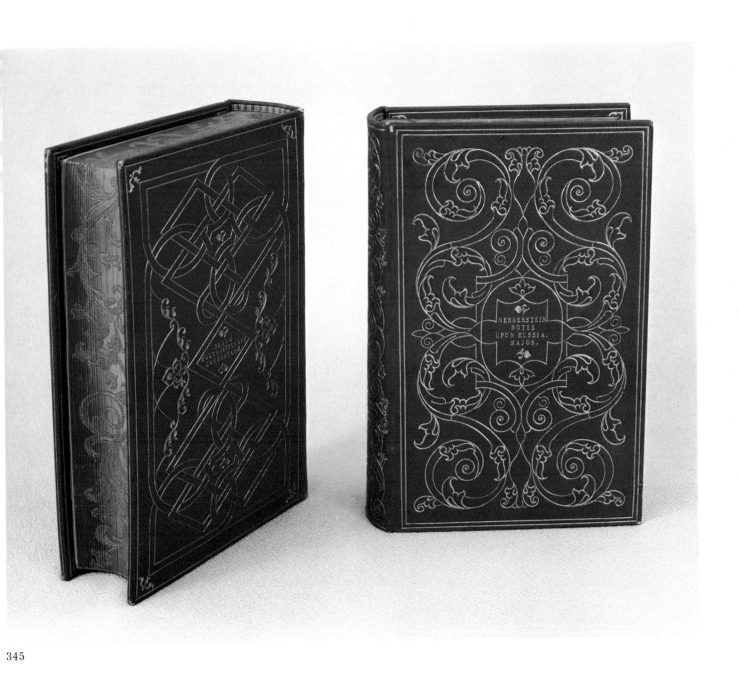

345

345

Bindings of Sigismund von Herberstein, Notes upon Russia . . . ,
vols. I–II, London, 1852

Leather, with gold tooling. 21.5×15 cm

Inventory Nos. 45006, 45007

Red leather bindings, covers and spines decorated in a manner
imitating 16th century ornamentation (the period from which
the book dates). Fly-leaves of blue moire. Edges gilded with an
impressed plant design. Before the title page is a presentation
inscription from the publisher to the heir of the Russian throne,
dated 21 November 1874.

Bindings of Œuvres complètes de Molière,
vols. I–IV, Oxford, 1900

Leather, with gold tooling and inlay. 7.3×11.5 cm

Inventory Nos. 150640–150643

Each of the four volumes decorated with a different design:
in the Art Nouveau style or with a stylized 17th century ornament.
Spines panelled. Edges gilded. Fly-leaves of coloured paper.

347

Binding of Tutte le opere di Dante Alighieri, Oxford, 1897

Leather, with gold tooling and inlay. 13×19 cm

Inventory No. 150618

Binding in the Art Nouveau style decorated with inlay of green
and red leather and linear pattern. Edges gilded.

350–352

Tapestry: The Adoration of the Magi. William Morris & Co., Merton Abbey, Surrey. Late 19th century

After a design by Edward Burne-Jones

Inscribed along the upper border: *THE 'ADORATION' DESIGNED BY SIR E. BVRNE-JONES AND EXECVTED BY MORRIS AND COMPANY AT MERTON ABBEY IN SVRREY ENGLAND*

Wool, handwoven. 255×379 cm

Transferred in 1949 from the Museum of Modern Western Art in Moscow. Inventory No. 15431

In 1887 Burne-Jones painted a large sketch in watercolours from which William Morris and John Dirl produced a cartoon for the tapestry, changing the colour scheme and outlining flowers and details in the background.
The first tapestry was woven in 1890 for the chapel of Exeter College, Oxford.

349

348

Binding of The Works of Alfred Lord Tennyson, London, 1899

Leather, with inlay. 12×18.5 cm

Inventory No. 150622

Binding in sand-coloured leather decorated with a fine inlay of green and red leather. Spine panelled. Edges gilded.

349

Binding of A. E. Haight, The Attic Theatre, Oxford, 1898

Leather, with tooling. 14×22 cm

Inventory No. 150620

Binding decorated in the Art Nouveau style. Spine panelled. Edges gilded. Fly-leaf in coloured paper with a leather frame decorated with gold tooling.

Published for the first time.

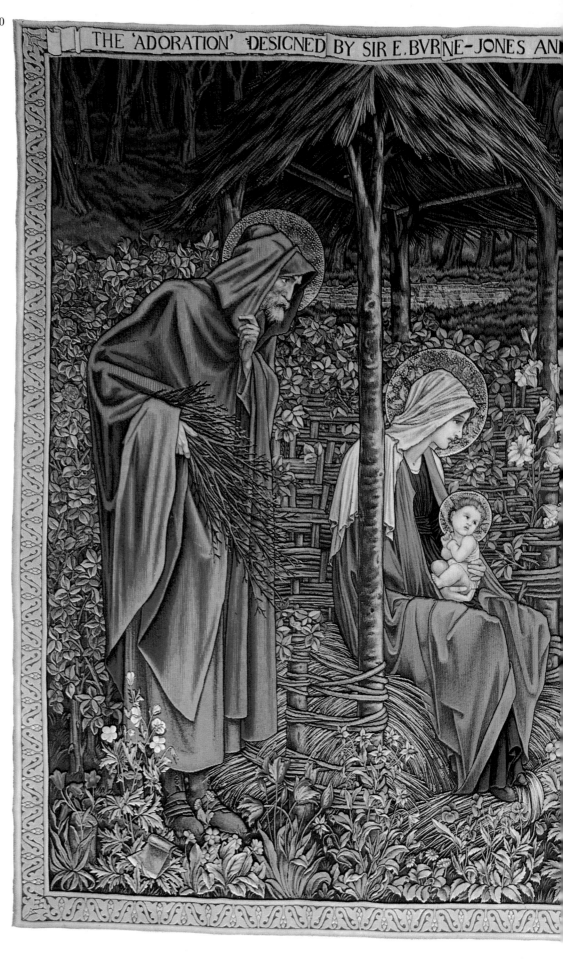

THE 'ADORATION' DESIGNED BY SIR E. BVRNE-JONES AN[D]

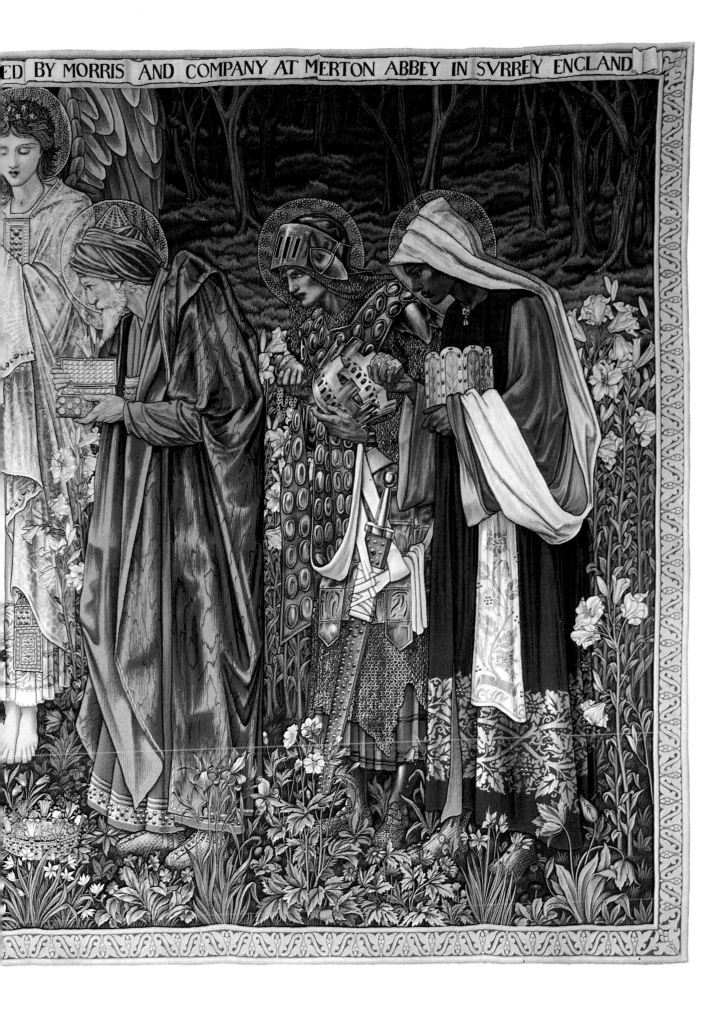

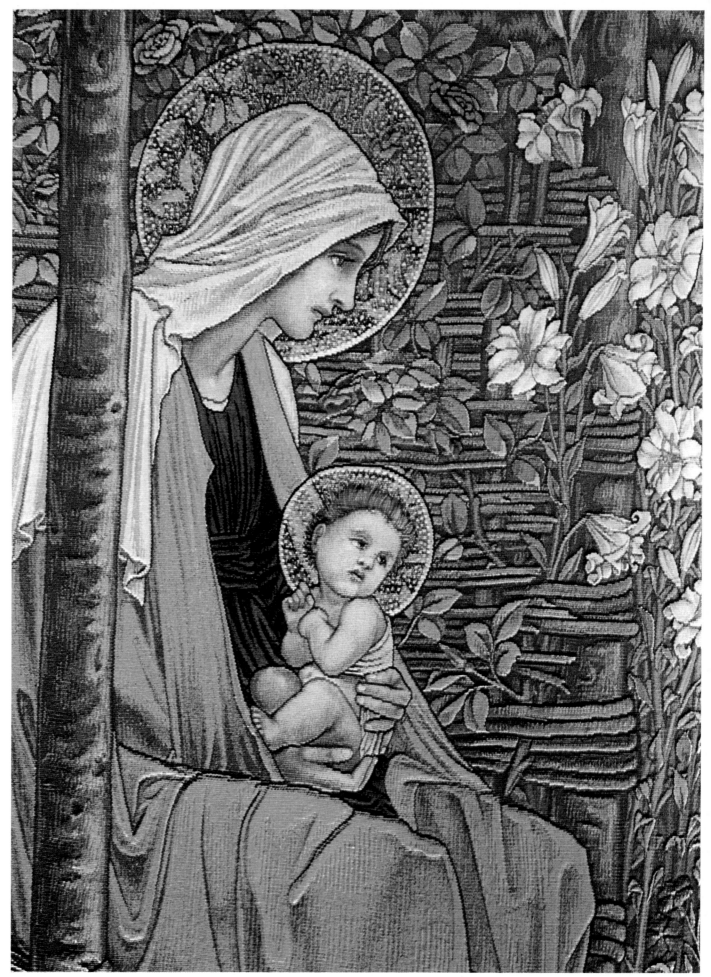

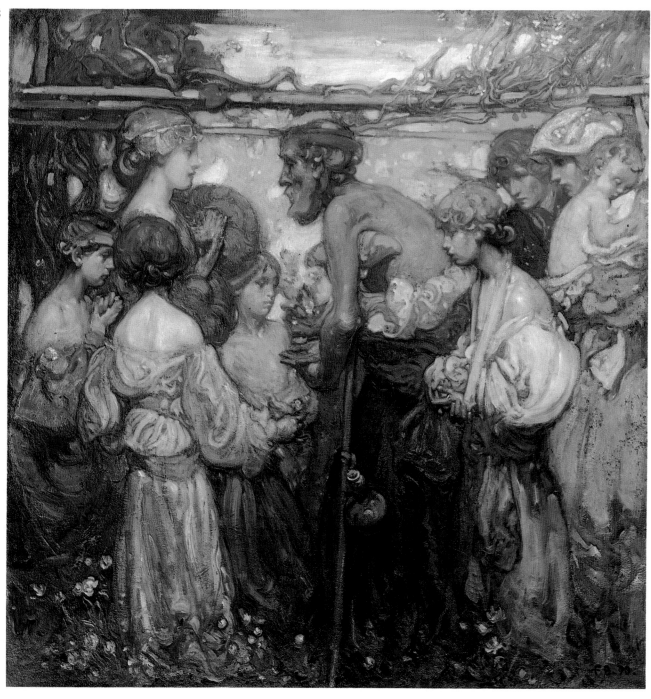

353, 354

FRANK BRANGWYN (1867–1956)

Charity. 1890

Oil on canvas. 94×91 cm

Signed and dated, bottom right: *F. B. 90*

Transferred in 1948 from the Museum of Modern Western Art
in Moscow. Formerly in the collection of S. Shchukin in Moscow.
Inventory No. 9091

The closest analogy is the picture of 1900 also called *Charity* (the
National Gallery of Canada, catalogue No. 562). Another version
of *Charity* was in the Belleroche collection (see Baldry 1900).
At the present time, the whereabouts of this picture are unknown.
The National Gallery of Canada also possesses seven undated
sketches (catalogue Nos. 1777–1783) which are preparatory studies
for the Hermitage and Canadian compositions.

SELECT BIBLIOGRAPHY

PAINTING

GENERAL WORKS

Aedes Walpolianae or a Description of the Collection of Pictures at Houghton Hall in Norfolk, the Seat of the Right Honourable Sir Robert Walpole, Earl of Orford, London, 1752

A. Graves, *The Royal Academy of Arts*, 8 vols., London, 1905–6

P. Veiner, "Sobraniye A. Khitrovo", ("The A. Khitrovo Collection"), *Stariye gody*, December 1912

Gosudarstvenny Ermitazh. Zapadnoyevropeiskaya zhivopis'. Katalog (The Hermitage. Western European Painting. Catalogue), vol. II, Leningrad, 1958

A. Krol, *Angliyskaya zhivopis' v Ermitazhe (English Painting in the Hermitage)*, Leningrad, 1961

E. Lisenkov, *Angliyskoye iskusstvo XVIII veka (English Art of the 18th Century)*, Leningrad, 1964

A. Krol, *Gosudarstvenny Ermitazh. Angliyskaya zhivopis'. Katalog (The Hermitage. English Painting. Catalogue)*, Leningrad, 1969

ALLAN

"Sir William Allan", *Art Journal*, 1849, p. 108

A. Graves, *The British Institution*, London, 1908

A. Krol, "Iz istorii russko-angliyskikh khudozhestvennykh sviazei nachala XIX veka. Kartiny angliyskogo romantika na russkiye temy" ("Notes on the History of Russian-British Art Relations in the Early 19th Century. Paintings of an English Romantic on Russian Subjects"), *Trudy Gosudarstvennogo Ermitazha (Papers of the Hermitage)*, vol. VI, 1961, pp. 389–392

BONINGTON

A. Dubuisson, "Richard Parkes Bonington", *Revue de l'Art*, vol. XXVI, 1909

A. Krol, "*Vid na Rim* R. P. Boningtona v Ermitazhe" ("*View of Rome* by R. P. Bonington in the Hermitage"), in: *Iskusstvo Zapada (Art of the West)*, Moscow, 1971

BRANGWYN

A. Baldry, "The Art of 1900", *Studio*, vol. XX, 1900, pp. 3–36

E. Brown, "Some Recent Purchases by the National Gallery of Canada", *Studio*, vol. LXII, 1914, p. 96

R. Hubbard, *The National Gallery of Canada. Catalogue of Painting and Sculptures*, vol. II, Ottawa, 1959

V. Galloway, *Oils and Murals of Sir F. Brangwyn*, Leigh-of-Sea, 1962

Gosudarstvenny muzei novogo zapadnogo iskusstva. Illiustrirovanny katalog (The Museum of Modern Western Art. Illustrated Catalogue), Moscow, 1928

DANCE

O. Millar, *The Late Georgian Pictures in the Collection of Her Majesty the Queen*, London, 1969

DAWE

L. Binyon, *Catalogue of Drawings by British Artists . . . in the British Museum*, London, 1900

D. Rovinsky, *Podrobny slovar' russkikh gravirovannykh portretov (An Exhaustive Dictionary of Russian Engraved Portraits)*, St. Petersburg, vol. I, 1886

V. Glinka, A. Pomarnatsky, *Voyennaya galereya Zimnego dvortsa (The 1812 War Gallery of the Winter Palace)*, Leningrad, 1974

DOBSON

C. Holmes, J. D. Miliner, "Two Recent Additions to the National Portrait Gallery", *Burlington Magazine*, vol. XIX, 1911

C. Collins-Baker, *Dobson*, in: Thieme–Becker, *Allgemeines Lexikon der bildenden Künstler*, Bd. XI, Leipzig, 1915

D. Piper, *Catalogue of Seventeenth Century Portraits in the National Portrait Gallery, 1652–1714*, Cambridge, 1963

EWORTH

L. Cust, "The Painter H. E. (Hans Eworth)", *Walpole Society*, vol. II, 1912–13

Tudor Portraits. Exhibition of English Portraiture in the 16th Century at Burlington House, London, 1951

E. Waterhouse, *Exhibition of English Portraiture in the 16th Century at Burlington House*, London, 1951

O. Millar, *The Tudor, Stuart and Early Georgian Pictures in the Collection of Her Majesty the Queen*, London, 1963

"A True Inventory of the Pictures in Hampton Court. Viewed and Apprised 3, 4 and 5 of October, 1649", *Walpole Society*, vol. XLIII, 1970–72

The Inventories and Valuations of the King's Goods. 1649–1651, edited with the introduction by O. Millar, Glasgow, 1972

GAINSBOROUGH

W. Armstrong, *Gainsborough*, London, 1898

E. Waterhouse, *Gainsborough*, London, 1958

A. Krol, *Gainsborough. "Portret gertsoghini de Beaufort"* (*Gainsborough. "Portrait of the Duchess of Beaufort"*), Leningrad, 1960

GHEERAERTS

L. Cust, "Marcus Gheeraerts", *Walpole Society*, vol. III, 1913–14, pp. 9–45

R. Pool, "Marcus Gheeraerts, Father and Son", *Walpole Society*, vol. III, 1913–14, pp. 1–8

R. Strong, *Tudors and Jacobean Portraits*, vols. I–II, London, 1960

JONES

G. F. Waagen, *Die Gemäldesammlung in der Kaiserlichen Ermitage nebst Bemerkungen über andere dortige Kunstsammlungen*, St. Petersburg, 1870

G. Williamson, "The Collection of Pictures in the Hermitage", *Connoisseur*, vol. IX, 1904

"Memoirs of Thomas Jones. Penkerrig Radnorshire. 1803", *Walpole Society*, vol. XXXII, 1946–48, 1951

KNELLER

J. Piper, *Catalogue of Seventeenth Century Portraits in the National Portrait Gallery. 1652–1714*, Cambridge, 1963

A. Trubnikov, "Stariye portrety starogo zamka" ("The Old Portraits of an Old Castle"), *Stariye gody*, July–September 1914

LAWRENCE

G. Williamson, "The Collection of Pictures in the Hermitage Palace at St. Petersburg", *Connoisseur*, vol. IX, 1904

W. Armstrong, *Sir Thomas Lawrence*, London, 1913

P. Weiner, *Meisterwerke der Gemäldesammlung in der Ermitage*, München, 1923

O. Galbraith, "Two Drawings by Sir Thomas Lawrence", *Bulletin of the Cincinnati Art Museum*, April 1935

The First Hundred Years of the Royal Academy. Catalogue, London, 1951–52

K. Karlick, *Sir Thomas Lawrence*, London, 1954

D. Shmidt, "Svedeniya iz-za granitsy" ("Information from Abroad"), *Stariye gody*, July 1908

LELY

R. Beckett, *Lely*, London, 1951

N. Wrangel, "Iskusstvo i imperator Nikolai Pavlovich" ("Art and the Emperor Nikolai Pavlovich"), *Stariye gody*, July–September 1913

MORLAND

Church and Home, 29 December 1892

The Sunday Sun, 29 December 1892

Ukazatel' sobraniya kartin i redkikh proizvedeniy khudozhestva, prinadlezhashchikh chlenam imperatorskogo doma i chastnym litsam (*A Guide to the Collection of Pictures and Rare Works of Art Belonging to the Imperial Family and Private Persons*), St. Petersburg, 1861

A. Krol, *George Morland i yego kartiny v Ermitazhe* (*George Morland and His Paintings in the Hermitage*), Leningrad, 1963

NASMYTH

D. Shmidt, "Dar V. Zurova Imperatorskomu Ermitazhu" ("V. Zurov's Gift to the Imperial Hermitage"), *Stariye gody*, March 1916

OPIE

Cl. Phillipps, "John Opie", *Gazette des Beaux-Arts*, vol. VII, 1892

RAEBURN

J. Greig, *Sir Henry Raeburn*, London, 1911

REYNOLDS

James Northcote, *Memoirs of Sir Joshua Reynolds*, 2 vols., London, 1913–15

Ch. R. Leslie, T. Taylor, *Life and Times of Sir Joshua Reynolds, with Notes of His Contemporaries*, 2 vols., London, 1865

A. Graves, W. V. Cronin, *A History of the Works of Sir Joshua Reynolds, P.R.A.*, 4 vols., London, 1899–1901

W. Armstrong, *Sir Joshua Reynolds*, London, 1900

A. Graves, *Art Sales from Early in the Eighteenth Century to Early in the Twentieth Century*, vol. III, London, 1921

F. W. Hilles (ed.), *Letters of Sir Joshua Reynolds*, Cambridge, 1929

E. Wind, "Borrowed Attitudes in Reynolds and Hogarth", *Journal of the Warsburg Institute*, vol. II, 1938

E. Waterhouse, *Reynolds*, London, 1941

Ch. Mitchel, "Three Phases of Reynolds's Method", *Burlington Magazine*, February 1942

F. Saki, R. Wittkower, *British Art and the Mediterranean*, Oxford, 1948

J. S. Y. Simmons, "Samuel Johnson on the Banks of the Neva. A Note on a Picture by Reynolds in the Hermitage", *Oxford Slavonic Papers*, vol. XII, 1965

L. Hermann, "The Drawings by Sir Joshua Reynolds in the Herschel Album", *Burlington Magazine*, December 1968

A. Trubnikov, "Popytka vyvezti 'Gerkulesa' Reynoldsa" ("An Attempt to Smuggle 'Hercules' by Reynolds"), *Stariye gody*, July 1912

A. Trubnikov, "Materialy po istorii tsarskikh sobraniy" ("Materials on the History of the Tsars' Collections"), *Stariye gody*, July–September 1913

A. Krol, *Joshua Reynolds. "Mladenets Gerkules"* (*Joshua Reynolds. "The Infant Hercules"*), Leningrad, 1959

ROMNEY

Illustrated Catalogue of the Second Hundred of Paintings by Old Masters... Belonging to the Sedelmayer Gallery, Paris, 1895

H. Ward, W. Roberts, *Romney*, London, 1904

WALKER

Livret de la Galerie Impériale de l'Ermitage, St.-Pétersbourg, 1838

P. Pearsson, G. Morant, *The Wilkinson Head of Oliver Cromwell and Its Relation to... Painted Portraits*, Cambridge, 1954

A. Somov, *Kartiny Imperatorskogo Ermitazha* (*Pictures of the Imperial Hermitage*), St. Petersburg, 1859

WHITE

Katalog kartinnoi galerei grafa N. Kusheleva-Bezborodko (*Catalogue of the Picture Gallery of Count Kushelev-Bezborodko*), compiled by B. Veselovsky under the supervision of A. Somov, St. Petersburg, 1886

DRAWINGS

Drawings by West European and Russian Masters from the Collections of the State Hermitage and the Russian Museum in Leningrad, 8th October to 7th December 1974. Whitworth Art Gallery, University of Manchester, 1974

Nikolai Mikhailovich, *Russkiye portrety XVIII i XIX stoletiy* (*Russian Portraits of the 18th and 19th Centuries*), vol. II, St. Petersburg, 1907

M. Dobroklonsky, *Risunki, graviury i miniatiury v Ermitazhe* (*Drawings, Engravings and Miniatures in the Hermitage*), Leningrad, 1937

T. Kamenskaya, *Gosudarstvenny Ermitazh. Akvarel' XVI–XIX vekov* (*The Hermitage. Watercolours of the 16th to 19th Centuries*), Leningrad, 1937

M. Dobroklonsky, *Gosudarstvenny Ermitazh. Risunki flamandskoi shkoly XVII–XVIII vekov* (*The Hermitage. Drawings of the Flemish School of the 17th and 18th Centuries*), Moscow, 1955

T. Kamenskaya, *Gosudarstvenny Ermitazh. Pasteli khudozhnikov zapadnoyevropeiskikh shkol XVI–XIX vekov* (*The Hermitage. Pastels by Western European Painters of the 16th to 19th Centuries*), Leningrad, 1960

V. Grashchenkov, *Risunki zapadnoyevropeiskikh khudozhnikov XIX veka* (*Drawings by 19th Century Western European Painters*), Moscow, 1961

ARCHITECTURAL DRAWINGS

T. Talbot Rice, "Charles Cameron — Catherine the Great's British Architect", *Connoisseur*, August 1967

Charles Cameron. C. 1740–1812. Architectural Drawings and Photographs from the Hermitage Collection, Leningrad and the Architectural Museum, Moscow, with an introduction by T. Talbot Rice, Edinburgh, 1967–68

I. Rae, *Charles Cameron. Architect to the Court of Russia*, London, 1971

M. Korshunova, "William Hastie in Russia", *Architectural History*, vol. XVII, 1974

V. Teleporovsky, *Charles Cameron*, Moscow, 1939

Kratkiy putevoditel' po vystavke "Arkhitektura Leningrada i yego okrestnostei v proektakh i risunkakh XVIII–XIX vekov" (*A Short Guide to the Exhibition "Architecture of Leningrad and Its Environs in the Designs and Drawings of the 18th and 19th Centuries"*), Leningrad, 1949

A. Petrov, *Pushkin. Dvortsy i parki* (*The Town of Pushkin. Palaces and Parks*), Leningrad, 1964

M. Korshunova, "Arkhitektor W. Hastie. 1755–1832" ("The Architect W. Hastie. 1755–1832), *Trudy Gosudarstvennogo Ermitazha* (*Papers of the Hermitage*), vol. XVIII, 1977

SCULPTURE

S. Troinitsky, *Biust Charl'za Foksa raboty Nollekensa v Ermitazhe* (*A Bust of Charles Fox by Nollekens in the Hermitage*), in: *Gosudarstvenny Ermitazh. Sbornik* (*The Hermitage. Collection of Articles*), issue II, Petrograd, 1923

Z. Zaretskaya, N. Kosareva, *Zapadnoyevropeiskaya skul'ptura XV–XX vekov. Gosudarstvenny Ermitazh* (*Western European Sculpture of the 15th to 20th Centuries. The Hermitage*), Moscow–Leningrad, 1960

Z. Zaretskaya, N. Kosareva, *Zapadnoyevropeiskaya skul'ptura v Ermitazhe* (*Western European Sculpture in the Hermitage*), Leningrad, 1970

SILVER AND JEWELLERY

W. J. Cripps, *Old English Plate*, London, 1886

E. A. Jones, *The Old English Plate of the Emperor of Russia*, London, 1909

P. Derwis, "More English Plate at the Hermitage", *Burlington Magazine*, July 1936

F. J. Britten, *Old Clocks and Watches and Their Makers*, New York, 1956

N. M. Pentzer, "The Jermingham-Kandler Wine-cooler", *Apollo*, September–October 1956

N. M. Pentzer, "English Plate at the Hermitage", *Connoisseur*, December 1958

J. F. Hayward, *Huguenot Silver in England. 1688–1727*, London, 1959

C. Oman, "English Plate at the Hermitage, Leningrad, and the State Historical Museum, Moscow", *Connoisseur*, August 1959

A. Voelckersahm, *Opisi serebra Yego Imperatorskogo Velichestva* (*Inventory of His Imperial Majesty's Silver*), 2 vols., St. Petersburg. 1907

S. Troinitsky, *Kratky putevoditel' po galereye serebra* (*A Short Guide to the Silver Gallery*), St. Petersburg, 1923

S. Troinitsky, *Angliyskoye serebro* (*English Silver*), St. Petersburg, 1923

Vystavka proizvedeniy angliyskogo iskusstva. Katalog (*Exhibition of English Art. Catalogue*), Moscow, 1956

M. Torneus, *Zapadnoyevropeiskiye veyera XVIII–XIX vekov iz sobraniya Gosudarstvennogo Ermitazha. Katalog vremennoi vystavki* (*West European Fans of the 18th and 19th Centuries from the Collection of the Hermitage. Catalogue of Temporary Exhibition*), Leningrad, 1970

E. Yefimova, M. Torneus, *Zapadnoyevropeiskiye chasy XVI–XIX vekov iz sobraniya Ermitazha. Katalog vystavki* (*Western European Clocks and Watches of the 16th to 19th Centuries from the Hermitage Collection*), Leningrad, 1971

MEDALS

R. W. Cochran-Patrick, *Catalogue of the Medals of Scotland from the Earliest Period to the Present Time*, Edinburgh, 1884

E. Hawkins, A. Franks, H. Grueber, *Medallic Illustrations of the History of Great Britain and Ireland to the Death of George II*, 2 vols., London, 1885

T. Carter, *Medals of the British Army and How They Won*, London, 1891

G. Tancred, *Historical Records of Medals and Honorary Distinctions Conferred on the British Navy, Army and Auxiliary Forces from the Earliest Period*, London, 1891

D. N. Irwin, *War Medals and Decorations Issued to the British Military and Naval Forces from 1588 to 1898*, London, 1899

G. Shackles, E. Yorks, *The Medals of British Freemasonry*, Hamburg, 1901

PORCELAIN

G. C. Williamson, *The Imperial Russian Dinner Service. A Story of a Famous Work by Josiah Wedgwood*, London, 1909

R. L. Hobson, *Worcester Porcelain*, London, 1910

A. Hayden, *Chats on English Earthenware*, London, 1912

E. Hannover, *Pottery and Porcelain. Vol. III: European Porcelain*, London, 1925

W. B. Honey, *Old English Porcelain*, London, 1928

B. Rackham, *Catalogue of the Schreiber Collection*, 2 vols., London, 1928–30

W. Mankowitz, *Wedgwood*, London, 1953

M. Olivar Daydi, *Das europäische Porzellan von den Anfängen bis zum Beginn des 19. Jahrhunderts*, Bd. I, Bern, 1955; Bd. II, Bern–München, 1957

W. Mankowitz, R. D. Haggar, *The Concise Encyclopedia of English Pottery and Porcelain*, London, 1957

Y. Hackenbroch, *Chelsea and Other English Porcelain . . . in the Irwin Untermyer Collection*, Cambridge–Massachusetts, 1957

Le Style anglais: 1750–1850, Paris, 1959

A. Lane, *English Porcelain Figures of the 18th Century*, London, 1961

G. Savage, *Englische Keramik*, Wien, 1961

The Sixth Wedgwood International Seminar. The Exhibition Catalogue, April 20–22, 1961, M. H. De Young Memorial Museum, San Francisco, California

B. Watney, *English Blue and White Porcelain of the 18th Century*, London, 1963

J. Corely, M. D. Schwartz, *The Emily Winthrop Mils Collection. The Work of Wedgwood and Tassie. The Brooklyn Museum*, New York, 1965

F. A. Barrett, *Worcester Porcelain and Lund's Bristol*, London, 1966

P. W. Meister, *Sammlung Pauls. Porzellan des 18. Jahrhunderts*, Bd. I, Meissen, Frankfurt a. M., 1967

Antiques, April 1968

A. L. Thorpe, "Derby Porcelain Figure of Andromache", *Burlington Magazine*, October 1968

A. Kelly, *Wedgwood Ware*, London–Sydney, 1970

F. A. Barrett, A. L. Thorpe, *Derby Porcelain*, London, 1971

R. Reilly, G. Savage, *Wedgwood, the Portrait Medallions*, London, 1973

Christie's Highly Important English and Continental Porcelain. The Property of Stewart Granger, Esq., 20 May 1963

Christie's, Fine Wedgwood Wares, English Porcelain and Pottery, 30 November 1964, Nos. 120, 121, pl. facing p. 30

Christie's, *The Montegu Collection of Fine Worcester Porcelain*, 19 February 1968, No. 257, pl. XI

Christie's, *English Pottery and Porcelain*, 4 March 1968, No. 90, pl. facing p. 25

Christie's, *Fine English Porcelain*, 28 October 1968, No. 73

Christie's, *English Pottery of the 18th and 19th Centuries*, 26 January 1970, No. 124, pl. facing p. 24

Christie's, *Fine English Porcelain*, 15 June 1970, No. 107, pl. IV

Christie's, *Fine English Porcelain*, 16 November 1970, No. 114, pl. facing p. 31

Christie's, *Fine English Porcelain*, 19 April 1971, No. 212, pl. 13

Christie's, *Fine English Pottery and Porcelain*, 22 May 1972, No. 161, pl. 6

Christie's, *Important English Porcelain*, 13 November 1972, No. 58, pl. facing p. 20; No. 106, pl. facing p. 38

Katalog sobraniya S. and V. Yevdokimovykh (Catalogue of the S. and V. Yevdokimov Collection), St. Petersburg, 1898

Katalog muzeya Obshchestva pooshchreniya khudozhestv (The Museum Catalogue of the Society for the Encouragement of Arts), St. Petersburg, 1904

N. Rotshtein, "Serviz s zelionoi liagushkoi" ("The 'Green Frog' Service"), *Stariye gody*, February 1910

M. Filosofov, "K istorii serviza s zelionoi liagushkoi" ("Notes on the History of the 'Green Frog' Service"), *Sredi kollektsionerov*, 1924, Nos. V–VI

R. Soloveichik, *Zapadnoyevropeisky farfor XVIII–XIX vekov (West European Porcelain of the 18th and 19th Centuries)*, Moscow, 1956

R. Soloveichik, "Farforovaya figura Davida Garricka v roli Richarda III" ("A Porcelain Figure of David Garrick As Richard III"), *Soobshcheniya Gosudarstvennogo Ermitazha (Reports of the Hermitage)*, vol. XVIII, 1960

L. Voronikhina, *Serviz s zelionoi liagushkoi (The "Green Frog" Service)*, Leningrad, 1962

E. Lisenkov, *Angliyskoye iskusstvo XVIII veka (English Art of the 18th Century)*, Leningrad, 1964

Gosudarstvenny Ermitazh. Prikladnoye iskusstvo kontsa XIX — nachala XX veka. Katalog vystavki (The Hermitage. Applied Art of the Late 19th and Early 20th Centuries. Exhibition Catalogue), Leningrad, 1974

ENGRAVINGS AND CARICATURES

G. K. Nagler, *Neues allgemeines Künstler-Lexikon*, München, 1828

Th. Wright, R. Evans, *Historical and Descriptive Account of the Caricatures of James Gillray*, London, 1851

Th. Wright, *The Works of James Gillray, the Caricaturist with the Story of His Life and Times*, London, s. a.

J. Grego, *Rowlandson the Caricaturist*, 2 vols., London, 1880

J. Ch. Smith, *British Mezzotint Portraits*, 4 vols., London, 1884

J. E. Wessely, *Richard Earlom*, Hamburg, 1886

J. E. Wessely, *John Smith*, Hamburg, 1887

A. Dobson, *William Hogarth*, London, 1891

J. Frankau, *Eighteenth Century Artists and Engravers William Ward, A.R.A., and James Ward, R.A. Their Lives and Works*, London, 1904

J. T. H. Baily, *Francesco Bartolozzi: a Biographical Essay with a Catalogue of Principal Prints*, London, 1907

F. O'Donoghue, *Catalogue of Engraved British Portraits in the Department of Prints and Drawings in the British Museum*, 6 vols., London, 1908–1925

M. D. George, *Catalogue of Political and Personal Satires . . . in the British Museum*, vols. V–X, London, 1938–52

J. Kainen, *John Baptist Jackson: 18th Century Master of the Color Woodcut*, Washington, 1962

R. Paulson, *Hogarth's Graphic Works*, London–New Haven, 1965

D. Hill, *James Gillray, 1756–1815. Drawings and Caricatures*, The Arts Council, London, 1967

R. Paulson, *Hogarth: His Life, Art, and Times*, 2 vols., New Haven–London, 1971

A. Benois, "Vystavka graviur" ("An Exhibition of Engravings"), *Riech*, 15 January 1916

E. Lisenkov, *Angliyskiye i frantsuzskiye graviury XVIII veka. Vystavka kruzhka liubitelei russkikh iziashchnykh izdaniy (English and French Engravings of the 18th Century. Exhibition of the Society of Lovers of Fine Russian Books)*, Petrograd, 1916

L. Dukelskaya, *Angliyskaya graviura XVIII veka. Katalog vystavki (English Engravings of the 18th Century. Exhibition Catalogue)*, Leningrad, 1963

L. Dukelskaya, *Angliyskaya bytovaya karikatura (English Topical Caricature)*, Leningrad–Moscow, 1966

L. Dukelskaya, *Tsvetnaya graviura na dereve J. B. Jacksona. Katalog vystavki (Coloured Woodcuts by John Baptist Jackson. Exhibition Catalogue)*, Leningrad, 1970

ENGRAVED GEMS

P. J. Mariette, *Description sommaire des pierres gravées du Cabinet de feu M. Crozat*, Paris, 1741

La Chau, La Blond, *Description des principales pierres gravées du Cabinet du Duc d'Orleans*, 2 vols., 1780–84

Catalogue des pierres gravées du Cabinet de feu le Duc d'Orleans . . ., Paris, 1786

R. E. Raspe, *Account of the Present State and Arrangement of Mr. James Tassie's Collection of Pastes and Impressions from*

INDEX OF ARTISTS, WORKSHOPS
AND CENTRES OF PRODUCTION WHOSE
WORKS ARE INCLUDED IN THE BOOK

ALKEN, SAMUEL

Aquatint engraver. Worked in London from 1780 to 1798. In 1780 exhibited an architectural drawing at the Royal Academy of Arts. In 1796 published *Views in Cumberland and Westmoreland*, and in 1798, *Views in North Wales*. Pl. 167

ALLAN, WILLIAM

Born in Edinburgh in 1782. Died there in 1850.

Painter of historical and genre scenes and portraits. Studied at the Trustees' Academy in Edinburgh. Worked mostly in London. From 1805 to 1814 and in 1844 lived in Russia. Pl. 303

ARCHAMBO, PETER

Silversmith. Apprenticed from 1710 to 1720. First hall-mark registered in 1721. Pl. 93

BACON, JOHN

Born in Southwark in 1740. Died in London in 1799.

Sculptor. Member of the Royal Academy. Exhibited at the Academy from 1796 to 1799. Made models for the Derby porcelain factory. Pl. 191

BARON, BERNARD

Born in Paris about 1700. Died in London in 1762.

Engraver. Apprenticed to the Parisian engraver Nicolas Henri Tardieu. Went to London in 1712 and returned to Paris in 1729, where Vanloo painted his portrait. Engraved works by Titian, Van Dyck, Holbein, Kneller, Ramsay and Hogarth. Pls. 75–78

BARTOLOZZI, FRANCESCO

Born in Florence in 1727. Died in Lisbon in 1815.

Stipple engraver and etcher. Studied at the Academy of Arts in Florence under the painter and engraver Ignatio Hugford. From 1745 to 1751 worked with Joseph Wagner in Venice. In 1764 went to London where he had a large studio. From 1768, member of the Royal Academy of Arts. After 1802 lived in Lisbon. Pls. 263, 264

BEDFORD, FRANCIS

Born in London in 1779. Died there in 1885.

Bookbinder. Pupil of the famous binder Levi, from whom he inherited his workshop. Worked in London from 1841 to 1850, where he had his own workshop at 61 Frith Street in Soho. For a few years he lived on the Cape of Good Hope. Returning to London, he opened a new workshop at 91 York Street. Bedford's bindings were awarded medals at exhibitions in England and France. Pl. 119a

BENTLEY, THOMAS. See WEDGWOOD, JOSIAH

BONINGTON, RICHARD PARKES

Born in Arnold, near Nottingham in 1802. Died in London in 1828.

Painter of landscapes and historical subjects. Studied under Louis Francia in Calais, and then at the École des Beaux-Arts and the studio of Antoine Jean Gros in Paris. In 1822 he displayed his first picture at the Paris Salon. Took part in the exhibitions of the Society of Artists of Great Britain and the Royal Academy in London. Travelled widely. Worked in France, England, Belgium and Italy. Pls. 299–302

BOREMAN, ZACHARIAH

Born in 1738. Died in 1810.

Landscape painter on porcelain. Worked first at the Chelsea porcelain factory, then, about 1783, moved to Derby. In 1794 returned to London. Pl. 197

BOW (Stratford-le-Bow, Middlesex)

A porcelain factory producing bone china. In 1744 the merchant Edward Heylin and the painter and engraver Thomas Frye, took out a patent for a new method of producing porcelain. The first known articles from the factory date from after 1749, when Frye had already registered another patent. In 1750 the business passed to the merchants Weatherby and Crowther, though Frye remained as manager until 1759. In 1776 the factory was taken over by William Duesbury, who closed it and transferred the moulds to Derby. Pls. 187–190

BOWER, GEORGE

Died in London in 1690.

Medallist. From 1650 to 1689, engraver at the London Mint. Pls. 47–50

BRAGG

Gem cutter. Worked in London in the late 18th and early 19th centuries. Pl. 236

BRANGWYN, FRANK WILLIAM

Born in Bruges in 1867. Died in Dichlingen in 1956.

Painter in oils and watercolours, graphic artist. Painted historical and religious subjects, genre scenes and still lifes. Worked in the decorative arts. Studied in London, first at the Arts School in South Kensington, then at William Morris's studio. Lived mostly in England and Belgium. Pls. 353, 354

BRETHERTON, JAMES

Born about 1750.

Aquatint engraver and etcher. Worked in London from 1770 to 1790. Engraved his own designs as well as works by other artists. The majority of his engravings are from the designs of Henry Bunbury. Pl. 170

Ancient and Modern Gems with a Few Remarks on the Origin of Engraving on Hard Stones and Methods of Taking Impression of Them in Different Substances, London, 1786

R. E. Raspe, *A Descriptive Catalogue of General Collection of Ancient and Modern Engraved Gems, Cameos as well as Intaglios, Taken from the Most Celebrated Cabinets in Europe; and Cast in Coloured Pastes, White Enamels, and Sulphur by James Tassie, Modeller*, 2 vols., London, 1791

C. W. King, *Antique Gems: Their Origin, Uses and Value*, London, 1866

F. M. O'Donoghue, *Descriptive and Classified Catalogue of Portraits of Queen Elizabeth*, London, 1894

S. Reinach, *Pierres gravées des collections Marlborough et d'Orléans...*, Paris, 1895

L. Forrer, *Biographical Dictionary of Medallists, Coin-, Gem- and Seal-engravers, Mint-masters, Ancient and Modern*, 8 vols., London, 1904–30

A. Graves, *The Royal Academy of Arts*, 8 vols., London, 1905–6

A. Graves, *The Society of Artists of Great Britain*, London, 1907

O. M. Dalton, *Catalogue of Engraved Gems of the Post-classical Periods in the British Museum*, London, 1915

R. H. Ilchester, "Cameos of Queen Elizabeth, and Their Reproduction in Contemporary Portraits", *Connoisseur*, June 1922, pp. 65–72

C. Lippold, *Gemmen und Kameen des Altertums und der Neuzeit*, Stuttgart, 1922

R. S. Strong, *Portraits of Queen Elizabeth I*, Oxford, 1963

Yu. Etkind (Kagan), "Russian Themes in the Works of the English Gem Cutters William and Charles Brown", *Burlington Magazine*, August 1965

Yu. Kagan, *Western European Cameos in the Hermitage Collection*, Leningrad, 1973

V. Antonov, "New Documents About the Brown's Gems", *Burlington Magazine*, December 1978

J. Georgi, *Opisaniye rossiyskogo imperatorskogo stolichnogo goroda Sankt-Peterburga (A Description of St. Petersburg, the Capital City of the Russian Empire)*, St. Petersburg, 1794

M. Maximova, "Imperatritsa Yekaterina II i sobraniye reznykh kamnei Ermitazha" ("Empress Catherine II and the Hermitage Collection of Engraved Gems"), in: *Gosudarstvenny Ermitazh. Sbornik (The Hermitage. Collection of Articles)*, issue I, Petrograd, 1921

M. Maximova, *Gosudarstvenny Ermitazh. Rezniye kamni XVIII–XIX vekov. Putevoditel' po vystavke (The Hermitage. Engraved Gems of the 18th and 19th Centuries. A Guide to the Exhibition)*, Leningrad, 1926

Gosudarstvenny Muzei izobrazitel'nykh iskusstv imeni A. S. Pushkina. Proizvedeniya angliyskogo iskusstva iz sovietskikh muzeyev. Katalog vystavki (The Pushkin Museum of Fine Arts. English Art from Soviet Museums. Exhibition Catalogue), Moscow, 1956

Yu. Etkind, "Animalisticheskiye motivy v reznykh kamniakh V. i Ch. Brownov" ("Animalistic Motifs in the Engraved Gems of William and Charles Brown"), *Soobshcheniya Gosudarstvennogo Ermitazha (Reports of the Hermitage)*, vol. XVIII, 1960

Yu. Etkind, "Rezniye kamni Williama i Charl'za Brownov v Ermitazhe. Istoriya kollektsii" ("Engraved Gems by William and Charles Brown in the Hermitage. History of the Collection"), *Trudy Gosudarstvennogo Ermitazha (Papers of the Hermitage)*, vol. VIII, 1965

Gosudarstvenny Ermitazh. Iskusstvo portreta. Katalog vystavki (The Hermitage. The Art of Portraiture. Exhibition Catalogue), Leningrad, 1972

Yu. Kagan, "Kabinet slepkov Jamesa Tassie v Ermitazhe" ("Cabinet for the Gem Casts of James Tassie in the Hermitage"), *Trudy Gosudarstvennogo Ermitazha (Papers of the Hermitage)*, vol. XIV, 1973

Yu. Kagan, *Gosudarstvenny Ermitazh. Rezniye kamni Williama i Charl'za Brownov. Katalog vystavki (The Hermitage. Engraved Gems by William and Charles Brown. Exhibition Catalogue)*, Leningrad, 1975

BROWN, CHARLES

Born in London in 1749. Died there in 1795.

BROWN, WILLIAM

Born in London in 1748. Died there in 1825.

Gem cutters. Worked independently and in collaboration. Exhibited at the Royal Academy. William Brown also took part in exhibitions at the Society of Artists and the British Institution. From 1786, and for nearly ten years, the brothers fulfilled commissions from the Russian Empress, Catherine II. In 1788 they visited Paris. Pls. 220–228

BRUNN

Gunsmith. Worked in London in the early 19th century. Pl. 322

BUNBURY, HENRY

Born in Mildenhall, Suffolk in 1750. Died in Keswick in 1811.

Caricaturist. Received no formal training. Sketched caricatures and humorous genre scenes. Exhibited at the Royal Academy of Arts from 1770 to 1809. Pl. 170

BURCH, EDWARD

Born in London in 1730. Died there in 1814.

Gem cutter, designer of wax portraits and miniaturist. Studied at the St. Martin's Lane Academy, then at the Royal Academy Schools. Took part in the exhibitions of the Society of Artists and the Royal Academy. From 1770, associate, after 1771, member, and from 1794 to 1812, librarian at the Royal Academy. Court cutter to George III and Stanisław Poniatowski. Pls. 232–234

BURNE-JONES, EDWARD

Born in Birmingham in 1833. Died in Fulham in 1898.

Painter and designer. Made designs for stained glass windows, tapestries, mosaics, and furniture. Also worked in ceramics. Did much, in collaboration with William Morris, to revive crafts. Studied theology at Exeter College, Oxford. In 1854 became interested in the work of the Pre-Raphaelite painters, such as Milles and Hunt. In 1855 met John Ruskin and Dante Gabriel Rossetti from whom he took painting lessons. In 1861 he became a founder member of the firm Morris, Marshall and Faulkner. In 1877 his first large exhibition was held in the Grosvenor Gallery. Pls. 350–352

CALLOW, WILLIAM

Born in Greenwich in 1812. Died in Great Missenden, Buckinghamshire in 1908.

Engraver and watercolourist. From 1823 worked as an engraver colourer. In 1829 moved to Paris. Member of the Royal Society of Painters in Watercolours and the Royal Geographical Association. Worked in London and Paris. Pl. 305

CAMERON, CHARLES

Born in London in 1746. Died in St. Petersburg in 1812.

Architect. Studied under his father Walter Cameron, a member of the Carpenters' Company. In 1767 exhibited six proof prints of the ancient Thermae at the Free Society of Artists. In 1772 published *The Baths of the Romans* (second edition appeared in 1775). In 1779 went to St. Petersburg. Court architect of Catherine II. From 1802 to 1805, Architect-in-Chief to the Admiralty. Worked at Tsarskoye Selo (now Pushkin), and Pavlovsk near St. Petersburg and also in the Ukraine. Pls. 151–157

CHELSEA

A porcelain factory in the suburbs of London. Founded about 1745. One of its first owners was Sir Everard Fawkener. From 1749 the manager of the factory was Nicholas Sprimont, who became its owner in 1758. In 1769 the factory was taken over by William Duesbury and John Heath of Derby. The Chelsea factory produced fine crockery, figurines, and the especially popular so-called Chelsea toys — scent-bottles, sweet jars, snuff-boxes, hand-seals, etc. Pls. 114, 116–118, 191–194

CHIPPENDALE, THOMAS

Born in Otley, Yorkshire in 1718. Died in London in 1779.

Cabinet-maker. Worked in London from 1748. In 1754 opened a workshop in St. Martin's Lane. In 1760 elected member of the Society of Arts. In 1754 published a pattern-book *The Gentleman and Cabinet-maker's Director*. Pls. 182, 183

COOPER, SAMUEL

Miniaturist. Pls. 24–26

COURTAULD, AUGUSTINE

One of the foremost silversmiths of the first half of the 18th century. Worked in England. Apprenticed from 1701 to 1708. First hall-mark registered in 1708. Pls. 85, 94

COURTAULD, SAMUEL

Born in 1720. Died in London in 1765.

Silversmith. Son of Augustine Courtauld. Apprenticed to his father from 1734 to 1747. First hall-mark registered in 1746. Member of the Guild after 1763. Pls. 108, 110

COX, JAMES

Watch-maker. Expert in clockwork mechanisms. Inventor of several mechanical devices. Worked in London from 1760 to 1788. Founded a museum of unusual clocks and mechanical figures at Sprint Gardens. Pls. 205, 207–209

COZENS, ALEXANDER

Born in St. Petersburg (?) about 1717. Died in London in 1786.

Drawing master and engraver. Settled in London no later than 1742. In 1746 moved to Italy and Germany. Taught drawing at Christ's Hospital and at Eton College. The author of a series of theoretical treatises and practical guides to landscape composition. Pls. 162, 163

CRANE, WALTER

Born in Liverpool in 1845. Died in London in 1915.

Painter, designer and illustrator. Studied under his father, Thomas Crane, and William Linton. Member of the Brotherhood of Pre-Raphaelites and successor of William Morris. Headed the Arts School in Manchester. Took part in exhibitions in England, the Paris Salon (1878) and at the World Exhibitions of 1889 and 1900. Pl. 335

CRIPPS, WILLIAM

Died in 1767.

Silversmith. Apprenticed from 1731 to 1738. First hall-mark registered in 1743. Member of the Guild from 1750. Pl. 95

CROKER, JOHN

Born in Dresden in 1670. Died in London in 1741.

Silversmith and medallist. Apprenticed to goldsmiths in Germany and the Netherlands. After 1691 studied medal die engraving. From 1697, assistant engraver, after 1705, principal engraver to the London Mint. Pls. 51, 52

DANCE (later DANCE-HOLLAND), NATHANIEL

Born in London in 1735. Died near Winchester in 1811.

Painter of portraits, literary and historical subjects. Studied under Francis Hayman. Worked in Italy and England. Pls. 132, 133

DAWE, GEORGE

Born in London in 1781. Died in Kentish Town in 1829.

Portrait painter and engraver. Studied under his father Philip Dawe, then at the Royal Academy of Arts. In 1819 moved to St. Petersburg, where executed, with the help of the Russian assistants, Wilhelm Golike (died 1847) and Alexander Poliakov (1803–1835), portraits for the 1812 War Gallery in the Winter Palace. From 1809, associate, and from 1814, member of the Royal Academy of Arts. In 1820 elected honorary member of the St. Petersburg Academy of Arts. Pls. 306–308

DEAN, JOHN

Born about 1750. Died in London in 1798.

Mezzotint engraver. Studied under Valentine Green. In 1777 opened his own studio. From 1777 to 1791, exhibited at the Royal Academy. Pl. 253

DERBY

A porcelain factory probably founded about 1750. The proprietors of the factory from 1756 were William Duesbury, who in 1752 and 1753 decorated Derby (or Derbyshire) figures in London, and John Heath. In 1769 they acquired the Chelsea factory. After 1779 Duesbury became the sole owner of the enterprise. In 1786 he passed the business over to his son, who ran it with Michael Kean. In 1811 Robert Bloor bought up the factory. In 1848 it was closed. The present Royal Crown Derby Porcelain Company is a different firm founded in 1876. Pls. 195–197

DIRL, JOHN

Born in 1860.

Stained glass window designer, draughtsman and tapestry weaver. Studied under William Morris, after the death of whom, in 1896, he managed the workshop at Merton Abbey, continuing the work of Morris. Made cartoons for tapestries after designs by Burne-Jones and his own works, produced carpet, textile and wall-paper designs. Pls. 350–352

DOBSON, WILLIAM

Born in London in 1610. Died there in 1646.

Portrait painter. Also painted pictures on biblical and historical subjects. Studied at the Robert Peake School in London. Worked in the studio of Anthony van Dyck. Pl. 20

DUBOIS, D. F.

Watch-maker. Worked in London in the late 18th century. Pl. 269

EARLOM, RICHARD

Born in London in 1743. Died there in 1822.

Engraver. Studied under Giovanni Battista Cipriani. In 1766 produced his first engravings, in 1767, his first mezzotints. In 1775 he issued a two-volume set of engravings called *The Picture Collections of Houghton Hall*, and in 1777, facsimile etchings after Claude Lorraine's *Liber Veritatis*. Pl. 259

EAST, ALFRED

Born in Kettering in 1849. Died in London in 1913.

Landscape painter and engraver. Studied first in Glasgow, then in Paris under Joseph Nicholas, Robert Fleury and William Adolphe Bouguerau. Exhibited regularly at the Royal Academy of Arts. Member of the Society of Artists of Great Britain. Travelled widely in Japan, France, Italy, Spain and Egypt. Pl. 334

ELLIS, WILLIAM

Born in London in 1747. Died there in 1810.

Engraver and draughtsman. Pupil and assistant of William Wollett. After 1785 worked in collaboration with his wife, Elisabeth Ellis. Pl. 266

ELMES, WILLIAM

Caricaturist (possibly an amateur and not a professional artist). Worked in the first quarter of the 19th century. Pls. 317, 318

ENGLEHEART, GEORGE

Born in Kew in 1752. Died there in 1829.

Painter. His teachers were George Barret and Joshua Reynolds. Began his career as a landscape and animal painter, also worked in watercolours. First exhibited at the Royal Academy in 1773. From 1775 painted portrait miniatures. Pl. 214

ETRURIA. See WEDGWOOD, JOSIAH

EWORTH, HANS

Worked in Antwerp and in London from about 1530 to 1570. Portrait painter. Also painted allegorical compositions. The artist's name is encountered in various spellings: Eworsz, Ewotes, Herrard, Hreet, etc. Pl. 4

FLAXMAN, JOHN

Born in York in 1755. Died in London in 1826.

Sculptor and draughtsman. After 1775 worked at the Wedgwood and Bentley ceramics factory Etruria, where he executed designs and models for articles in jasper and other ceramic ware. Pls. 249, 250

FOGELBERG, ANDREW

Jeweller. Active from 1773 to 1800. Pl. 180

GAINSBOROUGH, THOMAS

Born at Sudbury in 1727. Died in London in 1788.

Portrait and landscape painter. Studied in London under Hubert Gravelot and Francis Hayman. Worked in Ipswich, Bath and London. Pls. 131, 253

GHEERAERTS, MARCUS, THE YOUNGER

Born in Bruges about 1561. Died in London in 1635.

Painter. Painted mostly portraits. Probably studied under Dutch painters resident in London. Worked in London. Pl. 6

GIBSON, JOHN

Born in Gyffin in 1790. Died in Rome in 1866.

Sculptor. Studied in Liverpool, first under a cabinet-maker, and then under a mason. Began to exhibit sculpture in Liverpool in 1816 and in London in 1817. Moved to Rome in 1817. Influenced by Canova, with whom he studied in Rome. Sent his works to be displayed at exhibitions in London and accepted commissions from English patrons of the arts. In 1840 visited London. After 1847 visited England nearly every year. Member of the academies of London, Munich, Rome and others. Pls. 328, 329

GILES, JAMES

Born in 1718. Died in 1780.

Porcelain painter. Apprenticed to a goldsmith. Owned a workshop for porcelain painting in London. From 1760 to 1780, decorated pieces for the Bow, Worcester and other factories. Worked in partnership with the painter O'Neale. Pl. 204

GILLOIS, PIERRE

Gold- and silversmith. His name appears in the records of Dublin goldsmiths in 1753–54. First hall-mark registered in 1754. Pl. 109

GILLRAY, JAMES

Born in Chelsea in 1756. Died in London in 1815.

Engraver. Studied under the engraver Harry Ashby, then attended classes of the Royal Academy. After 1779, turned to caricature, engraving his own compositions as well as drawings by amateur caricaturists. After 1791 he worked for the publisher Mrs. Humphrey. The last of the artist's caricatures is dated 1811. Pls. 173–179

GIRL-IN-A-SWING FACTORY

A porcelain factory at Chelsea. So named from the first figure ascribed to it. The name survived to distinguish it from the other more famous Chelsea factory belonging to Nicholas Sprimont.
It is thought that the Girl-in-a-Swing factory operated from about 1749 to 1754 (according to some sources, it was still in existence in 1760). The factory specialized in producing various miniature painted pieces known as Chelsea toys: scent-bottles, seals, snuff-boxes, sweet jars, etc. Pieces from this factory are extremely rare. Generally, they are not painted. Pl. 115

GOLIKE, WILHELM. See DAWE, GEORGE

GREEN, VALENTINE

Born in Salford near Oxford in 1739. Died in London in 1813.

Mezzotint engraver. Studied under Robert Hancock in Worcester. In 1765 went to London. In 1775 elected associate engraver of the Royal Academy of Arts. In 1789 granted the right to engrave pictures from the Dusseldorf Arts Gallery. Pls. 254, 255, 257

HALLIDEY, THOMAS

Born in Birmingham about 1780.

Medallist and engraver of token dies. Owner of a button and cuff-links factory in Birmingham. Pls. 313, 314

HARRIS, WILLIAM

Gem cutter. Worked in London in the last quarter of the 18th century. Exhibited at the Royal Academy of Arts. Pl. 229

HASTIE, WILLIAM

Born in Edinburgh in 1755. Died at Tsarskoye Selo near St. Petersburg in 1832.

Architect. In 1784 arrived in St. Petersburg with a group of Scottish artists. Studied with Charles Cameron. Worked in the Tauride province (South Russia). Designed the first iron bridges in St. Petersburg. After 1810 headed the Construction Committee responsible for organizing the planning and construction of Russian towns. Pls. 149, 150

HEMMING, THOMAS

Died between 1795 and 1801.

Silversmith. Apprenticed between 1738 and 1746. First hall-mark registered in 1745. From 1760 to 1782, chief goldsmith to the King. Member of the Guild from 1763. Pl. 97

HEPPLEWHITE, GEORGE

Died in London in 1786.

Famous cabinet-maker. Began work in the Gillon workshop, then began his own business. His book *The Cabinet-maker's and Upholsterer's Guide* was published by his widow in 1788. Pls. 271–273

HERING, CHARLES

Bookbinder. Worked in London in the late 18th and early 19th centuries. Pl. 331

HOGARTH, WILLIAM

Born in London in 1697. Died there in 1764.

Painter, caricaturist and engraver. Until 1717 apprenticed to the goldsmith Ellis Gambe, then attended the St. Martin's Lane Academy, where he studied with John Thornhill. In 1753 published his aesthetic treatise *The Analysis of Beauty*. Pls. 74–78

HONITON

A lace producing centre in Devonshire. Pls. 325–327

HOPPNER, JOHN

Born in London in 1758. Died there in 1810.

Portrait painter. Attended classes of the Royal Academy of Arts. Worked in London. Pl. 129

HUNTER, GEORGE

Gunsmith. Worked in Edinburgh in the first half of the 19th century. Pl. 321

HUSSY

One of the two goldsmiths whose hall-mark, "Hussy and Joyce", was registered in 1729. It is possible that this was the same Edward Hussy, who from 1753 worked independently. Pl. 54

JACKSON, JOHN BAPTIST

Born in 1700 or 1701 in England. Died about 1777 in Teviot(?).

Engraver. Produced coloured woodcuts and chiaroscuro engravings. Studied xylography under Elisha Kirkall. Worked in London, then from 1725 in Paris, from 1730 in Italy, from 1738 to 1745 in Venice. In 1745 he returned to London. Pls. 83, 84

JONES, GEORGE

Silversmith. First hall-mark registered in 1719. Member of the Guild from 1731. Resigned in 1748. Pl. 93

JONES, JOHN

Born about 1745. Died in 1797.

Mezzotint and stipple engraver. From 1775 to 1791, took part in exhibitions of the Incorporated Society of Artists. In 1783 began his own press. Pl. 260

JONES, THOMAS

Born in Aberedw, Radnorshire in 1743. Died there in 1803.

Painter of landscapes with mythological figures. Studied under Richard Wilson in London. Worked in Italy and England. Pl. 123

JOYCE. See HUSSY

KALTHOEBER, CHRISTIAN

Outstanding bookbinder. Worked in London from 1780 to 1813 (sometimes in collaboration with Baumgarten) in the Empire style. Also imitated the famous French binder Roger Rayne. Pl. 119d

KANDLER, CHARLES FREDERICK

Silversmith. First hall-mark registered in 1727. Possibly German in origin and a relative of Johann Kandler, the modeller at the Meissen porcelain factory. Pls. 88–90

KENNING, GEORGE

Silversmith and publisher. Worked in London in the late 19th century. Produced a large number of Masonic medals. Pls. 323, 324

KNELLER, GODFREY

Born in Lübeck in 1646. Died in London in 1723.

Portrait painter. Pupil of Ferdinand Bol in Amsterdam. Worked in Rome and Venice; after 1675, in London. Pls. 42, 45, 46, 72, 73

LAMERIE, PAUL DE

One of the foremost English goldsmiths of the first half of the 18th century. Apprenticed from 1703 to 1713. From 1716, goldsmith to the King. Member on the Committee of the Company in 1738 to prepare the petition and bill to Parliament for revision of hall-marking. Elected fourth, third and second senior of the Guild. Pls. 59, 60, 86, 87, 93

LAWRENCE, THOMAS

Born in Bristol in 1769. Died in London in 1830.

Portrait painter. In 1786 attended classes at the Royal Academy of Arts. After 1792, court painter and associate of the Royal Academy, after 1794, member and from 1819, its president. Pls. 294–298

LELY, PETER (Pieter van der Faes)

Born in Suste, Westphalia in 1618. Died in London in 1680.

Portrait painter. Also painted mythological and religious subjects. Studied under Franz Pietersz de Grebber in Haarlem. In 1637 followed William of Orange to England. Worked in London. After 1660, court painter. Pls. 35, 39–41, 43, 44

LONGTON HALL

First porcelain factory in Staffordshire. Founded about 1750 by William Jenkinson, William Nicklin and William Littler, who managed it. Operated until 1760. Pl. 111

MacARDEL, JAMES

Born in Dublin in 1728 or 1729 (?). Died in London in 1765.

Engraver. Studied mezzotint engraving under John Brooks. In 1746 went to London, where he opened a print shop. Pl. 70

MARCHANT, NATHANIEL

Born in Sussex in 1739 (according to some sources, in Germany in 1755). Died in London in 1816.

Gem cutter and engraver of coin dies. Pupil of Edward Burch. After 1766, member of the Society of Artists of Great Britain. From 1773 to 1782, worked in Rome. From 1791, associate, and from 1809, member of the Royal Academy of Arts and the Society of Antiquaries in London. Member of the Stockholm and Copenhagen Academies of Art. From 1782 to 1815, worked at the London Mint. Pls. 235, 238, 240

MARLOW, WILLIAM

Born in Southwark in 1740. Died in Twickenham in 1813.

Landscape painter. Studied under Samuel Scott. Worked in Italy and England. Pl. 148

MASTER IB

Goldsmith. Worked in London in the late 18th century. Pl. 30

MENELAWS, ADAM

Born in Edinburgh in 1756. Died in St. Petersburg in 1831.

Architect. In 1784 went to St. Petersburg with a group of Scottish artists. Studied with Charles Cameron and Nikolai Lvov. Headed the School of Earthwork Construction, founded by Nikolai Lvov. Active in Torzhok, Moscow and Tsarskoye Selo near St. Petersburg. Pls. 158–161

MEYER, CHARLES

Bookbinder. Worked in London from 1797 to 1809. Meyer's bindings usually carried a label, marked: *Charles Meyer, bookbinder to the Queen and Princess. 2 Hemming's Row.* Pl. 330

MILTON, JOHN

Died in 1815

Medallist and gem cutter. Worked in the second half of the 18th and early 19th centuries. From 1789 to 1798, assistant engraver at the London Mint. After 1792, member of the Society of Antiquaries. From 1785 to 1802, exhibited at the Royal Academy of Arts. Pls. 311, 312

MINTONS, LIMITED. Stoke-on-Trent, Staffordshire

A factory producing porcelain and faïence. Founded in 1793 by the engraver Thomas Minton (1766–1836), William Pownall and Joseph Poulson. After 1808 Minton continued the business on his own account, and after 1817, with his sons (Thomas Minton & Sons). From 1883 the factory was called Mintons Ltd. In 1871 Marc-Louis Solon joined the factory and introduced the *pâte-sur-pâte* technique to decorate porcelain. Pls. 337, 338

MINTON, THOMAS. See MINTONS, LIMITED

MORLAND, GEORGE

Born in London in 1763. Died there in 1804.

Painter of genre scenes and landscapes in oils and watercolours. Studied under his father Henry Morland. From 1778 exhibited at the Royal Academy of Arts. Pls. 139–145, 164, 165, 258

MORRIS, WILLIAM

Born in Walthamstow, Essex in 1834. Died in London in 1896.

Poet, artist and social figure. In 1861 founded the firm Morris, Marshall and Faulkner. After 1865 the sole owner of Morris and Company. Tried to raise the level of artistic production and encourage the establishment in England of a number of handicraft societies and schools. Pls. 350–352

MORTIMER, JOHN HAMILTON

Born in Eastbourne in 1741. Died in London in 1779.

Painter of historical subjects and small portraits. Studied first under Thomas Hudson, then at the St. Martin's Lane Academy. In 1764 won first prize at the Society of Arts. From 1763 to 1773, took part in the exhibitions of the Incorporated Society of Artists. In 1778 exhibited for the first time at the Royal Academy of Arts, and in the same year was elected associate of the Academy. Pl. 123

MORTLAKE FACTORY

A tapestry factory founded in 1619. Its first supervisor was the weaver from Bruges, Josse Amy. The production of the factory reached a particularly high point during the reign of Charles I, when tapestries from the cartoons of Raphael (*The Acts of the Apostles*), Rubens (*The Story of Achilles*) and others were produced. Another high point was reached in the 1660s and 1670s, when tapestries were made under the guidance of the Italian artist Berrio de Lecce. Pls. 31–34

NASMYTH, PATRICK

Born in Edinburgh in 1787. Died in Lambeth in 1831.

Landscape painter. Studied under his father Alexander Nasmyth. Worked in London. Pl. 304

NEWTON, RICHARD

Born in 1757. Died in London in 1798.

Caricaturist and miniaturist. Made portrait sketches. Pl. 171

NOLLEKENS, JOSEPH

Born in London in 1737. Died there in 1823.

Sculptor. Studied in London, then in Rome, where he lived between 1760 and 1780. After 1771, member of the Royal Academy. Pls. 134, 135

OPIE, JOHN

Born at St. Agnes near Truro in 1761. Died in London in 1807.

Painter of portraits, genre scenes and pictures on historical and literary subjects. Worked in Cornwall and London. Pl. 268

PANTIN, SIMON

Born in about 1680. Died in 1728.

Silversmith. First hall-mark registered in 1701. From 1712, member of the Guild. Pls. 61, 93

PINGO, LEWIS

Born in London in 1743. Died in Camberwell in 1830.

Medallist. Engraver of coin dies. Son of the famous medallist Thomas Pingo, and his successor at the London Mint: after 1776, assistant engraver, from 1779 to 1815, principal engraver. Pls. 292, 293

PISTRUCCI, BENEDETTO

Born in Rome in 1784. Died at Flora Lodge near Windsor in 1855.

Gem cutter and medallist. Studied in Naples and Rome. From 1812 to 1814, undertook several commissions from members of Napoleon's family. After 1816 assistant engraver to the London Mint, after 1817, principal engraver. Pls. 315, 316

PLIMMER, ANDREW

Born in 1763. Died in 1837.

Painter of portraits and miniatures. Studied under Richard Cosway. Pls. 212, 215

PLYMOUTH

From 1768 to 1770, the first English factory to employ hard-paste porcelain (from kaolin discovered in Cornwall). Founded by William Cookworthy. In 1770 transferred to Bristol. Pl. 199

POLIAKOV, ALEXANDER. See DAWE, GEORGE

PRATT, WILLIAM PITT

Bookbinder. Worked in London in the second half of the 18th century. Pl. 119c

PRIDDLE, ROBERT

Gem cutter. Worked in London in the second half of the 18th century. Pl. 230

RAEBURN, HENRY

Born in Stockbridge in 1756. Died there in 1823.

Portrait painter and miniaturist. Studied under the goldsmith James Gilliland and then the painters David Deuchar and David Martin. From 1785 to 1787, lived in Italy. From 1792 exhibited at the Royal Academy. In 1812 elected president of the Edinburgh Society of Artists. From 1815, member of the Royal Academy. Pl. 267

RAWLINS, THOMAS

Born about 1620. Died in London in 1670.

Medallist, gem cutter and coin die engraver. Playwright. Apprenticed to Nicholas Briot. From 1641 worked at the London Mint. Pls. 17–19

REYNOLDS, JOSHUA

Born in Plympton in 1723. Died in London in 1792.

Painter and art theoretician. Painted portraits and historical pictures. Studied under the portrait painter Thomas Hudson. Worked in London. Founder member of the Royal Academy of Arts and its first president. Pls. 124–127, 254, 256, 257, 260

RIVIERE, ROBERT

Born in London in 1808. Died there in 1882.

Born into a family of French émigrés. His father was a drawing master and medallist. Worked first in the book trade, then opened a binder's workshop. Fulfilled commissions from celebrated collectors, such as the Duke of Devonshire and Captain Brooke. For his bindings he was awarded a gold medal at the London Exhibition of 1851. Pl. 119b

ROACH

Cabinet-maker. Worked in London in the last quarter of the 18th century. Details of his life are obscure. Probably he emigrated to America: in 1824 a certain Francis Roach, cabinet-maker, was active in Baltimore. Pls. 241–244

ROBINS, JOHN

Died in 1831.

Silversmith. Apprenticed from 1764 to 1771. First hall-mark registered in 1774. Member of the Guild after 1781. Pls. 288, 289

ROLLOS, PHILIP

Silversmith. Worked in England in the late 17th and early 18th centuries. Took British citizenship in 1690 or 1691. First hall-mark registered in 1697. Member of the Guild from 1698. Pls. 55, 56

ROMNEY, GEORGE

Born in Dalton-in-Furness, Lancashire in 1734. Died in Kendal in 1802.

Painter. Painted portraits and historical scenes. Studied under Christopher Stelle, a travelling portrait painter. Worked in Kendal, York and London. Pl. 128

ROWLANDSON, THOMAS

Born in London in 1757. Died there in 1827.

Draughtsman, etcher and caricaturist. Also produced landscape, genre and portrait sketches and watercolours. Studied at the Royal Academy Schools. From 1775 to 1787, exhibited regularly at the Royal Academy. Travelled widely in France, Italy, the Netherlands and Germany. Pls. 166–169, 172

RUSSELL, JOHN

Born in Guildford in 1745. Died in Hull in 1806.

Painter and engraver. Painted chiefly portraits. Frequently employed pastel and left a number of writings devoted to this technique. Studied under Francis Cotes. Took part in the exhibitions of the Society of Artists. From 1772, associate, and from 1778, member of the Royal Academy of Arts. From 1790, court painter. Pls. 251, 252

SHAYER, WILLIAM, THE ELDER

Born in Southampton in 1788. Died in Shirley in 1879.

Landscape and animal painter. Received no formal training. From 1824 to 1873, took part in the exhibitions of the Society of Artists of Great Britain. From 1862, member of the Society. Pl. 332

SHERATON, THOMAS

Born in Stockton-on-Tees in 1751. Died there in 1806.

Cabinet-maker and decorator. His fame rests on publications of furniture designs: *The Cabinet-maker and Upholsterer's Drawing Book*, 1791–94; *The Cabinet Dictionary*, 1803; *The Cabinet-maker, Upholsterer and General Artist's Encyclopaedia*, 1804–6. Pls. 274–276

SIMON, THOMAS

Born in Yorkshire in 1618 (?). Died in London in 1665.

Medallist, gem cutter, coin and seal die engraver. Apprenticed to Edward Greene and Nicholas Briot. In 1637 began to work as a medallist. From 1645, assistant engraver and from 1649 to 1660, principal engraver at the London Mint. Often worked from the models of his brother Abraham Simon. Pls. 22–26

SLEATH, GABRIEL

Born in 1674. Died in 1756.

Silversmith. Apprenticed from 1691 to 1701. First hall-mark registered in 1707. Pls. 57, 58

SMITH, JOHN

Born in Daventry in 1652. Died in London in 1742 (in some sources, the date of his death is recorded as 1720).

Mezzotint engraver. Apprenticed to Isaac Becket and Jan van der Vaard. Godfrey Kneller gave him permission to reproduce his works. Pls. 72, 73

SMITH, JOHN RAPHAEL

Born in Derby in 1752. Died in Doncaster, Yorkshire in 1812.

Mezzotint and stipple engraver, portrait painter in pastel. From 1768 lived in London. His first engraving appeared in 1769. Pls. 256, 262

SOLON, MARC-LOUIS. See MINTONS, LIMITED

SPODE, Stoke-on-Trent, Staffordshire

A factory producing faïence and porcelain. Founded in 1770 by Josiah Spode (1733–1797) who was apprenticed to Thomas Whieldon of Fenton, then to John Turner. After the death of its founder, the business passed to his son, Josiah Spode the Younger, and then to his grandson, also Josiah Spode. In 1829 the firm was bought by William Taylor Copeland. Pl. 291

SPRIMONT, NICHOLAS

Born in 1718. Died in 1770.

Silversmith. Probably arrived in England in 1742. Apprenticed to his uncle, Nicholas Joseph Sprimont. From 1747 lived in Chelsea, where he owned a porcelain factory. Pls. 99, 100

STAFFORDSHIRE

County in central England, famous in the 18th and 19th centuries, as a centre of stoneware and porcelain production. Pl. 290

SUNDERLAND

In the late 18th and early 19th centuries, there were several ceramic factories in this part of the country, which produced pieces from white and yellow porcelain, decorated with printed designs and sometimes with lustre. Pls. 319, 320

TEARLE, THOMAS

Goldsmith. Apprenticed from 1707 to 1715. First hall-mark registered in 1719. Pls. 68, 107

TEBO

Modeller and repairer. Ceramic figures bearing impressed marks T and $T°$ are attributed to him. These marks are found in Bow, Worcester and Plymouth pieces. After 1775 he worked at the Josiah Wedgwood factory. Pl. 193

THOMAS WEBB AND SONS

A glass factory at Wordsley near Stourbridge. In the last quarter of the 19th and early 20th century produced multi-layered coloured glass. Pls. 339–343

TORKLER, PETER

Watch-maker. Active in the second half of the 18th century. Pl. 206

TURNER, JOHN

Born in 1738. Died in 1786.

Ceramist. One of the most celebrated Staffordshire masters. In 1786 founded the Lane End factory which produced high-quality pieces in porcelain and stoneware. John Turner's sons, William and John, owned the factory until 1806. Pls. 277, 278

VINCENT, EDWARD

Silversmith. Apprenticed from 1699 to 1712. The first pieces bearing his hall-mark appeared about 1720. Pl. 93

WALKER, ROBERT

Born in 1607. Died in London between 1658 and 1660.

Portrait painter. Possibly studied under Anthony van Dyck. Worked mostly in London. Pl. 21

WALTON, FRANK

Born in Dorking, Surrey in 1840. Died in London in 1928.

Landscape painter in oils and watercolours. Attended classes at the Royal Academy of Arts. Worked chiefly in London. Pl. 333

WARD, WILLIAM

Born in London in 1766 (according to some sources, about 1762). Died in Mornington Place in 1826.

Mezzotint and stipple engraver. A pupil and assistant of John Raphael Smith. After 1786 worked independently. After 1795 exhibited at the Royal Academy of Arts. In 1814 elected associate engraver of the Royal Academy. Pl. 258

WATTS, JOHN

Mezzotint engraver. Worked in London in the 1760s to 1780s. Pl. 261

WEBB, THOMAS, AND SONS. See THOMAS WEBB AND SONS

WEDGWOOD, JOSIAH

Born in Burslem, Staffordshire in 1730. Died there in 1795.

Outstanding ceramist. Born into a family of potters. Apprenticed to his brother Thomas Wedgwood. From 1754 to 1759, partner of

Thomas Whieldon. In 1759 founded his own factory at Ivy House in Burslem. In 1769, in partnership with Thomas Bentley, founded a new factory, Etruria, which produced articles in porcelain, jasper, basalt and other ceramic ware. Pls. 113, 211, 245–250, 279–287

WEST, BENJAMIN

Born in Springfield, Pennsylvania in 1738. Died in London in 1820.

Painter. Received no formal training. Painted historical and mythological pictures and portraits. Active in Philadelphia, Rome and London. Pl. 130

WHIELDON, THOMAS

Born in 1719. Died in Staffordshire in 1798.

Celebrated ceramist. In 1740 founded his factory at Fenton Low (or Little Fenton) in Staffordshire. From 1754 to 1759, his partner was Josiah Wedgwood. The factory produced pieces in porcelain, then in great vogue, with coloured glazes (so-called marbled and tortoise-shell wares) and black wares with gilded decoration. In also produced earthenware in a variety of colours — agateware, for example. Creamware, which formed the basis of many of the Whieldon pieces, was later perfected by Josiah Wedgwood. Pls. 112, 113

WHITE, CHARLES

Died in 1780.

Painter. Painted still lifes with flowers and fruit. Worked in London. Pls. 146, 147

WHITE, FULLER

Died in 1775.

Silversmith. Apprenticed from 1734 to 1744. First hall-mark registered in 1744. Member of the Guild from 1750. Pls. 96, 98, 101, 102

WILLEMS, JOSEPH

Born in Brussels in 1716. Died in Tournay in 1766.

Sculptor. From the 1750s to the 1760s, worked in Chelsea. In 1766 returned to work in his native Tournay. Pl. 116

WOLLETT, WILLIAM

Born in Maidstone, Kent in 1735. Died in London in 1785.

Engraver and etcher. Studied under John Tynney and later François Vivarès. Engraved mostly landscapes and historical scenes. From 1766, member of the Incorporated Society of Artists. Pls. 265, 266

WOOD, SAMUEL

Born about 1704. Died in 1794.

Jeweller. Apprenticed from 1721 to 1730. First hall-mark registered in 1733. More than once elected senior of the Guild. Pl. 95

WOOLEY, JOHN

Gunsmith. Active in the late 18th and early 19th centuries. Pl. 270

WOOTTON, JOHN

Born about 1686. Died in London in 1765.

Painter of horses, sporting subjects and landscapes. Studied under Jan Weik. Worked in New Market and in London. Pl. 71

WORCESTER

One of the most important English porcelain factories. Founded in 1751 by the physician Dr. John Wall and the apothecary William Davis. In 1783 the factory was taken over by Joseph and John Flight. In 1792 Martin Barr joined the company. In the same year Robert Chamberlain founded a rival company in Worcester. In 1840 the two factories were amalgamated, and after 1852 the firm became known as the Royal Worcester Porcelain Company. Pls. 198, 200–204

WRIGHT, CHARLES

Died in 1815.

Silversmith. Apprenticed from 1747 to 1754. First hall-mark registered in 1757. Member of the Guild from 1758. Elected senior of the Guild in 1785. Pl. 122

WRIGHT, JOSEPH (Joseph Wright of Derby)

Born in Derby in 1734. Died there in 1797.

Painter of portraits, landscapes and genre scenes. Studied with Thomas Hudson. Worked chiefly in Derby. Pls. 136–138, 255, 259

WYATT, JAMES

Born in Staffordshire in 1748. Died near Marlborough in 1813.

Architect. Studied in Rome and Venice. After 1768 worked in England. From 1770, associate, and from 1785, member of the Royal Academy. Pls. 241, 242

WYLD, WILLIAM

Born in London in 1806. Died in Paris in 1889.

Lithographer and painter in watercolours. Painted mostly landscapes. Studied under Louis Francia in Calais. Strongly influenced by Richard Parkes Bonington. Lived for the greater part of his life in France. Exhibited at the Paris Salon, the New Society of Painters in Watercolours in London and the Royal Academy of Arts. Pl. 336

WYON, THOMAS, THE YOUNGER

Born in Birmingham in 1792. Died at the Priory Farmhouse near Hastings in 1817.

Medallist. Son of the celebrated medallist Thomas Wyon the Elder. Studied at the Royal Academy. In 1817 became principal engraver to the London Mint. Pls. 309, 310

YEO, RICHARD

Born in London about 1720. Died there in 1779.

Medallist, gem cutter and coin die engraver. From 1749, assistant engraver, from 1775, principal engraver to the London Mint. Took part in the exhibitions of the Incorporated Society of Artists and the Royal Academy. Pls. 91, 92, 231

LIST OF PLATES

134
Joseph Nollekens.
Laughing Child.
Second half of the 18th century

135
Joseph Nollekens.
Portrait of Charles Fox. 1791

136
Joseph Wright of Derby.
*Firework Display
at the Castel Sant'Angelo
in Roma (La Girandola).* 1778

137, 138
Joseph Wright of Derby.
*An Iron Forge
Viewed from Without.* 1773

139, 140
George Morland.
The Approach of the Storm.
1791

141
George Morland.
A Village Road. C. 1790

142
George Morland.
A Country Scene. C. 1790

143
George Morland.
Gypsies. C. 1790

144
George Morland.
Woman Selling Fish

145
George Morland.
Peasant at a Window

146, 147
Charles White.
Flowers and Birds. 1772

148
William Marlow.
A Seaside View

149
William Hastie. Project
for a country house. 1794

150
William Hastie.
Project for a house in the
pseudo-Gothic style. 1794

151, 153
Charles Cameron.
Design for a door. 1780–85

152
Charles Cameron.
Designs for a boudoir. 1780–85

154
Charles Cameron.
Design for a staircase. 1780–85

155
Charles Cameron.
Design for a ceiling. 1779–82

156
Charles Cameron.
Design for a stove. 1779–82

157
Charles Cameron.
Designs for stoves (?)

158
Adam Menelaws.
Project for gates. 1820s

159
Adam Menelaws.
Project for a farm. 1818

160
Adam Menelaws.
Project for a tower. 1821

161
Adam Menelaws. *Landscape
in the Alexandrovsky Park
at Tsarskoye Selo.* After 1828

162, 163
Alexander Cozens.
Studies of Skies

164
George Morland.
Landscape with Wayfarers

165
George Morland. *Morning.* 1790

166
Thomas Rowlandson.
Gossiping Women

167
Thomas Rowlandson.
The Art of Scaling. 1792

168
Thomas Rowlandson.
The Chase. 1793

169
Thomas Rowlandson.
The Dinner. 1787

170
Henry Bunbury.
A Sunday Evening. 1772

171
Richard Newton.
*Saturday Night, or a Cobbler
Settling the Week's Account
with His Wife.* 1795

172
Thomas Rowlandson.
A Butcher. 1790

173
James Gillray.
The Gout. 1799

174
James Gillray.
The Fall of Icarus. 1807

175
James Gillray. *Attitude!
Attitude Is Every Thing!* 1805

176
James Gillray.
Very Slippy-Weather. 1808

177
James Gillray.
Les Invisibles. 1810

178, 179
James Gillray.
Matrimonial-Harmonics. 1805

180
Andrew Fogelberg.
Vase. 1770–71

181
Vase-censer.
Beginning of the 19th century

182, 183
Dressing commode.
1760s or 1770s

184
Armchair. Mid-18th century

185
Cloth depicting the Siege
of Gibraltar. Last quarter
of the 18th century

186
Handkerchief depicting
a fishing scene. Last quarter
of the 18th century

187
Harlequin.
The Bow factory. *C.* 1755

188
Water.
The Bow factory. *C.* 1760

189
Minerva.
The Bow factory. *C.* 1760

190
Boscage: *Sporting Group.*
The Bow factory. *C.* 1765

191
David Garrick as Richard III.
Chelsea-Derby. *C.* 1775

192
An Allegory of Music.
Chelsea-Derby. *C.* 1775

193
The Shoe-black.
Chelsea-Derby. *C.* 1775–80

194
*Andromache Weeping over
the Ashes of Hector.*
Chelsea-Derby. *C.* 1775–80

195
Vase-censer and lid.
Derby. *C.* 1765

196
A Cow and Her Calf.
Derby. *C.* 1763–65

197
Solitaire set. Derby. *C.* 1790–94

198
Basket. Worcester. *C.* 1770

199
Winter. Plymouth. *C.* 1770

200
Basket with lid and stand.
Worcester. *C.* 1765–70

201
Sugar bowl and lid.
Worcester. *C.* 1775

202
Cup and saucer.
Worcester. *C.* 1775

203
Plate. Worcester. *C.* 1770

204
Side plate. Worcester. *C. 1770*

205
James Cox. Turnip watch. 1775

206
Peter Torkler.
Table clock. 1780s

207
James Cox. Table clock. 1770s

208, 209
James Cox.
Dressing-table clock. 1772

210
Girandole. Late 18th century

211
Girandole. Late 18th century

212
Andrew Plimmer.
Portrait of a Young Woman

213
Unknown painter. *Portrait of a Young Man in a Wig.*
1780s

214
George Engleheart.
Portrait of Princess Gagarina

215
Andrew Plimmer. *Portrait of a Man in a Blue Frock Coat*

216, 217
Fan. 1780s

218, 219
Fan. 1780s

220
William Brown.
Intaglio: *Head of Hygeia.*
Before 1785

221
Charles Brown.
Intaglio: *Mars and Bellona.*
C. 1785

222
Charles Brown, William Brown.
Intaglio: *The Death of Socrates*

223
Charles Brown, William Brown.
Cameo: *A Tiger*

224
William Brown. Intaglio:
The Abduction of Europa.
C. 1783

225
Charles Brown. Intaglio:
A Horse Frightened by a Lion

226
Charles Brown, William Brown.
Cameo: *Catherine II Crowning Prince Potiomkin with Laurels.* 1789

227
Charles Brown.
Cameo: *Allegory of the Defeat of the Turkish Fleet.* 1791

228
Charles Brown, William Brown.
Cameo: *Catherine II Instructing Her Grandsons*

229
William Harris. Intaglio:
Bust of a Woman in a Veil

230
Robert Priddle.
Intaglio: *Leda and the Swan*

231
Richard Yeo.
Intaglio: *Diana with a Bow*

232
Edward Burch.
Intaglio: *Head of Sappho*

233
Edward Burch.
Intaglio: *Sacrifice to Minerva*

234
Edward Burch.
Intaglio: *Dionysiac Bull*

235
Nathaniel Marchant.
Intaglio: *Head of Antinous* (?)

236
Bragg.
Intaglio: *Diana and a Dog*

237
Unknown engraver. Intaglio:
Portrait of Isaac Newton.
Second half
of the 18th century

238
Nathaniel Marchant.
Intaglio: *Profile of a Woman*

239
Unknown engraver. Intaglio:
Portrait of Elizabeth Hartley, an Actress of the Covent Garden Theatre. Second half of the 18th century

240
Nathaniel Marchant.
Intaglio: *Bacchus and Ariadne*

241, 242
Roach. Cabinet for gem casts

243, 244
Roach. Cabinet for gem casts

245
Medallion bearing the portrait of George Washington.
Wedgwood. 1778–79

246
Medallion bearing the portrait of Priestley. Wedgwood. 1778

247
Vase. Wedgwood. *C. 1770–75*

248
Ruin of a classical column.
Wedgwood. 1780s

249, 250
A pair of medallions,
War and *Peace.*
Wedgwood. Late 1770s

251
John Russell. *Portrait of Janet Grizel Cuming.* 1794

252
John Russell.
Portrait of a Young Girl in a Hood

253
John Dean.
Portrait of Mrs. Elliot. 1779

254
Valentine Green.
Portrait of Ladies Waldgrave.
1781

255
Valentine Green.
An Experiment on a Bird in the Air Pump. 1796

256
John Raphael Smith.
Portrait of Colonel Tarleton.
1782

257
Valentine Green.
Portrait of Emily Mary, Countess of Salisbury. 1781

258
William Ward.
The Farmer's Stable. 1792

259
Richard Earlom.
A Blacksmith's Shop. 1771

260
John Jones.
View from Richmond Hill.
1796

261
John Watts.
Portrait of Joseph Baretti.
1780

262
John Raphael Smith.
Portrait of Lady Caroline Montague (Winter). 1777

263
Francesco Bartolozzi.
Les Bacchantes. 1786

264
Francesco Bartolozzi.
Portrait of Miss Farren. 1792

265
William Wollett. *Shooting.*
1769

266
William Wollett, William Ellis.
Solitude. 1778

267
Henry Raeburn.
Portrait of Eleanor Bethune.
1790s

268
John Opie.
Portrait of Francis Winnicombe. 1796

269
D. Dubois.
Table clock. Late 18th century